D1483014

THE PHOTOGRAPH
and AUSTRALIA

THE

PHOTOGRAPH

and

AUSTRALIA

JUDY ANNEAR

ART
GALLERY
NSW

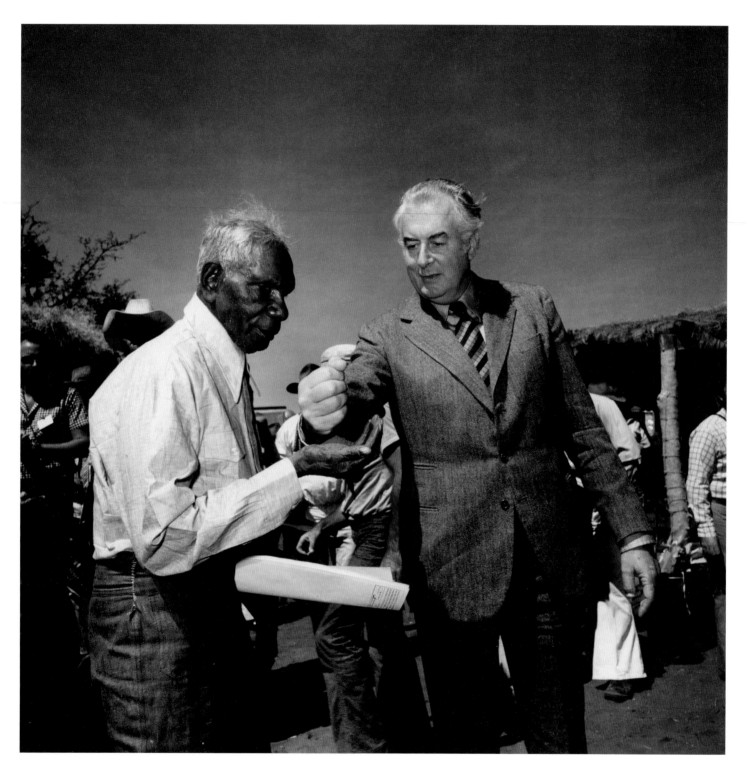

Mervyn Bishop
Prime Minister Gough Whitlam
pours soil into the hands of traditional land owner
Vincent Lingiari, Northern Territory 1975
Art Gallery of New South Wales, Sydney

FOREWORD

Photography has played a crucial role in the development of our understanding of Australia as a place and Australians as a people. For the colonists, it offered a way of documenting the colony; for settlers, it helped to represent new relationships between people and place; and for Indigenous Australians, it has been an important way of reclaiming the past and rebuilding identity. As a tool of documentation and self-reflection, photography charted the progress of modernisation in the early colonies and then in the states and territories after Federation in 1901. It also offered a way of critiquing ideas of nationhood and national identity.

This book is the product of extensive research undertaken by our senior curator of photographs, Judy Annear. It had its genesis in 2010 when the Art Gallery of New South Wales realised the need for a major photography project dealing with its conceptual and historical aspects in Australia. Gael Newton, the founding curator of photography at the Art Gallery of New South Wales, had undertaken groundbreaking research in the 1970s and early 1980s, particularly into pictorialism and modernism. In 2007 the Gallery published *Photography: Art Gallery of New South Wales collection*, in which multiple authors considered the Australian and international collections. However, the ever-expanding nature of the medium and changes in Australian culture meant that it was time for a new major publication and exhibition on the photograph and Australia that drew on holdings nationwide and beyond.

The photograph and Australia represents the latest thinking on photography and its connection to people, place, culture and history. We hope that it will contribute to an understanding of the richness and complexity of the medium and provide impetus for further explorations of the photograph's production, function and dissemination in this country. We trust that in doing so, it will also help place Australian photography in a broader international context.

I thank Geoffrey Batchen for his postscript, and the writers who contributed their expertise in the focus essays: Michael Aird, Kathleen Davidson, Martyn Jolly, Jane Lydon and Daniel Palmer. I also acknowledge the exemplary research and assistance of Eleanor Weber, Jess Hope and Georgina Cole on this project.

I am very grateful to the many lenders who have allowed their most rare and precious photographic material to be seen so that a new consideration of the dynamic between the photograph and Australia can be generated. My special thanks go to the President's Council for its support of this project.

Michael Brand
Director, Art Gallery of New South Wales

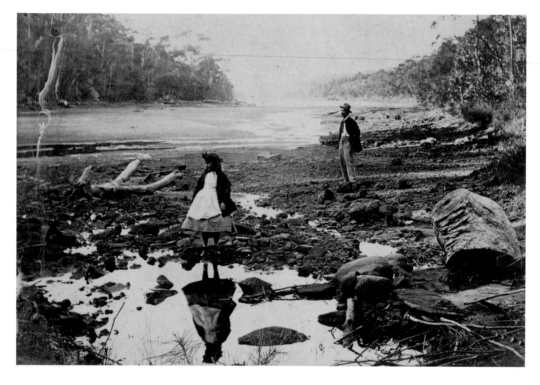

Unknown photographer
Australian scenery, Middle Harbour, Port Jackson c1865
Art Gallery of New South Wales, Sydney

INTRODUCTION
Judy Annear

There is no one simple trajectory if we think of 'Australia', whether as a European idea before colonisation, or as the land where Indigenous people lived well in advance of European settlement, and continue to do so. Australia in its current form has existed for 114 years. It has shifted and changed since the federation of the colonies in 1901 and while people might believe they know what 'Australia' and 'Australian' mean, apart from geographical realities, the rest seems to be fluid, open for discussion and debate.[1]

Photographic history in this environment is still being pieced together. Given the medium came into existence outside Australia, it joins all art forms, except the Indigenous, as being something photographers in Australia have both adapted to and adapted for their own purposes. Photography is, however, not only an art form, but also a recording device operated today by most people. It can function as mass communication and as esoteric art. There is nothing else quite like it, except perhaps the word, in terms of flexibility.

Before the advent of photography few people in the world saw their own image except in still water. Some could see themselves in glass or a mirror, but imaging the self in any sort of fixed way was the domain of the few who could afford a painted or drawn portrait, or a silhouette. The arrival of photography allowed for a new relationship to the image, one which rapidly became accessible to most. The first photographers in Australia were like travelling salesmen – they were men, as far as we know, and inveterate travellers. They spread the medium across the continent, as early contributors to the ubiquity for which photography is so renowned. They also brought from European pictorial conventions an understanding of how to pose and arrange their clients and their clients' possessions. These conventions had to be tailored to the limitations of the medium, its chemical processes, and the vagaries of light and time.

Photographing people, places and things enabled study of similarities and differences. It also led to an insatiable desire for images of anything that could be photographed. Daguerreotypes and ambrotypes were unique objects, but by the 1860s they had been superseded by cartes de visite, which were accessible and cheap. These were produced in their millions, traded between collectors, inserted into albums, and aided efforts in classifying the world at large. Prisoners were photographed and their images scrutinised for evidence that their crimes could be read in their faces or skulls.

Further, people found themselves being measured photographically and hierarchies developed around what were considered to be differences in race.

Recording photographically and then being able to access this record and distribute it is relatively recent and began with cartes de visite. In the nineteenth century, photographs were seen as memento mori, reminders of the transience of all earthly things; to the colonial mind it was acceptable to plunder the world and to have artefacts or living things exist just in photographs, shadowy stand-ins for the real thing. Such ideas have persisted, infiltrating André Malraux's 'museum without walls', which propounded a museum of reproductions or a collection of photographs of artworks, to make art more accessible.[2] Today we have the internet.

Ongoing research into Australian photography is occurring in academia, libraries and museums: there are many essays published, and as many popular picture books, but few scholarly books are available. Curator Gael Newton's *Shades of light: photography and Australia 1839–1988*, published in 1988 by the National Gallery of Australia, Canberra, paralleled and expanded upon photo historian Alan Davies' work in *The mechanical eye in Australia: photography 1841–1900*.[3] Neither of these important books is in print despite their invaluable research and overlapping but distinct approaches.

Shades of light traced, in chronological order, the arrival of photography in the colonies; early portraiture and depictions of town and country; the picture wars and pictorialism; camera clubs and global outreach. It examined the work of key photographers in relation to style and social realities: Harold Cazneaux and the rise of picture magazines, Max Dupain and modernity, war and society, expatriates, the 1970s social revolution, postmodernity, and the digital revolution. In parallel to Newton's research, Davies had been excavating the archives for the stories of photography's development, in the Macleay Museum at the University of Sydney and then at the State Library of New South Wales. His book *The mechanical eye in Australia*, which first appeared in 1977, was substantially revised and republished in 1985. It is a meticulously researched study of who was doing what where, when, and with what kind of apparatus. Peppered with contemporaneous accounts and facsimiles, the book remains the bible for Australian photo historians.

In 1988 the substantial work of Newton and Davies was furthered by cultural theorist Anne–Marie Willis, among others, with a critical approach to the social history of the photograph in Australia.[4] In more recent years, important publications by photo historian

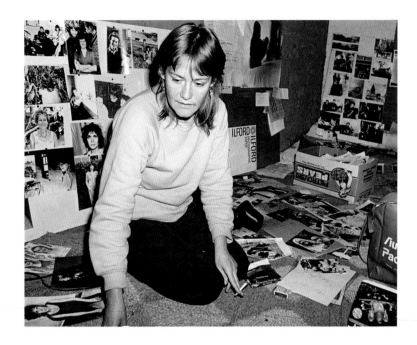

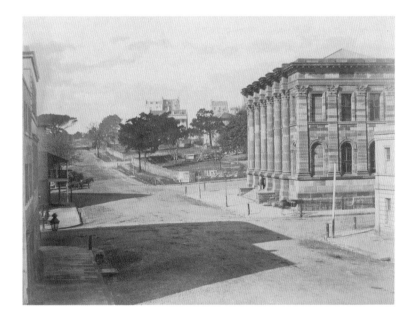

Sue Ford
Self-portrait 1983
from the series *Self-portrait with camera (1960–2006)* 2008
Art Gallery of New South Wales, Sydney

William Blackwood
Bridge Street and Exchange, Sydney in *Album*
by W Blackwood of Australian scenery c1858
National Gallery of Australia, Canberra

Helen Ennis, such as *Intersections: photography, history and the National Library of Australia* (2004) and *Photography and Australia* (2007) have appeared, along with other collection or state-focused books by the National Gallery of Victoria, Melbourne, and the Art Gallery of South Australia, Adelaide.[5]

Like its predecessors, this book emphasises the ways in which photographs, especially in the nineteenth century, function in social, cultural and political contexts, exploring photography's role in representing relationships between Indigenous and settler cultures, the construction of Australia, and its critique. It necessarily builds on the foundational work of Newton, Davies, and the following generation, but differs in taking a conceptual rather than strictly chronological approach to the medium, and in its consideration of the medium's relationship to time. Further, it examines the practices of collecting and disseminating the photograph, as well as the photographic constructions of place and webs of social connection.

In formulating a book on the photograph and Australia key issues had to be dealt with. There was the medium itself, Australia's history, and the relationship between them. Is Australian photography different? If so, how so, and in relation to what? One has to look at places with not dissimilar histories, such as Canada and New Zealand. And other questions: what has preoccupied photographers working in relation to Australia at various points in time? Have their concerns been primarily commercial, aesthetic, historical, realist, interpretive, or theoretical? Have they developed projects unique to the photographic medium; for example, large-scale classificatory projects? What have they achieved, what did it mean then, and what does it mean now?

In her 2007 book, Ennis noted 'one inescapable historical reality', that in Australia, unlike England and Europe, photography 'is not simply a product of the modern era, but is tied inextricably to the imperialist and colonialist underpinnings of modernity'. She proposed that the interaction between Indigenous and settler Australians had

> given rise to some of the most potent images in Australian visual culture, including studio studies of Aboriginal people taken in the second half of the nineteenth century, anthropological photographs produced during the late nineteenth and early twentieth centuries and ... works created by Aboriginal photographers themselves from the mid 1980s onward.[6]

Ennis also identifies photography of the land and its mythologising as landscape; and what she believes is a striking orientation toward realism. It is true that photography in Australia, New Zealand and Canada did not, in the twentieth century, explore abstraction,

whereas American photographers certainly did. Realist photography in the Australian context, however, takes many forms. In more recent decades the blurring between realism and narrative photography and the advent of overtly constructed photography is as conspicuous in Australia as it is elsewhere. Perhaps the tenuous hold that inhabitants of this country have over their national, social and political identities makes constructed photography appealing and this is true of other relatively recently post-colonial nations and societies.

Carol Payne and Andrea Kunard, in their 2011 book *The cultural work of photography in Canada*, identify three guiding questions:

> How have photographs contributed to visualising the 'imagined community' of Canada? In what ways does the narration of photographic images in the media or through exhibitions often shape our understanding of the past? And how do photographs that have been used in the broader project of memory work link past and present?[7]

Payne and Kunard, and their various essay writers, are concerned with how photographs and photographers have created the image of Canada over time, in contrast to Ennis who takes a variety of approaches to her range of subjects, such as land, Indigenous photography, pictorialism and modernism, contemporary practices, photojournalism and so on.

Angela Wanhalla and Erika Wolf use a different model in their book *Early New Zealand photography: images and essays* (2011). Each short, analytical essay accompanies a specific image or two. The accumulated material covers the period from photography's late arrival in New Zealand – possibly in 1848 – until about 1918. The editors note that the essays 'offer a variety of ways in which to read the visual' and 'address the changing and contradictory ways photographs have been read in the past and can be read today'. Further, their interest is in the materiality of the photograph, and they and their writers turn their attention to 'colonial cultures of photography and the photograph itself, as well as the photographer'. Finally,

> several themes connect these essays into a coherent statement about the place of photography in the cultural life of colonial New Zealand. Photographs played a key role in the construction of social identities of both Indigenous peoples and settlers.[8]

The common thread in their approaches is an interest in the ways in which photographs can be read over time, why they were made in the first place and how they were subsequently interpreted. This opens a liminal space. Photographs are in a perpetual state of becoming, of transition, depending on who looks at them and in what context. Because of what they may represent, and to whom, at different points in time, we can never know how 'real' they are despite their depictive character and their fixity. Digital images are also imbued with this tantalising tension.

A comparison can be made with photography in the United States and how its history is written, but North America was colonised one hundred years ahead of other former British colonies. Its photographic history is plural, being constantly written and rewritten, re-analysed and re-theorised by curators, critics, post-graduate students, and academics. Like all histories, the American model remains imperfect and incomplete; however, the very bulk of available material demands attention and engagement.

This book, *The photograph and Australia*, is structured around two major ideas or subjects: people and land (or country[9]). Australia-based photographers were and are exemplary as portraitists and landscape photographers, and continue to have much to say about people and the environment. How is photography used to approach these subjects, and how does it operate within society – aesthetically, technically, and politically? A significant focus is the photographs of people and the built and natural environment sent to world exhibitions in the nineteenth century. These presented an evolving image of the Australian colonies, and became the foundational wellspring of photography in the twentieth century. Photographs by practitioners such as George Goodman, Douglas Kilburn, Morton Allport, George Cherry, Louisa Elizabeth How, Thomas Glaister, Richard Daintree, the Duryea brothers, John Hunter Kerr, Samuel Sweet, Fred Kruger, Henry Chamberlain Russell, Charles Bayliss, JW Lindt, Paul Foelsche, Frank Hurley, Walter Baldwin Spencer, Harold Cazneaux, Ricky Maynard, and Sue Ford are considered alongside those by lesser known or anonymous photographers. Rare and unique objects sit beside quantities of cartes de visite, albums and selected publications. The non-chronological format highlights the dialogue between photographer and subject, the construction of place, the nature of family and relationships, distribution, collecting and classifying. Overriding is the consideration of the photograph as an aesthetic object and its evolution as an art form, not in terms of stylistic developments, but as a medium that induces wonder.

The six sections of this book (five chapters and postscript) consider overlapping themes – time, nation, people, place, transmission and history – creating a mosaic of ideas based on photographic practice in

Australia. The questions they pose around photography and its role in the evolution of the nation reveal a complex and adaptable medium.

The relationship of the photograph to 'Time' is discussed in chapter one, which examines how contemporary artists such as Anne Ferran, Rosemary Laing and Ricky Maynard reinvent the past through photography. The activities of nineteenth-century photographers such as George Burnell and Charles Bayliss are also discussed. Posing for effect and for posterity, whether in the landscape or in a studio, is practised early and quickly, regardless of culture. The manipulation by artists and photographers of imaginative time – the time of looking at the photographic image – allows for consideration of the nexus between space and time, how subjects can be momentarily tethered and, equally, how they can float free. The corresponding text by photo historian Daniel Palmer reflects upon memory and change in the evolution of self-portraiture.

Chapter two considers the idea of 'Nation', looking at the public role of the photograph in representing Australia at world exhibitions before Federation in 1901. Photography in this period enabled new classificatory systems to come into existence, affecting the rising sciences as much as evolving modernist art forms. Of particular importance was the use of the photograph to cement Darwinistic views that determined racial hierarchies according to superficial physical differences. The photograph also advertised the growing colonies to potential migrants and investors through the depiction of landscapes and amenities. Post Federation, photography interpreted and promoted the healthy (nationalist) body and, more recently, the mercurial forms and relationships of one subject to another. In a parallel text, photo historian Michael Aird discusses the importance for Aboriginal communities of identifying Indigenous people in nineteenth- and early twentieth-century photographs, referring to specific images by JW Lindt and Richard Daintree, among others.

The third chapter, 'People', analyses the uncertain post-colonial heritage that all Australians inherit and how that can be evidenced and examined in photographs. The chapter encompasses portraits by Tracey Moffatt and George Goodman, for example, and considerations of where and how people lived and chose to be photographed. These include the people of the Kulin nation of Victoria, those who resided at the Poonindie Mission in South Australia, the Yued people living at New Norcia mission in Western Australia, as well as the Henty family in Victoria, the Mortlocks of South

Australia, the children living at The Bungalow in Alice Springs and the people of Tumut in New South Wales. The associated text by historian Jane Lydon considers the relationships between photography, colonial culture and identity, specifically addressing the photograph as a form of cross-cultural communication.

'Place' is examined in chapter four, particularly in terms of the use of photography to enable exploration, whether to Antarctica (Frank Hurley), to map stars and further the natural sciences (Henry Chamberlain Russell, Joseph Turner), or to open up 'wilderness' for tourism or mining (JW Beattie, Nicholas Caire, JW Lindt, Richard Daintree). These largely positivist images are counterposed with the more contemplative work of Simryn Gill and David Stephenson, who use the photograph as a form of witnessing. Photographs are examined as both documents and imaginative interpretations of activity and place. In her related text photo historian Kathleen Davidson explores the role of photography in nineteenth-century science in the context of Empire, focusing on specific works by Thomas Glaister and Henry Barnes.

Chapter five, 'Transmission', considers the traffic in photographs and the fascination with the medium's reproducibility and circulation. The impossibility of making sense of the trillions of images now in existence animates the present-day interest in photographic archives in the work of scholars and artists such as Patrick Pound. The evidential aspect of the photograph has proven to be fleeting and only tangentially related to the thing it traces. The possibility of being able to fully decipher a photograph's meaning is remote, even when it has been promptly ordered and annotated in some form of album. Each photographic form expands the possibility of instant and easy communication, but the swarm of material serves only to prove the impossibility of order, classification, and accuracy. The photograph as an aestheticised object continues regardless of platform, and the imaginative possibilities of the medium have not been exhausted. Photo historian Martyn Jolly analyses the composition of carte-de-visite albums and the selection, classification and sharing of images in a corresponding text. He suggests that such albums functioned as the social media of the nineteenth century and reveal another side to the formality of the Victorian era.

Geoffrey Batchen's postscript elaborates his thinking around what a history of photography can be. Batchen noted at a 2011 seminar that nineteenth-century colonial identity is reflected in and refracted through photography, and this applies to subsequent identities.[10] There is much at stake in what might constitute the

nation state, which is as porous as photography is mutable. In this text, Batchen considers the relationship between the photograph and Australia, focusing on early ideas of the medium and its reception in the Antipodes alongside its mobility and that of its practitioners.

The task of this book is to formulate questions around Australian photography and its history, regardless of Australia's, and the medium's, permeable identity. While early photography in Australia made histories of the colonies visible, and a great deal can be read from the surviving photographic archives, interpretation of this material is often conjecture, and much remains oblique. Patrick Pound describes the sheer mass of photographs and images in the world today as an 'unhinged album'.[11] This dynamic of making, accumulating, ordering, disseminating, reinterpreting, re-collecting and re-narrating is an important aspect of photography. The intimate relationship, historically, between the photograph and the various arts and sciences, along with its adaptability to technological change and imaginative interpretations, allows for a constant montaging or weaving together of uses and meanings. This works against the conventional linear structure of classical histories and the idea of any progressive evolution of the medium. If what we are dealing with is a *phenomenon* rather than simply a *form* then analysing that phenomenon and its dynamic relationship to art, society, peoples, sciences, genres, and processes is critical to our modern understanding of ourselves and our place in the world as well as of the medium itself.[12]

In the 1970s, cultural theorist Roland Barthes wrote an essay entitled *The photographic message*.[13] While he focused primarily on press photography and made a distinction between reportage and 'artistic' photography, his pinpointing of the special status of the photographic image as a message without a code – one could say, even, a face without a name – and his understanding of photography as simultaneously objective and invested, natural and cultural, is relevant in the colonial and post-colonial context.

We search for clues in photographs of our past and present. In some ways this is a melancholy activity, in other ways valuable detective work. In many cases it is both. Photography since its inception has belonged in a nether world of being and not being, legibility and opacity. This book preserves some of the slipperiness of the medium, while providing a series of texts touching on the photographs at hand. The history of the photograph and its relationship to Australia remains tantalisingly partial; the ever-burgeoning archives await further excavation.[14]

1. See 'Timeline', pp 288-90.

2. André Malraux, *The psychology of art: museum without walls*, trans Stuart Gilbert, Zwemmer, London, c1949.

3. Alan Davies, *The mechanical eye in Australia: photography 1841-1900*, Oxford University Press, Melbourne, 1985; Gael Newton, *Shades of light: photography and Australia 1839-1988*, Australian National Gallery, Canberra & Collins Australia, Sydney, 1988 (for a text-only document based on this book see: photo-web.com.au/ShadesofLight/default.htm, accessed 20 May 2014).

4. Anne-Marie Willis, *Picturing Australia: a history of photography*, Angus & Robertson, Sydney, 1988.

5. See 'Bibliography', pp 266-69.

6. Helen Ennis, *Photography and Australia*, Reaktion books, London, 2007, p 8.

7. Carol Payne & Andrea Kunard, *The cultural work of photography in Canada*, McGill-Queen's University Press, Montreal, 2011, p xiii.

8. Angela Wanhalla & Erika Wolf (eds), *Early New Zealand photography: images and essays*, Otago University Press, Dunedin, 2011, pp 9, 13.

9. 'Country' is the term most often used by Indigenous Australians to refer to the land that is the core of their spirituality. The spirit of 'country' is central to the issues that are important to Indigenous people today. See australia.gov.au/about-australia/australian-story/austn-indigenous-cultural-heritage, accessed 29 July 2014.

10. Geoffrey Batchen, 'National histories of photography', seminar, Monash University, Melbourne, 4 August 2011; see also Geoffrey Batchen, 'Dutch eyes: a critical history of photography in the Netherlands,' in *Photography & Culture*, vol 1, no 1, July 2008, pp 119-24.

11. See 'Transmission', pp 227-33.

12. See Geoffrey Batchen, blog. fotomuseum.ch/2012/10/5-a-subject-for-a-history-about-photography, accessed 22 Apr 2014.

13. Roland Barthes, 'The photographic message', *Image, music, text*, trans Stephen Heath, Flamingo, London, 1984, pp 15-31.

14. Parts of this introduction were in a paper delivered at the symposium, *Borderlands: photography & cultural contest*, Art Gallery of New South Wales, Sydney, 31 Mar 2012.

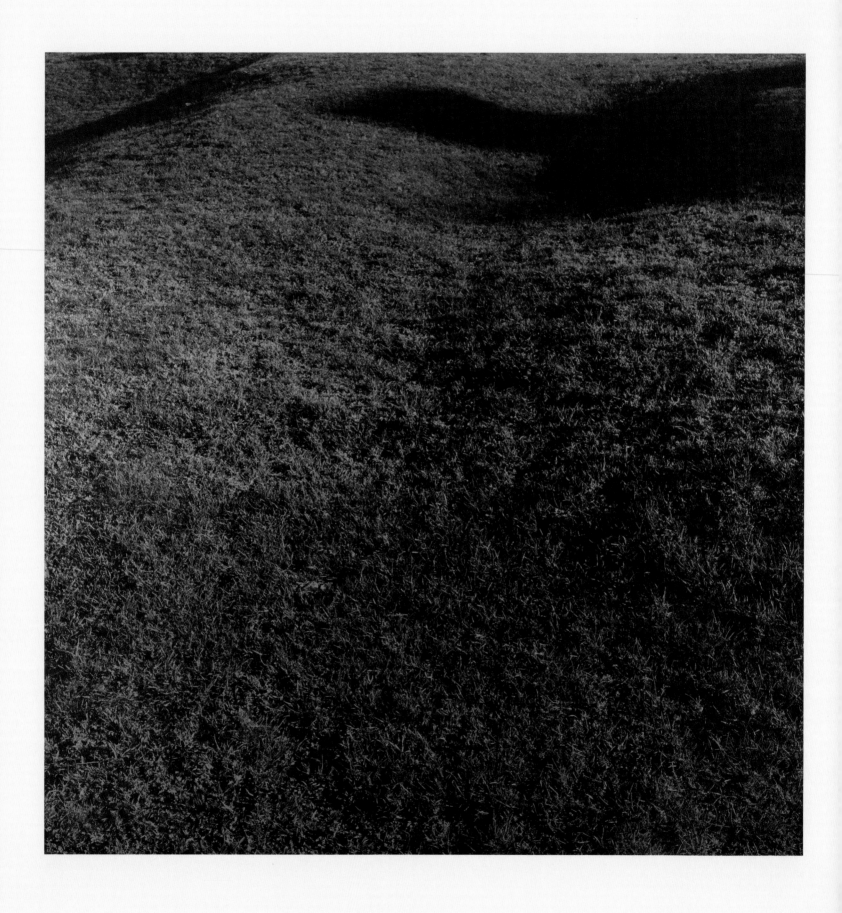

Looking at a photograph collapses time. In the act of looking we become cognisant of reading the photographic past through the grid of the image-laden present. That past can be a moment or a century ago. When we look we inevitably compare – what a place or person was like then, with what they are now. We reach back across time, or so we think, gazing directly into our own eyes or into the eyes of strangers, at places we have never been and events we have never experienced. Sometimes we consider how these things might be next time they are photographed. This kind of thinking and viewing presupposes linear time, and arises out of that much earlier recording device, writing.[1] The photograph is, in one very concrete way, always a slice of past time and this reinforces the idea of time as linear. But time, like the photograph, is not at all straightforward: 'the distinction between past, present and future', wrote physicist Albert Einstein in 1955, 'is only a stubbornly persistent illusion'.[2] We pore over photographs of people, places and events because of what we think we can glean of past time. Foolishly we believe that time, the most elusive phenomenon, can be controlled by our obsessive recording of it.

Photo historian Geoffrey Batchen has analysed the writings of William Henry Fox Talbot, English inventor of the calotype, and noted how in Talbot's struggle to describe photography and its function, it is as though the medium is 'an impossible conjunction of transience and fixity. More than that, it is an emblematic something/sometime … in which space *becomes* time, and time space'.[3] This fourth dimension, an imaginative space–time, can be summoned from the photographic form – whether daguerreotype, carte de visite, gelatin silver print or digital image – regardless of scale, colour or style. Although made at a specific moment, the photograph is particularly suited to reinvention each time it is viewed, its veracity always tested by its context and the subjectivity of the viewer.

Anne Ferran's 2008 series *Lost to worlds* (p 14) conjures out of the dark hollowed earth at Ross, Tasmania, ghostly presences of the women and children who lived and died at the Ross Female Factory between 1847 and 1854. The buildings have long gone but the ground contains a residue in its convexities and cavities. The large prints on aluminium shimmer a little so that the scale and effect of the photographs of the horizon-less ground add a kind of evanescence, the possibility of some kind of redemption through acknowledgment. This series is as poetic as its title yet what we are looking at is empty, as Ferran has noted.[4] Recognising the past can recede even further when attempting to capture a moment in time Ferran writes that such photographs 'know there is no living memory there

to reach for and subdued by this knowledge – they don't try'. To acknowledge belatedness (and muteness) is a very different way of understanding photography's relationship to time. This lag, which can be momentary or immense, is filled with looking, thinking and imagining.

The photographed landscape can therefore never be wholly empty; the application of the photographer to the ordering of the picture energises what the viewer sees. Ricky Maynard's series *Portrait of a distant land* 2005 (pp 34–35) presents, as the artist describes, 'history as an accumulation of lived experiences'.[5] The ten photographs contain the knowledge of what happened at each location and record how this is continuous and shared. In Maynard's work there *is* living memory and the photographs are constructed to hold and communicate remembered experiences. Maynard knows that Indigenous and settler Australians see particular places differently, and he takes ownership of the history of his people and shapes it, through images, for others.[6] The visual density and sense of the past in Ferran's work is not the same as Maynard's: while there is something embodied in *Lost to worlds* by virtue of the shape of the ground, *Portrait of a distant land* incorporates a self-awareness and authority through the inclusion of people in four of the pictures. Maynard's photography is always about a lived present which is strongly connected to time past. It conveys the experience and understanding of change and loss, and strength in continuity.

The photographer always intervenes in the picture, and in Rosemary Laing's 2010 series *leak* (pp 36–37), she built a larger-than-normal frame for a suburban home and photographed it half buried and upside down on a hillock on the Monaro plateau in New South Wales. In Australian art history, the Monaro symbolises a pastoral idyll; for nineteenth-century pastoralists, hard scrabble but money to be made; and for Indigenous people, dispossession and the fight for survival.[7] Laing considers the impact of colonisation, presenting the house frame as a misguided spaceship falling to earth. In *Eddie* from this series, the depiction of stormy weather and empty countryside works against colonial ambitions to fix place and time through settlement and cultivation of the land. The titles of the photographs embody ambiguity, taken as they are from the names of the peripatetic characters in Patrick White's 1979 novel *The Twyborn affair* where identities mutate across continents, gender and class. As art historian Abigail Solomon-Godeau writes: 'Cooma–Monaro is densely textualised. That is to say it is overwritten by narratives that even before Federation sought to establish and secure a notion of "Australian-ness"'.[8] In her work, Laing squeezes different forms of time (human and geological), as well as the familiar

page 14:
Anne Ferran
from the series
Lost to worlds 2008
Tasmanian Museum and
Art Gallery, Hobart

and unfamiliar, together. She uses the illusion of reality within the photographic plane to create a kind of imaginative shock.

Nearly 150 years earlier, adventurers George Burnell and EW Cole spent four months in 1862 voyaging nearly 2500 kilometres along the Murray River from Echuca in northern Victoria to Goolwa on the South Australian coast. Their small boat was both kitchen and darkroom. Along the way Burnell used a stereo camera to photograph people and views. A stop at Point McLeay where his brother-in-law Reverend George Taplin ran a mission for the Ngarrindjeri resulted in pictures of the people and their children (p 42). Long exposures, uniform horizon lines and distant views gave the river, sky and the Ngarrindjeri people a sombre and static air as details were bleached out by the exposure time or blurred through movement or wind or both. These stereographs are the first known photographic views of the Murray and they were marketed as a boxed set. A contemporary review noted that the stereos were 'all so true to nature as to carry one back in imagination to the scenes themselves'.[9] Burnell photographed the local Indigenous people on their canoes at Overland Corner on the Murray and twenty-five years later Charles Bayliss, on an official expedition, photographed the Ngarrindjeri again, this time at Chowilla Station.

Bayliss's 1886 series for the New South Wales Royal Commission into water conservation is a remarkable evocation, as much as documentation, of life along the Darling River in New South Wales, from Bourke in the north to Wentworth on the border of Victoria and South Australia, where the Darling meets the Murray. In the late nineteenth century Wentworth was the largest river port in Australia and dozens of paddle steamers worked the waterways. Bayliss captures the life of workers and travellers on and around the river. The photographer's ample foregrounds allow the breadth of the Darling, then in flood, to be seen in all its glory. Different kinds of boats and diverse people are carefully yet picturesquely posed. Bayliss injects dynamism through a use of diagonals and his subjects often gaze away from the camera into the distance, opening up a sense of space and vastness.[10]

Bayliss's photograph of Indigenous people at Chowilla Station (p 41) may appear as staged as a museum diorama but the description by fellow traveller, Canadian writer Gilbert Parker, provides another view of how the picture came to be and indicates the Ngarrindjeri's level of control:

> The photographer had nothing to suggest when it came to posing. The old men drew blankets round their shoulders, William arrayed himself in garments, that they should not be thought out of the fashion when posterity should gaze upon their counterfeit presentment; and without a word of suggestion these natives arranged themselves in a group, the grace and unique character of which a skilful artist only could show. And William with spear in hand upon a log, and with eyes upon an imaginary fish, said: 'his fellow blackfellow all right'.[11]

In the late 1970s when cultural theorist Roland Barthes was writing *Camera lucida* (1980), he could say of being photographed:

> I am at the same time: the one I think I am, the one I want others to think I am, the one the photographer thinks I am, and the one he makes use of to exhibit his art. In other words ... I do not stop imitating myself ... the Photograph represents that very subtle moment when ... I am neither subject nor object but a subject who feels he is becoming an object ... I am truly becoming a spectre.[12]

Here Barthes teases apart what the Ngarrindjeri already knew, what always happens in front of the camera lens and when the resulting image is viewed. The 'counterfeit presentment', which we see now when we look through time at the Ngarrindjeri posing for Bayliss, suggests the care which these people put into ensuring their representation should be appropriate for future scrutiny. The Ngarrindjeri's views on being photographed by Burnell twenty-five years earlier are not recorded, leaving us with the perspective of only those commentators who saw the resulting images and were carried back in time.[13] We are alerted to the whole process of photography, to consider how people posed and why others took photographs, in what contexts, and to ask how interpretations may shift over time. In this process we witness strange conjunctions of space and time, when the past, as much as the present and the future, becomes a zone that is multiple and mutable according to one's point of view.

If photographers and their subjects have often been at pains to communicate the meaning of events or to delineate accurately place or person, equally they have invented and extrapolated as much as viewers have. Photographic portraiture and self-portraiture are, at the least, designed to both expose and conceal. The self deliberately displayed to others for inspection was a rarity until the advent of cartes de visite in the 1860s. In the late 1880s, the democratisation of the camera enabled more people to take photographs, of themselves as much as others. More than 120 years on, digital imaging and instant transmission have enabled a kind of stop-motion scrutiny of life – slice by slice,

second by second. Anyone can be famous for exploiting themselves photographically, if for no other reason.

Photographing oneself compresses the relationship between actor and acted upon. The degree of control the photographer exerts over the self as subject, however, remains elusive even with the aid of mirrors. The final result is usually fluid – why else would self-portraitists persist in their endeavours?

As the classically posed studio pictures of Tasmanian photographers George Cherry and Alfred Bock demonstrate, early portraiture in Australia could be straightforward. Yet the genre encompassed more eccentric images too, like that of gentleman amateur Morton Allport dissecting a bird outdoors, or George Fordyce Story perched precariously with what may be some form of shutter release. And while Adelaide photographers such as Samuel Nixon or Philip J Marchant might appear with a camera and a double of themselves, others such as Samuel Dailey and Thomas Fox chose to be pictured in the elegant interior of their studio, broadcasting how they could make others look. It was noted in the press at the time that double exposures were akin to 'a man seeing a ghost of himself'.[14] Such images were novelties and good for business and so was the intimation of higher social status as constructed through the photographic frame.

As technology improved, outdoor shots became more numerous, whether of Bayliss fishing or JW Lindt's or Henry Toose's photography carts: the active self and tools of trade or business premises were subjects to advertise a novel and viable function. Photographs of photographers are the most calculated from the beginning of the medium and as film and social mores changed so did the form of such portraits. The most overtly constructed photographs are those from Simryn Gill's 1999 *Vegetation* archive, where the artist merges into the landscape and foliage, and Tracey Moffatt's *I made a camera* 2003. With its nostalgic, soft-focus, sepia tone, *I made a camera* (p 30) registers the history of the medium and who has controlled it, whereas the *Vegetation* archive (p 224) acknowledges the history of people and place over time, that 'original "snapshot" moment in which civilisation takes measure of its being different via its reflection in the other'.[15] In both, the protagonist's face is obscured. The very thing that made the medium so fascinating from its inception – the supposedly precise delineation of the face – is denied.

There is a distinction to be made between those who perform for the camera and those who sidestep the performative. The latter are more interested in how subjects interact with each other and how time might be recorded photographically. The scrutiny of the changing self in the work of Sue Ford, for example, has resulted in unique interlocking documents created with what seem to be the humblest of means. *Time series* 1962–82, *Self-portrait with camera (1960–2006)* 2008, the films *Faces* 1976 and *Faces 1976–1996* 1996 (with Ben Ford) have few parallels in approach, content and execution.[16] *Self-portrait with camera* is a group of forty-seven black-and-white and colour photographs of varying sizes (pp 10, 31, 270). Installed together on a long wall, some double or triple hung, and uniformly mounted in white, the series traces the life of the artist in a very specific way. Ford understood how the past could resonate in the present, noting in 1995: 'I have always been interested in how actions taken in the past could affect and echo in people's lives in the present. Most of my work is to do with thinking about human existence from this perspective'.[17]

Ford's depiction of herself and her friends in *Time series* and *Faces* left no room for the object of the camera to do anything other than stand there for the required number of seconds. In *Self-portrait with camera*, Ford tracks her adult life and her interaction with the still and moving camera. In part because the camera as an active tool is often as front and centre as Ford's face, there is a particular dynamism at work between the apparatus, the subject (Ford) and the viewer, from one photograph to the next. The forty-seven pictures progressing across the wall emphasise that dynamism and, equally, show how time knits things together and then unravels, dissolving at the last into thin air. This series is a dispassionate examination of the artist's own life, work and mortality, with friends, family and colleagues often entering the frame. Mirrors and reflections abound, some truly remarkable in the complexity of their presentation. Nonetheless, the plainness of the work provides its logic. Rather than ask, who am I? Ford's images ask, who is being photographed? And answer, this is me, a constantly changing yet curiously always recognisable entity both because of and regardless of time.[18]

The photographer reconstructs time, creating a pictorial environment which gestures toward a narrative more encompassing than words. In Robyn Stacey's *Chatelaine* 2010 (p 33) objects belonging to the Wentworth family in Sydney, and most particularly Sarah Wentworth, are presented.[19] As art historian Peter Timms writes, Stacey transforms 'inanimate objects into surrogate people. In the absence of their corporeal selves, those who made their lives in these [grand Sydney] houses are reborn through what they owned, loved, used and made'.[20] The wisteria seen in *Chatelaine* refers to Vaucluse House, the home of the Wentworths.

The chatelaine itself, a feminine version of a Swiss army knife, was Sarah's own. Through the photograph, Sarah Wentworth's life as well-to-do wife and gardener is contradicted by the florid arrangement which speaks of immodesty, a quality assigned to her by society at that time, despite her husband's power in colonial Sydney. Doomed to ostracism by the ruling class because of her convict origins and two children born out of wedlock, Sarah Wentworth sought succour through acquisition of the foreign objects which were, ironically, prized in that same 'new world'.

Cultural theorist Ross Gibson has written that 'being Australian might actually mean being untethered or placeless ... and appreciating how to live in dynamic patterns of time rather than native plots of place'.[21] Photographs always enable imaginative time and space regardless of their size and how little we might know of the ostensible subject. When people are oriented toward the camera and photographer, there is a gap which the viewer intuitively recognises. The gap is time as much as space. Occasionally – as in an anonymous 1855 daguerreotype taken at Ledcourt, Victoria, of Isabella Carfrae on horseback where we see a servant standing on the verandah, shading her eyes, and in the 1877 Fred Kruger photograph of the white-clad cricketer at Coranderrk – a subject in the photograph presses so close to the picture plane that we know for the time of the exposure they looked directly into an unknowable future and collide now with our gaze as we look back (pp 139, 149).

1. Helen Grace, *Culture, aesthetics and affect in ubiquitous media: the prosaic image*, Routledge, New York, NY, 2014, p 19; and Vilèm Flusser, *Towards a philosophy of photography*, Reaktion Books, London, 2006, p 9.

2. Albert Einstein, letter, 21 March 1955, Einstein archives, 7-245, quoted in Amelia Groom (ed), *Time: documents of contemporary art*, Whitechapel Gallery, London, 2013, p 13.

3. Geoffrey Batchen, *Burning with desire: the conception of photography*, The MIT Press, Cambridge, MA, 1997, p 91.

4. Anne Ferran, 'Empty', *Photofile*, no 66, Sept 2002, pp 7-8.

5. Ricky Maynard, *Portrait of a distant land*, Museum of Contemporary Art, Sydney, 2008, p 93.

6. Maynard 2008, p 93.

7. See Bill Gammage, *The biggest estate on earth: how Aborigines made Australia*, Allen & Unwin, Sydney, 2011, pp 331-33, for descriptions of the Monaro.

8. Abigail Solomon-Godeau, *Rosemary Laing*, Piper Press, Sydney, 2012, p 33.

9. *The South Australian Register*, 10 June 1862, p 2c, quoted in Ken Orchard, 'George Burnell 1830-1894: stereoscopic views of the River Murray, 1862', in Julie L Robinson (ed), *Century in focus: South Australian photography 1840s-1940s*, Art Gallery of South Australia, Adelaide, 2007, p 68; and Gael Newton, *Shades of light: photography and Australia 1839-1988*, Australian National Gallery, Canberra & Collins Australia, Sydney, 1988, p 49.

10. Helen Ennis, *A modern vision: Charles Bayliss photographer 1850-1897*, National Library of Australia, Canberra, 2008, pp 1-19.

11. Gilbert Parker, *Round the compass in Australia*, EW Cole, Melbourne, Sydney & Adelaide, 1892, pp 28-29.

12. Roland Barthes, *Camera lucida: reflections on photography*, Fontana, London, 1982, pp 13-14.

13. *The South Australian Register*, 10 June 1862, p 2c, where the unknown writer commends the stereographs for presenting 'a vivid and correct idea ... all so true to nature as to carry one back in imagination to the scenes themselves'.

14. *The South Australian Register*, 5 June 1865, p 2f, quoted in Robinson 2007, p 36.

15. Sharmini Pereira, 'The wink of recognition', in Wayne Tunnicliffe (ed), *Simryn Gill: selected work*, Art Gallery of New South Wales, Sydney, 2002, p 14.

16. Judy Annear, 'Getting close', *Like Art Magazine*, March 1999, Royal Melbourne Institute of Technology, Melbourne, pp 14-18; Anne Ferran, *Faces: 1976-1996, Sue Ford & Ben Ford*, Australian Centre for Photography, Sydney, 1997; Helen Ennis, *Sue Ford: a survey 1960-1995*, Monash University Gallery, Melbourne, 1995; Sue Ford, *A sixtieth of a second: portraits of women 1961-1981*, National Gallery of Victoria, Melbourne, 1987; and Shaune Lakin, *Sue Ford: self-portrait with camera (1960-2006)*, Monash Gallery of Art, Wheelers Hill, Vic, 2011.

17. Quoted in Ennis 1995, p 17.

18. An earlier version of part of this text appeared in Judy Annear, 'Why photograph people?', *Artlink*, vol 31, no 3, 2011, pp 36-38. See also Maggie Finch (ed), *Sue Ford*, National Gallery of Victoria, Melbourne, 2014; and Lakin 2011, pp 52-53.

19. Sarah was married to William Charles Wentworth (1790-1872) who was an explorer, author, barrister, landowner, statesman and highly influential in the colony of New South Wales. adb.anu.edu.au/biography/wentworth-william-charles-2782, accessed 27 July 2014.

20. Peter Timms, 'Playing a double game', *Tall tales and true*, Stills Gallery, Sydney, 2011, np; and Robyn Stacey & Peter Timms, *House*, Historic Houses Trust, Sydney, 2011.

21. Ross Gibson, 'Motility', in Catherine De Zegher (ed), *Here art grows on trees: Simryn Gill*, Australia Council, Sydney, & MER, Gent, 2013, p 260.

THE SELF-PORTRAIT
IN AUSTRALIAN PHOTOGRAPHY

Daniel Palmer

Today it has become a compulsion for anyone with a camera phone to turn it toward themselves, pose arm outstretched, tap the screen, and then share the picture on social media. Regardless of how we might interpret this contemporary phenomenon, the selfie reminds us that self-portraits are an occasion for photographers to play with their own representation. Photo-sharing platforms such as Facebook and Instagram encourage ordinary people to preen and pose so as to attract maximum attention and social cachet. Designed to inspire followers through strategically provocative images, or images that simply say 'look where I am', selfies are closely related to and often inspired by the narcissism of celebrity culture. Oxford Dictionaries named 'selfie' the word of the year in 2013 and Geoffrey Batchen has described this phenomenon as part of a 'shift of the photograph [from] memorial function to a communication device'.[1] As an evolving genre whose meaning has shifted over time, self-portraiture also demonstrates the changing status of the photographer. We are all photographers now, we can all say 'look at me', but during photography's first decades access to a camera was a privilege confined to a small commercial class of entrepreneurs, administrators and a few wealthy amateurs, most of whom aspired to more lofty official duties.

The unknown context for Australia's earliest self-portraits, and the uncertainty of their authorship, generates a degree of interpretive difficulty as we attempt to imagine the original scene. For instance, George Fordyce Story's disarmingly direct *Self-portrait* 1858–60 was, as its title suggests, probably set up by the aging physician, but the shutter may have been released by a family member or friend (p 25). The garden setting with watering can is surely autobiographical, given that the Quaker colonist was also an ardent naturalist (and briefly in charge of the Royal Tasmanian Botanical Gardens in Hobart). This image is among Australia's first photographic self-portraits, but we can only speculate as to its purpose.

George Cherry's studio photographs of his own family were clearly meant for personal remembrance. Nevertheless, two portraits of his son taken years apart – a sentimental ambrotype from 1856 and a cabinet card from the mid 1860s that shows the transformation of an infant into a young scholar (pile of books by his side) – also reveal developments in photographic technology (p 24). Cherry's own self-presentation eschews elaborate props: the bearded photographer simply stands next to a chair with a coat hung over it (p 24). This nonchalance, and the date of the image, suggests it might have been the simple result of a test of the new carte-de-visite equipment.

In the 1860s, the cheap-to-produce carte de visite provided the first opportunity in history for large numbers of people from virtually all social classes to own images of themselves. In their wide distribution, the images can even be viewed as an early version of social media. Competition between photographers for this lucrative market was intense, which helps explain a double self-portrait from Frederick Frith's studio showing the photographer taking a close-up portrait of himself, now seated, but dressed identically in pale trousers and a black jacket (p 23). At the time, double exposures were a novelty, and this highly self-conscious example advertises the skill of Frith's studio.[2] Also departing from the dominance of realism in Australian photography, a head-and-shoulder composite portrait of the photographer JW Beattie from around 1910 shows him surrounded by a triangle of three ghostly faces in the upper half (p 271).[3] Britain was enjoying a boom in spirit photography at the time. While the author of this photograph and the identity of the 'extras' remains a mystery, such images normally represented dead family members.[4]

Beyond the studio, portraits of photographers at this time are less common. *Captain Sweet taking photos in the far north* 1882 shows the photographer sitting on a push trolley rather than taking photographs, although the train seems to function as a camera dolly for the landscape images of colonial expansion for which he is known (p 22). Another remarkable self-portrait of a photographer at work is Frank Hurley's 1914 photograph of himself knee-deep in the Albert River in Burketown in North West Queensland taking a photograph of three Aboriginal women (p 27). Hurley presents himself as the intrepid explorer, sleeves rolled up, tripod in the water, documenting people of a race then assumed to be doomed to extinction. The women are staged holding various artefacts and appear not only frozen in time but miniaturised by perspective. Hurley had proved himself successful in the booming postcard business – an essential part of the emerging tourist economy – and he sent this image as a postcard to his friend Henri Mallard with a jocular racist anecdote scrawled on the back.

Recent self-portraits by artists such as Tracey Moffatt explicitly confront Australia's colonial past. Throughout her career Moffatt has represented herself in purposefully melodramatic ways, from starring in the iconic series *Something more* 1989 to self-portraits as a lone adventure photographer or a glamorous photojournalist. She has reworked her own family photographs and restaged scenes from her childhood. One such image, *I made a camera* 2003 (p 30), depicts a dream-like scene of the artist as an eight-year-old using a camera made out of a cardboard box. She photographs two Aboriginal children while in the background a white family – perhaps her own working-class foster parents – look on. A number of other Indigenous artists, including Ricky Maynard and Michael Riley, have made strategic use of biographical details to question the colonial gaze. Such approaches have strong links to postmodern feminist photography of the 1980s by artists like Anne Zahalka, whose work adopts a critical attitude to identity and photography's construction of stereotypes.[5]

Female photographers have used self-portraits as way to take control of their own representation.[6] Sue Ford's extraordinary body of self-portraits, taken over fifty years, is a case in point. A visual autobiography of wilfully diverse photographic styles and techniques, insistent in its self-scrutinising honesty and fascination with documenting time and change, it shows the photographer at various stages of her life and career, from a pigtailed teenager to wide-eyed, bouffant-clad commercial apprentice with a twin-lens reflex camera, from a new mother to an older woman staring at her reflection in the mirror on a beach. Intimately involved in the women's movement in the 1970s, Ford believed in the value of documenting her personal life for the insights it offered into the gendered structure of everyday life.[7] And for Ford, who spoke of the camera as a 'time machine' in relation to her best known *Time series* 1962–82, these self-portraits are also part of 'a broader reflection on the impermanence of life'.[8] Often taken in the mirror – a stand-in both for photography and the imagined self – and frequently inviting an interaction with the camera or possible future viewer, the images are both poignant and witty (in one domestic scene she disappears in silhouette). Many show the artist at work, editing pictures or in a gallery with her own photographs. Collectively they become a portrait of the artist's life, but also a moving story of changes in photographic culture and Australian society more broadly.

1. Geoffrey Batchen quoted in David Colman, 'Me, myself and iPhone', *New York Times*, 30 June 2010, nytimes.com/2010/07/01/fashion/01ONLINE.html, accessed 20 Feb 2014.

2. See Alan Davies, *Eye for photography*, Miegunyah Press, University of Melbourne Publishing, Carlton, Vic, 2004, p 144.

3. Helen Ennis argues that realism suited the pragmatic needs of a settler culture. See Helen Ennis, *Photography and Australia*, Reaktion, London, 2007, p 9.

4. Martyn Jolly recognises the 'extras' as consistent with the style of British spirit photographer Robert Boursnell, but there is no record of Beattie returning to Britain (email to author, 13 June 2014).

5. On the prevalence of self-portraiture in contemporary photography, see Susan Bright, *Auto focus: the self-portrait in contemporary photography*, Thames & Hudson, London, 2010.

6. See Marsha Meskimmon, *The art of reflection: women artists' self-portraiture in the twentieth century*, Columbia University Press, New York, NY, 1996.

7. Ford was aligned with an important wave of 1970s Australian feminist photographers that included Micky Allan, Virginia Coventry, Sandy Edwards, Ponch Hawkes and Ruth Maddison, many of whom also made self-portraits.

8. Maggie Finch, *Sue Ford*, National Gallery of Victoria, Melbourne, 2014, p 5.

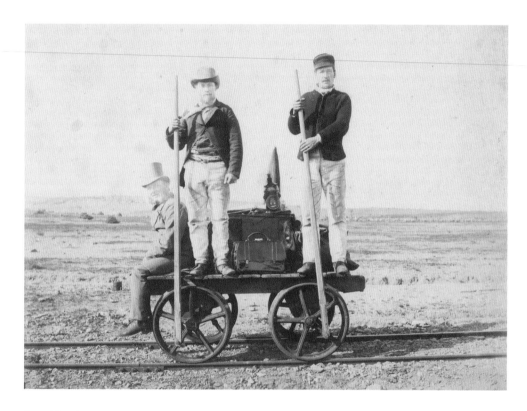

Samuel Sweet
Captain Sweet taking photos in the far north 1882
National Gallery of Australia, Canberra

opposite, from left:
Dailey & Fox
*Photographers SJ Dailey and Thomas Moorhouse
Fox in their Clarendon studio* c1862
Art Gallery of South Australia, Adelaide

Philip J Marchant
Double self-portrait c1866
RJ Noye Collection, Art Gallery of South Australia, Adelaide

Frederick Frith's assistant
Double self-portrait c1866
State Library of New South Wales, Sydney

P. J. MARCHANT GAWLER.

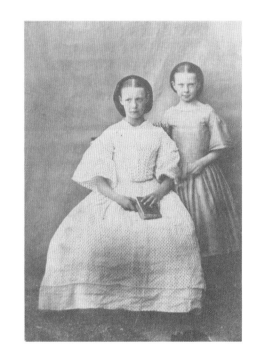

George Fordyce Story
Self-portrait 1858–60
National Portrait Gallery, Canberra

Emma and Esther Mather c1858
National Gallery of Australia, Canberra

opposite, clockwise from top left:
George Cherry
Portrait of George Rodney Cherry c1856

Portrait of Matilda Cherry c1850

George Cherry 1855

Portrait of George Rodney Cherry 1864–67

Pictures Collection, National Library
of Australia, Canberra

American & Australasian Photographic Company
*Photographer Charles Bayliss lazing on
the bank of the Parramatta River* 1870
Caroline Simpson Library & Research Collection,
Sydney Living Museums

opposite:
Frank Hurley
Burketown 1914
Art Gallery of New South Wales, Sydney

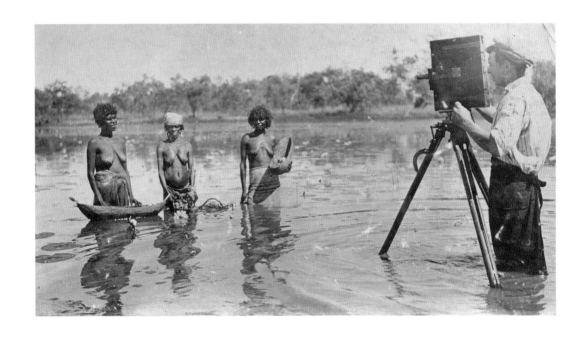

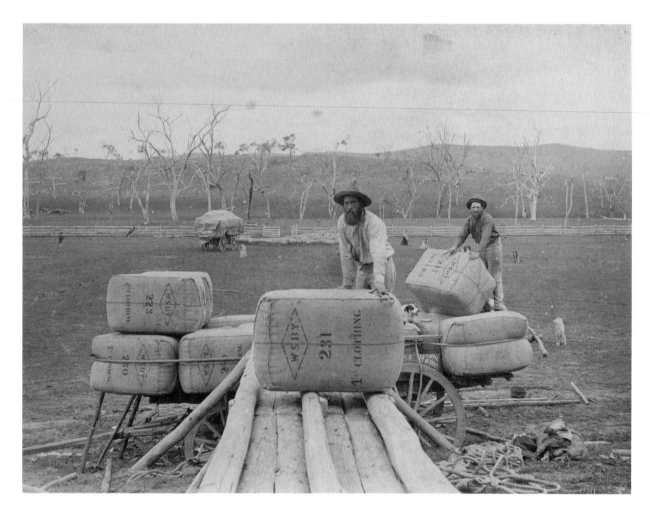

Charles Bayliss
Stacking wool bales onto a cart
from the series *Collection of a country property,*
New South Wales 1886–91
Art Gallery of New South Wales, Sydney

opposite:
Anne Zahalka
artist #13 (Rosemary Laing) 1990
from the series *Artists*
Collection of the artist

Brisbane, Australia, 1969

Tracey Moffatt
I made a camera 2003
Collection of the artist

opposite:
Sue Ford
Self-portrait 1986
from the series
Self-portrait with camera (1960–2006) 2008
Art Gallery of New South Wales, Sydney

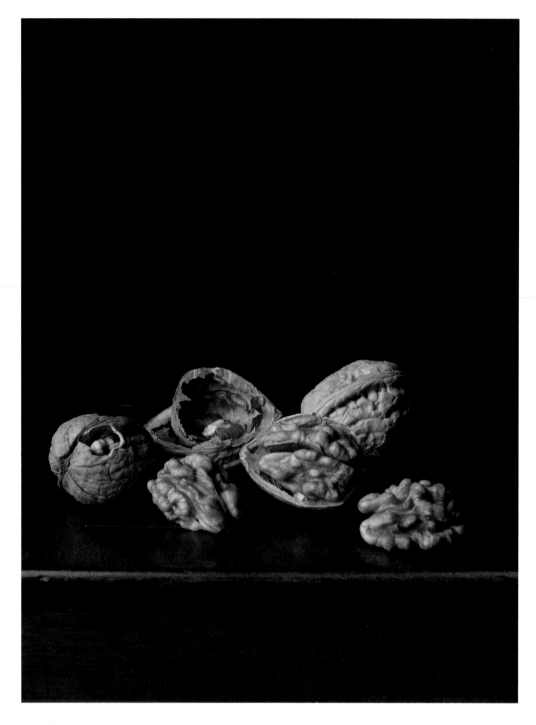

Robyn Stacey
Walnuts
from the series *Empire line* 2009

opposite:
Chatelaine
from the series *Tall tales and true* 2010

Art Gallery of New South Wales, Sydney

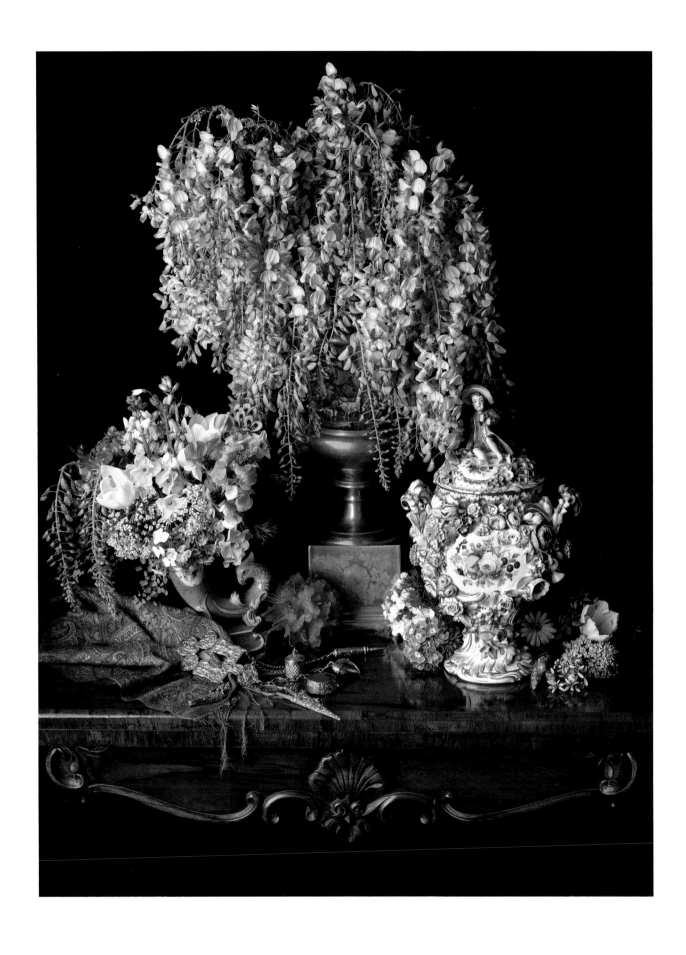

Ricky Maynard
Broken heart 2005

opposite:
The Healing Garden, Wybalenna, Flinders Island, Tasmania 2005
Coming home 2005
all from the series *Portrait of a distant land* 2005
Art Gallery of New South Wales, Sydney

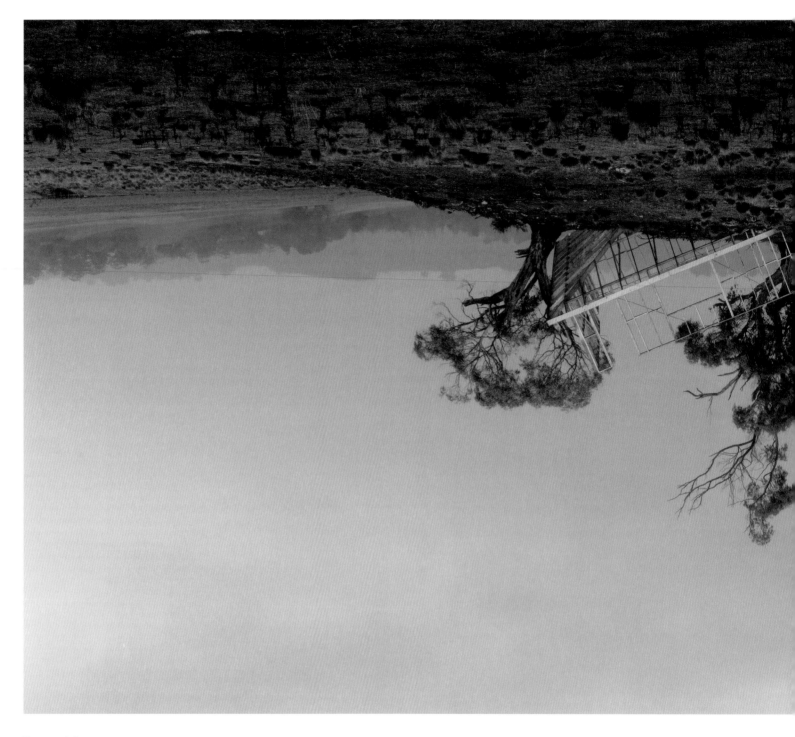

Rosemary Laing
Eddie from the series *leak* 2010
Art Gallery of New South Wales, Sydney

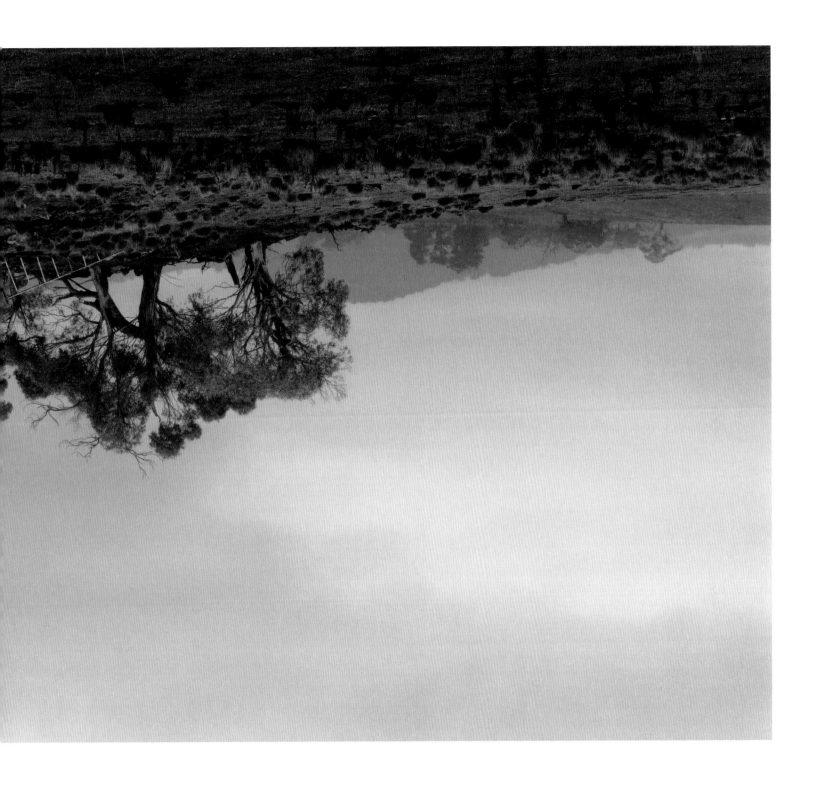

Charles Bayliss
View from Dunlop Range, near Louth,
Darling River (looking south) 1886

opposite:
Distant view of Jandra Rocks 1886

both from the series *New South Wales*
Royal Commission: Conservation of water.
Views of scenery on the Darling and
Lower Murray during the flood of 1886

Art Gallery of New South Wales, Sydney

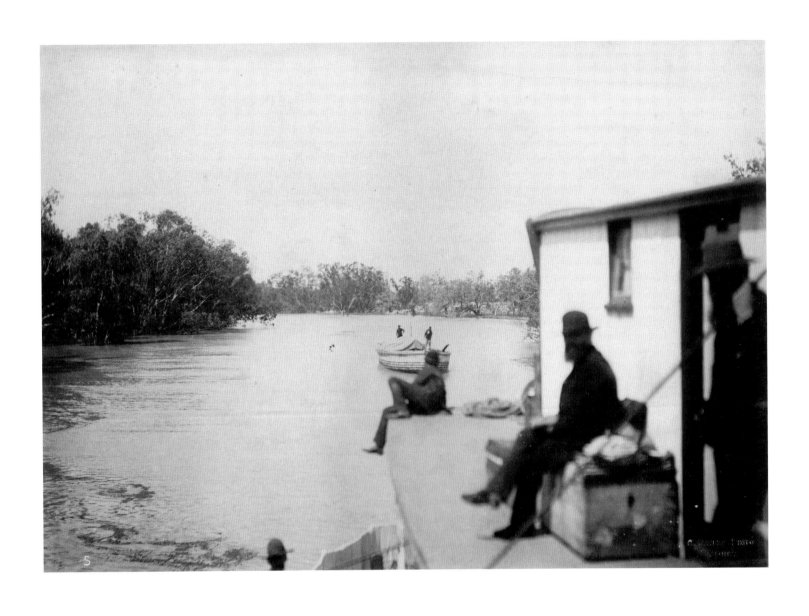

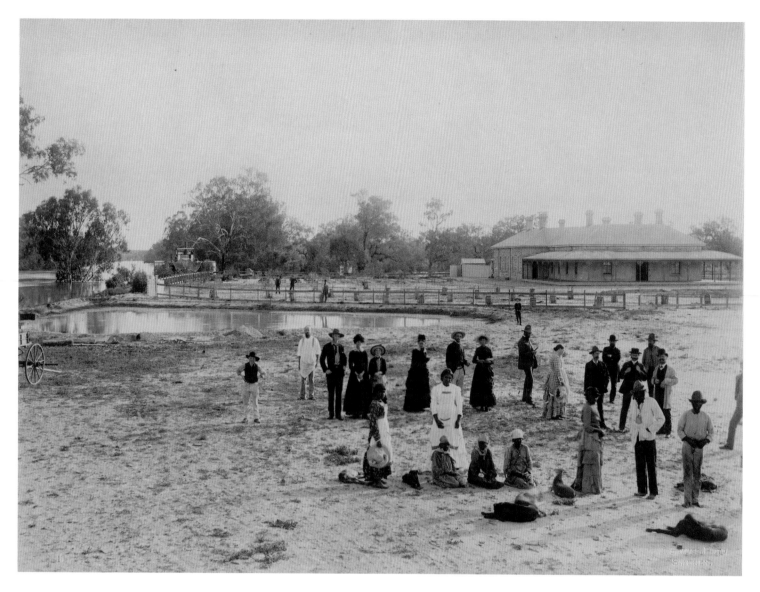

Charles Bayliss
Homestead, Dunlop Station, Darling River 1886

opposite:
*Group of local Aboriginal people, Chowilla Station,
Lower Murray River, South Australia* 1886

both from the series *New South Wales
Royal Commission: Conservation of water.
Views of scenery on the Darling and
Lower Murray during the flood of 1886*

Art Gallery of New South Wales, Sydney

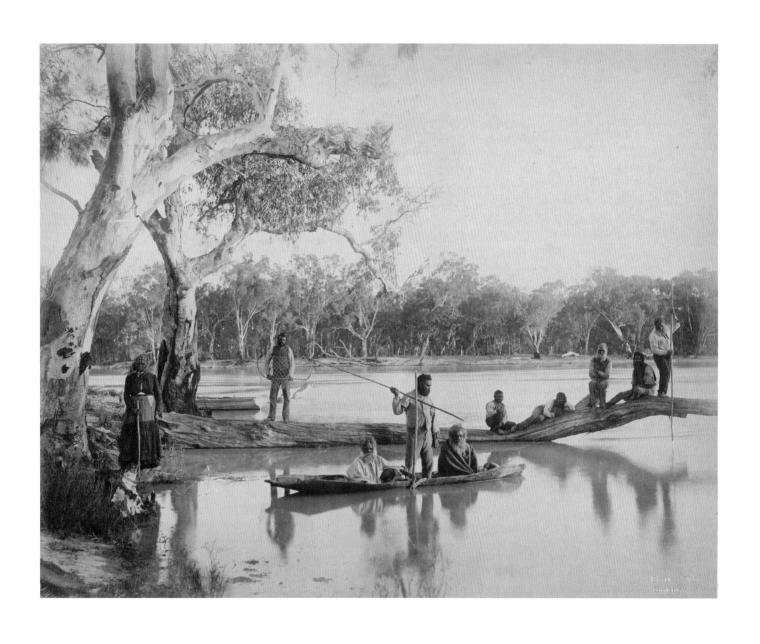

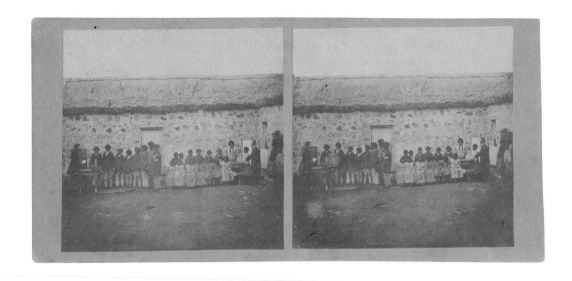

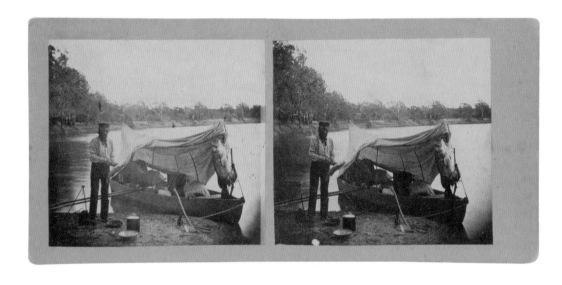

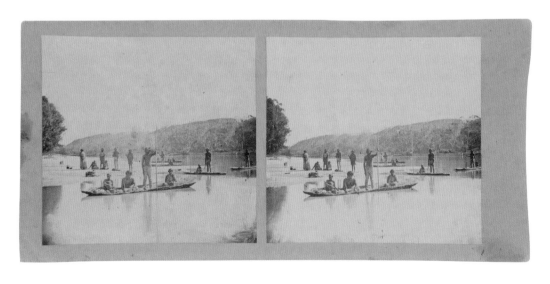

THE FLINDERS RANGE TRIBES.

1. POLICE-TROOPER NOBLE, Laura, assisted by a native.
2. The name of the tribe is Alury.
3. The tribe resides on Flinders Range, Crystal Brook, and the surrounding country.
4. There are two clans, Muttay and Arriee.
5. Each clan has a totem, known in the native language as "burdo."
6. There are no class-names.
7. The different clans intermarry.
8. There are no marriage ceremonies practised. The king of the tribe gives away the female. Marriages are not arranged by the clans.
9. Children belong to the fathers' tribe.
10. Polygamy is practised.
12. Blood relations may marry.
13. There is no form of government.
14, 15. There is no administration of justice. Previous to Europeans inhabiting the country, whoever committed murder, except in war, was waddied to death.
16. No kind of sorcery is known.
17. There are no funeral customs.
18. Property descends to the nearest relation.
19 to 23. No replies.
24. They are not cannibals at present.
25. Their weapons are boomerangs, spears, and waddies.
26. They make nets, lines, mats, and baskets.
27. Their tools are made of wood and stone.
28. No answer.
29. They call their language Youngye.
30 to 42. No replies.
44. Their diseases are principally colds and indigestion.
45. To cure disease they bleed the sick, and suck the blood till they are very weak.
46. The youths are initiated into manhood by the cutting off of the foreskin by a piece of glass bottle.
47. No reply.
48. Yes, they circumcise.

THE MOUNT REMARKABLE TRIBE.

1. Mr. BEDFORD HACK, Crown Lands Ranger, Mount Remarkable assisted by a native, named "Coonia."
2. The name of the tribe is Noocoona.
3. They reside on a tract of country extending from Bundaleer on the south to Port Augusta on the north, and from Coonatto on the east to Port Pirie on the west.

MATS, BASKETS, NETS, TWINE, GIRDLES, AND NECKLACES, MANUFACTURED BY THE NARRINYERI.

Unknown photographer

in Reverend G Taplin, *The folklore, manners, customs, and languages of the South Australian Aborigines: gathered from inquiries made by authority of the South Australian Government* 1879

Robert Dein collection, Sydney

opposite:

George Burnell

Mission School, Point McLeay, Lake Alexandrina

Artist's boat, Murray River

Aborigines in their canoes, Overland Corner

from the series *Stereoscopic views of the River Murray* 1862

Art Gallery of South Australia, Adelaide

The advent of photography collections in art museums from the early 1970s enabled a rewriting of Australian photographic history, facilitating a new kind of national imagery. Carol Jerrems' *Vale Street* 1975 (see p 108) became an icon of Australian photography not long after it was first printed and exhibited, featuring in the 1976 book *Australian photography* edited by Laurence Le Guay, and later on the front cover of *Australian photographers: the Philip Morris Collection* (1979), with Max Dupain's *Sunbaker* 1937 on the back (p 104). James Mollison, founding director of the National Gallery of Australia, was concurrently sole selector for the Philip Morris Collection. When the collection was exhibited in the National Gallery in 1983 under the title *A decade of Australian photography 1972–1982* it was noted that 'Jerrems' best compositions have a casual perfection: *Vale Street* has justifiably become an icon of 1970s Australian photography, yet seems free both of forced formalism and mere chance'.[1] Earlier, in postwar Australia, the depiction of the nation photographically had instead depended on the growth of reportage and documentary photographs in newspapers, magazines and books.[2] During Australia's colonial period it had been the world exhibitions that constituted the primary forum for encountering photographs of the nation.

World exhibitions in the nineteenth century were cathedrals to modernity: they were designed to fill their audiences with wonder at the magnificence of the made and natural world and to shore up a belief in the power of Empire. The dynamic between the colonies and the acknowledged seats of Western civilisation, London and Paris, was a complex one in which photography had an important role. The sheer spectacle of massed displays from various corners of the globe in purpose-built environments such as London's Crystal Palace, the venue for the first of the world exhibitions in 1851, led to a steady increase through the nineteenth century in classification and ordering across artistic, industrial and scientific categories, so that visitors could make sense of what they were experiencing.

While only six countries in 1851 presented photographs in their exhibitions in London – Australia did not – by Paris 1855 the medium was shown in its own right and used to record and interpret the wide-ranging displays. The colony of Victoria exhibited views of Melbourne and various portraits and landscapes. Gentleman amateur photographer John Hunter Kerr presented artefacts he had acquired from the Aboriginal people who lived where he had settled near the Loddon River in Victoria. Most of the photography and other material exhibited in Paris had previously been shown in Melbourne in 1854, and this set a pattern for contributions to later world exhibitions, enabling collaboration between

Australian colonies and a consolidation of thinking around what to present, why and how. The displayed items, including photographs, often found their way into the new art and natural-history museums, which were boosting their nascent collections. Historian Peter Hoffenberg writes: 'Colonial and English officials embraced these post-1851 exhibitions to refashion the ideas and practices of Britain and Empire, develop the culture and commerce of the New Imperialism, and forge colonial nationalisms'.[3]

The publication of Charles Darwin's *On the origin of species* in 1859, followed by *The descent of man* in 1871, crystallised ways in which photographs could be used to classify types. Historian Elizabeth Edwards notes that the image-making of people at this time and the use of such images to confirm notions of evolution was Darwinistic, rather than in accordance with Darwinism itself.[4] Darwin's interest in Tasmanian Aboriginal people, however, and his perception of their place in an evolutionary scale, overlapped with such mechanistic beliefs, leading to the popular Darwinistic idea that the measurement and photography of people could be used to confirm rigidly hierarchical and linear views of the development of the human race.

The earliest extant photographs of Indigenous Australians are daguerreotypes of Kulin people. Taken by Douglas Kilburn about 1847, the same year he opened Melbourne's first photography studio, they are justly famous for their clarity and intensity (pp 54–55). Kilburn exhibited the daguerreotypes in Melbourne and Hobart where he later settled and they achieved considerable currency in England and Australia due to their use as the basis for newspaper and book illustrations. All the people depicted are photographed against a plain background, leaning on each other to keep still because of the long exposures. The engagement of the various sitters ranges from what could be amusement to shock to the seeming avoidance by some of the women of the 'dangers of forbidden contact'.[5] By the time Kilburn was photographing in Melbourne the population of the Kulin nation had almost halved since first encounters in 1834.[6]

While Kilburn's daguerreotypes are notable for the engagement of his sitters and what may be his sympathy toward them, curator and writer Helen Ennis notes that '"sympathy" has a specific meaning in the colonial context, stemming from ideas based on difference, not on commonality' and was therefore 'not dependent on the recognition of a shared humanity and the equality of different races, but on an appreciation of the plight of a race believed to be less evolved and doomed to extinction'.[7] Certainly an anxiety is regularly reiterated in nineteenth-century accounts of relations between Indigenous and colonising populations, about the former

soon vanishing, and about their land as a 'wilderness'.[8] Yet this anxiety was passive, allowing the colonised people no recourse regardless of their adaption to change.

Kilburn had conceived the desire 'to portray the curious race of Aborigines by aid of the Daguerreotype',[9] and was clearly pleased with his efforts, though his images portray his sitters as anonymous ciphers.[10] Made exotic through their clothing and accoutrements they were curiosities to be wondered at rather than people to be acknowledged in their own right. Despite this, the photographs are vivid images that can be celebrated for their quality as early Australian portraits of a people who were surviving colonisation and dispossession.[11]

Australian colonies had various issues to deal with in presentations at the world exhibitions: the convict 'stain' (transportation continued to Western Australia until 1868 but ceased in the eastern colonies in the early 1850s), the status of Indigenous people, a supposed lack of 'civilised' amenities (whether places of confinement, commerce, education or transport), and a perceived inferiority with regard to the type or class of free settler. Further, they were in competition with each other over investment and migration, and with other British colonies such as Canada.[12] Nonetheless, nineteenth-century Australian colonists forged on, with Mother England as a model, engaging in a dynamic relationship with the bigger exhibition centres in the northern hemisphere. It is notable that photographs of Indigenous Australians consistently appear in world exhibitions until the 1890s (peaking in the 1870s and '80s with JW Lindt's and Paul Foelsche's various contributions), when they disappear.

The representation of Aboriginal people over these decades varies little despite changes in photographic technology. With the exception of Fred Kruger's outdoor photographs of the people living at Coranderrk and John Hunter Kerr's photographs where the viewer sees active lives portrayed, most are static portraits. The confluence of inherited pictorial codes of portraiture and experiments with anthropometrics tended to mummify the subject. Exemplary of this are the series of vignetted portraits by Charles Woolley of the Tasmanians Truganini, Wapperty, Patty, William Lanne and Bessy Clark (p 59). Woolley photographed these five people full-face, three-quarter view and profile. Though their gazes are always stoic and level, they are presented as living statues, not dissimilar to the life casts of Torres Strait Islanders and other Indigenous people made by Pierre-Marie Alexandre Dumoutier, an anatomist and phrenologist who travelled on explorer and botanist Dumont d'Urville's 1837–40 voyage to the South Pacific (p 260). The life casts were used to substantiate various beliefs in a racial hierarchy. On the expedition's return to France, they were photographed by the Bisson brothers and circulated

for study in lithographic form, just as Woolley's photographs of his living subjects were shown at Melbourne's Intercolonial Exhibition of Australasia in 1866, and collected by and displayed at the Pitt Rivers Museum, Oxford, as 'the last remnants of Palaeolithic man'.[13] Woolley's photographs have since appeared in a variety of albums and other contexts over many years.[14]

Of similarly wide currency in the 1860s were Carl Walter's photographs taken at Coranderrk. Made for the 1866 Melbourne exhibition, they were later shown at world exhibitions in Paris (1867), London (1872) and Vienna (1873), and also appeared across the globe in a variety of other contexts, from the personal and popular to the scientific. They too were collected by Pitt Rivers Museum and sent to Moscow where they appeared in the 1879 Anthropological Exhibition. Jane Lydon has written extensively about how the images were used and constructed by both Walter and the subjects.[15] Depending on how these photographs were arranged and titled they can be seen as forms of friendship exchange, an example being the Green Family Album in the Museum of Victoria where the material is carefully and personally inscribed.[16] In others, people were presented as objects of science, as seen in the panel of 106 photographs titled *Portraits of Aboriginal natives settled at Coranderrk*, which is ordered by 'blood'.[17] In scrutinising these portraits today, it is striking how the adults and children have prepared for the lens. While for some there is discomfort with the activity, all are dressed in their best and many are clearly engaged with the photographer and camera, whether presenting themselves according to status or simply through curiosity. That the sitters are named, and that there are extant narratives about many, makes these images part of a powerful and living network of social and personal histories.

The 1860s is a particularly rich decade to explore because advances in technology led to the dramatic expansion of the medium. The world exhibitions at this time represented a kind of apotheosis for colonial photography. The advent of commercially available albumen paper and the dry-plate process meant that it was no longer necessary for a photographer to take a darkroom along when venturing out of the studio. In Victoria, the gold rush had brought people and money into the colony over the preceding decade, leading to the creation of 'Marvellous Melbourne' and the rapid growth of towns such as Ballarat and Dunolly. Such expansion led to an increased desire for, and ability to purchase, the photographic image.[18]

For the London International Exhibition of 1862 the Australian colonies sent 600 photographs (fewer than fifty photographs had been sent to Paris in 1855). Victoria occupied over 1,725 square metres of exhibition

space; New South Wales half that, with 762 square metres.[19] Redmond Barry, president of the 1866 Intercolonial Exhibition of Australasia organising committee, had visited London in 1862 and noted that the photographs representing the Australian colonies had been 'greatly admired ... for their artistic excellence' and 'for their novelty of scenery', providing 'an unerring illustration, a perfect idea of the conditions under which the towns of Victoria were springing into existence, and the country being reduced from the wilderness of nature'.[20] Richard Daintree's early photographs of geological formations in Victoria had been shown in the Great London Exposition in 1862, as had photographs commissioned from Jean Baptiste Charlier, Edward Haigh and Davies & Co to show the finer points of Melbourne including streetscapes and places of confinement. Bishop Nixon's photographs of Tasmanian Aboriginal people and Morton Allport's stereographs were also included. The convergence between gentleman amateur (Allport and Nixon) and polished professional (Charlier and Haigh) was as common for the time as that of science and aesthetics, or botany and ethnology.

Photographs of the beauties of nature, the purposes to which it might be put in farming and mining, and the progress of the built environment functioned to advertise the colonies at world exhibitions but also appealed to those on home soil. Stereographs were popular for their ability to evoke the experience of 'being there', as they approximated human binocular vision as well as being intimate and portable objects. Professionals such as William Hetzer and his wife Thekla, who arrived in Sydney in 1850, quickly made a name for themselves through stereo views of the city and outskirts. Hetzer published a boxed set of thirty-six in 1858 and sixty the following year (p 65). He exhibited a substantial group of photographs of Sydney in the International Exposition of 1867 in Paris, with subjects ranging from the General Post Office to the Royal Botanical Gardens, bridges, private houses, wharves and a statue of Prince Albert.[21]

While photographic representations of the built environment showed evidence of the European style of construction and gardening in the Australian colonies, those of the land showed the places which could be described as empty and ostensibly available for development. Nonetheless, Hetzer in Sydney, Daintree in Queensland, and Foelsche in the Northern Territory, among many others, took and exhibited photographs which showed a diversity of inhabitants and migrants. Their views contradict the official perspective on the Australian people expressed in a poem from 1880 celebrating the Melbourne International Exhibition of that year: 'And that true spirit of the British race/Which makes the wilderness a dwelling place,/and wrestles the desert into fruitful soil;/Swift on the track of the bold pioneer/Science and learning and the arts appear ...'[22]

JW Lindt's series of photographs from 1873 to 1874 of the Gumbaynggirr and Bundjalung people living along the Clarence River in northern New South Wales had wide circulation through world exhibitions (pp 74–77). Taken in the studio as elaborate tableaux that attempt to show the sitters in realistic surroundings with plants and their 'tools of trade', they are paralleled by a small number of similar photographs of settlers. Unusually, one photograph shows an Aboriginal man and a settler together, the settler holding a spear and the Indigenous man holding a rifle and resting his head on the other's knee. Lindt's tableaux acknowledge the tradition of northern European 'books of trades' where people were depicted with emblems of their occupation. Such books constructed a hierarchy according to the social status of particular occupations, which aligned with nineteenth-century classifications according to physiognomy and other typologies. Lindt's initial album of twelve portraits was discussed in the *Sydney Morning Herald* in 1874:

> although decreasing yearly in numbers as their territories become more settled upon by white population – the blacks preserve their customs and traditions ... Mr Lindt can be complimented upon the artistic use he has made of the rugged subjects he has had at his disposal ... They represent very faithfully aboriginals, male and female, of all ages, as the traveller finds them in the wilds ... As a souvenir from Australia to friends in Europe Mr Lindt's album will be acceptable to many.[23]

Though the sitters are unnamed, these photographs now form the basis for the excavation of family trees for the people of the Clarence River region.[24]

From one end of the country to the other, Australia began to be exhibited as a mosaic of photographic images of place as much as of people. The picturesque tableaux of the 1860s, whether by Morton Allport of the expedition to Lake St Clair or by Richard Daintree in his painted photographs of Queensland, gave way to panoramas of burgeoning towns in the 1870s. The panoramas began to grow in size as photographic technologies became more sophisticated. An entrepreneur in Sydney, Bernard Otto Holtermann, was determined to make the biggest photographs with the largest glass plates and lenses in order to captivate the northern hemisphere with the magnificence of the medium and the wonders of the newest of the new worlds. Holtermann worked with the talented Charles Bayliss with the aim of creating a travelling exposition that could be seen worldwide. Though Holtermann's dream never eventuated, Bayliss did make the largest panoramas

of Sydney known, and one measuring ten metres won medals at the 1876 Centennial Exhibition in Philadelphia and the Paris Universal Exhibition of 1878.[25]

In the Northern Territory, Paul Foelsche documented the evolution of settlement around Palmerston, as Darwin was first called, from 1870 until his retirement in 1904. Foelsche was the Northern Territory's first police inspector as well as an amateur photographer, anthropologist, botanist, and assiduous contributor to world exhibitions in the 1870s and 1880s. Chiefly known for his portraits of the Larrakia, Djerimanga and Iwaidja people,[26] he also photographed the growth of the Territory, from about 350 settlers and 26 000 Indigenous Australians in 1872. There are conflicting reports about Foelsche's behaviour toward Aboriginal people and it is probable that his views and activities were no different to other settlers of those times. Certainly, as an amateur anthropologist, the papers he presented in the 1880s to the Royal Society of South Australia, Adelaide, are not distinguished by the view that the people he was encountering were anything other than lesser beings.[27] Toward the end of his life, however, he wrote: 'This is an old country with an old people. The new people must remember the claims of the old people. They were here first, and they have their established customs and institutions. So far as those customs and institutions can be related to our standards, they must be respected'.[28]

Foelsche began photographing in the 1870s, probably under the tutelage of Samuel Sweet, and at a time when the photographic process was still difficult in tropical climes. His landscape photographs are more common from the 1880s, when it had become less burdensome to photograph outdoors and on the road. Foelsche's photographs of the Edith and Adelaide rivers are sublime, the long exposures turning the water into glass, the skies cloudless (p 83). Foelsche composed his pictures carefully and when people seem to be appropriate inclusions he forms them into tableaux or carefully places an individual to enhance the picturesque aspects of the scene. His recording of the names of Indigenous subjects is unusual in the nineteenth century and regardless of Foelsche's motivation for doing this he has left a priceless archive for their descendants.[29]

Technological advances and tourism began to win out in colonial presentations at the world exhibitions as the century wore on. Government astronomer in New South Wales, Henry Chamberlain Russell, sent photographs of stars to Chicago in 1893 but the golden years of the colonial exhibitions were over and the events themselves were changing, away from Empire and into international expos, global conventions, and the modern Olympics.

The Royal Exhibition Building in Melbourne is the only surviving great hall built for nineteenth-century world exhibitions. Sydney's equivalent, the Garden Palace, lasted only three years before being burnt to the ground in 1882 (p 72). Colonial ambitions became unstuck as federation of the Australian colonies began to be seriously discussed. The boosterism associated with the colonies and how they displayed themselves to each other and to the world had been assisted by photography but the boom years had peaked in the 1880s and were followed by a massive economic bust in the 1890s, especially in Victoria. As librarian Ian Morrison has noted, the exhibitions

> were elaborately choreographed cultural exercises, displays at once pedagogic and promotional of the work of individuals within a society and of society as a whole, dedicated to enhancing the power and the reputation of their progenitors. As such they can tell us much about the minutiae of everyday life, about commerce and technology, and about the self-image, hopes and fears of the colonial elite.[30]

The six Australian colonies came together in Melbourne's Royal Exhibition Building in 1901 to celebrate the opening of the first Federal parliament and Australia's independence from Britain. In Australia's new constitution, Indigenous people ceased to be counted as part of the census – a policy that did not change until 1967 – and the Immigration Restriction Act of 1901 began what became known as the White Australia Policy. On the ground, away from the pomp and ceremony, the 'cleansing' of slums in The Rocks in Sydney following an outbreak of bubonic plague in 1900 was extensively documented by photographers (p 72).[31] In Tasmania, Thomas Hinton prepared for Federation by performing at local Launceston photography studios in elaborate tableaux of his own devising incorporating a pre-Federation coat of arms, a variant of which continues to be used by the Australian cricket team (pp 98–99). The colonial and emerging national body, which had been celebrated in intricately structured photographic mosaics of settlers and soldiers through the previous decades, was devolving, as individual interpretations of society and society itself demanded different representations.

Despite Federation, public political rhetoric throughout the twentieth century continued to emphasise 'being British' and photographic imagery evidenced a variety of attempts to constitute forms of nationalism until the 1960s. War historian CEW (Charles Edwin Woodrow) Bean's desire to enshrine the idea of the Anzac and the 1915 events at Gallipoli as forging a heroic patriotism are described by cultural historian Anne-Marie Willis as defining 'the digger as a specific racial type, an improved variety of Englishman nurtured in

the healthy environment of the Australian bush'.[32] The spilling of so much national blood at Gallipoli caused Bean, along with photographer Hubert Wilkins, painter George Lambert and others to revisit that location after World War I and extensively document the ground with close and long views. The mission aimed to record for posterity what evidence remained (p 95). Bean, however, acknowledged that 'almost every stage of the campaign' now involved 'puzzles'.[33]

Behind the rhetoric lay 60 000 Australians dead and more than 150 000 wounded alongside the shattered Allied and Central Powers who had lost millions. The desire to rebuild, in Australia's case, an emerging national body became centred upon the physical human form. From the late nineteenth century, through technological change and experimentations by photographer and subject, photography was beginning to focus on the individual as an exemplar of perceived national characteristics. An important if ironic example of this was the mythologising of images of bushranger and folk hero Ned Kelly and his gang (pp 96–97), which began in their lifetimes and was consolidated through the moving image in the 1900s.[34]

The role of photography in aiding the interpretation of bodies as healthy or degenerate has been analysed by art historian Isobel Crombie, who notes that 'the practice of discerning who carried a genetic predisposition towards degeneration became a pseudo-science, aided intentionally or not by the great evolutionary theorist of the nineteenth century, Charles Darwin'.[35] Eugenics was formed out of longstanding beliefs in human types, which fed into racial hierarchies and then to notions of racial purity. Photography was regarded as the perfect aid in determining who was pure or impure through documenting physiognomies. The Italian criminologist Cesare Lambroso, for example, corresponded with authorities in Victoria in the late nineteenth century, sending them his forms on English-speaking races to fill out with the physical details, together with photographs of the criminals, including bushranger Ned Kelly (p 97). Lambroso believed such details could prove inherited criminality, just as many others of the period and in the early twentieth century believed in physiologically ingrained 'degeneracy' of one sort or another. In general these ideas were promulgated by the professional middle classes in Australia, as elsewhere, and gathered pace after World War I.

The flip side of this obsession with documenting the 'impure' was the promotion of the pure and healthy body. Australian photographers had not generally taken the nude as a subject until the 1930s. The nineteenth-century anthropometric nudes of Indigenous people had not been aestheticised; and the motivation

for other photographs showing naked Aboriginal women or children in 'Arcadian' scenarios was usually more vulgar than classical. In the 1930s Max Dupain, Olive Cotton and Keast Burke focused on the nude as an object of beauty if not of purity. That Dupain's photographs, in particular, have come to represent the iconic Australian body relates as much to discussions around Australian modernist photography in the 1970s and 1980s as it does to any of the photographer's activities in the 1930s.[36] The atmosphere of the interwar years, however, is crucial to an understanding of how Dupain and Burke's photographs came into being.[37]

Dupain's 1937 *Sunbaker* has become one of Australia's most recognised photographs, alongside Harold Cazneaux's *Spirit of endurance* from the same year (p 101). The latter photograph was an icon of its time due to Cazneaux's reputation, and his description of it as his most Australian photograph. It came to commemorate the death of his only son at Tobruk in 1941.[38] *Sunbaker* was somewhat unusual in Dupain's oeuvre in the late 1930s, when he published mainly surrealist-inspired montages incorporating the nude figure rather than such reduced forms.[39] His montages incorporated the anxieties of the Great Depression, the fears of looming war, and the need for physical strength in both men and women as progenitors and warriors. The simplified yet monumental form of the bronzed male body in *Sunbaker* was prescient, however, as it prefigured Dupain's mature postwar work as well as adroitly harnessing a moment in time that came to symbolise the ambitions of the nation.[40]

Exposure to sunlight was considered to be crucial in the fight against diseases such as tuberculosis as well as aiding wellbeing and strength in general.[41] Keast Burke's portfolio of male nudes is exemplary in this regard, as the young healthy naked form is seen to perform various activities demonstrating strength and fertility (p 103). Similarly, Olive Cotton's portraits of women in the sun, absorbed in nature, emanate a feminine strength and power not previously seen in Australian photography (pp 102–03).

Comparing *Sunbaker* with Carol Jerrems' *Vale Street* is instructive. Dupain was more consciously interested in modelling form with light than in people, whereas Jerrems' motivation was the empathy between photographer and subject and how this translates into the picture and then to the viewer.[42] Both photographs have a certain monumentality and centrality. These features are common to photographs by Cotton, Burke and Cazneaux, and also characterise Mervyn Bishop's historic 1975 photograph *Prime Minister Gough Whitlam pours soil into the hands of traditional land owner Vincent Lingiari, NT* (p 6), and Michael Riley's *Maria* 1985 (p 109) and his related series *Portraits by a window* 1990.

1. *A decade of Australian photography 1972-1982: Philip Morris Arts Grant at the Australian National Gallery*, Canberra, 1983, p 2.

2. See Martyn Jolly, 'Exposing *The Australians* in focus: Australiana photo books of the 1960s', *History of Photography*, vol 38, no 3, 2014; and 'Transmission', pp 227-33.

3. Peter Hoffenberg, *An empire on display: English, Indian and Australian exhibitions from the Crystal Palace to the Great War*, University of California Press, Berkeley, CA, 2001, p 8.

4. Elizabeth Edwards, 'Evolving images: photography, race and popular Darwinism', in Diana Donald & Jane Munro (eds), *Endless forms: Charles Darwin, natural science and the visual arts*, Yale University Press, New Haven, CN/London, 2009, p 167.

5. Jane Lydon, *Eye contact: photographing Indigenous Australians*, Duke University Press, Durham, NC, 2005, p xiv.

6. See Helen Ennis, *Photography and Australia*, Reaktion Books, London, 2007, pp 18-21.

7. Ennis 2007, p 33.

8. See Isobel Crombie, 'Australia Felix: Douglas Kilburn's daguerreotype of Victorian Aborigines, 1847', *Art Bulletin of Victoria*, no 32, 1991, Melbourne, pp 21-31.

9. Nicholas Peterson, 'The changing photographic contract', in Nicholas Peterson & Christopher Pinney (eds), *Photography's other histories*, Duke University Press, Durham, NC, 2003, p 124.

10. Crombie 1991, p 27.

11. Brenda L Croft, 'Laying ghosts to rest', in Judy Annear (ed), *Portraits of Oceania*, Art Gallery of New South Wales, Sydney, 1997, p 13.

12. See Kate Darian-Smith, '"Seize the day": exhibiting Australia', in Kate Darian-Smith et al (eds), *Seize the day: exhibitions, Australia and the world*, Monash University ePress, Clayton, Vic, 2008, pp 1-10.

13. See Lydon 2005, p 170.

14. See Elizabeth Edwards, 'Photography and the making of the other', in Pascal Blanchard et al (eds), *Human zoos: science and spectacle in the age of colonial empires*, Liverpool University Press, Liverpool, UK, 2008, p 242.

15. Lydon 2005, 'Science and visuality: "communicating correct ideas"', ch 2, pp 73-121.

16. Lydon 2005, pp 100-106.

17. Lydon 2005, pp 78-79.

18. Melbourne's population was about 25 000 in 1851, about 130 000 in 1861, and about 200 000 by 1871. emelbourne.net.au/biogs/EM00455b.htm, accessed 28 Feb 2014.

19. Hoffenberg 2001, p 9.

20. Quoted in Paul Fox, 'The intercolonial exhibition (1866) representing the colony of Victoria', *History of Photography*, vol 23, no 2, 1999, p 174.

21. See Gael Newton, *Shades of light: photography and Australia 1839-1988*, Australian National Gallery, Canberra & Collins Australia, Sydney, 1988, p 27; Alan Davies & Peter Stanbury, *The mechanical eye in Australia: photography 1841-1900*, Oxford University Press, Melbourne, 1985, p 28; Joan Kerr, daao.org.au/bio/william-hetzer/biography/, accessed 7 Mar 2014.

22. Quoted in Linda Young, '"How like England can we be": the Australian international exhibitions in the nineteenth century', in Kate Darian-Smith et al (eds) 2008, p 12.7.

23. *Sydney Morning Herald*, 24 Nov 1874, p 5.

24. See *The John William Lindt collection*, Grafton Regional Gallery, Grafton, NSW; and Jude McBean (ed), *Dreaming the past: the Lindt story*, Grafton Regional Gallery, Grafton, NSW, c2012.

25. Alan Davies, *An eye for photography: the camera in Australia*, Melbourne University Press, Melbourne, 2004, p 68.

26. See in particular, Anne Maxwell, 'White/Aboriginal relations on the colonial frontier: reading the anthropometric photographs of Paul Foelsche', in David Callahan (ed), *Australia who cares?*, Network Books, Perth, 2007, pp 169-86; Croft, in Annear 1997, pp 8-14; Carol Cooper & Alana Harris, 'Dignity or degradation: Aboriginal portraits from nineteenth-century Australia', in Annear 1997, pp 15-22; and Timothy Smith, 'The policeman's eye: the photography of Paul Foelsche', PhD thesis, University of Melbourne, 2011.

27. See Anne Maxwell, *Picture imperfect: photography & eugenics 1870-1940*, Sussex Academic Press, East Sussex, UK, 2008, p 39.

28. Sidney Downer, *Patrol indefinite: the Northern Territory police force*, Rigby, Adelaide, 1963, p 206.

29. A much more extensive twentieth-century archive including photographs is the collection of Norman Tindale, held in the South Australian Museum Archives, Adelaide.

30. Ian Morrison, 'The accompaniments of European civilisation: Melbourne exhibitions 1854-88', *La Trobe Journal*, no 56, 1995, p 10.

31. Helen Grace, 'The conquest of darkness: photography, the metropolis and the colony', PhD thesis, Department of Fine Arts (Art History), University of Sydney, 1993.

32. Anne-Marie Willis, *Illusions of identity: the art of nation*, Hale & Iremonger, Sydney, 1993, p 160.

33. See Shaune Lakin, *Contact: photographs from the Australian war memorial collection*, 2006, p 75.

34. See Chris McAuliffe, *Live fast, die young and have a good-looking corpse: interdisciplinarity in portraits of the Kelly gang*, conference paper, AAANZ, Melbourne, 8 December 2013; and Alan Davies, *The mechanical eye in Australia: photography 1841-1900*, Oxford University Press, Melbourne, 1985, p 76. See also adb.anu.edu.au/biography/kelly-edward-ned-3933, accessed 30 July 2014 and australia.gov.au/about-australia/australian-story/ned-kelly, accessed 31 July 2014.

35. Isobel Crombie, *Body culture: Max Dupain, photography and Australian culture 1919-39*, Peleus Press, Melbourne, 2004, p 38.

36. See James Mollison, 'Introduction', *Australian photographers: the Philip Morris collection*, Philip Morris (Australia) Ltd, Melbourne, 1979, pp 4-5; and Newton 1988 p 125.

37. See Crombie 2004, pp 149-73.

38. See Newton 1988, p 109 & n 47.

39. See Anne-Marie Willis, *Picturing Australia: a history of photography*, Angus & Robertson, Sydney 1988, pp 164-69.

40. See Judy Annear, *Photography: Art Gallery of New South Wales collection*, 2007, pp 142, 149.

41. Crombie 2004, p 151.

42. See Judy Annear, 'Vale Street', in Natalie King (ed), *Up close: Carol Jerrems with Larry Clark, Nan Goldin and William Yang*, Heide Museum of Modern Art, Melbourne & Schwartz Media, Melbourne, 2010, pp 130-31 for a more detailed analysis.

EARLY QUEENSLAND PHOTOGRAPHERS AND THEIR ABORIGINAL SUBJECTS

Michael Aird

The commercial precinct of Brisbane in the mid 1800s would have proved quite an attraction to Aboriginal people, as a place where European commodities could be obtained. By the 1860s several photographers had formed relationships with local people, inviting them into their studios and photographing them. These photographers would have valued their sitters as something 'exotic' and 'savage' from which they could profit. Aboriginal people were likely well aware that the photographers intended this and at times may have negotiated some form of payment prior to posing. Historical research, however, can never fully reveal the complex relationships between the early photographers and the many Aboriginal people in their photographs.

By the late 1800s there was an ever-increasing number of Brisbane-based photographers working with Aboriginal subjects. In an exhibition *Captured: early Brisbane photographers and their Aboriginal subjects* (Museum of Brisbane 2014), I focused on four of them: John Watson, William Knight, Thomas Bevan and Daniel Marquis.[1] They were the first permanent Brisbane-based photographers to begin capturing Aboriginal people in the 1860s, who together made a significant contribution to documenting an important period of Brisbane's history.

Other photographers also took photographs of Aboriginal people at this time, among them Richard Daintree, who in 1869 was appointed government geologist for North Queensland. He travelled to London as commissioner in charge of Queensland's contribution to the 1871 International Exhibition of Art and Industry. This exhibition was a showcase of geological specimens, maps, photographs and other items that demonstrated the wealth and prosperity of Queensland, aimed at encouraging migration to the state.

Photographs of Daintree's 1871 contribution do not exist but documentation of the 1872 and 1873 exhibitions in London reveal he was displaying photographs of Aboriginal people.[2] Several of these were taken in Marquis's Brisbane studio, as other copies of the same or similar images have been firmly identified. Photographs that Daintree and Marquis took in the 1860s are very similar in style and it is easy to confuse them. One of the photographs that Daintree did take was of a girl holding a boomerang. She is standing in front of a canvas backdrop and a few branches and leaves are scattered on the floor to hide the base of the metal stand used to clamp her head in place, and keep her still during the long exposure time. A negative of this image was taken to England in the 1870s and exhibition prints were made. One of these prints was over-painted in oils and is now held in the collection of the Queensland Museum (p 92).

I have been fortunate to be able to locate well over one hundred different photographs of Aboriginal subjects taken by Daintree and Marquis and to determine which should be credited to each. I believe that these simple findings are very important, as we can now be sure as to the general region that each of the Aboriginal subjects came from, with Daintree working in north Queensland, and Marquis in Brisbane. It is known that Daintree photographed Brisbane street scenes between 1863 and 1870, but I am sure he did not take any photographs of Aboriginal people while he was in Brisbane.[3]

Another well-known series of photographs is that of a group of Queensland Aboriginal performers who travelled throughout the east coast of Australia in 1892 and 1893. On 5 December 1892 Archibald Meston's Wild Australia Show opened at Her Majesty's Opera House in Brisbane as the premiere of a planned world tour. As part of the show Meston gave lectures on the savagery of Aboriginal culture and live exhibits performed in front of a painted backdrop of the Bellenden Ker Range. Performances were also held at the Breakfast Creek sports grounds and at the Brisbane exhibition grounds, where corroborees and boomerang and spear throwing were demonstrated.

Meston travelled the east coast of Queensland to secure performers, but it was his business partner Harry Purcell who was responsible for recruiting most of the performers from Northern Queensland, including from Glenormiston Station, Dajarra, Cloncurry, Normanton, Gilbert River and Mitchell River, as well as Prince of Wales Island in the Torres Strait, and the Lake Nash region in the Northern Territory. Prior to travelling to Sydney, Meston spent three months drilling the troupe on how best to perform stereotyped acts of savagery, which included attacking an innocent swagman and tracking a murderer so as to demonstrate brutal punishment. The troupe was billed as 'true tribal' Aboriginals, not 'semi-civilised town-dwellers' or 'tame demoralised blacks'.[4] Following this commercial venture Meston lobbied the Queensland Government over their mishandling of Aboriginal issues and later became the Government's most senior advisor and administrator of Aboriginal policy.

The troupe sailed from Brisbane to Sydney and opened their first show on 26 December 1892 at the Bondi Aquarium. They then travelled to Melbourne in late January, but by 29 January 1893 the planned shows were cancelled and Meston, in financial straits, returned to Brisbane. In deserting the performers Meston freed himself from the responsibility for their living costs and return travel to Queensland. He left them with Purcell, who managed to organise some additional shows and took Meston's place giving lectures with live exhibitions. The troupe was back in Sydney by June of 1893. By July their engagements had ceased and all hope of taking the troupe on a world tour had ended. Purcell then requested that the government pay for the return of the performers to Queensland.

Over the eight or so months that the troupe performed, their journey was well documented by notable photographers. Several photographs exist of their time in the Brisbane district in 1892, with some of the images being attributed to the local photographer Will Stark. On their arrival in Sydney, Charles Kerry documented the twenty-seven members performing on the beach and in individual portraits taken in his studio. When they were in Melbourne, their portraits had been taken for a series by JW Lindt. On their return to Sydney in June 1893, Henry King took a number of outdoor images and studio portraits.

The photographs by Kerry and King show many similarities; both used plain studio backdrops and photographed subjects mostly from the waist up. Kerry had many of the performers decorate themselves in body paint and traditional ornaments, while King preferred them unadorned. The portraits taken by Lindt are similar in style and composition but focus more on the facial expressions of the sitters. In the portrait of a couple referred to as Coontajandra and Sanginguble from the Lake Nash region of the Northern Territory, there is an intimacy not seen in the Kerry and King photographs (p 240). The man in this image has striking features and he is easy to notice in many of the group photographs. Over a period of eight or so months he was photographed by three of Australia's most famous photographers.

These early photographs are only one form of historical document, but unlike written records, they give us the rare opportunity to look into the faces of people we will never meet, and ask ourselves about the lives that they may have lived. I have been fortunate to be able to document many aspects of the lives of Aboriginal people that lived over one hundred years ago. When looking at these people I am always reminded how important it is to acknowledge their lives and achievements in a time of massive change for Aboriginal society.

1. See also Michael Aird, *Portraits of our elders*, Queensland Museum, Brisbane, 1992; Michael Aird, *Brisbane Blacks*, Keeaira Press, Southport, 2001; and Michael Aird, 'Aboriginal people and four early photographers', in Jane Lydon (ed), *Calling the shots: Aboriginal photographies*, Aboriginal Studies Press, Canberra, 2014, pp 132–54.
2. Aird 2014, p 150.
3. Aird 2014, pp 149–51.
4. Judith McKay, 'A good show: colonial Queensland at international exhibitions', *Memoirs of the Queensland Museum*, Cultural Heritage Series, vol 1, part 2, April 1998, p 241.

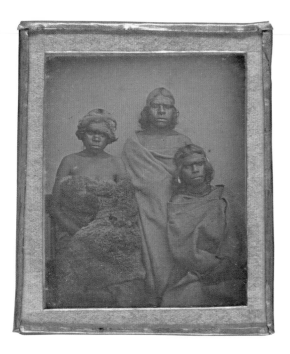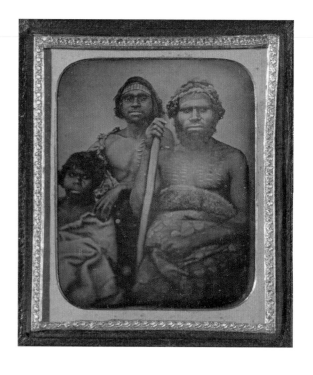

Douglas Kilburn

Group of Koori women 1847

Group of Koori men c1847
National Gallery of Victoria, Melbourne

opposite:

*South-east Australian Aboriginal man and
two younger companions* 1847
National Gallery of Australia, Canberra

Two Koori women c1847
National Gallery of Victoria, Melbourne

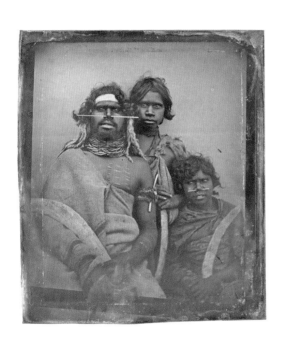

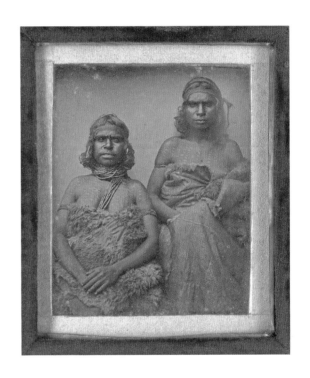

Frederick Frith, John Sharp
Panorama of Hobart, in five pieces,
taken from The Domain 1856
Tasmanian Archive and Heritage Office, Hobart

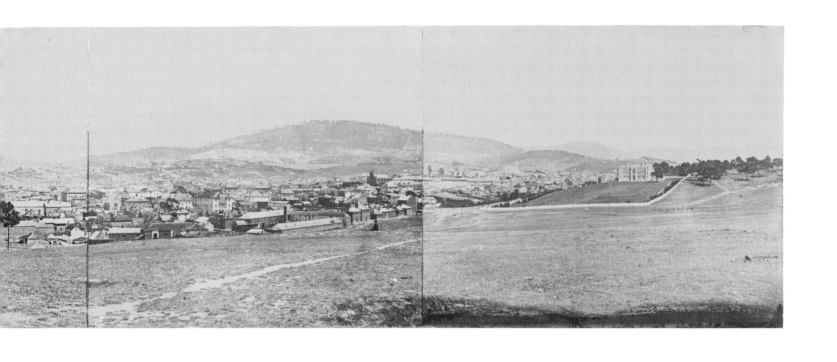

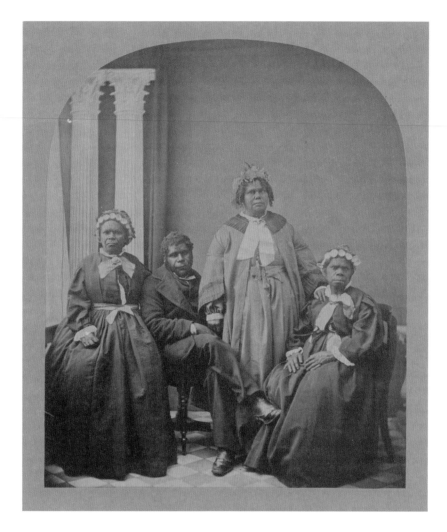

Henry Albert Frith
The last of the native race of Tasmania 1864
Auckland Art Gallery Toi o Tāmaki, New Zealand

opposite, clockwise from top left:
Charles Woolley
Truganini 1866

Patty – Kangaroo Point Tribe 1866

Wapperty, Ben Lomond Tribe portrait 1866

William Lanne, Coal River Tribe 1866

Bessy Clark 1866

Tasmanian Museum and Art Gallery, Hobart

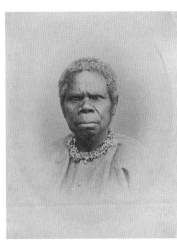

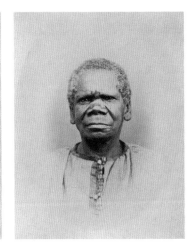

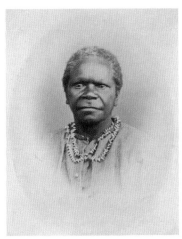

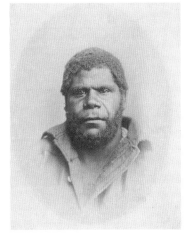

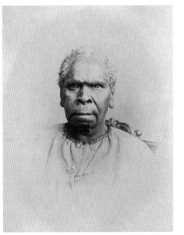

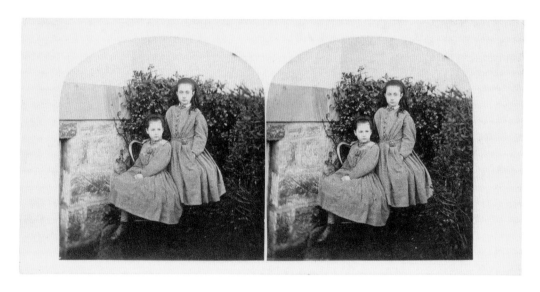

Morton Allport

Elizabeth Allport and baby Mary M Allport in garden of 'Fernleigh', Davey Street c1856

Mary Marguerite & Curzona FL Allport (?) taken at Morton Allport's residence, upper Davey Street c1860s

opposite:

No 19 Looking westward from Mt Arrowsmith

No 20 Mount Gell (Eldon Range to the extreme left) from the album *Excursion to Lake St Clair February 1863* 1863

Allport Library and Museum of Fine Arts, Hobart

Looking Westward from M.ᵗ Arrowsmith.

Mount Gell.
(Eldon Range to the extreme left.)

John Watt Beattie, Anson Bros
Dead Island, Port Arthur 1877

opposite:
Hall and cell, corridor, model prison, Port Arthur 1877

State Library of New South Wales, Sydney

John Watt Beattie, Anson Bros
The rocking stone, Mount Wellington, Tasmania 1880s
State Library of New South Wales, Sydney

opposite, from top:
William Hetzer
Australian Aborigines Burragorang tribe near Camden 1858
(Tharawal and Gandangara at Camden Park)

George Str. Sydney post office 1858–67

The Gap, Watson's Bay, NSW 1858–67

Macleay Museum, The University of Sydney

Charles Bayliss for
American & Australasian Photographic Company
glass-plate negative
State Library of New South Wales, Sydney

opposite:
Kirribilli, fifth panel of panorama of Sydney
Harbour and suburbs from the North Shore 1875
Art Gallery of New South Wales, Sydney

Charles Bayliss
Middle Head defences 1874
State Library of New South Wales, Sydney

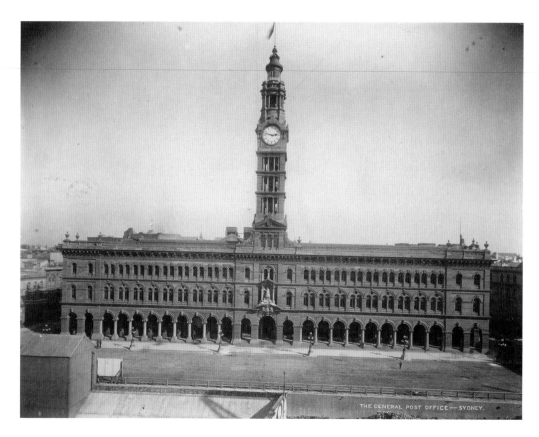

THE GENERAL POST OFFICE — SYDNEY.

NSW Government Printer
The General Post Office, Sydney 1892–1900

opposite:
Goulburn Gaol, New South Wales 1892–1900

State Library of New South Wales, Sydney

Goulburn Gaol, N.S. Wales

from top:

NSW Government Printer
The burning of the Garden Palace 1882
Museum of Applied Arts and Sciences, Sydney

John Degotardi (jr), **George McCredie**
No 841 George-street (kitchen) and *Rear of 883 George Street* from *Views taken during cleansing operations, quarantine area, Sydney, 1900, vol IV* 1900
State Library of New South Wales, Sydney

opposite:
possibly **Milton Kent**

two views of *William St, East Sydney* c1916
in *City architect and building surveyor's album* (known as *The Demolition Books*) 1906–49
City of Sydney Archives

William St — looking East.

William St. @ Kings Cross looking West.

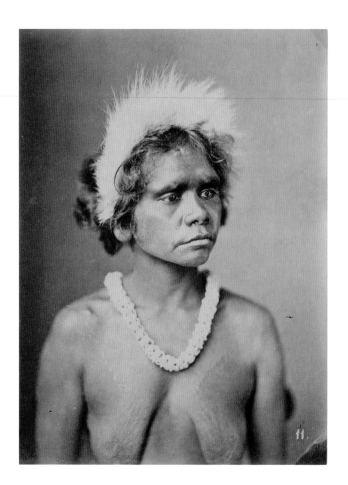 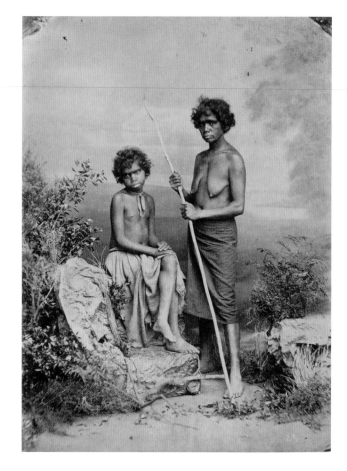

JW Lindt
No 11 Mary Ann of Ulmarra 1873
No 29 Mother and daughter from the Orara River 1873

opposite:
No 21 Reclining man 1873
No 36 Reclining miner 1873

JW Lindt Collection, Grafton Regional Gallery, Grafton

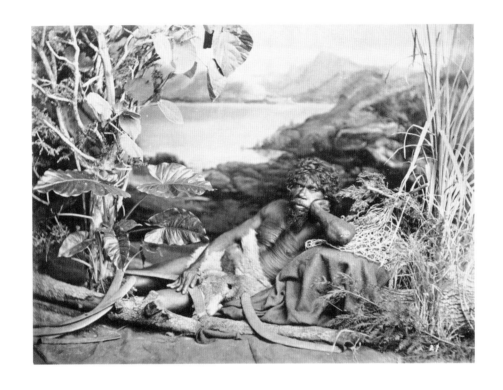

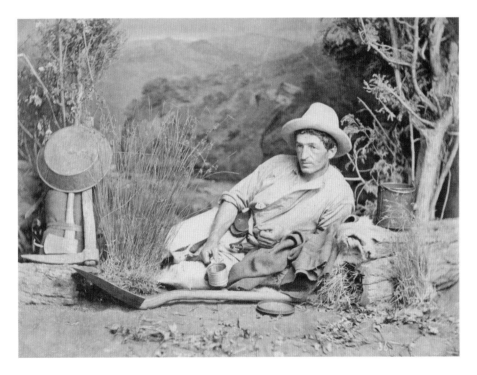

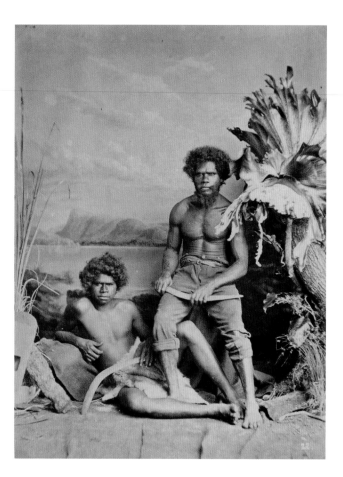
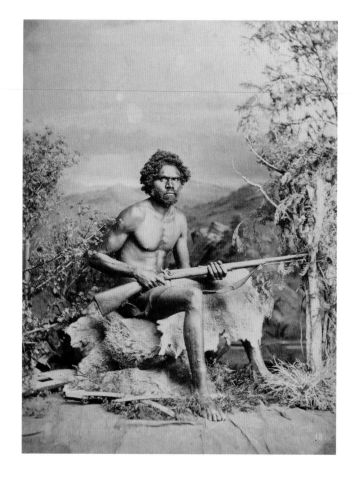

JW Lindt

No 22 Two stalwart men of the coastal tribe 1873

No 18 Man seated holding a rifle 1873

opposite:
No 34 Timbergetters 1873

No 37 Bushman and an Aboriginal man 1873

JW Lindt Collection, Grafton Regional Gallery, Grafton

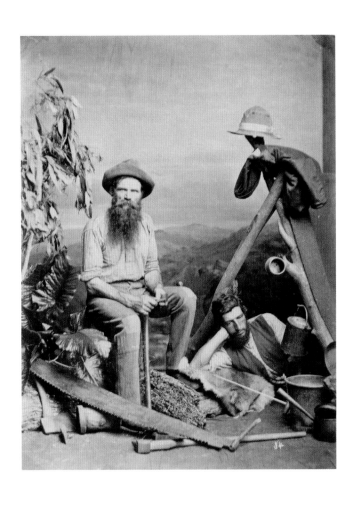

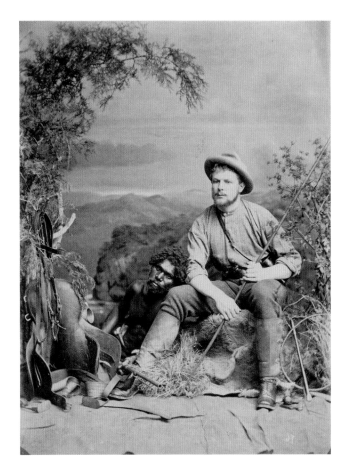

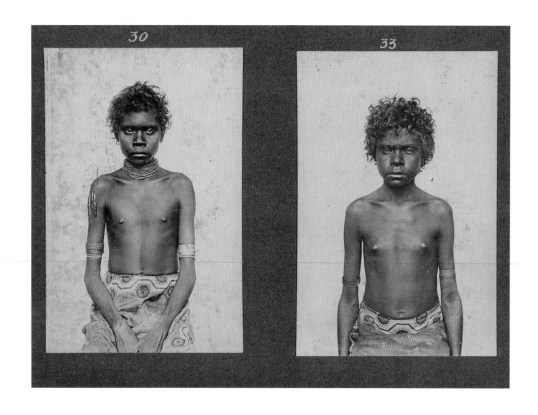

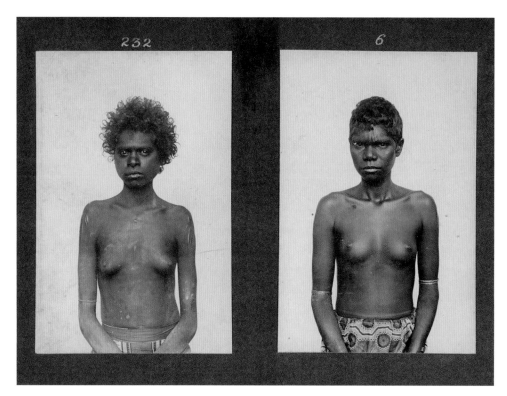

Paul Foelsche

clockwise from top left:

Portrait of 'Almarara', Point Essington and Malay Bay, Iwaidja, NT, aged 7 years November 1877

Portrait of a girl, Alligator River, Bunitj, NT, aged 15 years 1880s

Portrait of a woman, Minnegie, Limilngan, NT, aged 20 years 1887

Portrait of 'Nellie', Davy wife, Woolna, NT, aged 17 years January 1889

Art Gallery of New South Wales, Sydney

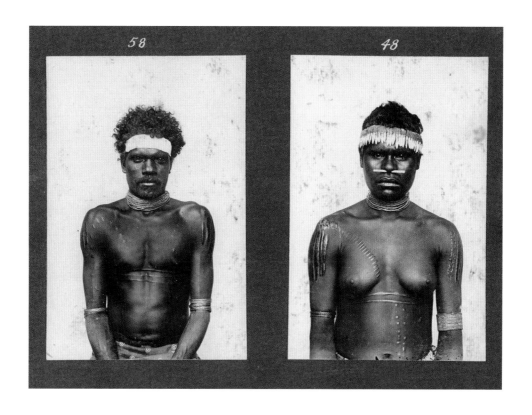

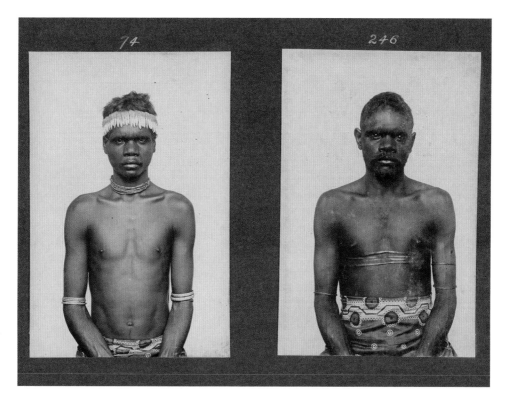

Paul Foelsche
clockwise from top left:
Portrait of man, Alligator River, Bunitj, NT, aged 27 years 1889
Portrait of a girl, Bunitj or Woolna, NT, aged 15 years 1889
Portrait of a man, 'Charley' Waggite/Daly River?, aged 24 years 1890
Portrait of a man, Daly River Copper Mine, Malak Malak, NT, aged 17 years 1890
Art Gallery of New South Wales, Sydney

Paul Foelsche
Port Darwin steam engine 1888

opposite:
In the gorge, Katherine River 1887
Art Gallery of New South Wales, Sydney

Paul Foelsche
Dr Stirling at Knuckey's Lagoon 1891

opposite:
Source of the Edith River, 2nd fall 1883

RJ Noye Collection, Art Gallery of South Australia, Adelaide

Group of Old Colonists.

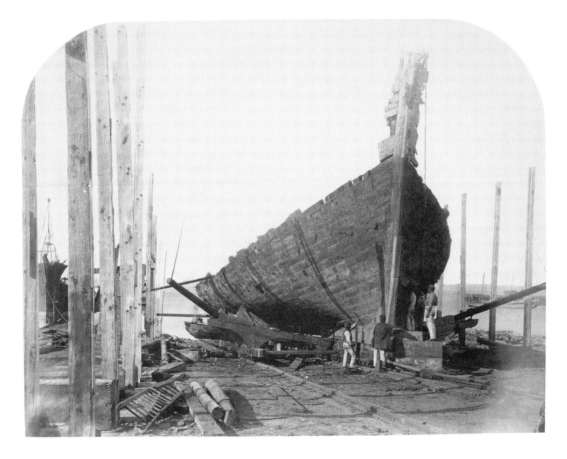

Edward Haigh
Patent slip Williamstown c1861
Picture Collection, State Library of Victoria, Melbourne

opposite:
Henry Jones
Women old colonists 1871
State Library of South Australia, Adelaide

Jean Baptiste Charlier
Cottages, Yarra Bend Asylum (Fairfield) c1861
Picture Collection, State Library of Victoria, Melbourne

opposite:
Alfred Morris & Co
Coliban viaduct c1860
Picture Collection, State Library of Victoria, Melbourne

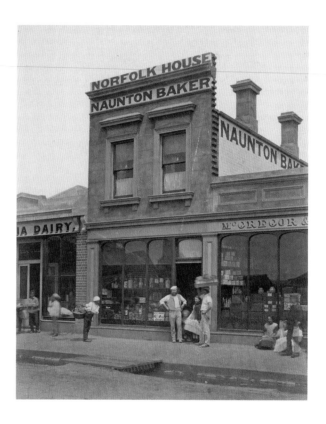

Davies & Co

Isaac Fawcett, tailor, Westmoreland House,
46 Gertrude Street, Fitzroy 1866

Norfolk House WB Naunton's Bakery,
105 Wellington Street, East Collingwood 1862

opposite:
Fred Hardie

Flinders Street, Melbourne 1892–93

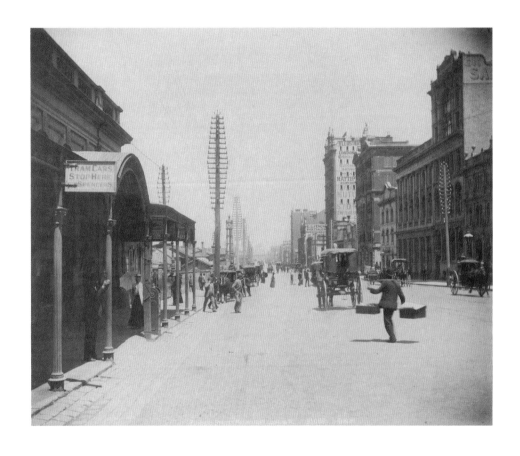

Richard Daintree
Midday camp 1864–70
Queensland Museum, Brisbane

opposite:
Gold diggers sale, Queensland 1864–70
Rex Nan Kivell Collection, National Library of Australia, Canberra

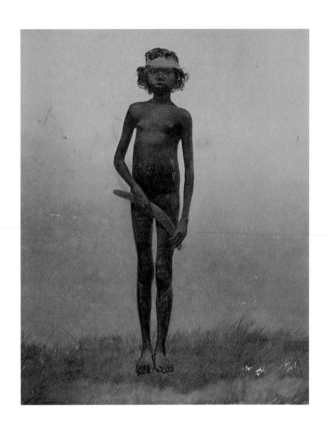

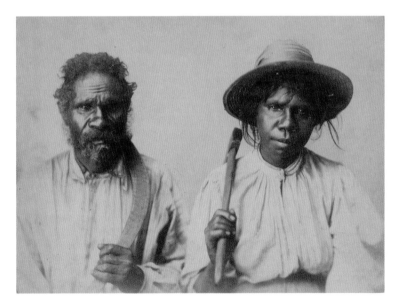

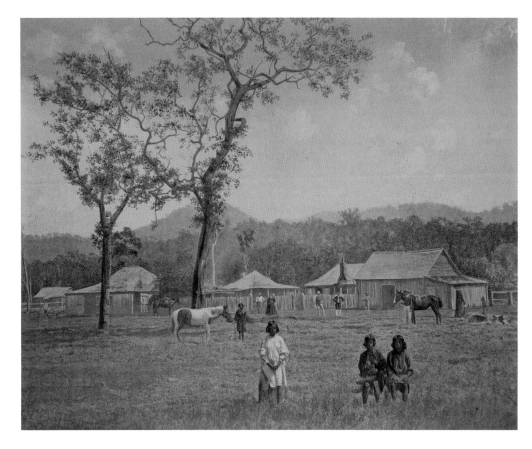

Richard Daintree
Homestead 1864–78
Queensland Museum, Brisbane

opposite:
Richard Daintree
Young Aboriginal female holding a boomerang 1864–78
Queensland Museum, Brisbane

Unknown photographer
Queensland natives c1890s
Queensland Art Gallery

Barcroft Capel Boake
NSW contingent. Soudan campaign 1885 c1890
Australian War Memorial, Canberra

opposite:
CEW Bean
*Official history, 1914–18 war: records of CEW Bean,
official historian 1914–18*
Australian War Memorial, Canberra

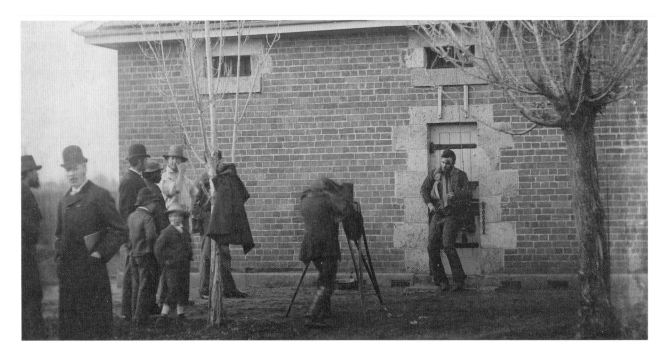

JW Lindt
Body of Joe Byrne, member of the Kelly gang,
hung up for photography, Benalla 1880
National Gallery of Australia, Canberra

opposite:
Unknown photographer
Criminal history sheet, Edward Kelly 1898
VPRS 8369/P1 Correspondence, Photographs and
History Sheets of Certain Male Criminals, Unit 1
Public Record Office Victoria

ENGLISH SPEAKING RACES.—Above 5 ft. 9 in.

Reg. No. *10926*　　　Name *Edward Kelly*

	On Arrival.	On Discharge.

Native Place　...　*Victoria*

Year of Birth　...　*1856*

Arrived in Colony...

„　per Ship　...

Trade　...　...　*Labourer*

Religion　...　...　*R.C.*

Education—Read or Write 〕　*Both*

Height without shoes　*5' 10"*

Weight　...　...　*11'4'*

Colour of Hair　...　*Dark Brown*

Colour of Eyes　...　*Hazel*

Particular Marks　...　*Scar top and crown of head, eyebrows meeting two natural marks between shoulder blades*

Where and when tried.				CONVICTIONS—	
				Offence.	Sentence. *& under what name*
Beechworth General Sessions	*2*	*8*	*71*	*Receiving a stolen horse*	*3 Years H.L.*
					Executed H M Gaol Melbourne 11/11/1880
					11·7·98

Louis Konrad
Thomas Hinton with 'Advance Australia' banner 1900
National Museum of Australia, Canberra

Duval & Co
Thomas Hinton in a diorama featuring a figure labelled 'Wolseley' 1900
National Museum of Australia, Canberra

opposite:
Unknown photographer/s
Thomas Hinton with 'Advance Australia' banner 1900

Thomas Hinton wearing a loincloth with 'Advance Australia' banner 1900

National Museum of Australia, Canberra

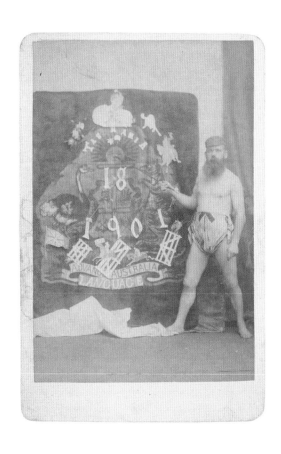

THE PHOTOGRAPH AND AUSTRALIA

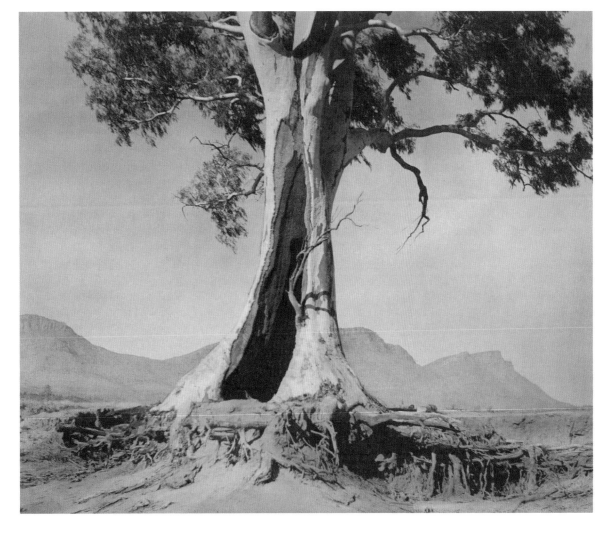

Harold Cazneaux
Spirit of endurance 1937
Art Gallery of New South Wales, Sydney

opposite:
Soil erosion near Robe 1935

Permo-carboniferous glaciated pavement,
Inman Valley 1937

State Library of South Australia, Adelaide

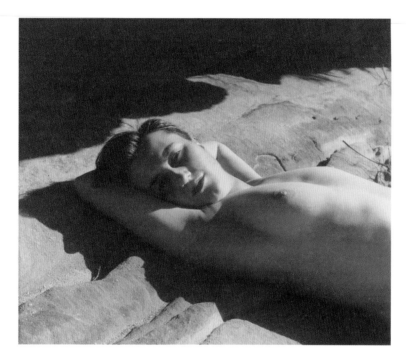

Olive Cotton
Nude 1941

opposite:
Olive Cotton
'Only to taste the warmth, the light, the wind' c1939

Keast Burke
Husbandry 1 c1940

Art Gallery of New South Wales, Sydney

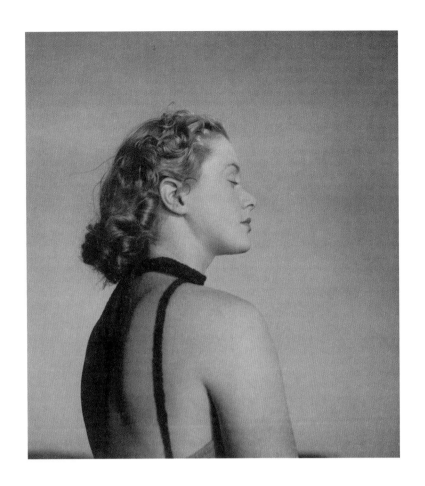

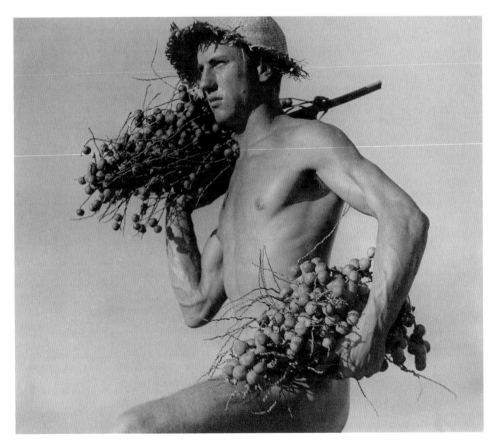

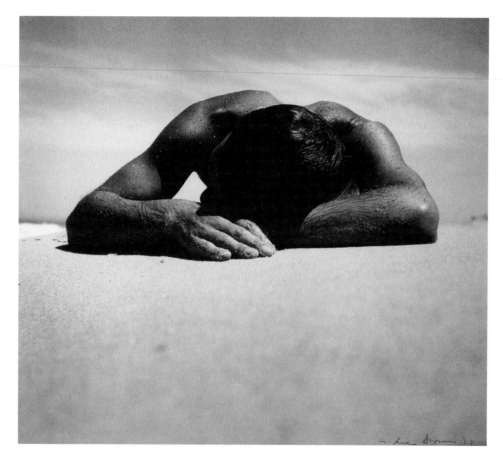

Max Dupain
Sunbaker 1937

opposite:
David Moore
Migrants arriving in Sydney 1966

Art Gallery of New South Wales, Sydney

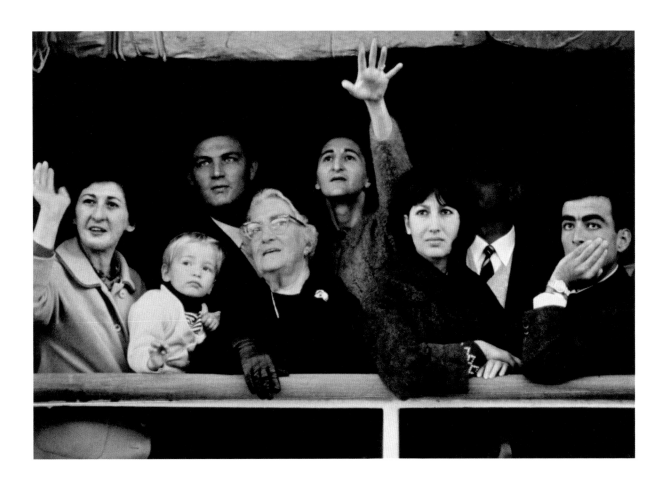

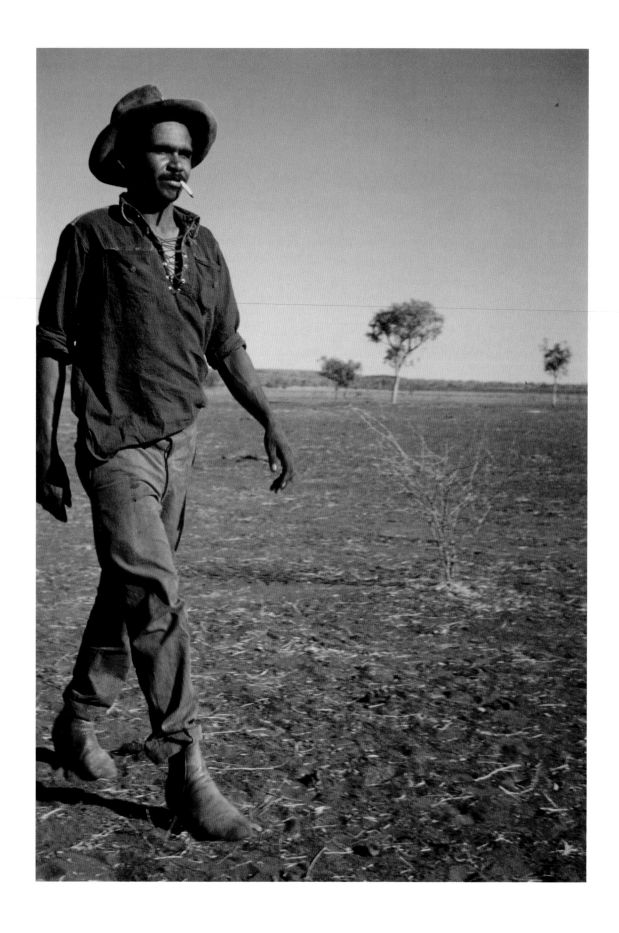

Mervyn Bishop
Jimmy Little – state funeral Kwementyaye Perkins
from the series *A Dubbo day with Jimmy* 2000

opposite:
Axel Poignant
Aboriginal stockman, Central Australia c1947

Art Gallery of New South Wales, Sydney

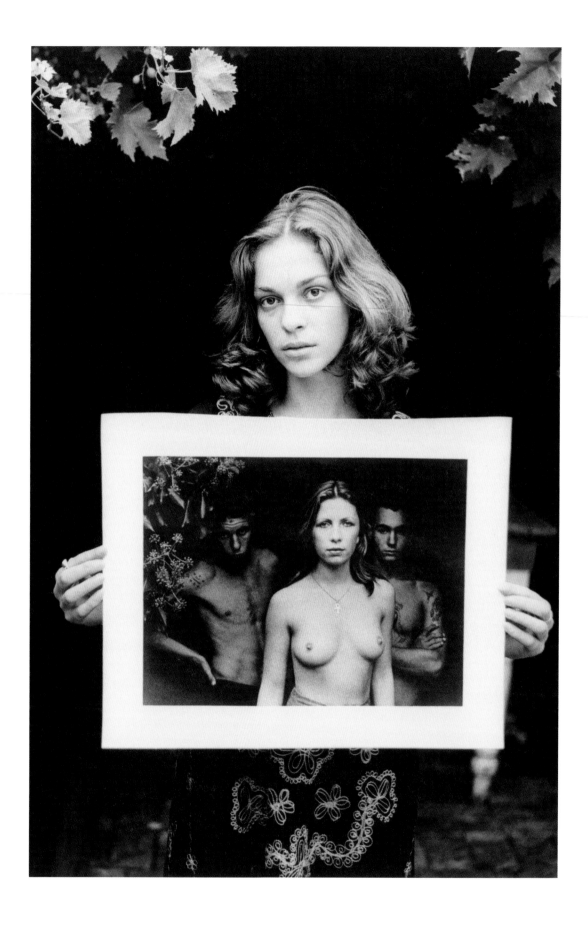

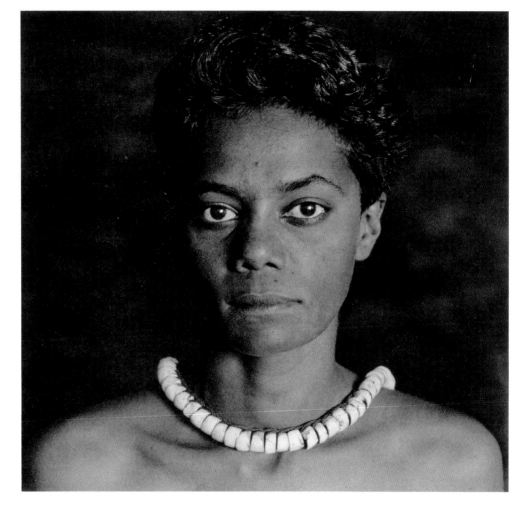

Michael Riley
Maria 1985
Art Gallery of New South Wales, Sydney

opposite:
Carol Jerrems
Juliet holding 'Vale Street' 1976
Art Gallery of New South Wales, Sydney

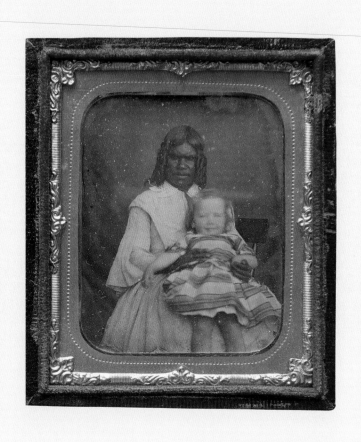

In the 1990s Tracey Moffatt produced a group of three pictures entitled *Beauties* (pp 120–21). The found photograph of a man is repeated, printed in cream, wine and mulberry tones, evocative of taste as much as look. The man is dark-eyed and olive-skinned, wears a pencil moustache which betrays a certain vanity given the difficulty of upkeep, a common t-shirt and a fancy, felt cowboy hat pushed back to show his face. The original photograph could have been taken between the late 1940s and early 1960s, in a studio, though by whom and whereabouts is as unknown to us as the subject. Posed three-quarter profile and photographed from the waist up, gazing out of frame, he is captured with a slightly quizzical look. The background is indeterminate, a typical mid-century studio effect. Everything about this trio of photographs is confusing and at the same time compelling. The man could be Central or South American, Mediterranean or Aboriginal. Moffatt's acknowledgment of Andy Warhol's serial screenprints in the appearance of the work implies that he must be someone deserving of fame. Yet the generic pose and studio presentation suggests the man is probably someone's relative or friend who was not famous in their lifetime, and that the photograph was most likely taken as a memento.[1] Since the beginning of her practice, Moffatt's subjects, regardless of being male or female, are likely to be 'beauties' – their beauty as often as not emerging through their very ambiguity, their refusal to be easily captured by categories.[2] They persistently transcend their supposed origins, just as Moffatt herself has been seen in her travels as part of many different racial groups because of her own uncertain post-colonial heritage and parentage.[3]

That uncertain heritage is the foundation of Australian portrait photography. Regardless of any desire by settlers to fix the identity of the inhabitants of the colonies in the nineteenth century and then the nation in the twentieth century, the use of photography as a recording and interpretative device, most especially of people and where they lived, created a divergence rather than convergence of aims, ideas and effects.[4] Recording a likeness, the nominal aim of portrait photography, instead enabled a performative and fictionalising element to enter, involving the sitter, the photographer and the image itself, not least because no sitter is ever particularly satisfied. This inventive or unpredictable aspect, so contrary to the notion of the veracity of the photograph, was not a local phenomenon – indeed in Australia it was less marked than nineteenth-century photography in Great Britain, France and the United States. Further, despite the deadening effect of long exposures, and neck and body clamps to keep the sitters still under bright sunlight,

these early photographs maintain an engagement across time and space regardless of whether we know who the subject or photographer is, or not.

On 9 December 1842, the *Australian* newspaper breathlessly announced that George Goodman's photography studio would open the following Monday:

> Photographic portraits, taken by the reflection of light. The proprietor of the reflecting apparatus, by which faithful miniature likenesses of the human countenance and person are 'won from the hand of nature' in the space of a few seconds, respectfully announces to the inhabitants of Sydney, that this extraordinary process will be open to the public, at the Royal Hotel, in which the Photographic Apparatus, the discovery of which is ranked among the greatest scientific achievements of the recent age, will be in daily operation from ten till five. The price of each portrait is one guinea, exclusive of frame.

Goodman worked in Australia between 1842 and 1847 producing daguerreotypes in Sydney, Melbourne, Adelaide and towns in between. The earliest extant Goodman daguerreotype is of the irascible Dr Bland, transported for murder, and the most beguiling are those of the Lawson family, taken in Bathurst in 1845 (pp 127, 260). In common with most early daguerreotypes, the backgrounds are plain, so the focus is firmly on the faces and figures of the sitters. Taking pride of place in the group is one of Caroline Lawson and her son Thomas. Caroline beams at the camera while her son, most likely grasped by unseen clamps, reluctantly complies. Portraits of two of the little girls show them almost hovering in space, dressed in their best, hands stilled with the task of holding posies and presented in the conventional three-quarter profile. One of the girls, Eliza, was ambrotyped fifteen years later, probably by Edwin Dalton, after her marriage to Edric Morisset, and in that image she appears elegantly 'at home' in her surroundings.

Early daguerreotypes can seem clumsy because of their plainness and the occasional blur of long exposures, but they have that trace of the real that no other medium can achieve. As cultural theorist Roland Barthes noted: 'From the real body, which was there, proceed radiations which ultimately touch me, who am here … A sort of umbilical cord links the body of the photographed thing to my gaze'.[5] The sheer directness of this relationship, regardless of time and familiarity, is what distinguishes the medium from other modes of representation.

The conventions of portraiture evolved quickly in early photography: supported by more elaborate props for sitters to lean on, painted backdrops, meaningful poses, hand tinting – and stylistic signatures such as

Tasmanian photographer Thomas Bock's ivy-draped column. The eager glances of the Barnard children or the unknown Tasmanian couple where the man looks tenderly at the woman who gazes out at us, are countered by more severe portraits, such as those of the Davenport siblings (p 122). These last have more of an affinity with fifteenth-century Netherlandish portraits than with more modern counterparts. Little Ann Plummer from Taree in New South Wales, ambrotyped in the 1860s, looks sad, probably having been told to not blink for many seconds (p 129). Grimly determined, her hands clutch a flower to keep them still. Teenaged Eleanor Stephen, who was to die seven years later at the age of twenty-one, was daguerreotyped, probably by Dalton. She returned for a second visit, seemingly not happy with the first, and a delicate hand-coloured image is the result (p 129). Young Eleanor gazes out of frame, neatly coiffed and expensively dressed. The ambitions of both subject and photographer in such images are similar: to record, display, and perform a role for the medium and the intended viewer.

Photographic representations of where and how people lived came later, when land or home ownership was more widespread and the medium had caught up to such aspirations. The earliest extant photographs of properties are from the 1850s and were mainly taken in Victoria. Somewhat pictorially askew are the daguerreotypes of Rose Cottage, Prahran, with its proud owners the Walkers in the backyard, or of Dr Howitt's Melbourne garden (p 138). These pictures attempt to broadcast town life, though their haphazard effect is more akin to a modern snapshot. Somewhat more legible is JW Newland's daguerreotype of Murray Street, Hobart – the earliest and biggest extant image of an outdoor scene (p 123). Though classically composed and shot from Newland's hotel window, the street life seems unforced. The daguerreotype of Nareeb Nareeb, the country property of pastoralist and artist Charles Grey, is similarly taken from high ground. Looking across to the homestead and related buildings, the view seems much as one might expect to see in country Victoria today (p 138). A rather plain ambrotype, with its substantial foreground, of the Boorowa store in New South Wales, residence of John Bourne Crego and his partner Henry Wilshire Webb, takes on a new life with the knowledge that the store was held up in 1863 by bushrangers Ben Hall, John O'Malley and John Jamieson (p 128). Is this a record of proud ownership or of a crime scene?

Often it is not known who took a photograph. Wealthy subjects such as the Henty family in Victoria, and Isabella Carfrae at Ledcourt, Stawell, were pictured for posterity with house, servants and land but the photographers are unknown (p 139). The itinerant practitioners going from town to town in order to make a living, like Newland or Goodman, worked concurrently with many who did not leave their names on their work, and with amateurs, fascinated by the medium, with the time and money to experiment. These last included John Hunter Kerr in Victoria and Louisa Elizabeth How in Sydney.

John Hunter Kerr's photography is unusual in that he photographed the active lives of the Indigenous people living where he had settled, at Fernyhurst Station on the Loddon plains run in Victoria. Views of his house with family on the verandah, a big tree on the property, and Aboriginal artefacts he accumulated, provide insights into his world (pp 134–37). Their impact is outdone, though, by his photographs of an Indigenous man wearing a skin cloak aiming a rifle, and of an Aboriginal stockman dressed for work and holding a whip (p 135). This last exhibits a casual grace, prompting one historian to ask, 'did he think of himself ... as adapting, shaping his own future, and participating with strength and confidence in the new colonial economy?'[6] During the 1850s and '60s an estimated 1500 Aboriginal workers were employed on Victorian stations, receiving wages and rations as the other workers. While Kerr, like other settlers, believed the Kulin people would soon vanish, he was curious and interested enough to want to form narratives around their lives and his own. His attempts to organise a photograph of a corroboree are instructive of the nature of his relationship with his neighbours:

> the dance is never performed by daylight, and the chosen time is at full moon. Being desirous of obtaining a photograph of the corroboree, I once prevailed on a few of the blacks to dance it by daylight. This was only done for the promise of a considerable present; but no arguments would induce them to allow the lubras to witness the exhibition at that unusual hour, and to complete my picture I was obliged to content myself with a group of young men, wrapped in their skins, to represent the absent ladies.[7]

Kerr's neighbours were not subservient to the settler's wishes and fair exchange was necessary. The photographs Kerr took were widely disseminated in Australia and Europe through engravings and prints from his plates. These prints were made later for commercial gain by professional photographers, appearing in various albums as well as in Kerr's own memoir, which was first published in 1872.[8] The images were adapted variously: for the demonstration of 'types', or the progress of Empire, to illustrate stories, and in exhibitions describing adaptability and industry.[9]

Meanwhile, within the different social milieu of Melbourne, John Gill was successfully practising as an architect and, possibly, under a pseudonym, skewering local politicians through caricatures in the press.[10] Gill and his wife Joanna Apperly Gill were close friends of a much younger couple Charles and Susan Norton and their children; indeed Susan was Joanna's sister-in-law. Despite the rather forbidding demeanour of Gill in the photograph of him and Joanna Kate Norton, or his wife's apparent haughtiness in a formal portrait by Antoine Fauchery, these pictures provide fascinating insight into society and family life in Melbourne in the late 1850s (p 143). Two photographs of the view, most likely from the verandah of the Gill-designed house at 1 Spring Street where the Norton family lived, show the children leaning on the fence in the middle distance as the camera captures Wellington Parade and the adjacent view across the Yarra (p 142). It is conjectured that Charles Norton took these outdoor views and a photograph of Gill and his daughter.[11] Buried in Gill's ample front, the ringleted child declines to be recorded.

As the nineteenth century wore on, the depiction of people in general became more varied and complex. However, Indigenous Australians were regularly portrayed as lesser beings, as in Louisa Elizabeth How's photograph of explorer William Landsborough, Tiger and JL on the verandah of her house at Kirribilli Point (p 130). They did appear from time to time standing shoulder to shoulder with the colonists, as can be seen in another portrait of Landsborough with guides Jack Fisherman and Jemmy after crossing Australia from north to south, initially in search of explorers Burke and Wills (p 130). The possibility of equivalence is, however, undercut by their generic names. Richard Daintree's painted photographs present various interpretations of Indigenous subjects, ranging from exotic others to industrious farmers to subservient camp followers; white or black, all his figures invariably devolve into types (pp 90–93). A large hand-tinted ambrotype housed in an elaborate, gilt, leather and blue-velvet case of an unknown Aboriginal man by an unknown photographer is intriguing. The subject's clothes are worn but his hair and person are neatly presented (p 152). Who was this man with his level gaze and why was he photographed and the ambrotype so beautifully encased?

Louisa Elizabeth How is a rarity in nineteenth-century photography, a woman whose photographs have survived.[12] Women did take photographs, as both professionals and amateurs. They owned or worked in various capacities in town or country studios, and exhibited in world exhibitions. Yet of all that has been lost of nineteenth-century Australian photography, it is disproportionately their photographs.[13] The How album and some related prints mostly taken over Christmas and New Year 1858–59, give a rare and fascinating insight into well-to-do Sydney life of the time. None of the photographs are of How herself, rather the menfolk and their friends and visitors. A stereo viewer and stereo cards feature prominently, probably acquired from photographer William Hetzer, whose studio was at 15 Hunter Street, Sydney. There are photographs of Woodlands, the house where How lived in Kirribilli, other residences and Sydney scenes. Her portraits are the most compelling: posed and yet relaxed, outdoor, convivial and engaged (p 131).

In South Australia, grazier William Ranson Mortlock and his wife Margaret Tennant had themselves, their children and servants recorded for posterity. Jemima was nanny to their only son William Tennant Mortlock (pp 110, 153). With her husband Jacky, Jemima would have come from Poonindie Mission, which had been established by Archdeacon Mathew Hale in the early 1850s near Port Lincoln in South Australia. By 1860 the mission covered around 15 000 acres carrying sheep, cattle, horses, and growing wheat and oats.[14] It became self-supporting, but this success led to its closure in 1894, when the land was subdivided and sold, and the people were dispersed to Point Pearce and Point McLeay.[15] Photographer Samuel Sweet visited in 1884 and photographed the schoolchildren outside the schoolhouse and the men with their farming equipment (p 156). The latter photograph is taken from above, showing the extent of the mission and, as was noted of Coranderrk in Victoria, its orderliness.

Various images of the Indigenous catechists at Poonindie were in circulation in the nineteenth century under different photographers' names. The original daguerreotypes and ambrotypes reside at Mill Cottage, Port Lincoln, and with Mathew Hale's papers at the University of Bristol in England. One of those so photographed was James Wanganeen; an 1867 carte de visite of him is held in the Pitt Rivers Museum, Oxford.[16] Originally a Maraura man from the Upper Murray, Wanganeen had been to school in Adelaide and in 1852 moved to Poonindie. His piercing gaze and neat attire is indicative of the ways in which the people at Poonindie presented themselves to the camera (p 238). Their confidence, and pride in dressing well – often to the point of dandyism – conveyed purposefulness and a certain affluence.

Poonindie men played cricket but those who formed the first Australian cricket eleven to tour England in 1868 were from Coranderrk in Victoria. The Aboriginal team won fourteen and drew nineteen of the forty-seven games played. Fred Kruger photographed the cricketers in 1877, though the first to have done so was

Patrick Dawson in 1867 in advance of the tour to England. Dawson made his full-length portraits of the cricketers – all of whom are named – in the studio (p 151). Posed with either cricket bat or boomerang, they demonstrate sporting or hunting prowess. The vignetted portraits are topped and tailed by those of their manager and coach. It has been noted that Dawson 'draws an anthropological connection between customs and reminds the European viewer that what they are seeing is Aboriginal people "progressing" through the adoption of British ways'.[17]

Kruger's photographs, made a decade later, of Coranderrk life in general and cricketing in particular, have been interpreted by historians Jane Lydon and Barry Judd as presenting an Aboriginal idyll.[18] Like Poonindie, Coranderrk became a self-supporting community through the 1860s and '70s yet, from the mid 1870s onwards, pressure was brought to bear to close it down. Kruger was commissioned by the Victorian Board for the Protection of Aborigines to produce a visual defence of the Board's work, and the resulting photographs show that he was able to engage sympathetically with his subjects. The range and variety of his work, from outdoor scenes to portraits, leaves a remarkable document of a strong and successful community.

In his analysis of Kruger's Aboriginal cricketers Judd notes that the photographer emphasises 'the cultural transformation of the Kulin into cricketers whose sporting habits mirrored those of their nineteenth-century English counterparts' and provides 'a scene reminiscent of cricket played on the village greens of Hampshire and Kent'.[19] For the English and settler Australians, cricket demonstrated the purity of 'muscular Christianity' and therefore the height of English civilisation. The activity of the Coranderrk cricketers is played out in Kruger's photograph showing children sitting in a line watching the men who are caught in the middle of play. Kruger would have needed time to compose this photograph and seconds to expose his plate so this is a highly choreographed image. What makes it all the more striking is that the man in the foreground – the only adult dressed entirely in white – has turned to look directly into the camera (p 149).

Kruger was not alone in making such composed depictions. In 1869 the Sherwood family, who had settled in the Richmond River district of New South Wales, were photographed at their property Unumgar Station, probably by Conrad Wagner.[20] The neighbouring Indigenous people were similarly posed by Wagner on the banks of the river. While the settlers were fully clothed, in the latter photograph the subjects, named after the station's owner (Henry Barnes of Ettrick) have been asked to remove their tops (p 133). Here the idea of an innocent pastoral idyll conveyed by the photograph of the Sherwoods is linked to the corresponding contemporary fantasy of the naked savage.

A photograph taken at the Benedictine New Norcia Mission in Western Australia in 1867, probably by itinerant photographer Walter William Thwaites, is distinctly different (p 171). According to historian Anna Haebich this particular photograph shows Brother Pablo Clos nursing baby boy Pat and flanked by two Yued men, one of whom is called Chiuck.[21] The baby and the children seated in front are clothed in smocks, while the men wear skin cloaks and carry spears. The monk in his black robe in the centre lends intensity to the tableau, as do the Yued men. There were many photographs taken at New Norcia in the nineteenth century, often by Father Santos Salvado, brother of the founder of the mission. Most, regardless of the photographer, are structured as solemn tableaux showing working Christianised lives in this monastic community. The Christlike aspect of Thwaites' photograph is clear through the formal relationships of monk to children. The Yued men flanking could be asserting their presence and co-existence, as Haebich writes, or posed to represent relics from an un-Christianised past.

Western Australia had grown slowly from 1829 with the establishment of the Swan River colony. The New Norcia Mission had begun north of Perth in 1846. A 1850s daguerreotype thought to be of Barrack Street, Perth, shows neat roads and orderly buildings (p 166). This is where the Hester family, despite their evident terror of being daguerreotyped, would have promenaded and taken the air (p 166). In 1850 the westernmost Australian settlement became a penal colony, as the need for labour grew and attracting free settlers had failed; transportation did not cease until 1868 when the population was about 25 000 (less than two per cent of Australia's total until the gold rush of the 1880s).[22] The Stone album of 1868 was put together by lawyer and amateur photographer Alfred Hawes Stone for his daughter Fanny Annette Hampton, and shows the continuing sparseness of Perth, a town still coming into existence (p 167). The panoramas of 1904 that Melvin Vaniman took in the state are of vast landscapes, still with few architectural features.

The tintype process reached Australia in 1858 five years after its invention in France, and was the most inexpensive mode of portraiture. The usual form of tintype was a thumbnail-sized 'gem', which was presented in albums and showed only the head and shoulders of the subject. The Simson family albums of carefully hand-tinted gems, one each for the men and

women, show them at their best in an array of family 'mugshots', generally in three-quarter profile akin to the later impromptu photo booth or street shots (p 124). Indeed tintypes were often taken by street vendors. Originating in San Francisco, tintype specialists Gove & Allen operated in the eastern Australian colonies in the 1880s and their carte-sized paper-holders for individual gems turn up across the country. The larger format tintypes are less common and because of their size allow for more elaborate studio settings and more of the person to be seen. The limited tonal range of all tintypes lends an almost otherworldly aspect to the subjects, flattening them and highlighting idiosyncrasies, as of the Thomas brothers, proprietors of the Ravenswood Hotel, Mandurah, who swap places and remove their hats (p 169); the men of the farming Weaver family; or the Reilly family of Kojonup (p 170). In Tasmania, the large over-painted tintypes of Launcestonians Susanna and Letitia Fisher from about 1865 exemplify a particular regional interest in using photography as a support for painting (p 125). In this technique detail and colour could coincide in ways that neither medium alone could then satisfy. The strangeness of the effect lies in the unpainted photographed visage and the heavily painted clothes and background.

By the late nineteenth century, the increasing speed and portability of the photographic process allowed for more diverse ways of representing people and where they lived. Henry Hammond Tilbrook owned a newspaper in South Australia, the *Northern Argus*, and such was its success that he could retire at the age of forty-one and devote himself to his hobbies, which included geology and photography.[23] Tilbrook often included himself in his photographs, which were taken on trips all over the state, mainly in the 1890s and 1900s. The static and detailed nature of his work, where all is carefully and clearly composed, makes his best photographs unusual for a period where the English style of pictorialism was taking hold in Australia. Tilbrook developed an ingenious shutter release that allowed him to appear in his own compositions, whether looking across the lake in *A stormy camp, Lake Frome* 1900 or out to sea from Corset Rock. When other figures appear, as in *Spoils of the ocean* 1898, they are formed into a tableau to assist in telling the story (p 159). Invariably, Tilbrook is spelling out a narrative associated with time and place.[24] He also took stereo views and his romantic imaging of the young woman Lizzie Smelat can be seen as an exercise in metaphysical portraiture.

The idea of photographically documenting people and the communities where they lived had begun soon after the advent of the medium. Technological difficulties, in the main, militated against this until the early 1870s when the American & Australasian Photographic Company began systematically visiting small towns in New South Wales and Victoria and making cartes de visite of the inhabitants. The 1861 GH Jenkinson ambrotypes of Dunolly were town views rather than showing an interaction between place and people (p 196). Photographs of Indigenous communities in this period tend to distance and exoticise, with some of John Hunter Kerr's photographs a rare exception. In the early twentieth century, easier-to-use equipment, continuing expeditions exploring the country and growing towns led to a steady increase in different types of social and scientific documentation.

Walter Baldwin Spencer was one of a number of photographer–scientists who traversed Australia and from 1894 until 1923 he made several expeditions photographing, filming and recording.[25] Though Spencer proceeded from the perspective of an anthropologist, his work has left a priceless archive of people and their lives for descendants and others to access. In 1923 he photographed the children at The Bungalow, 'a home for half castes' on the edge of Alice Springs comprising three corrugated-iron sheds in which over sixty children were housed (pp 161–63).[26] Though apparently he was shocked at what he saw, he nonetheless photographed the children quite formally rather than focusing on how they lived. While these portraits again leave a record (many of the subjects are named), photographing the actuality of lives lived at The Bungalow was left for another five years until Adelaide doctor William Delano Walker visited and documented conditions, thus forcing a slow improvement.[27]

There is at least one backstory, if not many, to every photograph, most particularly when the ostensible subject is a portrait. How people appear in their photographs is a small part of an elaborate construction through time, form and space. The people of Tumut in New South Wales, whom local photographer Richard Strangman photographed for nine years between 1915 and 1926, present themselves for the standard recordings of babies, marriages, anniversaries and other special occasions. Strangman clearly did his best to oblige with limited means. The floor covering, backdrop and side table remain the same with few exceptions (pp 164–65). His photographs are not captioned so we can only conjecture as to where his subjects came from and their subsequent fate. These humble prints were Strangman's archive for reference and future orders but many of the individuals they depict, like the photographer himself, must have been just passing through.

1. In fact the subject is Jack Moffatt, the artist's uncle. He grew up in Cherbourg, QLD.

2. See Rex Butler & Morgan Thomas, 'Tracey Moffatt: from something singular ... to something more', *Eyeline*, no 45, autumn/winter 2001, pp 23-31.

3. Some of this paragraph appeared in a lecture on Moffatt's work given by the author in Australasia (Wellington, New Zealand; Sydney, Adelaide and Canberra, Australia) in the 2000s.

4. Photography arrived in Sydney in 1841, though no one worked as a photographer in Australia until George Goodman, late in 1842. Adelaide and Melbourne were colonised in the 1830s, Brisbane and Perth in the 1820s, Hobart in 1803 and Sydney in 1788.

5. See Roland Barthes, *Camera lucida: reflections on photography*, trans Richard Howard, Hill & Wang, New York, NY, 1981, pp 80-81, quoted in Geoffrey Batchen, 'A perfect likeness', in Helen Ennis, *Mirror with a memory: photographic portraiture in Australia*, National Portrait Gallery, Canberra, 2000, p 28.

6. Elizabeth Willis, 'Re-working a photographic archive: John Hunter Kerr's portraits of Kulin people 1850s-2004', *Journal of Australian Studies*, vol 35, no 2, June 2011, pp 235-49.

7. John Hunter Kerr, *Glimpses of life in Victoria by 'a resident'*, The Miegunyah Press, Melbourne University Publishing, Carlton, Vic, 1996, pp 16-17.

8. Willis 2011, p 246.

9. Elizabeth Willis, 'Exhibiting Aboriginal industry: a story behind a "re-discovered" bark drawing from Victoria', *Aboriginal History*, vol 27, 2003, pp 48-50.

10. John Gill and 'Quiz' of *Melbourne Punch* may have been one and the same. See daao.org.au/bio/john-gill/biography, accessed 28 March 2014.

11. See Jennifer Phipps, *Squatter artist: Charles Norton (1826-1872)*, State Library of Victoria, Melbourne, 1989, np.

12. The photographs in the How album remain 'attributed to' Louisa.

13. See Barbara Hall & Jenni Mather, *Australian women photographers 1840-1960*, Greenhouse Publications, Richmond, Vic, 1986, for detailed research; and Virginia Fraser, 'To the person who said feminism is over as though she was right', *Art Monthly Australia*, no 250, June 2012, pp 34-38.

14. See 'A cruise in the Governor Musgrave', *South Australian Register*, 15 Feb 1876, p 6.

15. See Maria Zagala, in Julie L Robinson (ed), *A century in focus: South Australian photography 1840s-1940s*, Art Gallery of South Australia, Adelaide, 2007, p 120.

16. See Pauline Cockrill, community.history.sa.gov.au/blogs/emotional-homecoming, accessed 25 March 2014.

17. Isobel Crombie, *Fred Kruger: intimate landscapes - photographs 1860s-1880s*, National Gallery of Victoria, Melbourne, 2012, p 68.

18. Jane Lydon, *Eye contact: photographing Indigenous Australians*, Duke University Press, Durham, NC, 2005, pp 126-34; and Barry Judd, '"It's not cricket": Victorian Aboriginal cricket at Coranderrk', *La Trobe Journal*, no 85, May 2010, p 44.

19. Judd 2010, p 44.

20. Mrs Sherwood was a relative of Bishop Mathew Blagden Hale who as Archdeacon had founded Poonindie Mission in South Australia.

21. Anna Haebich, 'Unpacking stories from the New Norcia photographic collection', *New Norcia Studies*, 2009, p 60.

22. Nine thousand convicts were transported to Western Australia between 1850 and 1868.

23. See Alisa Bunbury, *The photography of HH Tilbrook: South Australia at the turn of the century*, Art Gallery of South Australia, Adelaide, 2001, p 2.

24. See Elspeth Pitt in Robinson 2007, p 56.

25. See Philip Batty, Lindy Allen & John Morton (eds), *The photographs of Baldwin Spencer*, The Miegunyah Press, Melbourne University Publishing, Carlton, Vic, 2005.

26. Batty, Allen & Morton (eds) 2005, p 200.

27. Jane Lydon, *The flash of recognition: photography and the emergence of Indigenous rights*, NewSouth Publishing, Sydney, 2012, pp 82-87.

PHOTOGRAPHY ACROSS CULTURES

Jane Lydon

Photographs of Australian Aboriginal people have often been understood solely as an expression of the white man's gaze – and indeed, Indigenous Australians were of great interest to photographers from the camera's arrival in the colonies in 1841. Yet from their first encounters with photography, Australian Aboriginal people actively participated in the picture-making process. While it is important not to dismiss the enormous power inequalities that shaped colonial relations, instead of seeing photography simply as a tool of colonialism we should also consider the views and experiences of the Indigenous participants, and the ways that photographs embody a cross-cultural form of communication.

There is much historical evidence for Aboriginal interest in photography, and particularly its potential to provide portraits of family. In Victoria in 1857, for example, Wurundjeri man Simon Wonga, son of the *ngurungaeta* (leader) Billibellary, was photographed by daguerreotypist Hubert Haselden, and his image was circulated in the form of newspaper engravings to a curious public. Later that year he exchanged the nest and egg of a superb lyrebird, known by the Wurundjeri as the *bullen-bullen*, for two photographs. The German artist and naturalist Ludwig Becker told how by presenting Wonga 'and one of his relations with their respective photographic portraits, I succeeded at last in making them fulfil a long given promise, and accordingly they brought a nest and egg of the *Menura superba* to Melbourne'.[1]

Coranderrk Aboriginal Station, close to Melbourne, was a magnet for photographers, and it was often noted that the Aboriginal residents collected and treasured portraits of their community. In 1865 an official visitor noted that 'on most of the side mantelpieces were photographs of the ladies and gentlemen of the establishment'.[2] In September 1876 the *Argus* reported that 'some of the chief objects of desire' were 'photographic representations of their own and their children's countenances'.[3]

As a result of the growing belief that the Aboriginal race was doomed to extinction, white photographers sought to record what was believed to be a disappearing way of life. They followed the 'frontier', seeking Aboriginal people apparently untouched by change – seemingly 'primitive', 'authentic' subjects, stripped of signs of European civilisation such as clothing.

Other photographs tell stories of adaptation, showing Aboriginal people who had successfully made a place for themselves and their families in colonial society. In South Australia around 1860 dignified portraits were produced of Tatiara couple Jacky Gunlarnman and his wife Jemima, servants of prominent pastoralist William Ranson Mortlock, who had settled in South Australia in 1844. Mortlock had 'rescued' Jacky in 1855, and a decade later, Jacky and Jemima lived in a house that contained three rooms, worth five to eight shillings per week as rent. Jacky could read and write a little and was 'said to possess a very fair degree of general intelligence', and to lead 'a very happy and useful life'.[4] His ambrotype portrait is dignified and serious, showing him dressed respectably and seated before a picturesque painted landscape (p 153).

But the harmony of this scene is undermined by other evidence of fraught and brutal relations between Mortlock and the Indigenous people of Port Lincoln. In 1859 a local Aboriginal shepherd named Colotoney died of injuries allegedly inflicted by Mortlock's brother-in-law Andrew Tennant for allowing his sheep 'to mix with others'. Aboriginal witnesses from nearby Poonindie Mission were contradicted by Mortlock, who argued that 'everybody knew that it was general practice in the bush to thrash the natives when they deserved it, it being the only way of managing them'.[5] The portraits of Jacky and Jemima were valued within a hierarchy that placed them in the subordinate role of servants.

Some colonists, however, recognised the shared humanity of Aboriginal people and believed in their future. Although premised on transformation and the abandonment of traditional culture, humanitarians such as missionaries worked hard to help Aboriginal people within the terms of their own culture and time. A remarkable series of portraits commissioned by Anglican clergymen at Poonindie Mission during the 1850s and 1860s express a conception of the essential unity of humankind and the equality of their subjects in a distinctively inclusive vision that marks a radical departure from contemporary photographs of Indigenous Australians.

Poonindie was established in 1850 by the Bishop of Adelaide, Augustus Short, and his Archdeacon, Mathew Blagden Hale. By early 1853 a group of eleven young men and women were baptised – Thomas Nytchie, James Narrung, Samuel Conwillan, Joseph Mudlong, David Tobbonko, John Wangaru, Daniel Toodko, Matthew Kewrie, Timothy Tartan, Isaac Pitpowie, and Martha Tanda, wife of Conwillan – during the first recorded conversion of Aboriginal people in Australia. Short and Hale defined the Indigenous subjects as gentlemen, the 'nucleus of a native church'.[6] Visible evidence for

their achievements at Poonindie took on particular significance, and Bishop Short linked the appearance of the people of Poonindie, measured by their clothing and personal grooming, with their spiritual transformation.

This group of Aboriginal Christians was frequently compared with aristocratic young upper-class Englishmen – especially on the sporting field. In February 1854, Sam (Conwillan), 'Sam junior' and Charlie were in Adelaide, and were invited to play cricket with the pupils of St Peters College. The Adelaide *Register* reported that they were 'very fine fellows', speaking 'pure English, without the slightest dash of vulgarism and are in truth far more gentlemanly than many'.[7] During this visit, Samuel Conwillan and Nannultera were painted by John Crossland, producing two dignified portraits now held by the National Library of Australia. The missionaries also commissioned photographic evidence of their success, including five early photographs that are very similar to Crossland's painting.

These two remarkable portraits (p 155) are ambrotypes, a technique invented in 1851 that produced a positive image on glass and was very quickly taken up in Australia after 1854. One is likely to be Samuel Conwillan, as a committed Christian and leader of his community. These portraits argued for the capacity for Indigenous civilisation and Christianisation, against those who argued for their essential difference on racial grounds. They also reveal the choices and ambitions of the Aboriginal sitters themselves.

Photographs travelled across racial lines, their value shifting according to context: often they were produced to satisfy curiosity, or serve scientific theories or popular views of humankind. Aboriginal people quickly grasped their potential to reveal family and social worlds and to stand in for *people*. Today, such photographs may prove or narrate Indigenous stories, and assert a historical presence. They reveal Indigenous strength, dignity and worth, and experience of change, and confirm the truth of a history otherwise known only through family stories. In the aftermath of colonialism, these images may also reinstate Aboriginal people within our national past, and show us a shared space of engagement and communication.

1. Ludwig Becker, 'The nest, egg and young of the lyrebird (*Menura superba*)', *Transactions of the Philosophical Institute of Victoria*, vol 1, 1857, pp 153-54. I thank John Kean for his re-telling of this story: John Kean, *Empirical eye: scientific illustration in colonial Australia*, Museum Victoria, Melbourne (forthcoming).

2. 'Country sketches: the blackfellows' home', *Australasian*, 5 May 1866, p 135.

3. *Argus*, 1 Sep 1876, p 7.

4. *Pastoral Pioneers of South Australia*, vol 1, Publishers Limited Printers, Adelaide, 1925, p 93.

5. Chief Secretary's Office no 819 61/59, from AJ Murray, Government Resident, Port Lincoln 26/1859, cited in Peggy Brock & Doreen Kartinyeri, *Poonindie: the rise and destruction of an Aboriginal agricultural community*, Aboriginal Heritage Branch and SA Government Printer, Adelaide, 1989, p 8.

6. Augustus Short, *The Poomindie [Poonindie] Mission: described in a letter from the Lord Bishop of Adelaide to the Society for the Propagation of the Gospel*, Society for the Propagation of the Gospel, London, 1853, p 18.

7. *South Australian Register*, 7 Feb 1854.

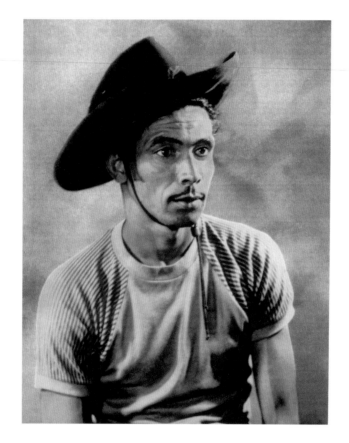

Tracey Moffatt
Beauties (in cream) 1994

opposite:
Beauties (in mulberry) 1997
Beauties (in wine) 1994
Queensland Art Gallery

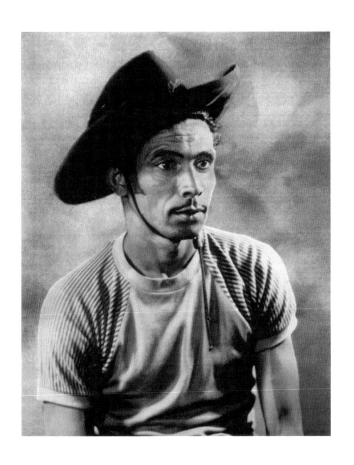 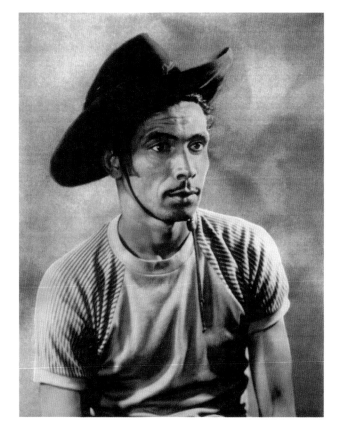

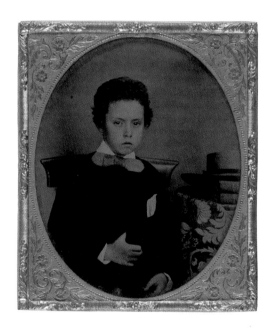

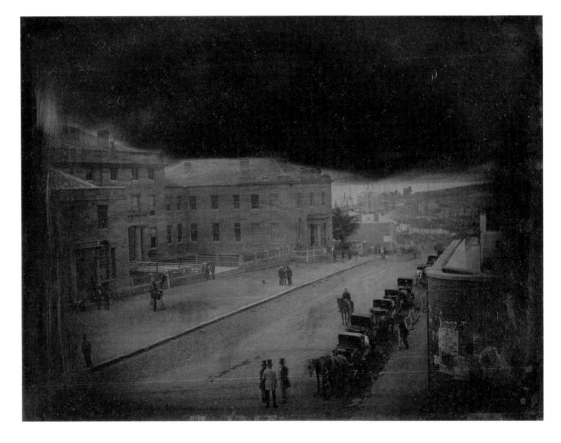

JW Newland
Murray St, Hobart 1848
Tasmanian Museum and Art Gallery, Hobart

opposite, clockwise from top:
Thomas Bock or **Thomas Browne** (?)
Portrait of unknown man and woman c1850
Tasmanian Museum and Art Gallery, Hobart

Unknown photographer
Fanny Maria Davenport, aged 12 years 1861

Walter Charles Davenport, aged 8 years 1861

Narryna Heritage Museum, Hobart

Gove & Allen
Portraits of the Simson family c1880
Tasmanian Museum and Art Gallery, Hobart

opposite:
Unknown photographer
Susanna Fisher c1865
Queen Victoria Museum and Art Gallery, Launceston

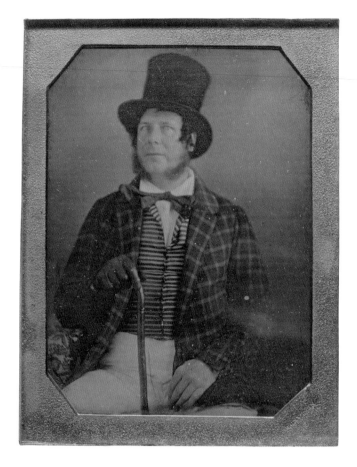

JW Newland
Portrait of Edward TYW McDonald 1848
Macleay Museum, The University of Sydney

opposite, clockwise from top left:
George Goodman
Sarah Ann Lawson 1845

Eliza Lawson 1845

Maria Emily Lawson 1845

Sophia Rebecca Lawson 1845

State Library of New South Wales, Sydney

H Toose
Aboriginal group in front of Toose's cart, Bega 1878
Private collection

Unknown photographer
The store and residence of John Bourne Crego and his partner, Henry Wilshire Webb 1863
Art Gallery of New South Wales, Sydney

opposite, clockwise from top:
Croft Brothers
Portrait of a man 1863–65
Private collection

Unknown photographer
Thomas Sutcliffe Mort and his wife Theresa c1847
National Portrait Gallery, Canberra

attributed to **Edwin Dalton**
Eleanor Elizabeth Stephen c1854
State Library of New South Wales, Sydney

Edward Irby
Studio portrait of a six-year-old girl Ann Plummer c1864
Museum of Applied Arts and Sciences, Sydney

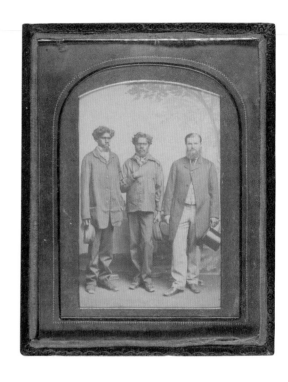

Louisa Elizabeth How
Mr William Landsborough, Tiger and JL 1858–59
Art Gallery of New South Wales, Sydney

Batchelder and O'Neill
William Landsborough with his native guides
Jack Fisherman and Jemmy c1862
Pictures Collection, National Library of Australia, Canberra

opposite:
Louisa Elizabeth How
John Glen in an untitled album 1858–59
National Gallery of Australia, Canberra

John Glen 2 January 1859

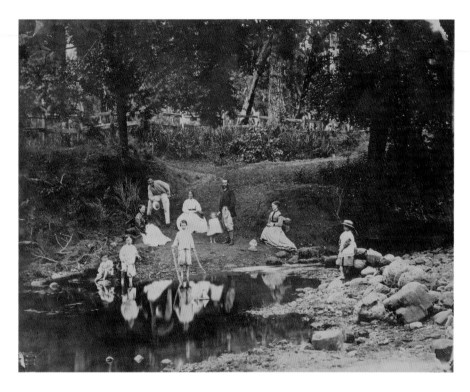

Conrad Wagner

Mr & Mrs Sherwood & family. Unumgar, Queensland c1869

opposite:

(Mr Barne's) Ettrick Blacks, Richmond River c1869

State Library of New South Wales, Sydney

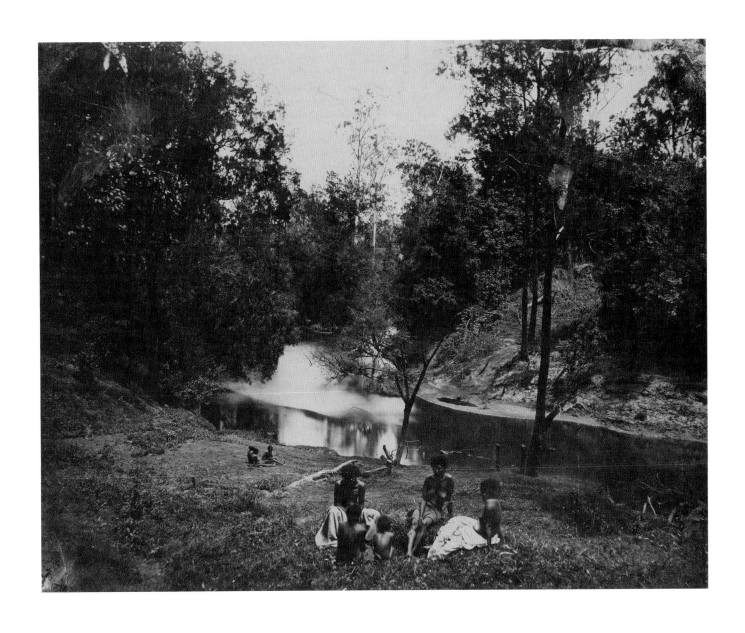

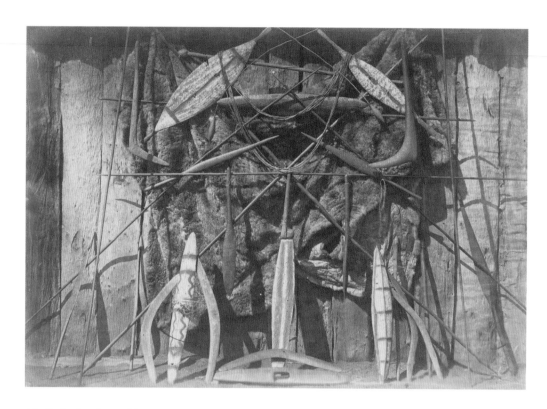

John Hunter Kerr, George Priston
Aboriginal spears, boomerangs and implements
c1865–75
Picture Collection, State Library of Victoria, Melbourne

opposite, from left:
John Hunter Kerr, George Priston
Full-length portrait of Aboriginal man, standing,
holding stockwhip and wearing European clothes
c1865–75
Picture Collection, State Library of Victoria, Melbourne

John Hunter Kerr
Native lad – Port Phillip c1851–55
Picture Collection, State Library of Victoria, Melbourne

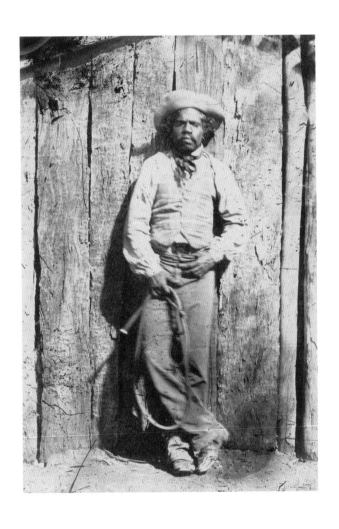

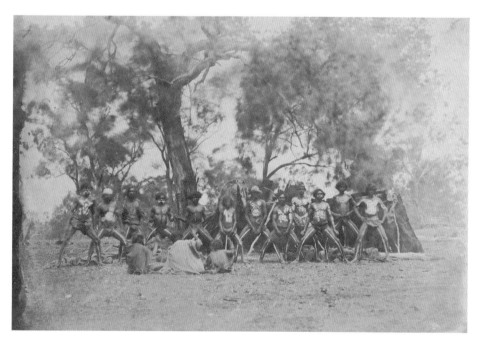

John Hunter Kerr, George Priston
View of a tree c1865–75
Picture Collection, State Library of Victoria, Melbourne

opposite:
John Hunter Kerr
J Hunter Kerr's station – Loddon Plains, Victoria c1851–61

A corrorobby [corroboree] *(Victoria)* c1851–55
Picture Collection, State Library of Victoria, Melbourne

Unknown photographer
Isabella Carfrae on horseback,
Ledcourt, Stawell, Victoria c1855
National Gallery of Australia, Canberra

opposite, clockwise from top left:
Unknown photographers
Nareeb Nareeb, residence of
Charles Gray c1849–61
Picture Collection, State Library of
Victoria, Melbourne

Sandford, the home of John Henty,
Portland Region, Victoria c1865
Pictures Collection, National Library of
Australia, Canberra

Dr Godfrey Howitt's garden c1850
Picture Collection, State Library of
Victoria, Melbourne

Southern or back view of Rose
Cottage, Prahran c1856
National Gallery of Australia, Canberra

Unknown photographers
James Henty c1855

Caroline McLeod c1865–70

Picture Collection, State Library
of Victoria, Melbourne

opposite:
Joseph Turner
James Henty and Co building,
Brougham Place, Geelong c1857–67
The University of Melbourne Art Collection

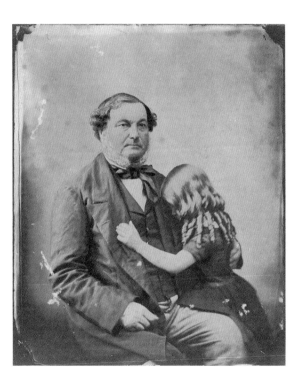

Unknown photographer
John Gill and Joanna Kate Norton 1856
Picture Collection, State Library
of Victoria, Melbourne

Antoine Fauchery
Joanna Apperly Gill 1858
Picture Collection, State Library
of Victoria, Melbourne

opposite
Unknown photographer
*2nd view of Yarra from corner of
Flinders St (Melbourne)* 1861

*View looking up Wellington Parade
from 1 Spring St before the road
was cut down (Melbourne)* 1861

Picture Collection, State Library
of Victoria, Melbourne

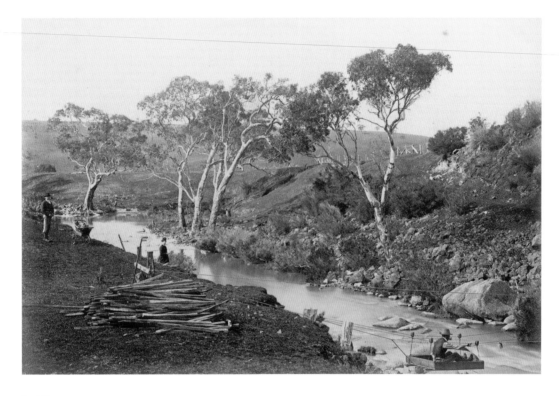

Fred Kruger
View on the Moorabool River, Batesford c1879

opposite:
Victorian Aboriginals' war implements, Coranderrk c1877

National Gallery of Victoria, Melbourne

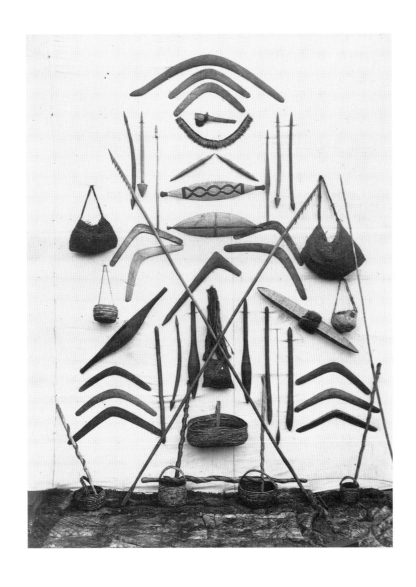

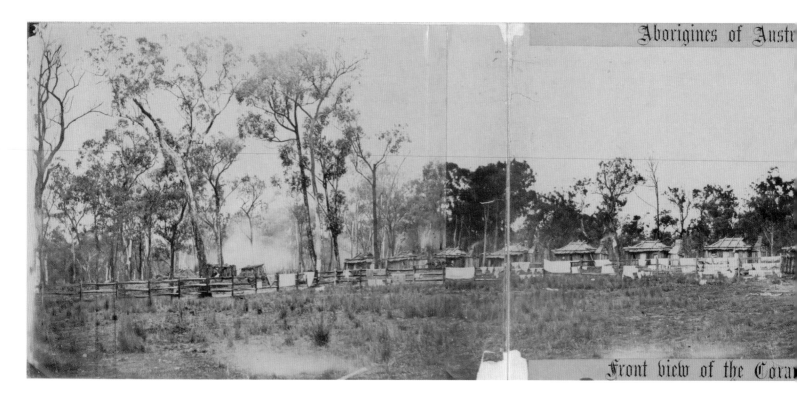

Within the image: Aborigines of Austr[alia]

Front view of the Cora[nderrk]

Charles Walter
Coranderrk Aboriginal settlement 1865
State Library of New South Wales, Sydney

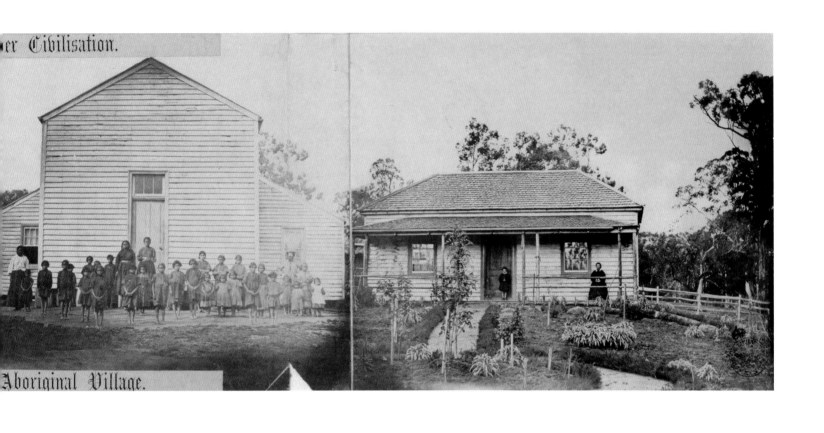

er Civilisation.

Aboriginal Village.

Fred Kruger
A view of the You Yangs, from Lara Plains c1882

opposite:
Aboriginal cricketers at Coranderrk c1877

National Gallery of Victoria, Melbourne

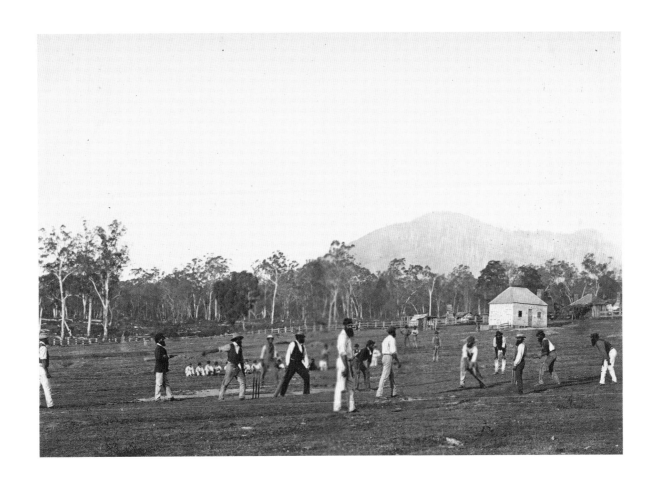

Talma & Co
Barak drawing a corroboree c1898
Picture Collection, State Library of Victoria, Melbourne

opposite:
Patrick Dawson
Aboriginal cricket team of 1868 1868
National Museum of Australia, Canberra

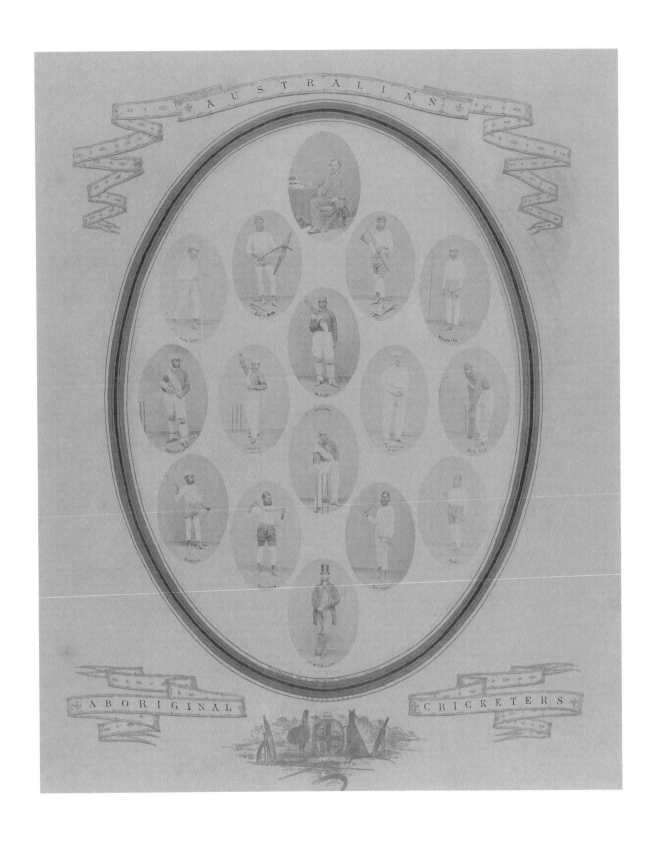

Unknown photographer
Unidentified Aboriginal Australian man in European dress 1854–65
Picture Collection, State Library of Victoria, Melbourne

opposite:
Unknown photographers
Margaret Mortlock and her daughter Mary c1855

William Ranson Mortlock 1860–65

Jacky, known as Master Mortlock c1860–65

Ayers House Museum, National Trust of
South Australia, Adelaide

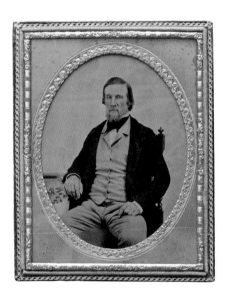

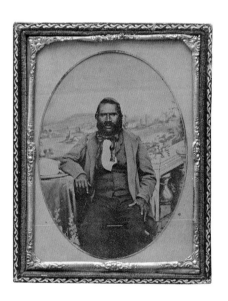

Unknown photographers
Lydia Featherstone c1860

*Brothers William Paul and Benjamin
Featherstone* c1860 (?)

Art Gallery of South Australia, Adelaide

opposite:
Unknown photographers
Aboriginal man of Poonindie c1855

Probably Samuel Conwillan c1855

Special Collections, University of Bristol Library,
United Kingdom

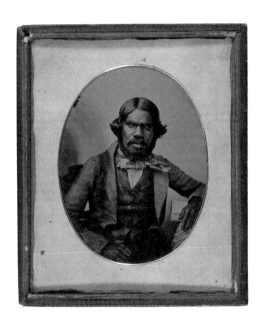 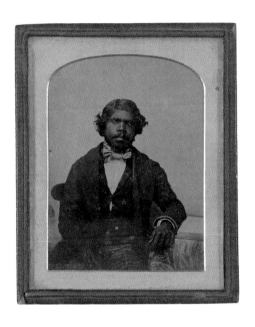

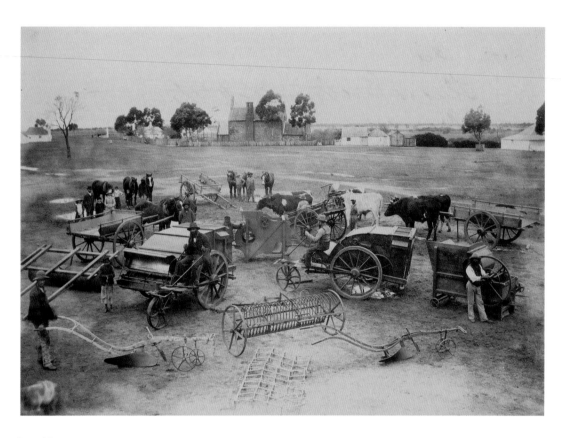

Samuel Sweet
Poonindie Mission – machinery, Aborigines,
Mr Bruce and children 1884
Art Gallery of South Australia, Adelaide

opposite:
Aboriginal woman with baby 1880
RJ Noye Collection, Art Gallery of South Australia, Adelaide

Aboriginal man in animal skin cloak c1876
Sweet Collection, South Australian Museum, Adelaide

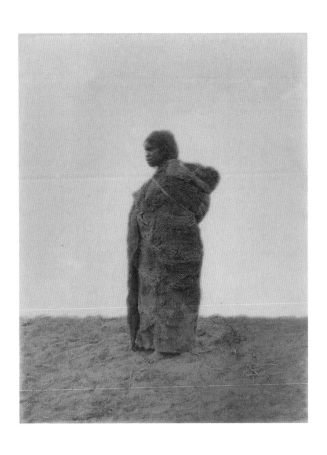

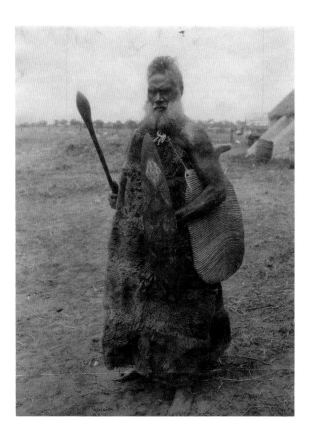

Henry Tilbrook
Elder Range panorama with inset self-portrait 1894

Spoils of the ocean (left) and *Breakfast in the boat* (right)
in *Album of photographs by HH Tilbrook (2)* 1898

RJ Noye Collection, Art Gallery of South Australia, Adelaide

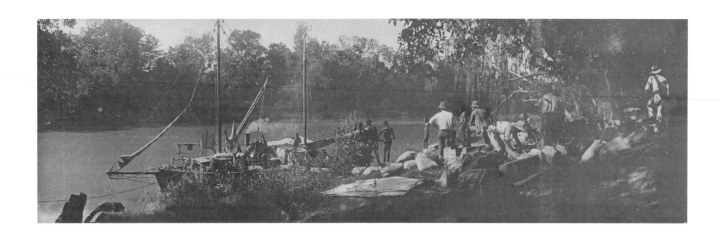

Walter Baldwin Spencer

*Unloading supplies, Daly River, Northern
Territory, Australia* 1911

*View of Roper River, Northern Territory,
Australia* 1911

opposite:
*Panorama photo of a group of children,
the Bungalow Mission, Alice Springs,
Northern Territory* 1923

Museum Victoria, Melbourne

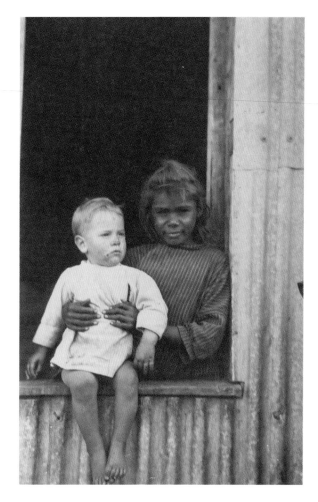

Walter Baldwin Spencer
*Portrait of Clem Smyth and Annie Giles
taken at the Bungalow Mission, Alice Springs,
Northern Territory* 1923

opposite:
*Portrait of a group of children taken at the
Bungalow Mission, Alice Springs, Northern
Territory* 1923

*Portrait of Agnes Draper taken at the Bungalow
Mission, Alice Springs, Northern Territory* 1923

Museum Victoria, Melbourne

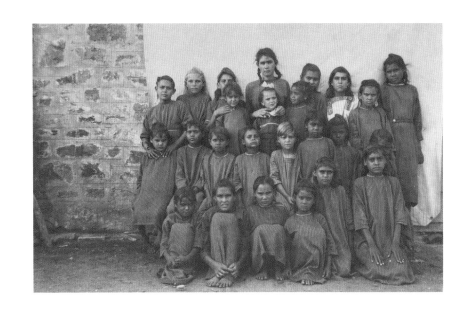

Richard Strangman
People of Tumut, New South Wales 1915-26
Pictures Collection, National Library of Australia, Canberra

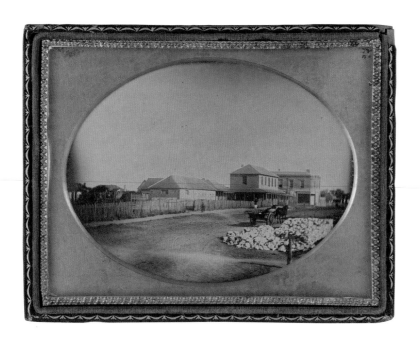

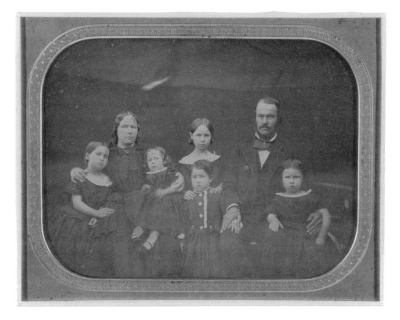

Alfred Hawes Stone
Panorama of Perth in the *Stone album of photographs of early Perth and Fremantle* 1860–68
State Library of Western Australia, Perth

opposite:
Unknown photographer
Barrack St, Perth (?) c1850
State Library of Western Australia, Perth

attributed to **Sanford Duryea**
Edward and Theodocia Hester and family c1859
Private collection, on loan to the National Gallery
of Australia, Canberra

Unknown photographer
Alfred and Fred Thomas, proprietors of the
Ravenswood Hotel 1880–90

opposite:
Unknown photographers
Unidentified members of the Olley family c1880

State Library of Western Australia, Perth

Unknown photographer
Portrait of Bridget Reilly c1887

William, Richard, George or Patrick Reilly c1887

Portrait of George Green c1887
State Library of Western Australia, Perth

opposite:
attributed to **Walter Thwaites**
*New Norcia Benedictine Mission: priest nursing
boy with Aboriginal men 'Chiuck' and 'Biug'
wearing skin cloak standing l–r, and mission
boys seated on floor* 1867
National Gallery of Australia, Canberra

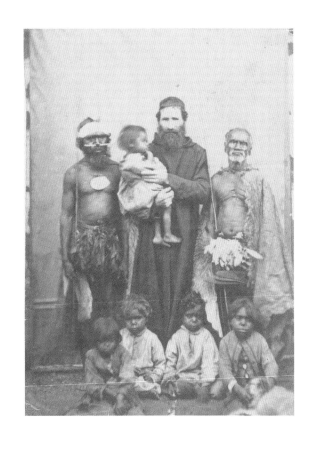

On 2 December 1911, photographer and budding film-maker Frank Hurley sailed from Hobart on the first of his voyages to the Antarctic. As a member of Douglas Mawson's ambitious Australasian Antarctic Expedition, Hurley was charged with recording the efforts of the explorers and scientists and the environments they found themselves in. Mawson had promoted his expedition as affording 'the world an opportunity of seeing what Australians can do', arguing that Australia would gain 'the prestige of being strong enough to investigate and claim new territory'.[1] Hurley was twenty-six years old and owned a business producing postcards. He had been noticed for his adventurous action and night photography, and his technical abilities, especially with the richly toned and durable carbon printing. He travelled to the Antarctic with Graflex cameras and Cooke lenses, as well as cine film and the necessary paraphernalia for developing his film and plates.[2] Despite such cumbersome equipment, which was difficult to work with in raging blizzards and sub-zero temperatures, Hurley more than completed his tasks, showing the resourcefulness, pragmatism, physical strength and mental toughness that made him a valuable member of the team.

The first photography in the Antarctic occurred some decades before Hurley's arrival but he and Englishman Herbert Ponting (who accompanied Robert Scott's 1910–13 expedition) were the first professional and official photographers of their respective parties. Hurley was born in Sydney in 1885, into what was seen as a far-flung part of the British Empire. In the words of one of his daughters, he was 'a man's man', who was happiest on the road, exploring new and exotic locales and recording the drama of his experiences, which he later showed to broad audiences through his lantern-slide lectures, exhibitions and documentary films.[3] He was an entrepreneur, adventurer and consummate storyteller in both words and pictures. His desire to embellish his work so that his audiences could feel the full effect of 'being there' would eventually bring him into conflict with the burgeoning documentary and reportage movements, which supported the accuracy of recording on location, and not constructions for effect.

Hurley's first and second trips to Antarctica produced some of the most sublime and enduring images of that continent as well as his first film *Home of the blizzard* (1911–12). This was one of Australia's earliest documentaries and assisted Hurley in raising funds to return to the frozen continent. One of his fellow travellers, Archie McLean, noted in his diary that when they made their first stop at Macquarie Island, 'Hurley, in a kind of photographic ecstasy, was striving to do justice to his phenomenal surroundings. Torn between the claims of cinematograph and camera, he rushed about using each one by turns'.[4]

Hurley's carbon photographs of Antarctica, with their beautiful skies and rich tonalities, were made from sandwiching negatives in order to gain the dramatic effects he desired (pp 184–87). The colours in this series reflect his diary entry of 1912: '[I] could not but admire the wonderful vista unfolded before us. The distant sea littered with innumerable icebergs – lit by the low evening sun glowing pink. The ocean a blue mirror expanse, rippleless; above a canopy of the most wonderful blue Nimbus clouds'.[5]

Hurley not only produced the most limpid of pictures of Antarctica, he also wished to show the harshness of the environment at the camp on Adélie Land. The average wind speed was eighty kilometres an hour and the men were subjected to endless blizzards. They learnt to 'wind walk' and to manage being blown, as helpless as leaves, onto ice and rock (p 186). Hurley's depiction of their endurance was enthralling to home audiences, as was his recitation of their experiences during screenings of the silent *Home of the blizzard*. Hurley's work is a true representation of the sublime, where the majestic beauty of nature in all its wildness and vastness reduces humans to small and fleeting interlopers whose only hope of survival is camaraderie and mental and physical toughness. Hurley's experiences of the magnificence of nature and his ability to record what he saw and felt made him – like many photographers – a campaigner for the conservation of the environment and its flora and fauna.[6]

Hurley's Antarctic photography and his way of working were broadly consistent with Victorian thinking about nature and culture as well as the purpose of photography. His forebears within Australia, whether Nicholas Caire in Victoria, or Morton Allport and JW Beattie in Tasmania, had also wished to use the new technology to record what they saw and experienced and use photographs to inform others. Their efforts had contributed to speedy advances in the disciplines of natural history and science. In 1878 Ludovico Hart addressed the Literature and Fine Art section of the Royal Society of New South Wales, noting that

> photography has placed its services at the disposal of all branches of human knowledge …To botany, geology, astronomy, and geography, it is the faithful delineator of their marvels; in surgery, sociology, jurisprudence, its services are too well known to be dispensed with; in scientific research it has opened out a new field for the investigation of the philosophy of light; commerce and industry alike avail themselves of it, and to art and to art education it has become a handmaid and graceful satellite.

He finished his presentation by quoting the Tasmanian Beattie, who described photography as a practice for the people,

> made to bring under popular view all that has been rare and almost unattainable, the forms and pictures of suns and planets, the portraits and forms of life whose whole existence is spent in the eternal darkness of deep ocean. Surely then the educational influence of photography is immense, and must take its value from so great a social power. The use of photography to social science could never be supplied by another art – nothing else could so hold up the mirror to nature.[7]

Throughout the nineteenth and into the twentieth century the growth in exploration and the corresponding use of photography led to new knowledge and specialisations. However, as interdisciplinary scholar Paul Carter asks: 'Was exploration a scientific activity? Did it produce the kind of objective knowledge which photography could validate?'[8] He concludes that notions of exploration as scientific were as erroneous as the belief that the surface of a photograph could yield objective truths. Exploration was dependent on the knowledge of the explorers, of how to get from A to B and then how to return, not least to tell the tale. Similarly, the photograph was dependent for its meaning not only on the photographer but also the viewer, on understanding how the image was taken and then seen and what knowledge both viewer and photographer carried with them.

Scientist and explorer Ludwig Leichhardt noted of his Aboriginal guides in his journal of the 1844–45 expedition from Moreton Bay to Port Essington: 'their recollections are remarkably exact, even to the most minute details ... in fact, a hundred things, which we should remark only when paying great attention to a place – seem to form a kind of Daguerreotype impression on their minds, every part of which is readily recollected'.[9] Carter argues that what the guides could see were not picturesque views but 'signs and clues composing a recognisable path'.[10] However, in the nexus between photography, exploration and the picturesque is a fourth and critical element that the guides understood, motivated by their instinct for survival, that of 'the world of returning ... the world which lies invisibly behind on the outward route'. Further, 'to look into a country which is composed photographically' – for instance, Hurley's Antarctica where he had to learn how to get to and from his locations – 'is to look into a mirror revealing what lies behind the explorer's shoulder. The strangest place in this looking-glass world is where we stand looking into it but fail to see ourselves mirrored there...'.[11]

Hurley was interested in the cinematic effect of 'being there' and communicating what Carter describes as 'spatial speculation',[12] the very thing that the photograph always strives to capture but can never achieve: the lived, bodily experience where the view is an extension of ourselves. Hurley's photography created a visual enticement for audiences who could feel they had experienced something of the grandeur of Antarctica (or the other major subjects of his oeuvre over the next decades). His work encapsulated the disjuncture between travel, exploration and photography. Further, it exemplified the argument between accurate recording and the metaphysics of the photographic image.

The famous argument between CEW Bean and Frank Hurley in 1917 is indicative of the ongoing issues to do with the photograph's veracity or otherwise. Both men saw how photographs documenting war could be nation forming.[13] However, they could not agree on how to make an image so that it communicated the essence of 'being there'. Bean saw artefacts and photographic records of the events of World War I as sacred relics and during and after the war assiduously collected material and documented battlegrounds so that the national memory could be reinforced. He wanted to trace, and memorialise, the nation's formative pathways. While these records tended to be seen as colourless by the mainstream media of the time, one hundred years later the carefully notated, low-key photographs have assumed the patina and rigour of a conceptual meditation. Conversely, Hurley's operatic material, whether of Antarctica or World War I, has retained its original aesthetic and become embedded in the national and international consciousness as 'how it was', regardless of accuracy.

Travel and tourism were fed by increasing access to photographs from the 1860s onwards via the views trade and the emergence of inexpensive cartes de visite which circulated in their millions. The photographs covered all aspects of life, from the personal to the scientific. Scientists could exchange more comprehensive and supposedly more factual textual and visual information about themselves and their work globally.[14] The rapid evolution of photographic apparatus and materials made the photograph increasingly adaptable to all sorts of scientific purposes, not only on the ground but also in relation to the heavens.

Charting the sky is an integral part of all human cultures, and it was the desire of the British Empire to record the transit of Venus in 1769 that brought Captain Cook and his sailors to the southern hemisphere. What began as a voyage of science continued as a voyage of exploration.[15] The first English observatory

in Australia was established in 1788 at Dawes Point in Sydney, and the first known photographs through a telescope in this country were taken in pursuit of the 1874 transit of Venus. Mapping the southern sky was regularly under consideration and in 1887 the first International Astrophotographic Congress was convened in Paris. Fifty-six representatives from nineteen nations and colonies, including Australia's Henry Chamberlain Russell, agreed to contribute toward the first photographic star atlas (Carte du Ciel). This mammoth undertaking made use of both Sydney and Melbourne observatories from 1892 onwards.[16] Though heavenly bodies had been photographed with some accuracy since the 1850s in the northern hemisphere, the difficulties of keeping the equipment still and having emulsions sensitive enough to capture the faint light were multiplied by the movements of the Earth and the celestial bodies themselves.[17] In the nineteenth and early twentieth centuries advances in photographic sensitivity made it clear that the more that could be captured, the more there was to investigate, and what was visible to the eye or to early cameras was a mere layer or surface that could be penetrated with improved technologies. An added mystique in photographs of stars is that they depict light from hundreds, thousands or even millions of years ago. What can be seen with the naked eye on a clear night is a tiny fraction of what had existed and could be registered with a Star Camera. Further, the building blocks of life come from stars and stars have always been dependable guides since humans first considered the patterns of the night sky.

The advent of more sensitive plates enabled Melbourne astronomer Joseph Turner to photograph nebulae using the Great Melbourne Telescope, including the first photographs of the Orion Nebula in February of 1883 (p 212). Later photographs from the Sydney Observatory, for example of Omega Centauri and the Trifid Nebula were probably taken with the Star Camera that had been installed for the Carte du Ciel (p 210). Photography made it possible for images of phenomena previously invisible to be circulated in the scientific community and more broadly. Further, evidence of sophisticated Antipodean science meant to some extent a release from imperial directives.[18] The observatories were also important for meteorological work and were used to photograph clouds, lightning and other events (p 209). Due to lengthy exposures, such recordings became ever more detailed. This enabled greater accuracy in analysing weather as well as producing images that could be seen as beautiful, even magical.

A century later David Stephenson's photographs of stars, from a series begun in 1995, seem to register the regular movement of stars in the sky (pp 216–17).

In fact they record the movements of the Earth and Stephenson's camera, and in so doing, also 'impose an order, the random geometry of reason, on a view that would otherwise signify as vast and incomprehensible'.[19] Like Hurley, Stephenson has remained throughout his career vitally interested in notions of the sublime and how to animate these visually. He has also photographed extensively in Antarctica. Regardless of subject matter, Stephenson thinks of his art as 'essentially spiritual', and as 'exploring a contemporary expression of the sublime – a transcendental experience of awe with the vast space and time of existence'.[20]

In a paper given in 2004 considering photography of the natural environment, Stephenson pleads for an end to 'some of the largely artificial boundaries we have erected between nature and culture'. He asks that 'the inclusion of human presence, either literally or symbolically' as well as 'the process of photography … be consistently acknowledged rather than persistently concealed'.[21] Stephenson's forebears held a variety of perspectives on this subject. Hurley never hid his processes but his most famous photographs of Antarctica avoid human presence and present a cinematic envelopment. In Tasmania, photographers who used the stereograph, which remained popular there until the 1930s, such as the nineteenth-century Hobart-based Morton Allport and the early twentieth-century Launcestonians Frederick Smithies and Florence Perrin, wanted to impart the pleasures of the Tasmanian landscape with their friends and family firmly in view. Gentleman amateur Allport was an early and intrepid tourist in his new land. He sent photographs documenting and advertising adventures in beautiful and wild surroundings to the London International Exhibition of 1862, which was attended by more than six million people. Subsequent practitioners such as the commercial photographer JW Beattie likewise saw no contradiction in conservation, development and tourism.[22] While believing nature was a thing to be admired they all felt it should be made available for the use of humankind. Photography was a way of cementing this view. Perrin, Smithies and other members of the North Tasmanian Camera Club were inveterate bush adventurers and amateur photographers, precursors of the first committed wilderness photographers who worked in the latter part of the twentieth century (pp 190–93). Yet as Stephenson and other contemporary writers note, the genre of wilderness photography is a misnomer in the Australian context regardless of how useful photography might have been and may continue to be in representing a conservationist's agenda.[23] It implies a land empty of humankind and uncultivated, a description true of Antarctica but not of Tasmania or

mainland Australia, both of which had been inhabited and tended for about 60 000 years.

Early European explorers, then settlers followed by photographers, attempted to describe what they saw, their reactions to landscapes, flora and fauna ranging in detail and intensity. A major focus was Antipodean ferns, especially the giant tree ferns that populated many parts of Australia, including the vicinity of Mount Seaview, inland from Port Macquarie in New South Wales. Gordon Charles Mundy travelled through the area in 1847 and wrote:

> The fern-tree here attains a maximum of about 20 feet. Its wide and graceful plume seems to rise at once perfect from the earth, – as Venus from the sea, – the growth of the trunk gradually lifting it into mid air … When I left England some of my friends were fern-mad, and were nursing little microscopic varieties with vast anxiety and expense. Would that I could place them for a moment beneath the patulous umbrella of this magnificent species of Cryptogamia![24]

In the 1870s Allport photographed magnificent ferns in Tasmania, as did Nicholas Caire in Victoria (pp 182–83). By the time they did, however, many of the areas where ferns had grown in abundance had been despoiled, the result of fern fever, or pteridomania, which had consumed the Empire for decades. England was lacking the huge variety of ferns to be found in the Antipodes and the market became immense. Fern hunting was encouraged and no one left town for a weekend expedition to Ferntree Gully or Blacks' Spur in the Dandenongs without taking a trowel in case a choice sample was spotted (JW Lindt sold 25 000 photographs of this area from his Melbourne studio between 1882 and 1892). The trunks of the big ferns were chopped down to make huts, and people looking for timber which was available in great quantities in the same areas were allowed in to work from 1861.[25] Attempts at conservation aside, Hurley, Caire, Lindt, Beattie and Allport were all complicit in promoting the natural marvels they encountered. The Victorian and Edwardian appetites for exotica and the acquisition of whatever new thing was to be found in the natural and constructed world led to unprecedented crazes. The relationship between the desirable object and its photographic representation became more diversified and extensive. In the case of ferns this meant, on a domestic scale, bringing samples into the home and attempting to keep them alive in the confined space of a Wardian case, or pressing the fronds flat in the pages of an album and photographing the results. On a global scale, the range of fern species could be reconstituted in an artificial zoo-like enclosure such as Kew Gardens in London, which became

the storehouse of all things botanical in the Empire. Alternatively, or in addition, one could collect photographs of ferns and their locales in order to study or simply admire. Caire's *Fairy scene at the Landslip, Blacks' Spur* c1878 is his most published image and was available in various formats as well as being used as the basis for engravings.[26] Its reach was enormous and, alongside related photographs, it was shown at the Melbourne Centennial International Exhibition of 1888–89, which was attended by more than two million visitors.[27]

Photo historian Kathleen Davidson's recent research is invaluable in teasing apart the complexity of interactions resulting from the rise of 'informative entertainments' – often photo-based – that were 'representative of the nineteenth-century acquisitive impulse and the concomitant desire to be in immediate contact with all aspects of the world'.[28] The scientists, photographers and viewers could not have anticipated the effects of the wholesale accumulation of everything that could be documented. The sense of wonder generated in the nineteenth century around technological change, most particularly photography and its multiple uses, was also fuelled by an idea of progress and social improvement. This is evident in Sydney-based commercial photographer James Freeman's 1859 paper *On the progress of photography and its application to the arts and sciences*:

> we must acknowledge how important a science [photography] has become. The greatest of philosophers have made it their study. We have seen it aiding alike the meteorologist and the astronomer, the physiologist, and the pathologist; it has become an adjunct to the pencils of the artist and the burin of the engraver. We have seen it depict the delicate tracery of the microscopic object, and the mighty machinery of the engineer … who shall attempt to define its limits?[29]

The Australian gold rush of the 1850s was documented with pride, as were subsequent nineteenth-century discoveries nationwide. The bulk of early prospecting was done with simple hand tools by whomever could make it to the locations. In little more than twenty years from the late 1850s, the geologist and photographer Richard Daintree managed to be prospector, surveyor of minerals in Victoria and Queensland, pioneer of photography in geological fieldwork, exhibitor at world exhibitions and promoter of Queensland in particular, through photography. There is some uncertainty as to who composed and took some photographs under his name: those that emphasise geological formations and landscapes would probably have been taken by Daintree, whereas the portraits that appear in the album *Sun pictures of Victoria* were more likely by his then partner

Antoine Fauchery (p 194). Later Queensland material, whether of people or locations, and the painted and hand-coloured photographs, may be by various photographers. Tableaux of prospectors, showing where and how they lived, formed a series which Daintree regularly presented to London and European audiences in the 1870s in order to educate and inspire emigration. Daintree constantly petitioned his political masters in Brisbane, emphasising the value of showing photographs along with maps and geological samples to encourage travel to and investment in Australia.[30] Further, he wanted the series of photographs to be seen in Queensland in order to instil pride. His constant references to the educative and conserving role of museums indicate his understanding of their ability to consolidate and expand knowledge and photography's role in this. Indeed, in the *London Graphic* of 11 October 1873 the photographs were described as giving 'a better idea of Queensland than is possessed by many persons who have lived in that country half their lives'.[31] One of the striking features of Daintree's work is his depiction of Aboriginal people, which ranges from long shots of pastoral environments showing where people lived, to hieratic representations divorced from the landscape, to tableaux of Indigenous people and settlers showing the Indigenous in subservient poses (pp 90–93). In such images Daintree reflected the determinist views of the time: 'As the white race advances with his boasted civilisation, the blackfellow recedes before him, conscious that his race is nearly run, and that soon he will exist only in the memory of the new settlers, who have obtained possession of the broad hunting grounds over which his ancestors roamed.'[32]

Photographic portraits of towns and individuals documented the settlements that grew up around prospecting. The people who came hoping to make their fortunes often wanted to be recorded by the new medium, thus enabling photographers to earn a living. Daintree and others made photographs for an educational purpose, while practitioners like Hurley and Melvin Vaniman were consummate entrepreneurs. Vaniman's brief photographic career lasted from 1901 until his untimely death in 1912. His Australian panoramas were made between 1903 and 1904 and encompass scenic and city views used to promote tourism and migration (pp 204–05, 222–23). The Tasmanian Government presented Vaniman's photographs of town, country and industry to promote the state in London.[33]

Fast-forward more than 150 years and we arrive at Simryn Gill's *Eyes and storms*, part of her installation *Here art grows on trees* in the Australian Pavilion at the 2013 Venice Biennale (p 225). Rather than using photography to try to fix meaning, Gill uses the medium's history and idiosyncrasies in order to convey the fluidity of time, place and nationhood. Her large-format aerial shots of mining operations in the Australian landscape flatten depth and breadth and give few clues to scale, though it is clear that the shapes are not naturally occurring and are in a constant state of flux. Michael Taussig writes of these vast holes or eyes in the Earth as entry points 'to the beginning of the beginning', due to the extent of the operations (mining billions of tons) and the time the planet takes to make the minerals (billions of years). In Venice, Gill removed the roof of the pavilion and left the photographs to decay along with the other parts of her installation. Paper, books, found objects, steel, all were subjected to the elements and variously transformed. They were seen by about half a million people, many more than those who would have made the aerial journey over Australia's increasingly pock-marked landscape. Did they 'get' the correspondence between the naturally occurring and the human-made, and how they act on one another and are subject to both entropy and exhaustion? Taussig also writes: 'when miners mine the earth on the unbelievable scale shown in these photographs, they are undertaking time–space travel … to the life force that pulses through your body … as well as through the images provided by Gill soaring like a lost angel above the sublime debris of the once-was'.[34]

Gill, among others, has been able to take to the air in order to photographically survey our relentless penetration of the Earth's crust, no longer from the perspective of progress and advertising but as a form of witnessing.

1. Douglas Mawson, quoted in Alasdair McGregor, *Frank Hurley: a photographer's life*, Viking, Melbourne, 2004, p 28.

2. David Millar, *From snowdrift to shellfire: Capt. James Francis (Frank) Hurley 1885-1962*, David Ell Press, Sydney, 1984, p 20.

3. Toni Hurley, *Australian Women's Weekly*, 21 December 1966, quoted in Helen Ennis, *Man with a camera: Frank Hurley overseas*, National Library of Australia, Canberra, 2002, p 9.

4. Archie McLean, quoted in McGregor 2004, p 44.

5. Ennis 2002, p 13.

6. Millar 1984, p 28.

7. Ludovico Hart, 'An apology for the introduction of the study of photography in our schools of art and science', *Journal and Proceedings of the Royal Society of New South Wales*, vol. 12, 1878, pp 269, 280.

8. Paul Carter, 'Invisible journeys: exploration and photography in Australia', in Paul Foss (ed), *Island in the stream: myths of place in Australian culture*, Pluto Press, Sydney, 1988, p 50.

9. FWL Leichhardt, *Journal of an overland expedition in Australia, from Moreton Bay to Port Essington, a distance of upwards of 3000 Miles, during the years 1844-1845*, Boone & Sons, London, 1847, p 118, quoted in Carter 1988, p 59.

10. Carter 1988, p 59.

11. Carter 1988, p 60.

12. Carter, 1988, p 52.

13. See Martyn Jolly, 'Australian First-World-War photography: Frank Hurley and Charles Bean', *History of Photography*, vol 23, no 2, summer 1999, pp 141-48.

14. Kathleen Davidson, Introduction in 'Exchanging views: empire, photography and the visualisation of natural history in the Victorian era', PhD thesis, The University of Sydney, 2011.

15. See Wayne Orchiston, 'James Cook's 1769 transit of Venus expedition to Tahiti', DW Kurtz (ed), *Transits of Venus: new views of the solar system and galaxy*, proceedings IAU colloquium no 196, International Astronomical Union, 2004, pp 52-64.

16. 'The International Astrophotographic Congress 1887', *Monthly notices of the Royal Astronomical Society*, vol 48, Feb 1888, p 212. articles.adsabs.harvard.edu/full/1888MNRAS..48..212./0000217.000.html, accessed 20 May 2014.

17. See Geoff Barker, 'Carte du Ciel: Sydney Observatory's role in the international project to photograph the heavens', *History of Photography*, vol 33, no 4, Nov 2009, pp 346-353; and Corey Keller (ed), *Brought to light: photography and the invisible 1840-1900*, San Francisco Museum of Modern Art, CA & Yale University Press, New Haven, CT, 2008.

18. This was hard won in Sydney. See Raymond & Roslynn Haynes, David Malin, Richard McGee, *Explorers of the southern sky: a history of Australian astronomy*, Cambridge University Press, Cambridge, UK, 1996, p 48.

19. Geoffrey Batchen, 'Forever dark', in Christina Barton (ed), *Dark sky*, Adam Art Gallery, Wellington, New Zealand, 2012, p 16.

20. David Stephenson, 'Sublime space: photographs by David Stephenson 1989-1998', National Gallery of Victoria, Melbourne, 1998, np.

21. David Stephenson, 'Beautiful lies: photography & wilderness', *Imaging nature: media, environment and tourism*, proceedings of conference held at Cradle Mountain, Tas, 27-29 June 2004, np.

22. See Nic Haygarth, *The wild ride: revolutions that shaped Tasmanian black & white wilderness photography*, National Trust of Australia (Tasmania), Launceston, 2008.

23. Stephenson 2004; Haygarth 2008; Marcia Langton, *Lecture 4: the conceit of wilderness ideology*, 2012 Boyer Lectures, Australian Broadcasting Commission, Radio National, 9 Dec 2012; and Langton, *What do we mean by wilderness? Wilderness and terra nullius in Australian art*, lecture, Sydney Institute, Sydney, 12 Oct 1995.

24. Godfrey Charles Mundy, *Our Antipodes*, vol 2, R Bentley, London, 1852, p 27.

25. See Tim Bonyhady, 'Fern fever', *The colonial earth*, The Miegunyah Press, Melbourne University Publishing, Carlton, Vic, 2000, pp 100-25.

26. See Anne & Don Pitkethly, *NJ Caire: landscape photographer*, Anne & Don Pitkethly, Rosanna, Vic, 1988; and Isobel Crombie & Susan van Wyk, *Second sight: Australian photography in the National Gallery of Victoria*, National Gallery of Victoria, Melbourne, 2002, p 28.

27. See Ian Morrison, 'The accompaniments of European civilisation: Melbourne exhibitions 1854-88', *La Trobe Journal*, no 56, Spring 1995, p 10. The 1880s were the height of the Melbourne boom years. Technological wonders on display included telephones, ice making machines, and torpedoes.

28. Davidson 2011, p 7.

29. James Freeman, 'On the progress of photography and its application to the arts and sciences', in Joseph Dyer (ed), *Sydney Magazine of Science and Art*, vol 2, James W Waugh, Sydney, 1858-59, p 140.

30. See Peter Quartermaine, 'International exhibitions and emigration: the photographic enterprise of Richard Daintree, agent general for Queensland 1872-76', *Journal of Australian Studies*, no 13, Nov 1983, pp 40-55.

31. Quoted in Jennifer Carew, 'Richard Daintree: photographs as history', *History of Photography*, vol 23, no 2, Summer 1999, p 160.

32. *Daylesford Express*, 23 April 1864, quoted in Dianne Reilly & Jennifer Carew, *Sun pictures of Victoria: the Fauchery-Daintree collection 1858*, Currey O'Neil Ross Pty Ltd, Melbourne, 1983, p 108.

33. See Alan Tierney, *Melvin Vaniman (1866-1912): a biographical note*, Alan Tierney, Goulburn, NSW, 2000; and Alan Davies, *Vaniman panorama*, State Library of New South Wales, Sydney, 2010.

34. Michael Taussig, 'Reverse engineering', in Catherine de Zegher (ed), *Simryn Gill: Here art grows on trees*, Australia Council for the Arts, Sydney & MER/Paper Kunsthalle, Gent, 2013, pp 238-39.

COLONIAL SCIENCE AND PHOTOGRAPHIC PORTRAITS

Kathleen Davidson

In an album held in the Australian Museum archives is a sequence of photographs portraying Gerard Krefft, the museum's curator, posing alongside a specimen of a manta ray (p 207). Photographed by the museum's taxidermist, Henry Barnes, these intriguing portraits – and the fish album in which they are preserved – belong to a group compiled over several decades from the 1860s. The albums indicate the collecting priorities of the institution and also aspects of its relationships with stakeholders and professional networks. Containing a rich and sometimes curious assortment of images, they reveal the complex and dynamic role of photography in nineteenth-century science. The albums bring together images that have been presented to the museum at different times and from any number of geographic, institutional and private sources, as well as providing a record of the museum's pioneering efforts in museum and expeditionary photography. Conspicuously, there are changes in the subjects of the photographs collected over time, with the albums quickly altering from a catalogue of natural history specimens to a more complex engagement with the progress of colonial science and the role of the museum within the context of Empire.

The photographs of Krefft, produced in 1868, appear deceptively informal despite Krefft adopting a range of poses and variations of attire. His composure in front of the camera and the performative nature of the portraits is striking. Swapping between vest and shirt sleeves, and then top hat and coat, his changing dress and posture create a narrative in which his guise alternates between that of a man of leisure – leaning proprietarily against a wall with his hands in his pockets – and a more reflective thinker. He assumes control of the space in which he variously stands and sits. Yet it is the huge manta ray, laid out before him and extending from wall to wall of the museum courtyard, which dominates the composition and gives meaning to the photographs. Certain conventions have been adopted: the placement of the fish in different orientations to show its features from all sides; and the use of the human figure and surroundings to indicate scale.

The portrait series is a tribute to the official visit of the Duke of Edinburgh in 1868, for whose entertainment Krefft staged a fight between snakes and a mongoose during a museum tour, a spectacle that went beyond

the bounds of the curator's role and exemplified the colonial museum as a site of multifarious identities and sometimes unconventional activities.[1] This powerful, impromptu performance was intended to impress Prince Alfred and to distinguish Krefft not only as a loyal subject to the British throne but to draw attention to a tacit connection between them due to their shared German heritage.[2] Having discovered the manta ray that same year, Krefft declared his loyalty to the Prince by naming this new species in his honour: *Ceratoptera alfredi* Anonymous [Krefft]. The portraits also celebrate Krefft's achievements in imperial science and increased standing in colonial society. As one of the first colonial scientists to assert his independence from London's control and to demand recognition for his discoveries, Krefft was an advocate of photography in the natural sciences and its importance for the colonial museum. He turned increasingly to photography to demonstrate his knowledge of Australian fauna, to validate his growing status in natural history circles, and to augment his network and facilitate exchanges.

We tend to think of photography in science in terms of documenting natural phenomena or producing records of experiments. For nineteenth-century scientists, the medium had a wider purview. The trustworthiness of scientific knowledge typically centred on the figure of the individual scientist. With science's growing profile and status depending heavily on the kinds of people it attracted, there seemed to be a genuine awareness of the temperament, motivations and virtues of those involved in formulating new knowledge. In this way, the scientific enterprise was socially sanctified.[3] Consequently, while towards the end of the century scientific knowledge was increasingly being presented as the product of accepted and shared practices and institutions, for the major part of the Victorian era the individual was perceived to be the basis of scientific authority.[4]

Thomas Glaister's portrait of Professor John Smith is a hand-coloured stereoscopic daguerreotype taken c1858 (p 206). Smith presents himself to the viewer unambiguously in terms of his profession. As well as being the foundation professor of chemistry and experimental physics at the newly established University of Sydney, he was dedicated to modernising education in New South Wales.[5] Writing to an associate in 1859, he remarked that the university was progressing 'so far as stone and lime [were] concerned' but seemed to be going backwards in the number of students.[6] A proficient photographer, Smith produced stereographic ambrotypes and glass-plate negatives extensively recording the construction and decoration of the university's main building during 1856–62.[7] Glaister's portrait of Smith reflects the professor's interest in

stereo-photography. Daguerreotypes are also intended to be examined closely. Produced as a stereo-pair of images and mounted in a Mascher proprietary case fitted with a folding stereoscopic viewer, this photographic format requires an attentive and systematic – scientific – approach to observation. Glaister's high-end photographic studio came to specialise in this style of presentation.[8] Smith's portrait conveys the sitter's concern with intellectual pursuits, science education, and the move towards professionalisation in the sciences.

Scientists were eager to demonstrate their knowledge and skills by being portrayed with the objects of their study as symbols of their expertise, often selecting these items in order to communicate specific information about themselves and their vocation. The distinctive tablecloth in Smith's portrait has been identified as a familiar Glaister studio accessory, and several studio head-clamps are also discernible.[9] It is most likely that the sitting was conducted in the photographer's studio. Yet, when the professor visited Glaister's establishment in Pitt Street, Sydney, he took along numerous objects that would virtually recreate his laboratory in the studio. The resulting photograph illustrates a high degree of collaboration between the subject and photographer, and how meticulously they developed the iconography. On a table beside Smith and behind him on an improvised shelf is an array of laboratory glassware and other specialist equipment. Smith rests his hand on a book and pamphlet which symbolise the dissemination of knowledge. On the shelf to the left of Smith – precisely aligned with his eye level – is a Brewster stereoscopic viewer. As well as characterising Smith's diverse interests, the Brewster stereoscope was the most popular drawing-room entertainment in its day and would have been recognisable to any contemporary viewer.

While portraits of scientists were vehicles for self-promotion and tapped into the burgeoning industry of studio photography, they were nevertheless quite sophisticated in their conception and presentation. By portraying the practitioner and the practice of science, photographic portraits represented both the individual and shared accumulation of knowledge and kudos.

Usually, the general public encountered scientific discoveries through various forms of popular culture. As the most prevalent genre in Victorian popular culture, photographic portraits were designed to personify and exemplify scientific practice and knowledge. In this way, they addressed a range of audiences, connecting amateur and professional practitioners, metropolitan and colonial scientists, and also the general public.

1. 'The Duke of Edinburgh in New South Wales', *Sydney Morning Herald*, 15 Feb 1868, p 7.

2. During his royal visit to Australia, Alfred demonstrated his attachment to Germany as heir to the duchy of Saxe-Coburg-Gotha by wearing the uniform of a Prussian colonel at a review of troops in Adelaide in November 1867 and that of a general officer of Saxe-Coburg-Gotha at a review of military and volunteer forces in Sydney the following January – 'The Duke of Edinburgh in Adelaide', *Sydney Morning Herald*, 15 Nov 1867, p 6; 'The Duke of Edinburgh in New South Wales: the review', *Sydney Morning Herald*, 25 Jan 1868, p 7.

3. Michael Shortland and Richard Yeo (eds), *Telling lives in science: essays on scientific biography*, Cambridge University Press, Cambridge, 1996, p 37.

4. Shortland and Yeo, p 37; and Richard Yeo, *Defining science: William Whewell, natural knowledge and public debate in early Victorian Britain*, Cambridge University Press, Cambridge, UK, p 117.

5. Michael Hoare and Joan T Radford, 'Smith, John (1821-1885)', *Australian dictionary of biography*, National Centre of Biography, Australian National University, adb.anu.edu.au/biography/smith-john-4608, accessed 7 May 2014; and Roy Macleod (ed), *University and community in nineteenth-century Sydney: Professor John Smith 1821-1885*, The University of Sydney, Sydney, 1988.

6. Prof John Smith, Sydney, to Rev David Bruce DD, Auckland, 6 May 1859: M47, John Smith correspondence, The University of Sydney Archives.

7. John Smith (1821-1885): ref P206, The University of Sydney Archives.

8. Marcel Safier, 'Glaister, Thomas Skelton (1824-1904)' in John Hannavy (ed), *The encyclopedia of nineteenth-century photography*, Routledge, London, 2007, pp 594-95.

9. Alan Davies and Peter Stanbury, *The mechanical eye in Australia: photography 1841-1900*, Oxford University Press, Melbourne, 1985, p 18.

Morton Allport
Fern Gully, Tasmania 1865–70
National Gallery of Australia, Canberra

opposite:
Nicholas Caire
Fairy scene at the Landslip, Blacks' Spur c1878
National Gallery of Victoria, Melbourne

Frank Hurley
Coastal ice formation, Antarctica c1912

opposite:
Antarctic views – a turreted berg c1912

State Library of New South Wales, Sydney

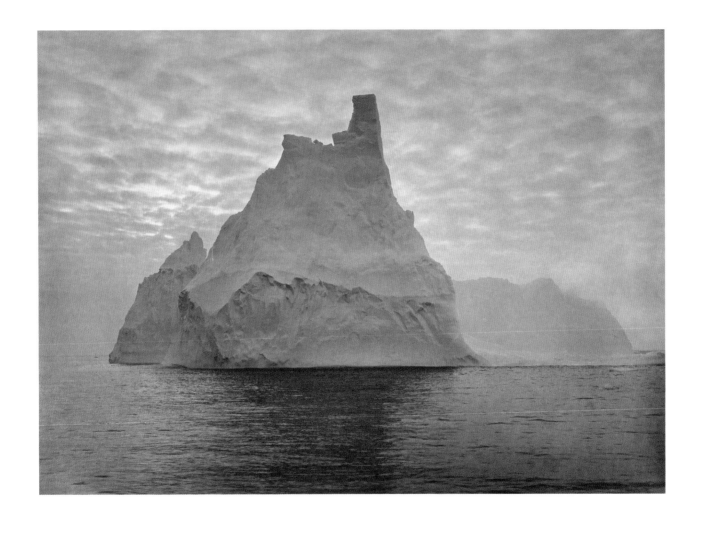

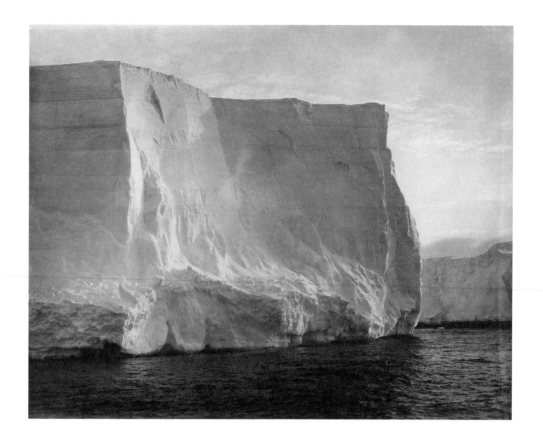

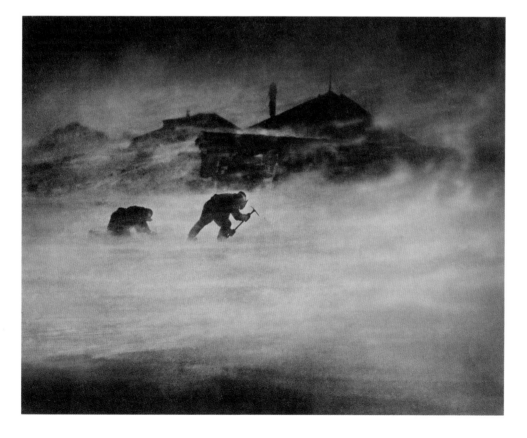

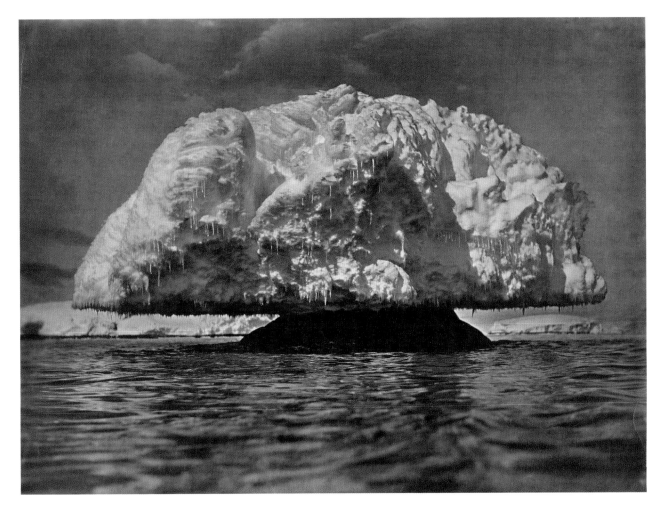

Frank Hurley
Mushroom ice formation, Antarctica c1912

opposite:
Antarctic views c1912

Blizzard at Cape Denison, Antarctica c1912

State Library of New South Wales, Sydney

Kerry & Co
Fern Gully, Blue Mountains c1884–95
Art Gallery of New South Wales, Sydney

opposite:
Ernest B Docker
Junction Falls Lawson 1893

*The Three Sisters, Katoomba – Mrs Vivian,
Muriel Vivian and Rosamund* 1898

Macleay Museum, The University of Sydney

Florence Perrin
*View of Cradle Mountain and Dove Lake,
Tasmania* 1920s

opposite:
*View taken from the kitchen door at Waldheim
Chalet, Cradle Mountain, Tasmania* 1920s

*View of Flynn's Tarn and Little Horn, Cradle
Mountain area, Tasmania* 1920s

Queen Victoria Museum and Art Gallery, Launceston

Frederick Smithies
Paddy Hartnett on Mount Oakleigh c1930
Queen Victoria Museum and Art Gallery, Launceston

opposite:
Anson Bros
Fern Tree Gully, Hobart Town, Tasmania 1887
Art Gallery of New South Wales, Sydney

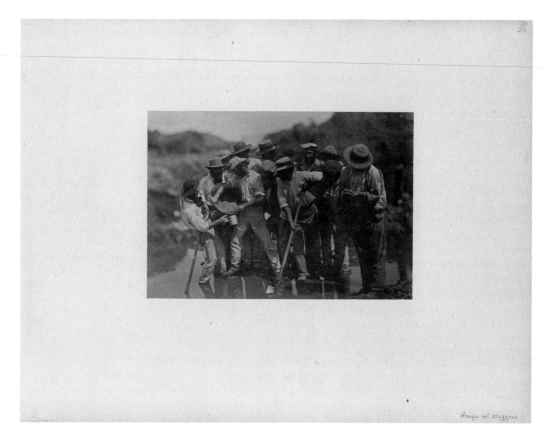

Richard Daintree & Antoine Fauchery
Group of diggers c1858 in the album
Sun pictures of Victoria 1857–59
Picture Collection, State Library of Victoria, Melbourne

opposite:
Richard Daintree
Alfred Daintree in the *Cogger album
of photographs* c1854–62
Picture Collection, State Library of Victoria, Melbourne

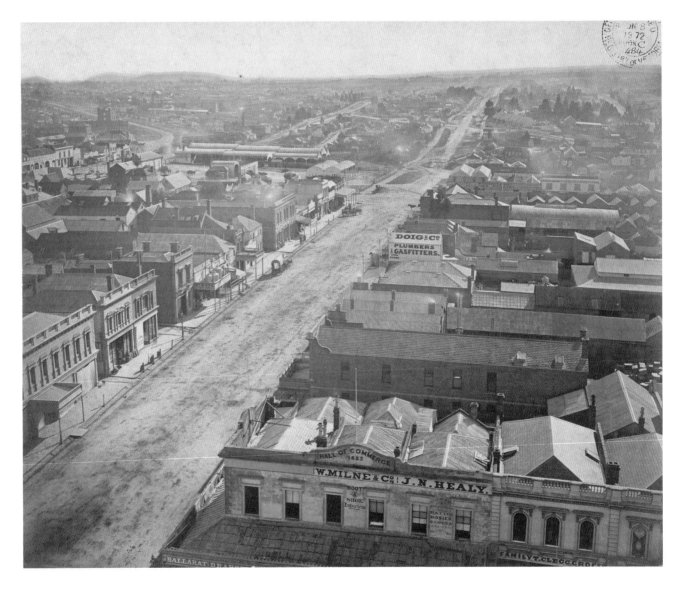

William Bardwell
Ballarat from the Town Hall Tower looking east 1872
Picture Collection, State Library of Victoria, Melbourne

opposite:
GH Jenkinson
Broadway Dunolly c1861

Broadway 'looking north' (Dunolly) c1861

Picture Collection, State Library of Victoria, Melbourne

Unknown photographer
Henry Kay c1855–60
Picture Collection, State Library of Victoria, Melbourne

opposite:
Unknown photographer
*Lewis and Nickinson's crushing battery
at the Balaclava Mine, Whroo* c1858–59
Picture Collection, State Library of Victoria, Melbourne

Charles Bayliss, Henry Beaufoy Merlin
Holtermann gold as ingots c1872
Art Gallery of New South Wales, Sydney

opposite:

American & Australasian Photographic Company
*B Holtermann with the largest specimen
of reef gold* c1873
State Library of New South Wales, Sydney

JJ Dwyer
Kalgoorlie's first post office c1900

opposite, from top:
*Sacred Nugget Kanowna/Crowd promising not
to ask Father Long any more questions* 1898

Associated Northern 600ft level c1900

Kerry Stokes Collection, Perth

Sacred Nugget, Kanowna 1898
Crowd promising not to ask Father Long any more questions
113 Dwyer

A

Associated Northern
1665 ft Level
48'

Dwyer Photo

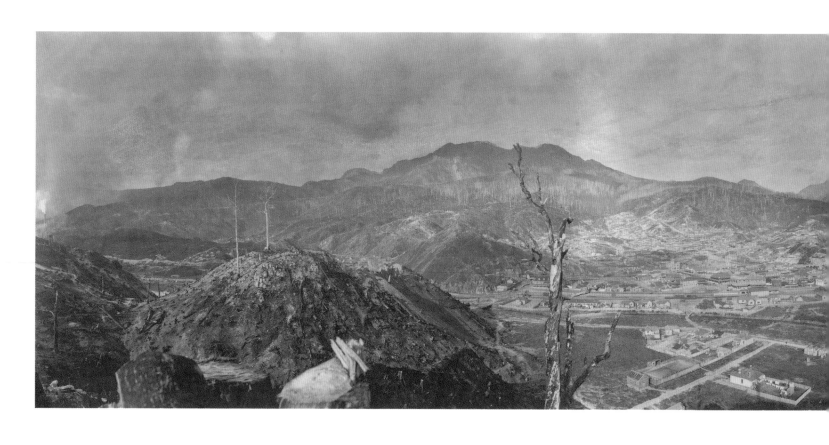

from top:

Melvin Vaniman

Queenstown 1903 1903
Tasmanian Archive and Heritage Office, Hobart

*Panorama of intersection of Collins and
Queen Streets Melbourne* 1903
State Library of New South Wales, Sydney

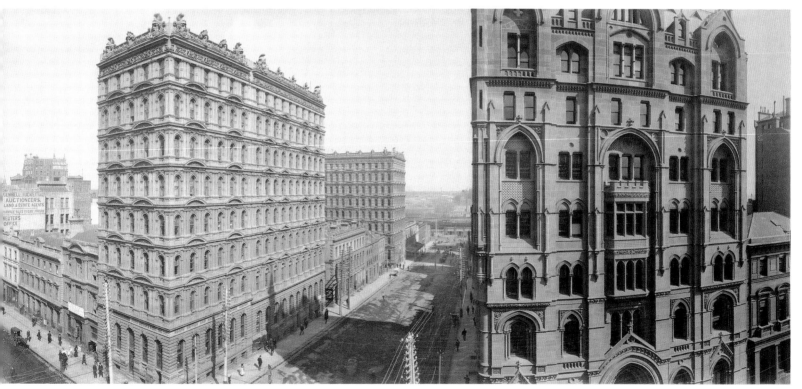

Henry Barnes
Four views of curator Gerard Krefft in the courtyard of
Australian Museum with holotype of the Alfred Manta,
Manta alfredi [Krefft, 1868] *(Australian Museum*
specimen no 1.1731) 1868 in *Australian Museum*
photograph albums 1870–90, vol 14, fishes 1 c1880
Australian Museum, Sydney

opposite:
Thomas Glaister
Professor John Smith, 1821–85. First professor of
chemistry and experimental philosophy, University
of Sydney c1858
Tasmanian Museum and Art Gallery, Hobart

THE STAR CAMERA,
SYDNEY, N.S.W.

INTRODUCTION.

The important place which photography has now assumed as a means of promoting astronomical discovery and research, demands that some record should be preserved of the instruments, more especially of those used for carrying out the great work which was the outcome of the Congress of the world's astronomers which met at Paris, in 1887. In the same year the Minister for Public Instruction authorised the purchase in Europe of a photographic objective of the same size and quality as that used at Greenwich, Paris, and other European Observatories, and decided that, since the mounting for this instrument could be made in Sydney with all needful accuracy, it should all be made in the colony, save one wheel, which had to be finished on the dividing-engine of Messrs. Troughton and Simms, because there was not in the colony any such machinery as that firm possesses; this was the large tangent screw wheel which had to be finished with the accuracy of a finely graduated circle.

After careful enquiry in Europe, the order for the photographic objective was in October, 1887, given to Sir Howard Grubb, of Dublin, who had previously received orders for similar objectives from Greenwich, Oxford, the Cape, and Melbourne. The objective did not arrive in Sydney until 19th September, 1890. Meantime the mounting described in the following pages had been finished and in use for several months, a large sized (6in.) Dallmeyer portrait lens having been mounted on it and used for photographing the Milky Way, and for gaining experience in stellar photography.

It will appear in this work that the general plan of the Sydney instrument is similar to that at Paris, but that it differs in being very much heavier, weight having been introduced to avoid vibration; also in having separate tubes for the camera and pointer telescopes, and in many details which I thought would be improvements when designing it. The decision to have the mounting made in the colony has been fully justified by the result, which is a highly satisfactory one, the instrument having proved itself, in use, admirably adapted to the purpose.

The following pages, with Photograph and Plates, have therefore been prepared as a record of the instrument used at Sydney. The Plates shew all details, and it has been deemed unnecessary to describe every part in the letter-press.

It is right to mention here that the labour of making this instrument has been divided; some of the heavy parts were made at Mort's Dock and Engineering Co.'s, others at the Atlas Engineering Co., but the clockwork microscopes, all the smaller parts, and the putting together of all the parts into a smooth working and highly satisfactory instrument have been done by Mr. W. I. Masters, Instrument Maker in the Observatory.

H. C. RUSSELL,
GOVERNMENT ASTRONOMER.

Observatory, Sydney, January 19th, 1892.

Henry Chamberlain Russell
Lightning strikes taken from Sydney Observatory 1892
Museum of Applied Arts and Sciences, Sydney

opposite, from top:
Unknown photographer
Henry Chamberlain Russell 1859–65
Museum of Applied Arts and Sciences, Sydney

Henry Chamberlain Russell
The Star Camera of the Sydney Observatory, Sydney, New South Wales, Australia, ST Leigh & Co Pty Ltd, Sydney, 1892 introduction and frontispiece
Museum of Applied Arts and Sciences, Research Library

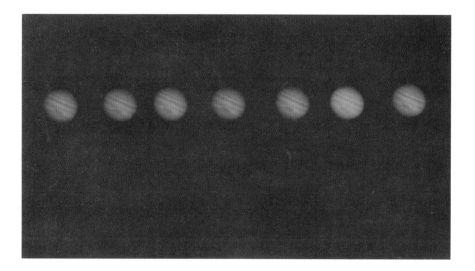

James Short
Trifid Nebulae 1908

Henry Chamberlain Russell
Jupiter 1889–92

opposite:
James Short
Total solar eclipse c1890–1922

Museum of Applied Arts and Sciences, Sydney

Joseph Turner
Orion Nebula taken with the Great Melbourne Telescope 26 February 1883

Eta Argus Nebula taken with the Great Melbourne Telescope 7 January 1883

opposite:
Kappa Crucis Cluster taken with the Great Melbourne Telescope 3 March 1883

Museum Victoria, Melbourne

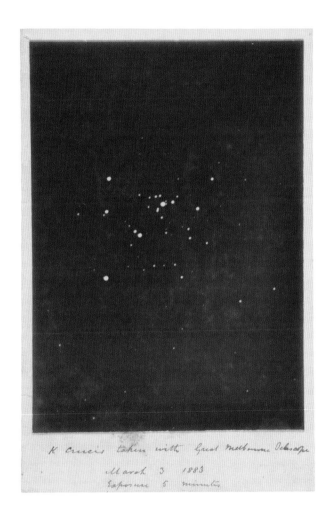

K Crucis taken with Great Melbourne Telescope
March 3 1883
Exposure 5 minutes

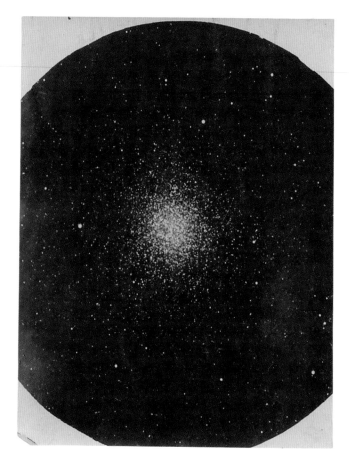

James Short
Omega, Centauri 1899–1930

opposite:
Sun spot 6 April 1914

Museum of Applied Arts and Sciences, Sydney

Sunspot — 6th April, 1914.

David Stephenson
Stars #1008 1995

opposite:
Stars #1311 1995
Art Gallery of New South Wales, Sydney

Frank Styant Browne
Hand 1896
Queen Victoria Museum and Art Gallery, Launceston

opposite:
Charles Bayliss
Eight Lawrence Hargrave flying machine models 1885
Museum of Applied Arts and Sciences, Sydney

Charles Bayliss
*Lawrence Hargrave trochoided plane model
consisting of two floats* 1884

opposite:
Lawrence Hargrave trochoided plane model 1884

Museum of Applied Arts and Sciences, Sydney

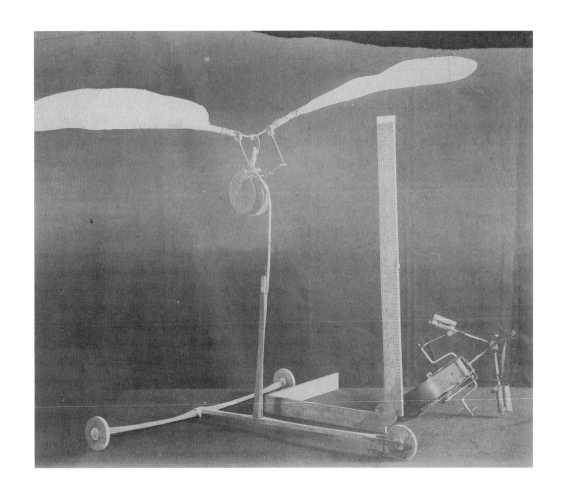

Melvin Vaniman
Panorama of Fitzroy Vale Station, near Rockhampton 1904
State Library of New South Wales, Sydney

Simryn Gill
from the *Vegetation* archive (Melaluca) 1999
Collection of the artist

opposite:
Eyes and storms #13 2012
Art Gallery of New South Wales, Sydney

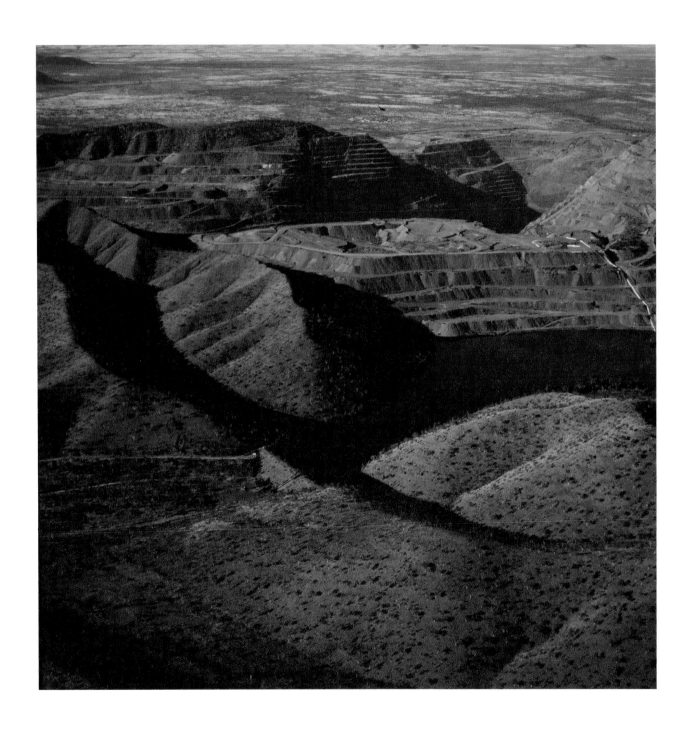

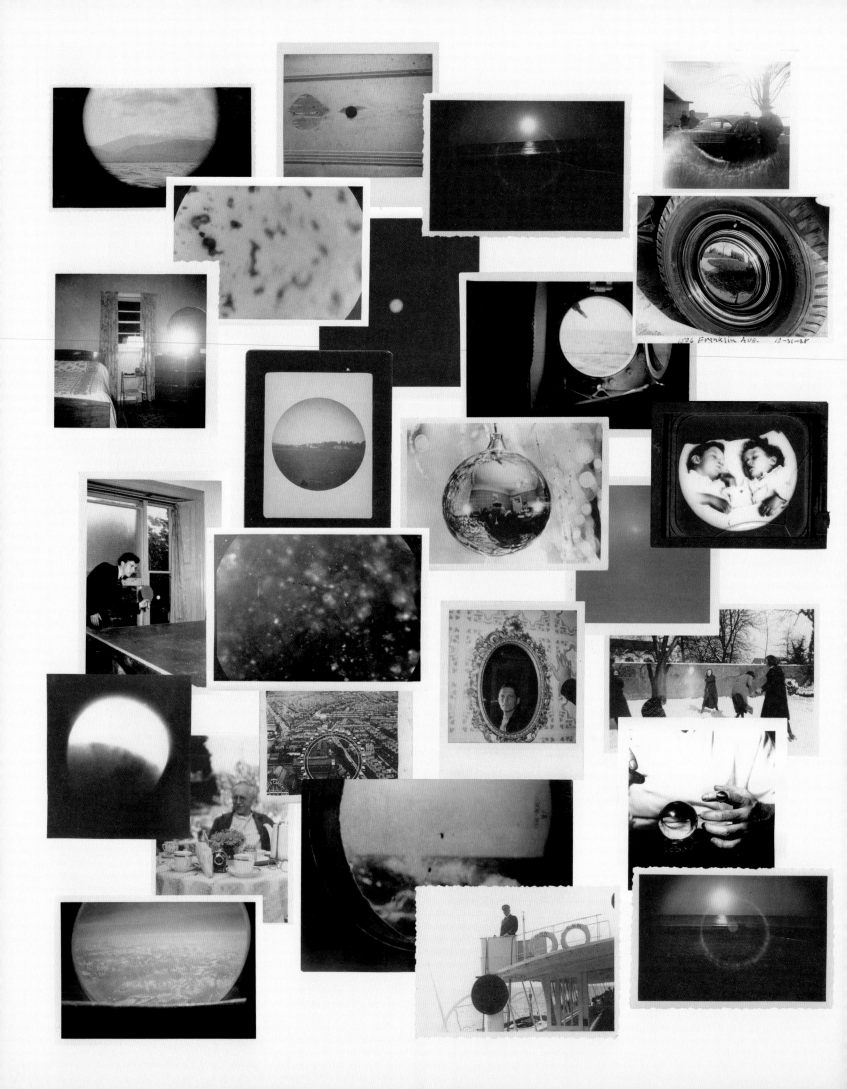

Patrick Pound collects photographs and re-purposes them. In finding, sorting and re-presenting ordinary photographs in various configurations, he makes them extraordinary. The haphazard details of the world that the photographs represent come to assume another order of significance (p 226). As Pound notes: 'my collections ... are a systematic copy-world. Each photograph offers the possibility of completing a set ... the collections might add up to a world picture ... if we could only get all the pieces together, we could solve the puzzle. This is a condition of taking and collecting snaps'.[1]

Pound is assembling an 'archive of archives', of words and images sorted into an ever-evolving catalogue, which he has also described as being like an 'unhinged album'. Anyone or any institution that collects does so to order or make sense of the world and all it contains. Photography aids in and parallels this aim – up to a point. It has the tendency to either create dead ends – by appearing to reflect reality back to the viewer in a way which is ultimately unsatisfying – or to open up previously unthought-of imaginative routes through the unexpected conjunction of things.

In the nineteenth century there was a conviction that photography's identification of difference, together with its wide application and availability, enabled the accurate classification and categorisation of people and things. Most early commentators were idealistic in their belief in the ordering power and benefits of photography. These included American writer Oliver Wendell Holmes who, in 1859, foresaw vast photographic archives where images could be retrieved for whatever purpose,[2] and Sydney photographer James Freeman who, in the same year, noted the progress of the medium in the twenty years since its birth, and how pervasive, useful and limitless in application it had become.[3]

The 210 photographs assembled in the album *Who and what we saw in the Antipodes* 1868–70 are acknowledged as having a clear logic in their order (the album is intact) yet who exactly ordered them remains elusive (p 253). Attributed to Helen Lambert, wife of Commodore Rowley Lambert, the commander in chief of the Royal Navy's Australia Station from 1867 to 1871, the album has been comprehensively researched by photo historian Martyn Jolly.[4] The extensive and consistent decoration of the album by hand suggests, writes Jolly, that the selection of photographs and their ordering was most likely done by a woman of leisure. The story the album tells is that of privileged, insular lives interwoven with the twin themes of Antipodean exoticism and British civilisation.[5]

Other less meticulously ordered albums, for example those from the Dewhurst and Lethbridge families, contain similar types of photographs, juxtaposing individuals, groups, pets, favourite places and royalty. The woebegone children clamped into place that feature in the 1860s albums are superseded in the Lethbridge album of 1885–95 by the more relaxed Effie Dalrymple, sister to Florence Lethbridge, who leans back in the chair, arms behind her head and smiling into the camera (p 252). In general, though, these compilations remain tantalising puzzles. Who the depicted people were, what their relationships were to each other, why they were so ordered and by whom, remain obscure. Such riddles from past time entice the viewer to reach back and inhabit pictorial fragments of earlier lives. The enigma of these collations, whether hinged or unhinged, reveals the elusiveness of one of the most direct aids to memory, the photograph. This applies also to official albums such as those documenting the cleansing of The Rocks area after the outbreak of bubonic plague in 1900; the visit of the federal parliamentary party to the Northern Territory in 1912 (meticulously photographed, compiled and annotated by JP Campbell); William Street, Sydney, before its widening in 1916 (p 73); or the Fiat trek from Perth to Adelaide in 1926.

As rigorous and comprehensive as such documentation can appear to be, the compilations are essentially fragmentary. In the album documenting the Fiat trek, for example, the people depicted are ciphers, and for all the detail in the JP Campbell album it forms a partial record only. We are caught in the tension between what was proposed or intended by the maker and what we see now in regarding such material. Richard Daintree and Antoine Fauchery's *Sun pictures of Victoria* 1858, for example, combines photographs of august gentlemen; scenic, town and geologically useful views; and Aboriginal people posed as both farmers and exotic curiosities. The photographs in this album provide a composed and confident impression of place and people that transcends the merely descriptive, yet the lives lived and the places inhabited remain elusive, never able to be fully comprehended (p 194).

Geoffrey Batchen has written of 'how we tend to look through a photograph as if the photograph itself isn't there, as if a photograph is nothing but its image'.[6] This is borne out in responses to the photograph since its inception, where the process of its coming into being, regardless of its final form, is continually elided. Whether it is a daguerreotype or a digital print we focus primarily on what it depicts, not the materiality of the photographic object. Yet even that content is elusive, an imperfect

page 226:
Patrick Pound with
Rowan McNaught
*The compound lens
project* 2014–15
Collection of the artists

trace of reality, and prone to our imaginative translations. We see what we want to see, then as now. As it was spelled out in 1862: 'We explain ourselves in our different ways when we have our first interview with our own portraits after they come from the photographer's'.[7]

The arrival of stereographs and then cartes de visite in Australia in the second half of the 1850s led first to a stereoscopic craze, followed in the 1860s by carte mania.[8] Stereographs emulated binocular viewing of local and foreign scenes, allowing armchair travel for many more people than ever had the opportunity to leave their immediate environs. The traffic in stereographs quickened the evolution of what became known as tourism, a phenomenon that had begun in travel writing, then sketching. People were interested in experiencing the sense of wonder which a natural formation, a view or an exotic specimen could induce.[9] They collected written and visual information and discussed their encounters so that others were also drawn to the possibility of escaping the mundane. While travel outside the main centres in search of picturesque locales to photograph had occurred since the late 1850s, it had been sporadic. The advent of progressively faster, lighter and cheaper photographic equipment enabled professional photographers such as the Anson brothers, JW Beattie, John Paine, Nicholas Caire and Charles Kerry to venture further afield. Their views of mountains, gorges, rivers and caves taken across Australia and disseminated through cartes de visite, cabinet cards, albums and postcards contributed to a growth in tourism as well as further exploration and settlement. This dynamic interaction between photographic imaging, dissemination and social, national, economic, cultural and political purpose was to escalate and expand exponentially throughout the twentieth century.

The invention of the carte de visite in Paris in 1854 was the moment that photographs first became easily reproducible. The millions of cartes that circulated globally from the 1860s until the turn of the twentieth century, when they were eclipsed by a sheer variety of multiples, from postcards to amateur snapshots, reveal a period of complex social, cultural and technological change. It has been argued that the carte 'embodies the ascendency of the bourgeoisie and its systems of social and economic life'.[10] These systems included industrialisation, standardisation, repetition, and mass distribution. Yet the collecting and classifying of masses of images had strange and unforeseen consequences, as what at first appeared similar in form when brought together, instead revealed unpredictability when closely observed and analysed.[11] Social classes could shift

within the pages of a personal album but once that album was removed from its owner it could lose its logic entirely and become an enigma.

It took two years from the introduction of cartes de visite into Australia by photographer William Blackwood in 1859 before this egalitarian form took off. The size of a calling card, at first a carte would reside with other such cards in a basket or pile in the home or office and was no more than novel proof of an encounter. Albums for filing cartes de visite arrived in Australia in late 1860, coinciding with portraits of the British royal family being made available in sets of cartes.[12] The craze for celebrity portraits, of which the royal family was the first, escalated. Ordinary people could be similarly posed and photographed in front of 'a series of variable and appropriate backgrounds',[13] and these images filed in an album alongside those of the royals, thus elevating the status of the burgeoning middle classes. Photographic proximity was nearly as satisfying as the real thing. Soon it was possible to accumulate cartes of other prominent identities, such as politicians, churchmen, scientists, actors, musicians and writers, as well as images of places visited, and all things strange and desirable. The size, reproducibility and low cost of cartes also enabled exchanges to take place and increasingly specialised collections of people, places or things to emerge. The larger cabinet card allowed for more elaborate typography and greater visibility of detail in the attached photograph. Correspondingly there were more opportunities to scrutinise difference, as can be seen, for example, in the various images of Chang 'the Chinese giant' and others of his less popular but equally tall rival, Chonkwicsee (p 242).

If cartes were inexpensive at ten for a guinea, tintypes were even more affordable at thirty gems for three shillings. Unlike cartes, tintypes were unique objects, and their effect is softer and darker, but they were a dead-end for photography at that time as they could not be reproduced. The drive toward the standardisation of photographic processes, reproducibility and ease of dissemination is there from the medium's birth and conceptualised well before.[14] Correspondingly, the desire for instantaneity and accuracy were important factors in how photography evolved.

The advent of the postcard early in the twentieth century allowed for a massive increase in the circulation of images: in New South Wales alone more than 1.7 million postcards were mailed in 1902, the first year of their proliferation.[15] The improvement in printing processes late in the nineteenth century and the appetite for both

mundane and exotic subjects unleashed by the popularity of cartes de visite (and an associated form, the leporello[16]), contributed to exponential leaps in the production and circulation of postcards until World War I. Henry Mobsby represented Queensland at the 1908 Franco–British Exhibition in London; many of the coloured postcards in the state's display expanded on Daintree's earlier efforts to market the finer points of the state.[17] Charles Kerry was a prime mover of photographic material in New South Wales, through his Sydney studio (as were Nicholas Caire in Melbourne and JW Beattie in Tasmania), and in 1903 he had 50 000 postcards in stock.[18] Cards of Aboriginal people in various 'traditional' poses were big business and Kerry sold material which may have been shot by others decades before: semi naked 'dusky maidens', fighting men, 'chiefs', men posed with boomerangs, and performances of fake corroborees (p 243). In general, because the subjects' hair and beard styles were the same as those of settlers, it is clear they were cast as types and performing for the camera. It was possible to buy similar postcards during a visit to Coranderrk in Victoria. Such mementos and souvenirs were and are an integral part of the tourist trade, which in the nineteenth and well into the twentieth century could include a trip to an Aboriginal settlement to gaze upon 'the vanishing race'.[19]

Despite its errant ways, photography contributed to the institutionalisation and transmission of Darwinistic ideas regarding the extinction of Indigenous people. Putting the living on display has a lengthy history but had become a vogue in the mid-nineteenth century in tandem with the world exhibitions, the rapidly enlarging middle-class appetites for spectacle, and the rise of modern sciences – in 1888 people from Coranderrk were exhibited at the Melbourne Zoo.[20] In 1884 American entrepreneur PT Barnum toured 'The 'Great ethnological congress of curious people ...', which presented RA Cunningham's troupe of 'Australian Aborigines', among many other Indigenous groups. Inevitably the viewing public wanted souvenirs and a carte de visite and cabinet card were available. Anthropologist Roslyn Poignant has researched the stories of the people from North Queensland who were taken by Cunningham in two groups in 1883 and 1892, and over a sixteen-year period were exhibited extensively in the northern hemisphere.[21] The first group of nine: Tambo, Wangong, Billy, Jenny, her son Toby and husband Toby, Sussy, Jimmy and Bob were from the Palm Island and Hinchinbrook communities. They were photographed on numerous occasions and in various configurations including by William Robinson for Negretti & Zambra

at the Crystal Palace, London, in 1884 (p 241). They were also depicted in the press in Frankfurt in 1885 selling photographs of themselves. By 1888, six of the nine had died, leaving Jenny, her son Toby and Billy to return to live in Australia.[22]

JW Lindt photographed Coontajandra and Sanginguble early in the 1890s (p 240).[23] They were Workii clan members from North West Queensland and were part of Archibald Meston's Wild Australia Show, which toured the east-coast colonies and which Meston hoped to take to the Chicago World's Fair in 1893. Meston was a former associate of RA Cunningham. The large carbon photograph which Lindt produced is of exceptional quality. Its tightly cropped composition and large scale draw viewers close, as do the level gazes of Coontajandra and Sanginguble, their scarifications and proximity to each other. Other documentary photographs of these two people exist but this powerful formal portrait which Lindt marketed as art achieved wide currency and went on to form the basis of a poster in Paris in 1900 advertising *Cirque Robinson et ses peuplades sauvages* (the Robinson Circus and its savages).

Given the drive for distribution and communication, it was inevitable that the photographic album – which was most often unique or existed in very limited numbers – would turn into a photographically illustrated book capable of reaching a specialised or wider general audience. In the 1870s Richard Daintree had produced his photographs as books of autotypes, a form of carbon printing, for distribution at world exhibitions. In 1893 the New South Wales government astronomer Henry Chamberlain Russell exhibited star photographs and books at the Chicago World's Fair. At first, photographs of the machinery involved in imaging the heavens were as instructive as those depicting the end result (p 208). Such pictures were taken as clear evidence that the apparatus did exist and could function. The same year marine biologist William Saville-Kent produced a 388-page tome on *The Great Barrier Reef of Australia: its products and potentialities*, which contained both 'copious coloured and photographic illustrations', showing the transition between the drawn and the photographed.

Photographically illustrated magazines and newspapers proliferated in the twentieth century. There was great variation in aesthetic quality, according to what publishers had access to or could afford and the requirements of their target audience. At the top end internationally, Alfred Stieglitz's *Camera Work*, published in New York between 1903 and 1917, was

considered the most beautiful publication in the world. *Camera Work* did much to cement its (small) audience's belief in photography as art through the use of high-quality photogravures, a technique invented in 1879 that had greatly furthered the mechanical reproduction of photographs. At the other end of the scale, in Australia, newspapers became a mass vehicle for photographs from the 1910s, as magazines did from the 1920s.[24]

Photographic journals and photo books were desirable objects and following Stieglitz, Australian photographers such as Harold Cazneaux, John Kauffmann and Cecil Bostock considered design, production values and reproduction quality very seriously in the presentation of their own and other photographers' work in the first decades of the twentieth century.[25] In the broader arena, governments and the new corporations wanted promotional and commemorative material for themselves and their clients, as well as for national and international distribution: the photo book could be an elegant and portable solution. According to photo historian Martyn Jolly, the 1960s was the decade when such books came into their own in Australia. The postwar period brought a dramatic escalation in quality and reach, the integration of photography and text (in part due to the increased use of offset printing from the 1950s), and a new-found sophistication of approach to the most common subject and the closest at hand – Australia. Of the sixty picture books published in this decade, Jolly writes, 'they were timely, about Australia in the 1960s, rather than timeless, about a generic Australia. And they were quite explicitly about the new Australian identity that was emerging'.[26]

Axel Poignant and Mark Strizic were among the photographers who published their work on aspects of Australia, and writers such as Robin Boyd, Donald Horne, Craig McGregor, Geoffrey Blainey and Douglas Lockwood analysed its history and contemporary society. *The Australians*, which was published in 1966, brought together the talents of writer George Johnston, American National Geographic photographer Robert B Goodman and designer Harry Williamson (p 259). Funded by mining, transport, banking, insurance and technology corporations, among others, *The Australians* was the official gift of state at Expo 67 in Montreal and had sold ninety thousand copies by 1970. Printed by Griffin Press, Adelaide, who specialised in quality offset printing, this was a very attractive publication that looked at 'the Australians as a new and fascinating race of people'. Intriguingly only one photograph in this book is of an Indigenous person and Johnston's text is romantic, laudatory and historically inaccurate.[27]

The following year, Collins published *Southern exposure*, with text by Donald Horne and photographs by David Beal. Though more modest in size and in black-and-white it was a well-designed and printed book. It focused on the question 'How do you start a nation?'[28] and attempted 'an honest and intelligent evocation of what life is *really* like in Australia today'. There is a chapter on 'Non-mates: the blacks', the photographs are stylistically gritty and the texts provocative. Photographer Jeff Carter went further with *Outback in focus*, published in 1968 and designed by Valda Stobie (p 258). Carter was damning on the subject of race relations, noting in the text accompanying his photographs that 'few white people would willingly swop places with a black station worker, male or female'.[29] In 1969 Thomas Nelson published *In her own right: women of Australia*, edited by Julie Rigg with photographs by Russell Richards (p 258). Photo books that had previously been regarded as having a highly specialised audience or a niche market due to their subject matter or politics were, momentarily, seen by mainstream publishers to have relevance and market value.

These books attempted to weld photograph and word together in order to anchor meaning, and tell stories about Australian life. Outside the confines of the books with their associated texts the images lose their intended meaning. Robert B Goodman's photographs of Australians and Australian landscapes, for example, have the international style of National Geographic images, a generic quality that masks anything a viewer might describe as idiosyncratically 'Australian'. By the 1970s photo books dealing with what contemporary Australian society was or could be had dwindled. Large publishers produced much smaller books and small publishers, for a while, produced interesting material by photographers on women, environmental concerns, and urban fringe dwellers, among other subjects.[30] Photographers who aspired to be artists moved away from the page and onto the walls of the newly receptive art museums and galleries. The photograph was on the cusp of yet another technological revolution, with the advent of digital processes and a previously undreamt-of scale and speed of transmission. Intriguingly, this revolution came on the back of the vastly increased acceptance of photography as an authentic art form.[31]

From its inception, the photograph has been both a surrogate and an object in its own right, its ordinariness made extraordinary through viewers' recollections and its inherent facility to substitute

'an image for an event'.[32] At the same time, the technological shifts which have allowed for exponential increases in the making and transmission of images seem to have elasticised our understanding of image usage and meanings. For example, there is what cultural theorist Helen Grace calls '"face value": namely, the tendency to take for granted the *reality* of the image, knowing however that it is an image, which has the capacity to both reflect and produce reality'.[33] Beyond the thing in itself and the ever-shifting context it might inhabit, there is the means of production, which, for most of photography's life, has included a lens. This floating prosthesis is usually attached to or embedded within a photographic apparatus, as well as appearing in the shape of other more or less circular things, such as portholes, eclipses, funnels or shaving mirrors, which we might also look through or at and which loosely frame the world. In emulating the ocular and the bodily, these extensions can be so mundane as to be completely forgettable. The rectangular frame of a photographic plate and print has now been replicated in the rectangular frame of a digital phone or computer screen. This 'edge', like the lens, is something we have become used to, along with the corresponding framing of our perception. Similarly, we tend to forget or not care what a photographic object is, because of its sheer ubiquity. In artist and theorist Hito Steyerl's discussions on the contemporary politics of the image she has noted: 'The poor image ... is about its own real conditions of existence: about swarm circulation, digital dispersion, fractured and inflexible temporalities. It is about defiance and appropriation just as it is about conformism and exploitation. In short it is about reality'.[34] While Steyerl is talking in the main about the moving image and its new life as a cheap digital download, her ideas have resonance for the still digital image and the photographic object set free from its original archive and repurposed. The seemingly endless proliferation of images allows us to make endlessly new copy-worlds and new photo histories.

1. Patrick Pound, 'Copy-world: mobilis in mobile', in Amelia Barikin & Helen Hughes, *Making worlds: art and science fiction*, Surpllus, Melbourne, 2013, p 251.

2. Oliver Wendell Holmes, 'The stereoscope and the stereograph', *Atlantic Monthly*, June 1859, quoted by Geoffrey Batchen, 'Australia and photography: a reckoning', symposium paper, *Dark matter: photo histories and archives*, Art Gallery of New South Wales, Sydney, 12 April 2014.

3. James Freeman, 'On the progress of photography and its application to the arts and sciences', in Joseph Dyer (ed), *Sydney Magazine of Science and Art*, vol 2, James W Waugh, Sydney, 1858-59.

4. See martynjolly.com/2013/10/02/unpublished-manuscript-for-a-talk-on-the-album-who-and-what-we-saw-at-the-antipodes-in-the-collection-of-the-national-gallery-of-australia-written-circa-1983-no-citations-c1983, accessed 29 April 2014.

5. The presentation of the photographs and their embellishments provide insight into how the ruling class lived. While there is no evidence to suggest that Helen Lambert took the photographs in the album, there is no evidence to suggest that she took none. Photography had become acceptable as a hobby for some women in the nineteenth century. A decade earlier in the late 1850s Thekla Hetzer had assisted her husband in his photography studio and Louisa Elizabeth How is thought to be the photographer of items in another album held at the National Gallery of Australia. See 'People', ch 3, pp 111-17; and Alan Davies, *The mechanical eye in Australia: photography 1841-1900*, Oxford University Press, Melbourne, 1985, p 30.

6. See blog.fotomuseum.ch/2012/09/2-form-is-henceforth-divorced-from-matter, accessed 22 April 2014. While Batchen writes this in relation to literature on photography, it can also apply in a more general sense.

7. 'The carte de visite', *Mercury*, Hobart, 31 July 1862, p 3; and *Sydney Morning Herald*, 27 October 1862, p 8, reprinted from *All the year round*, London, vol 7 no 157, pp 165-68, 26 April 1862.

8. See Warwick Reeder, 'The stereograph and the album portrait in colonial Sydney 1859-62', *History of Photography*, vol 23, no 2, summer 1999, pp 181-87.

9. See Julia Horne, *The pursuit of wonder: how Australia's landscape was explored, nature discovered and tourism unleashed*, The Miegunyah Press, University of Melbourne Publishing, Carlton, Vic, 2005.

10. Geoffrey Batchen, 'Dreams of ordinary life: cartes de visite and the bourgeois imagination', in Jonathan James Long, Andrea Noble & Edward Welch (eds), *Photography: theoretical snapshots*, Routledge, London, 2009, p 86.

11. Batchen 2009, pp 90-91.

12. Reeder 1999, p 183. Sixty thousand sets of the photographs from *The royal album* were sold in Britain, the US and British colonies.

13. 'Cartes de visite and paper portraits', *Sydney Morning Herald*, 2 July 1862, p 2, quoted in Reeder 1999, p 184.

14. See Gael Newton, 'Introduction: a global picture', *Shades of light: photography and Australia 1839-1988*, Australian National Gallery, Canberra & Collins Australia, Sydney, 1988, pp ix-xiii; and Geoffrey Batchen, *Burning with desire: the conception of photography*, The MIT Press, Cambridge, MA, 1997.

15. See Nicholas Peterson, 'The popular image', in Ian Donaldson & Tamsin Donaldson (eds), *Seeing the first Australians*, Allen & Unwin, Sydney, 1985, pp 164-80.

16. The leporello album is a series of pictures (single views of towns, districts, people) in book form that can be folded together concertina-like. It is named after the list of the numerous lovers of Don Juan (in Mozart's opera), compiled by his servant Leporello. In the nineteenth century, a leporello was often made from cartes de visite. See bookcollectorsnews.wordpress.com/2009/08/21/notes-and-queries-leporello-margaret-woodhouse/, accessed 11 August 2014.

17. See *Queensland in 1908: a souvenir of the Franco-British exhibition, Queensland court*, Government Printer, Brisbane, 1908, which promoted land settlement extensively.

18. Newton 1988, p 82.

19. See Jane Lydon, *Eye contact: photographing Indigenous Australians*, Duke University Press, Durham, NC, 2005, pp 177-213. For example in 1921, five thousand people visited Coranderrk.

20. P Blanchard et al (eds), *Human zoos: science and spectacle in the age of colonial empires*, Liverpool University Press, Liverpool, UK, 2008, pp 1-49.

21. Roslyn Poignant, *Professional savages: captive lives and western spectacle*, Yale University Press, New Haven, CT/London, 2004.

22. Poignant 2004, p 152.

23. See Gael Newton, 'JW Lindt: Coontajandra and Sanginguble, Central Australian Aboriginals', *Artonview*, no 45, March 2006, p 43.

24. See Anne-Marie Willis, 'The popular press', *Picturing Australia: a history of photography*, Angus & Robertson, Sydney, 1988, pp 114-25.

25. See Newton 1988, 'Live in the year 1929', pp 102-14.

26. Martyn Jolly, martynjolly.com/2013/11/14/exposing-the-australians-in-focus, accessed 7 May 2014.

27. Robert B Goodman & George Johnston, *The Australians*, Paul Hamlyn, London, 1966, p 43.

28. David Beal & Donald Horne, *Southern exposure*, Collins, Sydney & London, 1967 p 9.

29. Jeff Carter, *Outback in focus*, Rigby Limited, Adelaide, 1968, p 37.

30. Three examples: Rennie Ellis & Wesley Stacey, *Kings Cross, Sydney*, Thomas Nelson, Australia, 1971; Carol Jerrems & Virginia Fraser, *A book about Australian women*, Outback Press, Melbourne, 1974; and Marion Hardman & Peter Manning, *Green bans: the story of an Australian phenomenon*, Australian Conservation Foundation, Melbourne, 1975.

31. See Ewen McDonald & Judy Annear (eds), *What is this thing called photography? Australian photography 1975-1985*, Pluto Press, Sydney, 2000; and Judy Annear, 'Introduction', *Subject and object in 21st century photography*, symposium paper, Art Gallery of New South Wales, 9 April 2011, https://itunes.apple.com/au/itunes-u/agnsw-photography-symposium, accessed 8 May 2014.

32. Paul Carter, 'Invisible journeys: exploration and photography in Australia', in Paul Foss (ed), *Island in the stream: myths of place in Australian culture*, Pluto Press, Sydney, 1988, p 56. While Carter is talking about nineteenth-century photography, much of what he discusses is relevant for more recent forms of the photograph and photographic effect.

33. Helen Grace, *Culture, aesthetics and affect in ubiquitous media: the prosaic image*, Routledge, Oxford, 2014, p 15.

34. Hito Steyerl, 'In defense of the poor image', *The wretched of the screen*, Sternberg Press, Berlin, 2012, p 44.

DELICIOUS MOMENTS: THE PHOTOGRAPH ALBUM IN NINETEENTH-CENTURY AUSTRALIA

Martyn Jolly

Photographs were never just images, they were always also things: objects to be touched or held, given or received, hidden or revealed, kept or destroyed. Photo historians are paying increasing attention to objects such as photographic albums, and as they do so, new insights into the way people once loved, shared and remembered are opening up to us.[1] But, as we look afresh at these old albums, connections with the way we use photographs today are also emerging, even though photographs are no longer the things they once were.

On 18 October 1860 a Sydney merchant announced: 'We have received per mail a few photographic portraits of The Queen, the Prince Consort, and all members of the Royal Family. They have been taken from the life by Mr Mayall of Regent Street and are highly interesting from their truthfulness and unexaggerated appearance'.[2] The royal portraits were in the new carte-de-visite format – full-length portraits photographed in sets of eight by special multi-lens cameras and glued onto small mass-produced visiting cards. By early 1862 Sydney stationers were regularly advertising another new commodity, the carte-de-visite album.[3] These albums had thick, decorated pages with pre-cut slots to hold cartes de visite. By July that year the Sydney photographers Freeman Brothers were announcing that they had 'arranged a series of variable and appropriate backgrounds, so as to produce increased effect and add interest to the pictures [...] in order to meet the increasing demand for these elegant varieties of the photographic art'.[4] The global carte-de-visite craze had hit Australia – the product of the coming together of an international postal service, a modular album, and a standardised photographic format. A popular poem that was placed on the first page of many Australian albums instructed the reader on how to use this new object:

> Yes, this is my album
> But learn ere you look:
> That all are expected
> To add to my book.
> You are welcome to quiz it
> The penalty is,
> That you add your own portrait
> For others to quiz[5]

The album was therefore a site of mutual obligation and reciprocal exchange. Mayall's portraits, which reportedly sold in their hundreds of thousands around the empire, set up the royal family as the template for all the other families in the colony, while carte-de-visite albums became a physical manifestation of one's place in a rigid social system. As she tucked images of the famed, such as those of the royal family with their 'truthfulness and unexaggerated appearance', into the same intimate pockets as the portraits of people she knew, each album's owner stitched herself tightly into her immediate family as well as concentric social circles extending all the way up to the stratospheric reaches of royalty. The *Sydney Morning Herald* quoted one satirist who poked fun at the 'claims to gentility' the carte-de-visite album had unleashed; but his social vignette also points to how tactile the albums were, how startlingly immediate the portraits were, and how the combination of portraits was animated by a compiler's narration:

> You place it in your friend's hands, saying, 'This only contains my special favorites, mind', and there is her ladyship staring them in the face the next moment. 'Who is this sweet person?' says the visitor. 'Oh that is dear Lady Puddicombe', you reply carelessly. Delicious moment![6]

There was much that was formulaic about the carte-de-visite's iconography. The 'series of variable and appropriate backgrounds' Freeman Brothers arranged for their clients would have been necessarily limited, and the repertoire of poses, derived from paintings, equally formulaic.[7] But cartes de visite allowed the middle classes to 'perform' themselves as they wanted to be seen, then socially articulate themselves within the juxtapositions of the album, and finally even to see themselves ensconced in global networks. These were all powerful forces so, not surprisingly, albums themselves began to appear as talismanic objects within carte-de-visite portraits. Townsend Duryea, for instance, photographed a young Moonta woman gazing wistfully off into the distance; we don't know whom she is thinking of, but we are certain their portrait is in the album which sits open in front of her (p 237).

Not all nineteenth-century albums followed the modular conventions of the pre-made carte-de-visite album; some were surprising informal. Around Christmas-time 1858 Louisa Elizabeth How, the wife of a wealthy merchant, briefly took up photography.[8] Her photographs of visitors to her harbourside home provide an insight into the day-to-day social life of friends in a domestic space. The settlers John Glen and Charles Morrison lounge with stereoscopes and stereo cards – an earlier photography craze – while William Landsborough, just returned from opening up new land for pastoral claims

in southern Queensland, sits stiff-leggedly. His young Aboriginal companion 'Tiger' has obviously been told by How to wedge his elbow on the back of Landsborough's chair in a fraternal gesture. He loosely holds his doffed cap in one hand, but hovers his other hand just above the explorer's shoulder, barely touching it with his stiff fingers.

Albums such as How's, which take us so closely into the bodily interrelationships of colonial Australians, are extremely rare. More common are the large, elaborately hand-painted, collaged scrapbook albums that became popular among middle- and upper-class women in the late 1860s.[9] Mrs Lambert, the compiler of one of these albums, *Who and what we saw at the Antipodes*, not only records the social circles of Sydney's colonial elite, but also their houses and drawing rooms. For one photograph she flung open the curtains to her own drawing room at 46 Phillip Street. Though the streaming sun reduced the exposure time, Edith Gladstone, the young sister of Countess Belmore, the Governor's wife, still has to hold her head to keep it from moving while she is photographed reading at a desk. There is an air of casual immediacy to the image, and a domestic informality is revealed as our eye wanders through the clutter of novels, albums and knick-knacks.[10]

Another album, from the Lethbridge family of Queensland pastoralists, contains a lovely and remarkably modern-looking portrait of a fresh-faced young girl leaning back in her chair and looking frankly into the camera with her fingers laced behind her head (p 252). Somebody, at a later date, has added the necessary metadata in pencil: 'Effie Dalrymple, sister to Florence Lethbridge'. Thanks to those worker-bees of history, the family genealogists, and the digitisation of photographic collections, it only takes Google 0.45 seconds to find me another image of Effie, this one taken in 1900 after she had been married for twenty years and borne four children to the Mayor of Mackay, David Dalrymple. In the image that Google delivers, her face is now set hard and her hair tightly drawn back.

To jump from a nineteenth-century portrait album to the internet is now an automatic leap. And plenty of people have noticed the structural similarities between carte-de-visite albums and Facebook.[11] This comment from 1862 about the process of being turned into a carte de visite seems remarkably familiar today:

> you have the opportunity of distributing yourself among your friends, and letting them see you in your favorite attitude, and with your favorite expression. And then you get into those wonderful books which everybody possesses, and strangers see you there in good society, and ask who that very striking looking person is?[12]

Nineteenth-century albums mediated between the private and the public, allowing people to invent themselves and to feel connected with each other over vast distances of space and time, networked into global, virtual communities. Just like online photo-sharing today.

1. See, for example: Geoffrey Batchen, *Forget me not: photography and remembrance*, Van Gogh Museum, Amsterdam, 2004; Martha Langford, *Suspended conversations: the afterlife of memory in photographic albums*, McGill-Queen's University Press, Montreal, 2001; Elizabeth Edwards, 'Photographs as objects of memory', in Marius Kwint, Christopher Breward & Jeremy Aynsley (eds), *Material memories*, Berg, Oxford, 1999, pp 221-36; Deborah Chambers, 'Family as place: family photograph albums and the domestication of public and private space', in Joan Schwartz & James Ryan (eds) *Picturing place: photography and the geographical imagination*, IB Tauris, London, 2003, pp 96-114; and Verna Posever Curtis, *The album in the age of photography*, Aperture/Library of Congress, New York, NY & Washington, DC, 2011.

2. *Sydney Morning Herald*, 18 October 1860, p 8. For more on carte-de-visite albums in the 1860s see Warwick Reeder, 'The stereograph and the album portrait in colonial Sydney 1859-62', *History of Photography*, vol 23, no 2, summer 1999, pp 181-91.

3. *Sydney Morning Herald*, 15 March 1862, p 2; *Sydney Morning Herald*, 26 Apr 1862, p 7.

4. *Sydney Morning Herald*, 2 July 1862, p 2.

5. A carte-de-visite copy of this poem appears in an album in the papers of Isobel Mackenzie, State Library of New South Wales, MLMSS 2996/SPG/1; another is in the State Library of Tasmania, TL.P 779.POR. The poem is also cited in Reeder 1999, p 182; Deborah Chambers 2003, p 99; and Risto Sarvas & David M Frohlich, *From snapshots to social media: the changing*

picture of domestic photography, Springer, London, 2011, p 41.

6. *Sydney Morning Herald*, 27 Oct 1862, p 8.

7. For more on carte-de-visite conventions see Geoffrey Batchen, 'Dreams of ordinary life', *Photography: theoretical snapshots*, Routledge, London, 2009, pp 80-97.

8. Isobel Crombie, 'Louisa Elizabeth How: pioneer photographer', *Australian Business Collectors Annual*, 1984, pp 82-85; and Joan Kerr (ed), *Dictionary of Australian artists: painters, sketchers, photographers, engravers to 1870*, Oxford University Press, Melbourne, 1992, pp 375-76.

9. For international examples of these albums see Elizabeth Siegel, *Playing with pictures: the art of Victorian photocollage*, The Art Institute of Chicago, Chicago, IL, 2010.

10. Martyn Jolly, '"Who and what we saw at the Antipodes": who and what?', martynjolly.com/writing/ nineteen-century-albums/, accessed 30 June 2014.

11. See Martyn Jolly, 'A nineteenth-century Melbourne spiritualist's carte de visite album', in Anne Maxwell (ed) *Migration and exchange*, Australian Scholarly Publishing, Melbourne, 2014 (forthcoming); Esther Milne, 'Magic bits of pasteboard: texting in the nineteenth century', *M/C Journal*. vol 7, no 1, Jan 2004, journal.media-culture.org.au/0401/02-milne.php, accessed 30 June 2014; Simone Natale, 'Photography and communication media in the nineteenth century', *History of Photography*, vol 36, no 4, Nov 2012, pp 451-56; and Sarvas & Frohlich 2011, pp 35-42.

12. *Sydney Morning Herald*, 27 Oct 1862, p 8.

 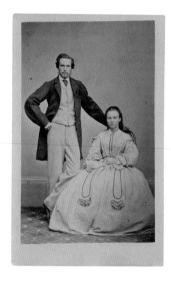

clockwise from top left:

Townsend Duryea

Portrait of child wearing plaid dress, toy dog at side 1865
Portrait of child upon chaise longue 1868
Portrait of seated woman, gentleman at side c1864–65
Portrait of little girl named Frances, aged four years 1864
Portrait of woman, photographic case in hand 1866 (?)
Portrait of small child, basket of flowers upon parlour chair 1868

RJ Noye Collection, Art Gallery of South Australia, Adelaide

Edwin Duryea

*Portrait of young woman against trompe l'oeil screen,
umbrella and bag in hands* c1890
Portrait of two young women, one with crucifix at neck c1885

RJ Noye Collection, Art Gallery of South Australia, Adelaide

 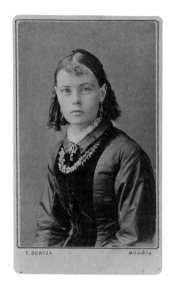 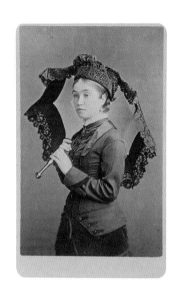

 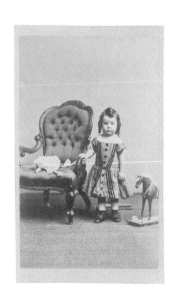

clockwise from top left:

Townsend Duryea Studio

*Portrait of young woman, one hand held to cheek, the
other lightly clasping flower* c1875
Portrait of James and Amelia Bowering 1881
*Portrait of young woman wearing dress with velvet
bodice panel* c1875
Portrait of young woman with open parasol c1880
Portrait of young woman seated at side table with open album c1875

RJ Noye Collection, Art Gallery of South Australia, Adelaide

Townsend Duryea

Studio portrait of small girl with toy horse, beside chair 1864–65
Portrait of gentleman, hand directed skyward 1864–65
Portrait of girl, elbow resting on writing desk 1869 (?)

RJ Noye Collection, Art Gallery of South Australia, Adelaide

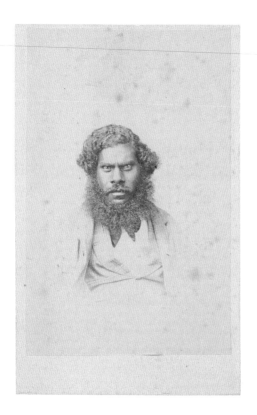 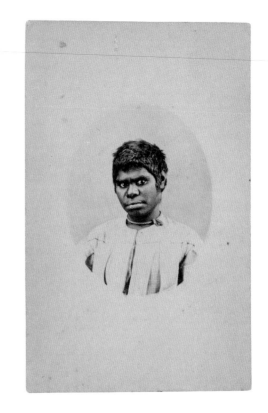

Frazer Smith Crawford
James Wanganeen 1864–67
Art Gallery of New South Wales, Sydney

'Professor' Robert Hall
Untitled 1855–65
Art Gallery of New South Wales, Sydney

opposite, from left:
Fred Kruger
Album of Victorian Aboriginals - kings, queens, &c c1877
Johann Freidrich Carl Kruger Collection, South Australian Museum, Adelaide

Charlotte Arnott and child at Coranderrk Aboriginal station, Victoria c1876–77
Museum Victoria, Melbourne

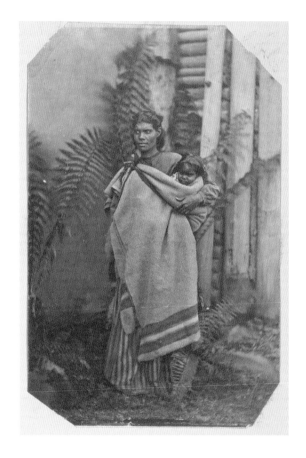

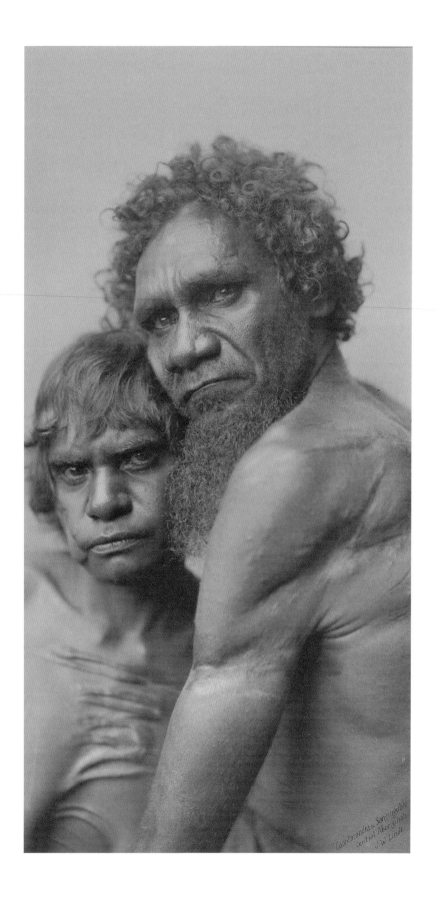

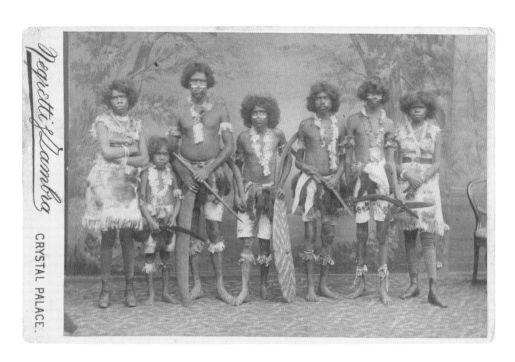

William Robinson, Negretti & Zambra
Remaining seven of the first group of
Aboriginal people removed from Queensland,
Crystal Palace, London 1884
Pictures Collection, National Library of Australia, Canberra

opposite:
JW Lindt
Coontajandra and Sanginguble 1893
National Gallery of Australia, Canberra

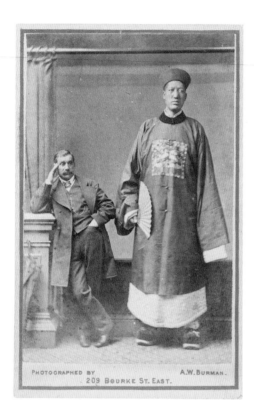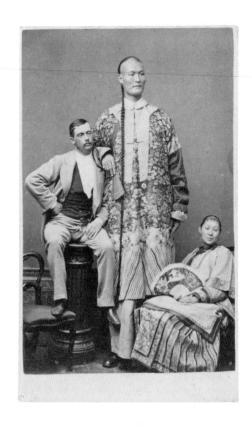

Arthur W Burman
Chinese giant Chonkwicsee and companion 1876
National Portrait Gallery, Canberra

Archibald McDonald
Chang the Chinese giant with his seated wife
Kin Foo with fan and manager c1871
National Portrait Gallery, Canberra

opposite, clockwise from top left:
Kerry & Co
Aboriginal with throwing stick 1901–07

An Australian wild flower 1901–07

Untitled 1901–07

A fighting man 1901–07

Aboriginal chief 1901–07

Aboriginal with devils mask 1901–07

Art Gallery of New South Wales, Sydney

Photographers cards

Thomas Foster Chuck 1868
Joseph Charles Milligan 1868–71
Wykes Norton 1882–85

opposite, from left:
Arthur W Burman 1878–88
Herman Moser 1877–87
Frederick Frith 1866–71

Art Gallery of New South Wales, Sydney

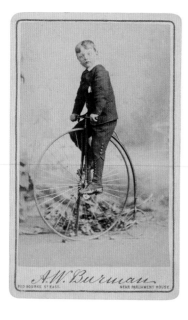
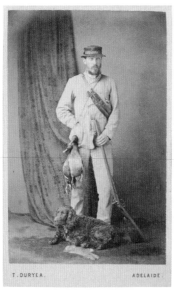

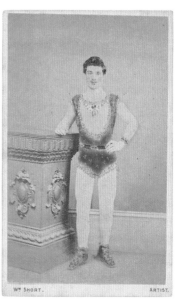

Cartes de visite 1860–90s

clockwise from top left:
Arthur W Burman 1878-88
Townsend Duryea 1860–75
Alexander Carlisle 1879–81
Unknown photographer 1860–90s
William Short 1874–76
Thomas Boston 1867–70
Henry Jones 1870–71
Henry Hall Baily 1866–81

Art Gallery of New South Wales, Sydney

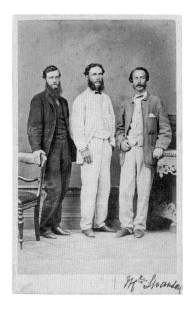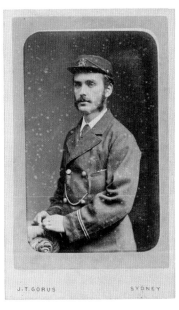

clockwise from top left:
Thomas Glaister 1855–70
John Tangelder Gorus 1864–79
William Bear 1877–82
J Davis 1860–90s
Thomas Glaister 1863–70
James Manning 1866–91
Thomas JJ Wyatt 1860–90s
Freeman Brothers 1873–79

Art Gallery of New South Wales, Sydney

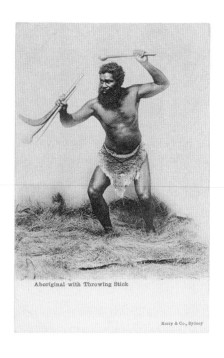

Aboriginal with Throwing Stick

Kerry & Co., Sydney

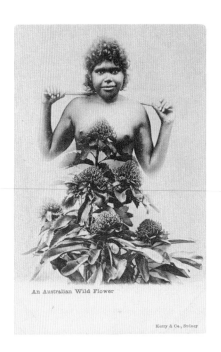

An Australian Wild Flower

Kerry & Co., Sydney

Kerry & Co., Sydney.

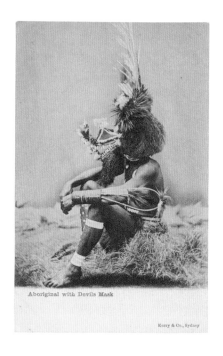

Aboriginal with Devils Mask

Kerry & Co., Sydney

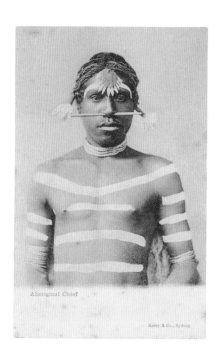

Aboriginal Chief

Kerry & Co., Sydney

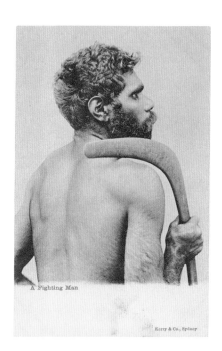

A Fighting Man

Kerry & Co., Sydney

WHERRETT & McGUFFIE, Hobart

J. W. FRY, PHOTO ARTIST, PENRITH

BARDWELL'S ROYAL STUDIO. BALLARAT

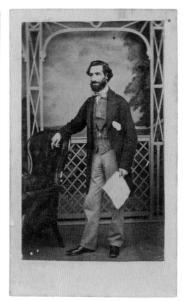

E.E. HIBLING,
7, Collins St.E. Melbourne.

clockwise from top left:
Thomas Boston 1867–70
Wherrett & McGuffie 1887
JW Fry c1871
William Bardwell 1875–91
'Professor' Jeffrey Hawkins 1860–74
Alfred Bock 1859–67
JW Fry c1871
Everitt E Hibling 1873–77

Art Gallery of New South Wales, Sydney

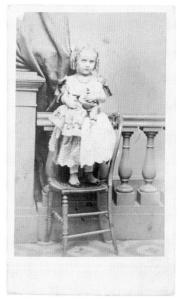

HENRY KING, 316 GEORGE STREET.

clockwise from top left:
Barcroft Capel Boake 1867–77
Edward Nagel 1885–92
John Degotardi (sr) 1867–70
JW Fry c1871
Henry Goodes 1861–65
Henry King 1881–94
JW Fry c1871
Edward Holledge 1860–90s

Art Gallery of New South Wales, Sydney

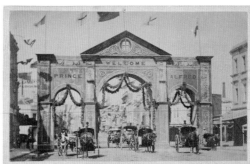

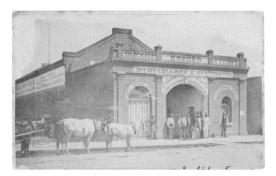

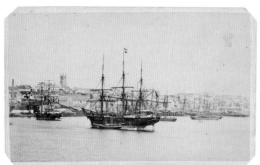

Cartes de visite 1860–90s

far left, from top:
Charles Collins 1860–90s
Unknown photographer c1869
Unknown photographer 1860–90s
John Degotardi (sr) 1867–70
Charles Nettleton 1867–74
Art Gallery of New South Wales, Sydney

left, from top:
Davies & Co 1863–70
Thomas Foster Chuck 1868
H Roach & Co 1860–90s
Samuel Clifford 1866–78
John Degotardi (sr) 1867–70
Art Gallery of New South Wales, Sydney

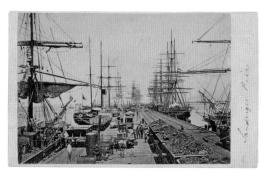

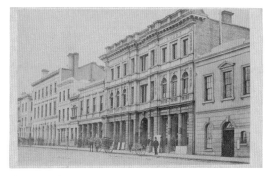

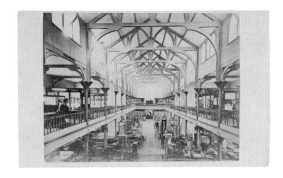

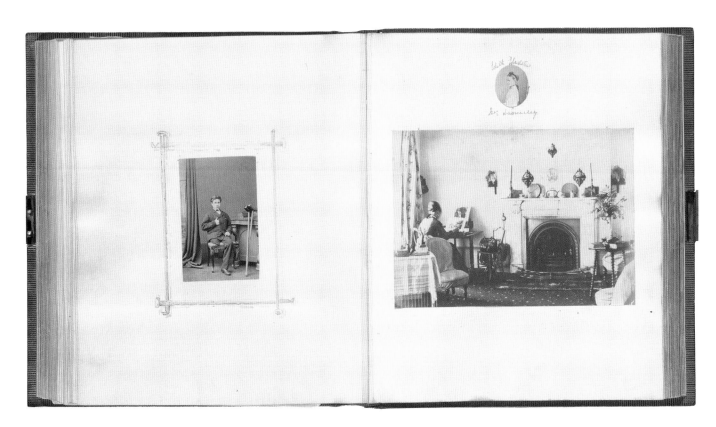

attributed to **Helen Lambert** (right-hand page)
Oval portrait of Edith Gladstone, Mrs Dumaresq and
My drawing room Phillip Street Sydney in the album
Who and what we saw at the Antipodes 1868–70
National Gallery of Australia, Canberra

opposite, from top:
Unknown photographer
Carte de visite from the *Dewhurst family album* 1861–62
Art Gallery of New South Wales, Sydney

Unknown photographer
Effie Dalrymple in *Lethbridge family photograph album*
1885–95
John Oxley Library, State Library of Queensland, Brisbane

JW Lindt
Sandridge railway pier in an untitled
album 1880s–90s
National Gallery of Australia, Canberra

opposite, from top:

Bernard Goode
Rundle Street, Adelaide c1866 and
Rundle Street, Adelaide 1869
in album of 50 photographs 1860s–70s
Art Gallery of South Australia, Adelaide

Chamber of Mysteries, Yallingup Cave

Unknown photographer, Caves Board of Western Australia
Chamber of mysteries, Yallingup cave in the album *Photos of caves between Capes Naturaliste and Leeuwin* 1901
State Library of Western Australia, Perth

opposite:
Charles P Mountford
Dingo: hand, with fingers turned tightly inward, is moved up and down from wrist in the album *Gesture language of the Australian Aborigine: the Nagagadjara tribe; the Wilbiri* [Walpiri] *tribe* 1938–49
State Library of South Australia, Adelaide

DINGO

Hand, with fingers turned tightly inward, is
moved up and down from wrist.

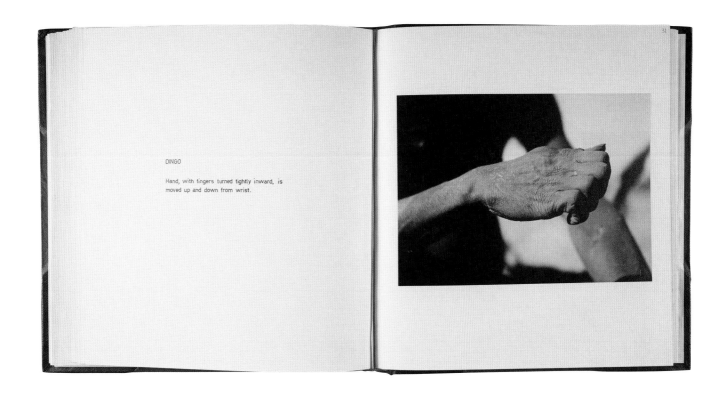

from left:

Julie Rigg (ed), **Russell Richards** (photographer)
In her own right: women of Australia, published 1969

Jeff Carter
Outback in focus, published 1968

opposite:

Robert B Goodman (photographer), **George Johnston**
The Australians, published 1966

Marion Hardman (photographer), **Peter Manning**
Green bans: the story of an Australian phenomenon,
published 1975

Art Gallery of New South Wales Research Library and
Archive, Sydney

The Australians

Robert B. Goodman
George Johnston

GREEN BANS

The Story of an Australian Phenomenon

Marion Hardman, Peter Manning

AN AUSTRALIAN CONSERVATION FOUNDATION PUBLICATION

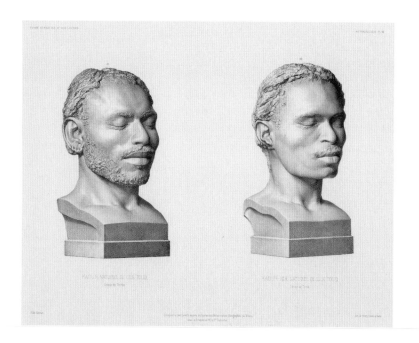

top:
Leveillé after **Bisson Brothers**
Kaour & Kaour-Iga, natives of Torres Strait 1846
Art Gallery of New South Wales, Sydney

above, from left:
George Goodman
Dr William Bland c1845

Caroline and son Thomas James Lawson 1845
State Library of New South Wales, Sydney

POSTSCRIPT
Antipodean photography: an itinerant history
Geoffrey Batchen

What, then, are we to make of the relationship of the photograph and Australia? It is of course traditional to think in terms of *national* histories of photography, as if this medium can somehow be magically confined to the boundaries of a designated nation-state. Such histories are written to serve what is regarded as a vital national interest – that is, to define what is essential about the people who live within those boundaries and what is specific to the culture they have produced. It is interesting that historical models like this remain popular at the very moment when global capitalism, mass migrations, modern transportation systems, and electronic communications have combined to make a nation-state's boundaries relatively permeable. In this context defiantly nationalist narratives can be understood as operating in two, perhaps complementary ways – as nostalgic for a wholeness or purity of identity that never was and/or as strategically resistant to the threat of global homogenization or other unwanted incursions across a nation's borders.[1]

So the motivations behind the writing of national histories of photography are perfectly understandable. But do they also result in a misleading view of that same history? Take histories of Australian photography, for example. The Great South Land, although Terra Incognita for many centuries, was nevertheless always part of the European imaginary, if only as a projected antipodean counterweight to known lands in the northern hemisphere. Arguably, the Antipodes (according to the dictionary, 'something that is the exact opposite or contrary of another') always already exists, before and after, inside and outside, the nation-state that Australia became. It's also there in every photograph, wherever it may have been made, in the sense that Australianness is inscribed within the very concept–metaphor of photography as an epistemic desire.[2] For example, on 31 January 1839 William Henry Fox Talbot, in his earliest publication on his invention of photogenic drawing, speaks of his first photographs as having been 'very perfect but extremely small pictures ... such as without great stretch of the imagination might be supposed to be the work of some Lilliputian artist'.[3] Lilliput, one of the fictional sites featured in Jonathan Swift's *Gulliver's travels* of 1726, was located in Swift's map a little to the North West of Van Diemen's Land or Tasmania, about where Adelaide

is today. As Ross Gibson has written, 'Swift deliberately chooses the known areas of New Holland and Van Diemen's Land as reference points from which he can draw up a society of wonders and radically altered perspectives'.[4] Making themselves 'without the aid of the artist's pencil', and appearing as inverted and upside-down images in the back of a camera obscura – and thereby overturning all fixed traditions of picture making – the first photographs were, in other words, imagined by their inventor to be entirely *antipodean* productions.

The imaginary is one of those realms that tend to be left out of histories, being an immaterial mode of thought rather than a physical artefact. And yet this play between the immaterial and the material has always been central to the relationship of photography to Australia. For example, the first-ever reproduction of a photograph consisted of a wood-engraved 'fac-simile' of a photogenic drawing made using Talbot's process that was published in April 1839 on the cover of the *Mirror of Literature, Amusement, and Instruction*, a London journal. It showed a contact print of three sprigs of fern, printed in rust to imitate the look of the original photograph.[5] This, then, is how most people encountered their first photograph, as a second-order reproduction, as an apparition of a photograph, with photography being presented as a process *about* the making of such apparitions, before it was anything else.

The three ferns were reproduced to illustrate a text written by Dr Golding Bird and titled 'A treatise on photogenic drawing'. Bird, the inventor of the stethoscope, published at least two other such essays during 1839. One of them was read by the English-born painter Conrad Martens, who had arrived in Sydney in 1835, and lived and worked there until his death in 1878. Some time before August 1840 Martens carefully wrote out a recipe for photogenic drawings in his notebooks, the source being a reprinted essay by Bird that Martens read in his copy of the *Visitor, or Monthly Instructor* of 1839, a magazine published in London by the Religious Tract Society. Based on his reading, and perhaps on his own experiments, Martens recommended using 'glazed writing paper of the thinnest kind' and the 'stopping solution recommended by Mr Bird' in order to obtain 'the dark colour produced by the action of the sun'. He also suggests applying the 'photogenic fluid using a brush' and doing so by candlelight.[6] Although we have no other evidence that Martens made any photogenic drawings himself, I think we can reasonably say that he had at least photographed in his imagination well before any camera arrived on these shores.

Nor was he the only one. In September 1840 Sir John Franklin, Governor of Tasmania between 1836 and 1843, received in Hobart some examples of photographic

images – three lithographs of fossils originally 'engraved on a daguerreotype plate' that had been exposed (one of them by limelight, a combustible compound of oxy-hydrogen and calcium) at the Royal Polytechnic Institution in London by a man named LL Boscawen Ibbetson. As Franklin's benefactor, William Buckland, wrote in his accompanying letter, 'there is no calculating the importance of this invention for multiplying figures in Natural History'.[7] By this time Sir John would surely have read about the invention of the daguerreotype – 'one has heard of writing by steam; but drawing by sunshine (or moonshine) is a novelty for which the world is indebted to Mr Daguerre of Paris' – on page four of his copy of the *Colonist*, published in Sydney on Saturday 1 June 1839. The article asked its readers to 'figure to yourself … a mirror which, after having received your image, gives you back your portrait, indelible as a picture, and a much more exact resemblance … [although capturing] only outline, the lights and shades of the model … they are drawings … pushed to a degree of perfection that art never can reach'.

Shortly thereafter, on 19 September, Franklin would also have read a reprinted American essay in the *Launceston Advertiser* telling of Talbot's competing invention of photogenic drawing ('the phantasmagoria of inventions passes rapidly before us … [resulting in] a revolution in art'), and shortly after that, on 18 January 1840, would have learned from the *Colonist* that a daguerreotype had been taken in London by a visiting Frenchman. By March of 1840, Australian newspapers provide evidence that the language of photography had become part of the vernacular, with the *Hobart Town Courier* using the word 'daguerreotype' to indicate the 'extraordinary resemblance' between Hobart and Cape Town.[8] All this, remember, before any photograph had been made on Australian soil.

The introduction of lithographic or wood-engraved copies of photographs, often disseminated in mass-media outlets like the *Illustrated London News*, meant that photographic images were themselves now itinerant entities, with the potential to be distributed all over the world and capable of being experienced, simultaneously, in – say – Sydney, Hobart, Hong Kong, Bombay and London. This sharing of printed images allowed the British Empire to maintain a sense of its own coherence as an apparently benign and yet all-seeing, all-powerful colonial enterprise. Indeed Australians were avid readers of the *Illustrated London News*; a Dr Maberley of Market Street, Sydney, for example, had a complete run of two hundred volumes auctioned with the effects of his house in 1849.[9] By 1851, when Harden Melville completed his painting titled *Australia: news from home*, it seems even squatters were able to get it. The reclining man in Melville's

painting is shown perusing his copy, dedicated to the Great Exhibition that had opened in London in May of 1851. During that year's issues, such a man would have encountered no less than twenty-seven wood engravings made after daguerreotypes by the London photography studio of Antoine Claudet alone, including portraits of 'Distinguished Jurors and Celebrities of the Great Exhibition', and a picture of some charmingly posed cats, prepared by Hermann Ploucquert, a taxidermist at the Royal Museum in Stuttgart, and photographed by Claudet at the exhibition itself.[10]

So, it is clear that colonists in Australia were familiar with various kinds of photography separate from any encounter they may have had with Australian-made photographs. In any case, no doubt many immigrants to Australia saw daguerreotypes in England before they left, or brought photographs with them, or had some sent out by loved ones back home after they had arrived here.[11] As a consequence, any comprehensive account of the photographic experience in the Antipodes must find a way to include some of these border-crossing photographic images and photographs, along with those made here.

As is well known, the first daguerreotype camera and its related equipment arrived in Sydney on 29 March 1841 on board a French ship called the *Justine*, which had already stopped in the Bay of Islands in New Zealand. A report in a local newspaper announced the sale of this apparatus on April 13, and a month later it was reported as having produced the first Australian photograph, of 'Bridge-street and part of George-street', a photograph that is no longer extant. The *Australian* newspaper states in its story about the event that 'our readers will be aware that this instrument is the recent invention of M. Daguerre', one more signal that, in Australia, photography long preceded photographs, arriving in the colony as an idea, a piece of received news, and in reproduction, well before it was manifested in a workable apparatus and a local daguerreotype picture.[12]

We're also reminded that this particular apparatus came to Australia via New Zealand, where it landed but apparently was not used. Although no photographs are known to have been taken in New Zealand until 1848, the two colonies were after this date treated by early photographers as a single market, with many travelling back and forth looking for customers. In other words, the practice of photography in the Antipodes was always a transnational affair, unlike most of our subsequent histories.

Let's come back to Sydney for a moment and to the establishment of the first professional photography studio in Australia, opened by George Goodman on 12 December 1842. Goodman announced that he would

be operating 'By Her Majesty's Royal Letters Patent' and describes his camera as a 'Reflecting Apparatus'.[13] Both these references strongly suggest his practice was an extension of that established by the Richard Beard enterprise back in London. This suggestion is reinforced by the fact that Goodman's advertising copy also included a full column of reviews of Beard's studio at the Royal Polytechnic Institution from the British press, a practice very much in the Beard style. Goodman, like Beard, charged one guinea for a portrait – about a week's wages – plus the cost of a frame, and advertised exposure times of about ten seconds. Beard had established commercial photography as a franchise system in March 1841, when, having acquired the English patent rights to Daguerre's process, he began selling licences, training and equipment to other operators. As part of the licensing deal, those operators were obliged to stamp all their own daguerreotypes with the words 'Beard Patentee'.[14] One might say that Beard was a particularly prescient contributor to photography's future in that he fully embraced all the consequences of its modernity – even to the point of his own dissolution in favor of a purely corporate existence.

Beard's eagerness to find new licence holders led him to open the photography business to persons usually excluded from such pursuits, including women, colonials and Jews. An advertisement in the *Times* of 19 April 1842 declares that 'Licences for working the invention in provincial towns and the British colonies granted by Mr Richard Beard, patentee'.[15] In that same year, Beard appears to have sold a licence to an ambitious Jewish would-be-photographer, George Barron Goodman (real name: Gershon Ben Avrahim), who was preparing to emigrate to the British colony of Australia. Goodman duly arrived in Sydney on 5 November 1842 with a 'reflecting apparatus' daguerreotype camera and twenty-seven boxes of blue glass to use in his photography studio, which opened in the upper floor of the Royal Hotel at 72 George Street.

That camera was invented in New York by Alexander Wolcott, an instrument maker who made the first recorded photographic portrait on 6 October 1839. The Wolcott Reflecting Camera doesn't use a lens, instead consisting of a box with its interior painted black, fitted inside with a seven-inch concave mirror. The mirror sits at the rear of the box, facing forward so that it focuses light on the small rectangle of polished metal placed before it. The light-sensitive daguerreotype plate therefore faces away from the portrait subject at the moment of its exposure. Though this camera could make only relatively small ninth-plate daguerreotypes which tended to be dark in tone and softly focused, Beard bought the rights and took out an English patent on 13 June 1840. This, plus

related innovations – such as the use of reflectors ('small squares of looking-glass of five or six inches square', covered in varnished tissue paper to disperse the reflected light); a blue glass ceiling; the heating and polishing of the plates using two rollers, acids, and powdered chalk and charcoal; the lining of the iodine box with a square glass vessel; and the use of a mixture of iodine and bromine to sensitise the plate about to be exposed – were all sold under licence to operators like Goodman.[16]

None of Goodman's earliest daguerreotypes seem to have survived. And perhaps that's just as well, as the *Sydney Morning Herald* described them as having a 'cadaverous, unearthly appearance'.[17] What we do have is a series of slightly later ninth-plate daguerreotypes that Goodman made in Bathurst of members of the Lawson family in May 1845. For these he used a new, lens-based camera he had received in 1843, the same year in which Beard also replaced the Wolcott camera in his own studios. That Goodman continued operating as a colonial franchise under licence to Beard is evidenced by an advertisement in the *Sydney Morning Herald* of 13 April 1843, where Goodman advised potential clients that they should hasten to his studio 'previous to his final departure for India and the other British colonies to which the patent extends'. Although Goodman in fact remained in Australia, his assistant, John Flavelle, established a studio in Launceston, Tasmania, in 1844, advertising in the *Launceston Examiner* of 2 March that he had purchased from Goodman 'the whole of the buildings, machinery, copyright, etc' and again referring to the authority of 'her Majesty's letters patent'. Goodman nevertheless continued to operate photography studios elsewhere in the colony, announcing in one advertisement in the *Sydney Morning Herald* of 28 November 1844 that 'he has just received from the Patentee in England, the new process, lately discovered, of colouring the Daguérréotype Portraits' (Beard having taken out a patent on such a process on 10 March 1842). On 14 January 1846 Goodman advertised in the *South Australian Register* his 'special advantage of obtaining from the patentee in England every recent improvement of the art of the Daguerreotype'.[18]

So Goodman's first daguerreotypes are all undoubtedly Australian photographs, but that adjective now needs to come with an asterisk. After all, they also turn out to have been made by a Hebrew-speaking immigrant operating under an assumed Anglicised name while using a French photographic process, an American camera, and English copper plates and blue glass, all under licence to an English patent holder and adopting established English conventions for posing in front of a camera. This new Australian arrived in 1842, moved constantly during the few years that he was

here – photographing in Hobart, Bathurst, Melbourne, Adelaide, Maitland, Newcastle and Goulburn – made at least ten thousand daguerreotypes, and then sold his business and moved back to Europe, dying in Paris in 1851. George Goodman was, in other words, the very embodiment of itinerancy and his practice was in every respect a multinational one.

That Beard continued to be a ghostly presence in Australian photography is suggested by the work of a slightly later English photographer operating in Melbourne. Douglas Kilburn arrived in 1847 to establish that city's second commercial photography studio, and is remembered today primarily for a series of daguerreotypes he made of local Aboriginal people in about October of that year. At least one of those daguerreotypes was placed in a gilt brass Wharton tray, manufactured in Birmingham and patented in England on 24 August 1841, a type of tray extensively used by the Beard studios.[19] Another of Kilburn's images exists as two near-identical daguerreotype copies, one in the National Gallery of Victoria and the other in Museum Victoria. Alexander Wolcott and his partner, another American named John Johnson, both of them working for Beard in England by this stage, patented a device to make copies of existing daguerreotypes on 18 March 1843. No doubt it was a version of this kind of device that enabled Kilburn to turn his Melbourne daguerreotypes into multiples of themselves. Despite this multi-national pedigree, can we at last say that these are quintessentially *Australian* photographs? After all, they feature various Aboriginal subjects, subjects seen at that time – like Australian flora and wildlife – as signs of our distinctive differences from Europe, of our *Australianness*. And yet, as we'll see, these photographs are once again entirely itinerant entities, as if to be Australian is to be always divided from oneself, to be simultaneously inside and outside any designated boundary, including that of the nation.

It's often said, in fact, that these are the earliest extant photographic images of Indigenous Australians. This is true only if you again exclude from such a claim any images made *after* photographs, such as the lithograph titled *Kaour and Kaour-Iga, natives of Torres Strait* 1846 (p 260). It's an image that enjoys a complex lineage, involving a series of exchanges between media and maintaining its visual authenticity only through a shared investment in the power of the indexical sign. The image is in fact a lithographic reproduction of daguerreotypes made by the French photographer Louis-Auguste Bisson of life-casts of two men encountered in Torres Strait. The cast moulds were among the fifty-one similar examples made by phrenologist Pierre-Marie Alexandre Dumoutier during the French explorer

Dumont d'Urville's last voyage through the Pacific, between 1837 and 1840.[20] These moulds, equivalent to a negative or matrix, were then taken back to Paris, where they were turned into plaster three-dimensional positive impressions and photographed. Bisson's daguerreotypes of these impressions are usually dated to about 1841–42, the same dates given to his surviving photographs of skulls of Polynesians plundered from graves by the Dumont expedition. Published between 1842 and 1847, the lithographs after Bisson's daguerreotypes show pairs of named individuals who have been captured for posterity as if in a perpetual state of peaceful slumber, a consequence of the life-casting process. Photographed in three-quarter view, they are presented as both portraits and ethnographic exemplars.

Kilburn's series seems to have been motivated by commerce rather than science, with the photographer having to offer bribes to get his subjects into his studio; strikingly, none of them consented to come a second time. These daguerreotypes were likely taken to certify native Australia's presumed otherness, pictured for the perusal of curious European eyes precisely because Aboriginal people were thought to represent everything civilised people were not. Kilburn's pictures show their subjects in contemporary dress – a mixture of animal skins, European blankets, ornaments and scarification, along with wooden boomerangs and digging sticks. They speak, therefore, of the complex situation of these people in 1847, forced to negotiate a new world of cameras, pastoral leases, rapid urbanisation and unfamiliar European customs – among them, the ethnographic portrait and systematic genocide. Daguerreotypes are unique and relatively fragile objects, but as Isobel Crombie has documented, these particular examples were frequently disseminated in other media, thus enjoying a significant afterlife and wide dispersal.[21] They appeared, for example, as wood engravings in foreign publications, first in a book about Australia published in 1848 in Edinburgh (where there has been a sex-change engineered for one of the figures) and then, in a further translation of this first engraving, in a Danish magazine in 1849. In 1851, illustrations after these daguerreotypes even found their way into a journal devoted to 'religion, science and general intelligence' in India.[22]

But these daguerreotype images perhaps found their widest audience when a number of them were reproduced as wood engravings in an 1850 issue of the *Illustrated London News* (published on 26 January), with an accompanying text that expressed the usual racial prejudices of the time.[23] This is how most residents of Australia would have seen these photographic images, as engravings rather than daguerreotypes, and at the end of a temporal, spatial and representational arc that took them from Melbourne to Scotland, Denmark, London and India, and then back again to Australia, via the pages of imported copies of this popular English newspaper. The fate of these particular images highlights what this new hybrid medium of photographic engraving transmitted throughout modern culture, a continual splicing of real and copy, here and there, us and them, time and space – in short, a disintegration of all those oppositional boundaries that too many of our histories of photography continue to maintain and defend.

Even the most cursory examination of the relationship of Australia and the photograph up until about 1850 reveals that we need to abandon the illusion that the word 'photography' encompasses no more than the collectivity of extant photographs. Or that the word 'Australian' refers only to things that occur within that nation-state's geographic boundaries. Why not emphasise instead the reproducibility and mobility of the photographic image and the permeability of those boundaries? On a purely pragmatic level, an emphasis on this kind of mobility in our histories of Australian photography would allow us to incorporate numerous images that exist today only in other media, or that survive only as textual references. This emphasis would also ensure that future histories of Australian photography fall into sync with the political economy of their subject, tying the fate of the photograph to the processes and social implications of both capitalism and colonialism.[24] Most significantly, our supposed object of interest – photography – is revealed as a disconcertingly schizophrenic entity, a non-medium-specific apparition detached from, even while it remains inextricably tied to, the photograph itself. Photography, in other words, is best regarded as incorporating both the photograph, a material object, and the photographic image, its immaterial double. Not easily exhibited and of no great value in the marketplace, doubly displaced from its origins (which it nevertheless haunts as a ubiquitous presence), crossing borders without restraint, rejected or ignored by our culture's authority figures (including by photography's historians) – this virtual entity, the itinerant ghost that is the photographic image, is, in every sense, photography's *refugee*.

The question is, can we dare to give that refugee the home it deserves? Can we devise a history for Australian photography built around the logic of immigration and dissemination? Can we abandon the familiar safety of the nation-state and allow the structure of our histories to emulate the dynamic flow back and forth across borders that has always characterised Australian life and culture? These, I believe, are the questions about Australia and the photograph we now need to be asking ourselves.

1. See Geoffrey Batchen, 'Photography and nation', *Art Bulletin*, vol 93, no 4, December 2011, pp 497–501; and Geoffrey Batchen, '*Dutch Eyes*: review', *Photography & Culture*, vol 1, no 1, July 2008, pp 119–124.

2. For more on this desire, see Geoffrey Batchen, *Burning with desire: the conception of photography*, The MIT Press, Cambridge, MA, 1997.

3. William Henry Fox Talbot, 'Some account of the art of photogenic drawing, or, the process by which natural objects may be made to delineate themselves without the aid of the artist's pencil' (1839) in Beaumont Newhall (ed), *Photography: essays and images*, Museum of Modern Art, New York, NY, 1980, pp 23–31.

4. Ross Gibson, *The diminishing paradise: changing literary perceptions of Australia*, Angus & Robertson, Sydney, 1984, p 17.

5. See *The Mirror of Literature, Amusement, and Instruction*, no 945, 20 Apr 1839.

6. Conrad Martens, *Notes on painting: a commonplace book on technique with an extract catalogue of paintings commissioned*, 1835–1856, DLMS 142, Mitchell Library, State Library of New South Wales, pp 16–19. The entry is dated circa 5 Aug 1840.

7. William Buckland to John Franklin, quoted in Alan Davies and Peter Stanbury, *The mechanical eye in Australia: photography 1841–1900*, Oxford University Press, Melbourne, 1985, p 6. See also Gael Newton, *Shades of light: photography and Australia 1839–1988*, Australian National Gallery, Canberra & Collins, Sydney, 1988, pp 2–3. Having been lithographed by A Friedel, these images appeared as LL Boscawen Ibbetson, *Fossils, engraved on a daguerreotype plate … with the apparatus at the Polytechnic Institution*, in *The Westminster Review*, London, vol 34, no 2, Sep 1840, pp 460–61.

8. See *Colonist*, 1 June 1839, p 4; 'New discovery – drawing by solar light', *The Launceston* Advertiser, 19 Sep 1839, p 1; 'The daguerreotype', *Colonist*, 18 Jan 1840, p 4; and 'Cape of Good Hope', *Hobart Town Courier and Van Diemen's Land Gazette*, 27 Mar 1840, p 3.

9. See the report in *Sydney Morning Herald*, 13 Feb 1849, p 4. Thanks to Alan Davies for this reference.

10. See 'Stuffed cats – from Wirtemburg – from a daguerreotype by Claudet', *Illustrated London News*, 26 July 1851, p 133; and 'Distinguished jurors and celebrities of the great exhibition', *Illustrated London News*, 25 Oct 1851, p 536.

11. Of course this flow went in both directions, with Australia's colonists no doubt sending many photographs back to friends and family members in Europe. As Helen Ennis has remarked, 'it is therefore possible to imagine a future in which histories of early photography in Australia will be written in England, Wales, Scotland and Ireland rather than in Sydney, Hobart, Melbourne and Adelaide'. Helen Ennis, *Photography and Australia*, Reaktion Books, London, 2007, p 14.

12. See *Australian*, 15 May 1841, as quoted in Newton 1988, p 5.

13. George Goodman, 'Photographic portraits', *Australian*, 9 Dec 1842, as reproduced in Davies and Stanbury 1985, p 123.

14. For more details of Beard's career, see Bernard V Heathcote & Pauline F Heathcote, 'Richard Beard: an ingenious and enterprising patentee', *History of Photography*, vol 2, no 4, Oct 1979, pp 313–29; and Bernard V Heathcote & Pauline F Heathcote, *A faithful likeness: the first photographic portrait studios in the British Isles 1841 to 1855*, Bernard and Pauline Heathcote, Lowdham, 2002.

15. Advertisement, *Times*, 19 Apr 1842, p 5.

16. Richard Beard, Royal Letters Patent No. 8546, 13 June 1840.

17. *Sydney Morning Herald*, 4 May 1846, as quoted in Davies and Stanbury 1985, p 8.

18. On Goodman's career, see Jack Cato, *The story of the camera in Australia*, Georgian House, Melbourne, 1955, pp 4–5; Newton 1988, pp 6–9, p 174; and Sandy Barrie, 'GB Goodman, Australia's first daguerreotypist', *Daguerreian Annual*, 1995, pp 173–78. The advertisement mentioned is headed 'Coloured Daguerreotypes!!!', and appeared in *Sydney Morning Herald*, 28 Nov 1844, p 3.

19. Alexander Simon Wolcott and John Johnson, Royal Letters Patent No. 9672, issued on 18 Mar 1843.

20. For more on these life-casts, see Fiona Pardington, *The pressure of sunlight falling*, Otago University Press, Dunedin, 2011.

21. Isobel Crombie, 'Australia Felix: Douglas T Kilburn's daguerreotype portraits of Australian Koories, 1847', *Daguerreian Annual*, 2004, pp 34–46.

22. These publications included William Westgarth, *Australia Felix*, Edinburgh, 1848; *Nordisk Penning-Magazin*, 3 Mar 1849; and *The Orunudoi*, India 1851. Thanks to Gael Newton for this last reference.

23. Unknown, 'Australia Felix', *Illustrated London News*, 26 Jan 1850, p 53.

24. As Ennis has argued, 'colonial photography therefore calls for a different approach that admits the centrality of colonialism in determining the nature of photographic production, and colonisation itself as the primary contextualising factor'. Helen Ennis, 'Other histories: photography and Australia', *Journal of Art Historiography*, no 4, June 2011, p 11.

Addison, Jon, Daniel Quilliam, Nic Haygarth et al. *Into the wild: wilderness photography in Tasmania*, Queen Victoria Museum & Art Gallery, Launceston, Tas, 2013

Aird, Michael. *Portraits of our elders*, Queensland Museum, South Brisbane, 1993

Aird, Michael. 'Growing up with Aborigines', in Christopher Pinney, Nicolas Peterson (eds), *Photography's other histories*, Duke University Press, Durham, NC, 2004, pp 24–39

Aird, Michael. 'Defining who we are', in Djon Mundine (ed) *Sunshine state, smart state*, Campbelltown Arts Centre, Campbelltown, NSW, 2007

Annear, Judy (ed). *Portraits of Oceania*, Art Gallery of New South Wales, Sydney, 1997

Annear, Judy (ed). *Photography: Art Gallery of New South Wales collection*, Art Gallery of New South Wales, Sydney, 2007

Annear, Judy. *Photography & place: Australian landscape photography 1970s until now*, Art Gallery of New South Wales, Sydney, 2011

Annear, Judy & Ewen McDonald (eds). *What is this thing called photography? Australian photography 1975–1985*, Pluto Press, Sydney, 2000

Australian Archives and the Public Record Office of Victoria. *'My heart is breaking': A joint guide to records about Aboriginal people in the Public Record Office of Victoria and the Australian Archives, Victorian Regional Office*, AGPS, Canberra, 1997

Australian Dictionary of Biography, National Centre of Biography, Australian National University, adb.anu.edu.au

Baldwin, Gordon. *Looking at photographs: a guide to technical terms*, J Paul Getty Museum, Malibu/ British Museum Press, London, 1991

Bancel, Nicolas, Pascal Blanchard, Gilles Boëtsch et al (eds). *Human zoos: from the Hottentot Venus to reality shows*, Liverpool University Press, Liverpool, 2009

Barker, Geoffrey. '"Carte du Ciel": Sydney Observatory's role in the international project to photograph the heavens', *History of Photography*, vol 33, no 4, 2009, pp 346–53

Barrie, Sandy. *Australians behind the camera: directory of early Australian photographers 1841 to 1945*, S Barrie, Sydney South, NSW, 2002

Batchen, Geoffrey. *Burning with desire: the conception of photography*, The MIT Press, Cambridge, MA, 1997

Batchen, Geoffrey. *Each wild idea: writing, photography, history*, The MIT Press, Cambridge, MA, 2001

Batchen, Geoffrey. 'Book review: Dutch eyes: a critical history of photography in the Netherlands', in *Photography & Culture*, vol 1, issue 1, July 2008, pp 119–24

Batchen, Geoffrey. 'Dreams of ordinary life: cartes-de-visite and the bourgeois imagination' in JJ Long, Andrea Noble & Edward Welch (eds), *Photography: theoretical snapshots*, Routledge, London, 2009, pp 80–97

Batchen, Geoffrey. '1. Dissemination'; '2. "Form is henceforth divorced from matter."'; '5. A subject for, a history about, photography', 15 Sept, 23 Sept, 17 Oct, 2012, Fotomuseum Winterthur, blog.fotomuseum.ch/ author/geoffrey-batchen, accessed 26 May 2014

Barnard, Edwin. *Exiled: the Port Arthur convict photographs*, National Library of Australia, Canberra, 2010

Batty, Philip, Lindy Allen & John Morton (eds). *The photographs of Baldwin Spencer*, The Miegunyah Press, Melbourne, 2005

Bean, CEW. *Gallipoli mission*, ABC Books, Sydney, 1990

Best, Susan. 'Witnessing and untimely images: Anne Ferran's "Lost to worlds"', *History of Photography*, vol 36, no 3, 2012, pp 326–36

Bhathal, Ragbir. *Australian astronomers: achievements at the frontiers of astronomy*, National Library of Australia, Canberra, 1996

Bonyhady, Tim. *The colonial earth*, The Miegunyah Press, Melbourne, 2000

Braithwaite, Sari, Tom Gara & Jane Lydon. 'From Moorundie to Buckingham Palace: images of "King" Tenberry and his son

Warrulan, 1845–55', *Journal of Australian Studies*, vol 35, no 2, 2011, pp 165–84

Briggs, Maxine, Jane Lydon & Madeleine Say. 'Collaborating: photographs of Koories in the State Library of Victoria', *The La Trobe Journal*, Melbourne, no 85, 2010, pp 106–24

Buckland, Francis T. *Curiosities of natural history*, vol 2, Richard Bentley, London 1868

Bunbury, Alisa. *The photography of HH Tilbrook: South Australia at the turn of the century*, Art Gallery of South Australia, Adelaide, 2001

Burgess, CH. 'The Spurling legacy and the emergence of wilderness photography in Tasmania', PhD thesis, University of Tasmania School of History and Classics, Tasmania, 2010

Burke, Keast. *Gold & silver: photographs of Australian goldfields from the Holtermann collection*, Penguin Books, Melbourne, 1977

Butler, Rex & Morgan Thomas. 'Tracey Moffatt: from something singular … to something more', *eyeline 45*, autumn/winter 2001, pp 23–31

Carew, Jennifer. 'Richard Daintree: photographs as history', *History of Photography*, vol 23, no 2, 1999, pp 157–62

Carter, Paul. 'Invisible journeys: exploration and photography in Australia 1839–1889', in Paul Foss (ed), *Island in the stream: myths of place in Australian culture*, Pluto Press, Sydney, 1988

Cato, Jack. *The story of the camera in Australia*, Georgian House, Melbourne, 1955

Cooper, Carol. 'Early photographs of Aborigines in the picture collection', *The La Trobe Journal*, no 43, autumn 1989, pp 33–35

Couchman, Sophie. 'Making the "last Chinaman": photography and Chinese as a "vanishing" people in Australia's rural local histories', *Australian Historical Studies*, vol 42, no 1, pp 78–91

Cowley, Des & Marg McCormack (eds). 'Victoria at the great exhibitions 1851–1900', *La Trobe Library Journal*, vol 14, no 56, spring 1995

Croft, Brenda L. *Michael Riley: sights unseen*, National Gallery of Australia, Canberra, 2006

Croft, Brenda L with Janda Gooding. *South west central: Indigenous art from south Western Australia 1833–2002*, Art Gallery of Western Australia, Perth, 2003

Crombie, Isobel. 'The sorcerer's machine: a photographic portrait by Douglas T Kilburn, 1847', *Art Bulletin of Victoria*, no 40, 1999, pp 7–12

Crombie, Isobel. 'Australia Felix: Douglas T Kilburn's daguerreotype portraits of Australian Kooris, 1847', in *The Daguerrian annual*, Cecil, PA, 2004, pp 35–46

Crombie, Isobel. *Body culture: Max Dupain, photography and Australian culture, 1919-1939*, Peleus Press, Mulgrave, Vic, 2004

Crombie, Isobel. *Fred Kruger: intimate landscapes*, National Gallery of Victoria, Melbourne, 2012

Crombie, Isobel & Susan van Wyk. *Second sight: Australian photography in the National Gallery of Victoria*, National Gallery of Victoria, Melbourne, 2002

Cross, Karen & Julia Peck. 'Editorial: special issue on photography, archive and memory', *Photographies*, vol 3, no 2, 2010, pp 127–38

Darian-Smith, Kate, Richard Gillespie, Caroline Jordan et al (eds). *Seize the day: exhibitions, Australia and the world*, Monash University ePress, Melbourne, 2008

Davidson, Kathleen. 'Exchanging views: empire, photography and the visualisation of natural history in the Victorian era', PhD thesis, University of Sydney, Department of Art History and Film Studies, Sydney, 2011

Davidson, Kathleen. 'Photography and the triumph of science in *European vision and the South Pacific*', paper presented at Legacies of Bernard Smith symposium, University of Melbourne & Art Gallery of New South Wales, 2012

Davies, Alan. *An eye for photography: the camera in Australia*, Melbourne University Press, Melbourne, 2004

Davies, Alan. *The greatest wonder of the world*, State Library of New South Wales, Sydney, 2013

Davies, Alan & Peter Stanbury. *The mechanical eye in Australia: photography 1841–1900*, Oxford University Press, Melbourne, 1985

Davis, Keith F & David Stephenson. *Stars*, Space + Light Editions, Fern Tree, Tas, 1999

De Lorenzo, Catherine. 'In and out of register: images, designs and the Garden Palace', in Peter Proudfoot, Roslyn Maguire, Robert Freestone (eds), *Colonial city, global city*, The Crossing Press, Sydney, 2000, pp 169–88

De Lorenzo, Catherine. 'Framing exchange: French images of Australian Aborigines, 1878–1885', paper presented at Migration and Exchange Symposium: Early Australian Photography, University of Melbourne, 29–30 Nov 2012

De Zegher, Catherine (ed). *Here art grows on trees: Simryn Gill*, Australia Council for the Arts, Sydney & MER Paper Kunsthalle, Gent, 2013

Design and Art Australia Online, University of New South Wales, daao.org.au

Donaldson, Ian & Tamsin Donaldson (eds). *Seeing the first Australians*, Allen & Unwin, Sydney, NSW, 1985

Downer, Christine. 'Portfolios for the curious: photographic collecting by the Melbourne Public Library 1859–1870', in Ann Galbally et al (eds), *The first collections: the Public Library and the National Gallery of Victoria in the 1850s and 1860s*, The University of Melbourne Museum of Art, 1992, pp 73–79

Downer, Christine & Jennifer Phipps. *Charles Norton: a squatter artist in Australia Felix 1842–1872*, State Library of Victoria, Melbourne, 1992

Dowson, John. *Old Fremantle: photographs 1850–1950*, University of Western Australia Press, Fremantle, WA, 2004

Dowson, John. *Old Albany: photographs 1850–1950*, National Trust of Western Australia, Perth, 2008

Dunbar, Diane (ed). *Thomas Bock: convict engraver, society portraitist*, Queen Victoria Museum & Art Gallery, Launceston & Australian National Gallery, Canberra, 1991

Edwards, Elizabeth. *Raw histories: photographs, anthropology and museums*, Berg, Oxford & New York, 2001

Edwards, Elizabeth. 'Evolving images: photography, race and popular Darwinism', in Diana Donald, Jane

Munro (eds), *Endless forms: Charles Darwin, natural science and the visual arts*, Yale University Press, New Haven, CT, 2009, pp 167–93

Ennis, Helen. *Olive Cotton*, Art Gallery of New South Wales, Sydney, 2000

Ennis, Helen. *Man with a camera: Frank Hurley overseas*, National Library of Australia, Canberra, 2002

Ennis, Helen. *In a new light: Australian photography 1850s–1930s*, National Library of Australia, Canberra, 2003

Ennis, Helen. *Intersections*, National Library of Australia, Canberra, 2004

Ennis, Helen. *Photography and Australia*, Reaktion Books, London, 2007

Ennis, Helen. *A modern vision: Charles Bayliss, photographer 1850–1897*, National Library of Australia, Canberra, 2008

Ennis, Helen. 'Other histories: photography and Australia', *Journal of Art Historiography*, no 4, June 2011, pp 1–15

Ennis, Helen & Geoffrey Batchen. *Mirror with a memory: photographic portraiture in Australia*, National Portrait Gallery, Canberra, 2000

Ennis, Helen & Sally McInerney. *Olive Cotton: photographer*, National Library of Australia, Canberra, 2004

Fauchery, Antoine. *Letters from a miner in Australia* (trans AR Chisholm), Georgian House, Melbourne, 1969

Ferran, Anne. 'Empty', in Helen Ennis (ed), *Photofile 66*, Australian Centre for Photography, Sydney, Sept 2002, pp 4–9

Finch, Maggie. *Sue Ford*, National Gallery of Victoria, Melbourne, 2014

Fox, Paul. *Geelong on exhibition: a photographic image*, Geelong Art Gallery, Geelong, 1987

Fox, Paul. 'The Intercolonial Exhibition (1866): representing the colony of Victoria', *History of Photography*, vol 23, no 2, 1999, pp 174–80

Fraser, Virginia. 'To the person who said feminism is over as though she was right', *Art Monthly Australia*, no 250, June 2012, pp 34–38

Freeman, James. 'On the progress of photography and its application to the arts and sciences', *Sydney

Magazine of Science and Art*, vol 2, Jan–Feb 1869, pp 136–41

Gammage, Bill. *The biggest estate on earth: how Aborigines made Australia*, Allen & Unwin, Sydney, 2011

Garnons-Williams, Victoria. 'JW Lindt's Colonial man and Aborigine image from the Grafton album', paper presented at Migration and Exchange Symposium: Early Australian Photography, University of Melbourne, 29–30 Nov 2012

Gillespie, Richard. *The great Melbourne telescope*, Museum Victoria, Melbourne, 2011

Goldswain, Philip & William Taylor. *An everyday transience: the urban imaginary of goldfields photographer John Joseph Dwyer*, University of Western Australia Publishing, Crawley, WA, 2010

Gooding, Janda, *Gallipoli revisited: in the footsteps of Charles Bean and the Australian Historical Mission*, Hardie Grant, Melbourne, 2009

Grace, Helen. 'The conquest of darkness: photography, the metropolis and the colony', PhD thesis, University of Sydney, 1992

Grace, Helen. *Culture, aesthetics and affect in ubiquitous media: the prosaic image*, Routledge, London & New York, 2014

Groom, Amelia (ed). *Time: documents of contemporary art*, Whitechapel Gallery, London & The MIT Press, Cambridge, MA, 2013

Haebich, Anna, 'Unpacking stories from the New Norcia photographic collection', *New Norcia Studies*, vol 17, 2009, pp 55–62

Hall, Barbara & Jenni Mather. *Australian women photographers 1840–1960*, Greenhouse Publications, Richmond, Vic, 1986

Harding, Alan, 'JP Campbell: pictorialist photographer at home and at war', PhD thesis, Monash University, Vic, 2010

Hart, Ludovico. 'An apology for the introduction of the study of photography in our schools of art and science', *Journal and Proceedings of the Royal Society of New South Wales*, vol 12, 1878, pp 269–80

Hart, Ludovico. 'Photography – its relation to popular education', *Journal and Proceedings of the Royal Society of New South Wales*, vol 13, 1879, pp 87–94

Haygarth, Nic. *Booming Tasmania: how the Anson/Beattie photographic studio sold the island and itself 1880–1901*, N Haygarth, Perth, Tas, 2008

Haygarth, Nic. *The wild ride: revolutions that shaped Tasmanian black-and-white wilderness photography*, National Trust of Australia (Tasmania), Launceston, Tas, 2008

Haynes, Raymond, Roslynn Haynes, David Malin & Richard McGee, *Explorers of the southern sky: a history of Australian astronomy*, Cambridge University Press, Cambridge, UK, 1996

Haynes, Roslynn. *Tasmanian visions: landscapes in writing, art and photography*, Polymath Press, Sandy Bay, Tas, 2006

Hays, Leigh. *Worth telling, worth keeping: a guide to the collections of the JS Battye library of West Australian history*, State Library of Western Australia, Perth, 2002

Hoffenberg, Peter H. *An empire on display: English, Indian and Australian exhibitions from the Crystal Palace to the Great War*, University of California Press, Berkeley, CA & London, 2001

Holden, Robert. *Photography in colonial Australia: the mechanical eye and the illustrated book*, Hordern House, Sydney, 1988

Horne, Julia. *The pursuit of wonder: how Australia's landscape was explored, nature discovered and tourism unleashed*, The Miegunyah Press, Melbourne, 2005

Hughes, PJ, JK Huxley, CD Judd, GK Walker-Smith et al (eds). *Collection*, Tasmanian Museum and Art Gallery, Hobart, 2007

Hughes-d'Aeth, Tony. *Paper nation: the story of the picturesque atlas of Australasia 1886–1888*, Melbourne University Press, Melbourne, 2001

Johnson, Felicity. *Anne Ferran: shadow land*, Lawrence Wilson Art Gallery, Perth, 2014

Jolly, Martyn. 'What makes the lantern slide experience distinctive from other media experiences?', paper presented at National Film and Sound Archive, Canberra, 2011

Jolly, Martyn. 'Disinfected Sydney: the panoramic, the evidential and the picturesque: the idea of Atget and archival delirium in Australian photography', paper presented

at Cities in Transition symposium, Art Gallery of New South Wales, Sydney, 25 Aug 2012

Jolly, Martyn. 'An Australian spiritualist's personal carte-de-visite album', paper presented at Migration and Exchange Symposium: Early Australian Photography, University of Melbourne, 29–30 Nov 2012

Jolly, Martyn. 'Exposing the Australians: Australiana photobooks of the 1960s', *History of Photography*, vol 38, issue 3, 2014

Jolly, Martyn. '"Who and what we saw at the antipodes" – who and what?', paper presented at the National Gallery of Australia, Canberra, c1983 martynjolly. com/2013/10/02/unpublished-manuscript-for-a-talk-on-the-album-who-and-what-we-saw-at-the-antipodes-in-the-collection-of-the-national-gallery-of-australia-written-circa-1983-no-citations-c1983/, accessed 22 October 2014

Jones, Philip. *The policeman's eye: the frontier photography of Paul Foelsche*, South Australian Museum, Adelaide, 2005

Jones, Philip. *Images of the interior: seven central Australian photographers*, Wakefield Press, Adelaide, 2011

Judd, Barry. '"It's not cricket": Victorian Aboriginal cricket at Coranderrk', *The La Trobe Journal*, no 85, May 2010, pp 37–54

Judd, Craig. *Anne Ferran: the ground, the air*, Tasmanian Museum & Art Gallery, Hobart, 2009

Kaus, David. *A different time: the expedition photographs of Herbert Basedow 1903–1928*, National Museum of Australia Press, Canberra, 2008

Keller, Corey (ed). *Brought to light: photography and the invisible 1840–1900*, San Francisco Museum of Modern Art, CA & Yale University Press, New Haven, CT, 2008

Kelly, Max. *Faces of the street: William Street, Sydney, 1916*, Doak Press, Sydney, 1982

Kerr, Joan. *The dictionary of Australian artists: painters, sketchers, photographers and engravers to 1870*, Oxford University Press, Melbourne, 1992

Kerr, Joan (ed). *Heritage: the national women's art book, 500 works by 500 Australian women artists from colonial times to 1955*, Art and Australia, Sydney, 1995

Kerr, John Hunter. *Glimpses of life in Victoria by 'a resident'*, The Miegunyah Press, Melbourne, 1996

King, Natalie (ed). *Up close: Carol Jerrems with Larry Clark, Nan Goldin and William Yang*, Schwartz Media, Melbourne, 2010

Kundera, Milan. 'Part 8: Paths in the fog', in his *Testaments betrayed: an essay in nine parts* (trans Linda Asher), Harper Collins, New York, 1995, pp 237–38

Lakin, Shaune. *Contact: photographs from the Australian War Memorial Collection*, Australian War Memorial, Canberra, 2006

Lendon, Nigel. 'Ashton, Roberts and Bayliss: some relationships between illustration, painting and photography in the late nineteenth century', in Anthony Bradley, Terry Smith (eds), *Australian art and architecture: essays presented to Bernard Smith*, Oxford University Press, Melbourne, 1980, pp 71–82, and 238–39

Long, Chris. *Tasmanian photographers 1840–1940: a directory*, Tasmanian Historical Research Association & Tasmanian Museum and Art Gallery, Hobart, 1995

Long, Chris. *Worth taking and keeping: Tasmanian photography to 1914*, Queen Victoria Museum & Art Gallery, Launceston, Tas, 1996

Lydon, Jane. *Eye contact: photographing Indigenous Australians*, Duke University Press, Durham, NC & London, 2005

Lydon, Jane. '"Watched over by the indefatigable Moravian missionaries": colonialism and photography at Ebenezer and Ramahyuck', *The La Trobe Journal*, no 76, 2005, pp 27–48

Lydon, Jane. 'Return: the photographic archive and technologies of Indigenous memory', *Photographies*, vol 3, no 2, 2010, pp 173–87

Lydon, Jane. *The flash of recognition: photography and the emergence of Indigenous rights*, NewSouth Publishing, Sydney, 2012

Lydon, Jane. 'The interesting couple: Simon Wonga in 1857', paper presented at Migration and Exchange Symposium: Early Australian Photography, University of Melbourne, 29–30 Nov 2012

Lydon, Jane (ed). *Calling the shots: Aboriginal photographies*, Aboriginal Studies Press, Canberra, 2014

Lydon, Jane & Sari Braithwaite. '"Cheque shirts and plaid trowsers": photographing Poonindie Mission, South Australia', *Journal of the Anthropological Society of South Australia*, vol 37, 2013, pp 1–30

Magee, Karen. 'Selling the colonial dream: photographs from the 1869 Northern Territory survey expedition', paper presented at Migration and Exchange Symposium: Early Australian Photography, University of Melbourne, 29–30 Nov 2012

Marsh, Anne. *Look: contemporary Australian photography since 1980*, Macmillan Art Publishing, Melbourne, 2010

Maxwell, Anne. *Colonial photography & exhibitions: representations of the 'native' and the making of European identities*, Leicester University Press, London, 2000

Maxwell, Anne. 'White/Aboriginal relations on the colonial frontier: reading the anthropometric photographs of Paul Foelsche', in David Callahan (ed). *Australia, who cares?*, Network Books, Perth, 2007

Maxwell, Anne. *Picture imperfect: photography and eugenics 1870–1940*, Sussex Academic Press, Brighton, UK, 2008

McAuliffe, Chris. *Live fast, die young and have a good-looking corpse: interdisciplinarity in portraits of the Kelly gang*, paper delivered at the Art Association of Australia and New Zealand conference, Melbourne, 8 Dec 2013

McBean, Jude (ed). *The John William Lindt collection*, Grafton Regional Gallery, Grafton, NSW, 2005

McBean, Jude (ed). *Dreaming the past: the Lindt story*, Grafton Regional Gallery, Grafton, NSW, 2012

McFarlane, Kyla (ed). *Photographer unknown*, Monash University Museum of Art, Melbourne, 2009

McGregor, Alasdair. *Frank Hurley: a photographer's life*, Viking Books, Melbourne, 2004

McPhee, John. 'The artist photographer and the work of the Rev John Dixon', *Australiana*, vol 29, no 3, 2007, pp 4–7

McPhee, John. *The painted portrait photograph in Tasmania: 1850–1900*, Queen Victoria Museum & Art Gallery, Launceston, Tas, 2007

Miles, Melissa. 'Out of the shadows: on light, darkness and race in Australian photography', *History of Photography*, vol 36, no 3, 2012, pp 337–52

Miles, Melissa. 'Review: The flash of recognition: photography and the emergence of Indigenous rights', *History of Photography*, vol 38, no 1, 2014, pp 96–98

Moffatt, Tracey. *In dreams: Mervyn Bishop, thirty years of photography 1960–1990*, Australian Centre for Photography, Sydney, 1991

Moffatt, Tracey & Elizabeth Ann Macgregor. *Tracey Moffatt*, Museum of Contemporary Art, Sydney, 2003

Morrison, Ian. 'Boom-town picturesque: CB Walker's photographs of Melbourne', *Script & Print: Bulletin of the Bibliographical Society of Australia & New Zealand*, vol 29, 2005, pp 234–46

Morton, John. 'Seeing eye to eye: photography and the return of the native in Aboriginal Australia', *Arena Journal*, no 27, 2006, pp 47–59

Mundy, Godfrey Charles. *Our Antipodes: or, residence and rambles in the Australian colonies with a glimpse of the gold fields*, vol II, Richard Bentley, London, 1852

Munro, Keith. *Ricky Maynard: portrait of a distant land*, Museum of Contemporary Art, Sydney, 2010

Neville, Richard. *Faces of Australia: image, reality and the portrait*, State Library of New South Wales Press, Sydney, 1992

Newton, Gael. *Max Dupain*, The David Ell Press, Sydney, 1980

Newton, Gael. *Axel Poignant: photographs 1922–1980*, Art Gallery of New South Wales, Sydney, 1982

Newton, Gael. *Shades of light: photography and Australia 1839–1988*, Australian National Gallery, Canberra and Collins Australia, Sydney, 1988

Newton, Gael. *The spread of time: the photography of David Moore*, National Gallery of Australia, Canberra, 2003

Newton, Gael. 'RA Cunningham's Australian Aboriginal international touring company and JW Lindt: Coontajandra and Sanginguble, Central Australian Aboriginals', *artonview*, no 45, Autumn 2006, pp 42–43

Orchard, Ken. 'JW Lindt's *Characteristic Australian Forest Scenery* (1875), and the construction

of an emblematic Australian landscape', paper presented at Migration and Exchange Symposium: Early Australian Photography, University of Melbourne, 29–30 Nov 2012

Orchiston, Wayne. 'From research to recreation: the rise and fall of Sydney Observatory', *Vistas in Astronomy*, no 32, 1988, pp 49–63

Orchiston, Wayne. 'Illuminating incidents in Antipodean astronomy: Philip Parker King and the founding of Sydney Observatory', *Vistas in Astronomy*, no 32, 1988, pp 285–301

Orchiston, Wayne. 'James Cook's 1769 transit of Venus expedition to Tahiti', in DW Kurtz (ed), *Transits of Venus: new views of the solar system and galaxy, Proceedings of IAU Colloquium* 196, 2004, Cambridge University Press, 2005, pp 52–66

Palmer, Daniel, Kara Rees & Anne Zahalka. *Hall of mirrors: Anne Zahalka portraits 1987–2007*, Centre for Contemporary Photography, Fitzroy, Vic, 2007

Parker, Gilbert. *Round the compass in Australia*, EW Cole, Melbourne, Sydney, Adelaide, 1892

Peck, Julia. 'The making of the Australian landscape: photographic contributions to the construction of a nation from New South Wales and Victoria 1870–1917', PhD thesis, University of Wales, Newport, 2008

Peck, Julia. 'Performing Aboriginality: desiring pre-contact Aboriginality in Victoria, 1886–1901', *History of Photography*, vol 34, no 3, 2010, pp 214–33

Peck, Julia. 'Pulletop and Thornthwaite: photographs of pastoral properties in nineteenth-century New South Wales', *Journal of Australian Studies*, vol 36, no 2, 2012, pp 155–75

Peterson, Nicolas. 'The changing photographic contract: Aborigines and image ethics', in Christopher Pinney, Nicolas Peterson (eds) *Photography's other histories*, Duke University Press, Durham, NC, 2003

Pitkethly, Anne & Don Pitkethly. *NJ Caire: landscape photographer*, Anne & Don Pitkethly, Rosanna, Vic, 1988

Poignant, Roslyn. *Professional savages: captive lives and western spectacle*, Yale University Press, New Haven, CT & London, 2004

Pound, Patrick. *Systematic: toward a theory of everything*, Australia Council, Sydney, 2004

Pound, Patrick. 'Copy-world: *Mobilis in mobile*', in Amelia Barikin & Helen Hughes (eds), *Making worlds: art and science fiction*, Surpllus, Melbourne, 2013, pp 241–53

Powell, Geoffrey. 'Photography – a social weapon', *Contemporary Photography*, vol 1, no 1, 1946, pp 16–17, 60

Quartermaine, Peter. '"Speaking to the eye": painting, photography and the popular illustrated press in Australia, 1850–1900', in Anthony Bradley, Terry Smith (eds), *Australian art and architecture: essays presented to Bernard Smith*, Oxford University Press, Melbourne, 1980, pp 54–70, 237–38

Quartermaine, Peter. 'International exhibitions and emigration: the photographic enterprise of Richard Daintree, Agent General for Queensland 1872–76', *Journal of Australian Studies*, vol 7, no 13, 1983, pp 40–55

Reeder, Warwick. 'The stereograph and the album portrait in colonial Sydney 1859–62', *History of Photography*, vol 23, no 2, summer 1999, pp 181–87

Reilly, Dianne & Jennifer Carew. *Sun pictures of Victoria: the Fauchery–Daintree collection, 1858*, Currey O'Neil Ross on behalf of the Library Council of Victoria, Melbourne, 1983

Richards, Paul AC, Barbara Valentine & Peter Richardson (eds). *Voyages in a caravan: the illustrated logs of Frank Styant Browne*, Launceston Library & Brobok, Launceston, Tas, 2002

Robinson, Julie L. *A century in focus: South Australian photography 1840s–1940s*, Art Gallery of South Australia, Adelaide, 2007

Russell, Henry C. *Photographs of the Milky Way and nubeculae taken at Sydney Observatory, 1890*, Sydney Observatory, Sydney, 1890

Rydell, Robert. *All the world's a fair: visions of empire at American international expositions, 1876–1916*, University of Chicago Press, Chicago, IL, 1984

Rydell, Robert. *World of fairs: the century-of-progress expositions*, University of Chicago Press, Chicago, IL, 1993

Say, Madeleine. 'John Hunter Kerr: photographer', *The La Trobe Journal*, no 76, 2005, pp 71–76

Sayers, Andrew, Carol Cooper. *Aboriginal artists of the nineteenth century*, Oxford University Press, Melbourne, 1994

Smith Jr, Ian, Michael Wardell. *Painting in a library*, Artspace, Mackay, Qld, 2008

Smith, Tim. 'Capturing the dream: the beginnings of photography in the Top End', paper presented at Migration and Exchange Symposium: Early Australian Photography, University of Melbourne, 29–30 Nov 2012

Smith, Tim. *Foelsche*, Michael Graham-Stewart, London, 2014

Solomon-Godeau, Abigail. *Rosemary Laing*, Piper Press, Sydney, 2012

Stacey, Robyn & Peter Timms, *House: imagining the past through the collections of the Historic Houses Trust of New South Wales*, Historic Houses Trust of New South Wales, Sydney, 2011

Stephenson, David. 'Beautiful lies: photography and wilderness', paper presented at Imaging Nature: Media, Environment and Tourism Conference, 27–29 June 2004, Cradle Mountain, Tasmania

Steyerl, Hito. *The wretched of the screen*, Sternberg Press, Berlin, 2012

Tunnicliffe, Wayne. *Simryn Gill: selected work*, Art Gallery of New South Wales, Sydney, 2002

Van Wyk, Susan. *Sublime space: photographs by David Stephenson 1989–1998*, National Gallery of Victoria, Melbourne, 1998

Whittingham, Sarah. *Fern fever: the story of pteridomania*, Frances Lincoln Ltd, London, 2012

Willis, Anne-Marie. *Picturing Australia: a history of photography*, Angus & Robertson, Sydney, 1988

Willis, Anne-Marie. *Illusions of identity: the art of nation*, Hale & Iremonger, Sydney, 1993

Willis, Elizabeth. '"People undergoing great change": John Hunter Kerr's photographs of Indigenous people at Fernyhurst, Victoria, 1850s', *The La Trobe Journal*, no 76, 2005, pp 49–70

Willis, Elizabeth. 'Re-working a photographic archive: John Hunter Kerr's portraits of Kulin people, 1850s–2004', *Journal of Australian Studies*, vol 35, no 2, 2011, pp 235–49

Wilson, Robert. *Great exhibitions: the world fairs 1851–1937*, National Gallery of Victoria, Melbourne, 2007

Wilson, Roger. *Bishop Nixon – drawings*, Runnymede, National Trust of Australia (Tasmania), Hobart, 2002

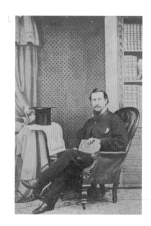

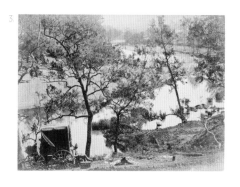

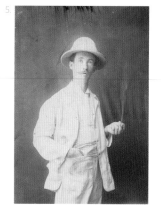

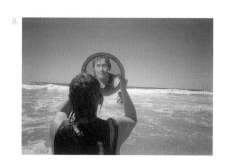

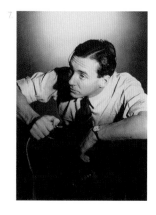

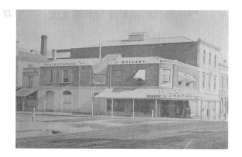

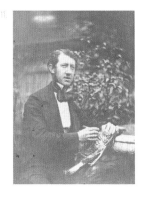

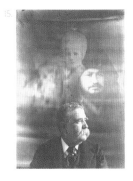

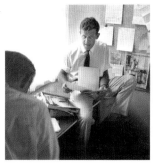

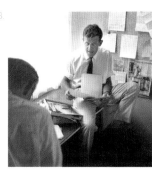

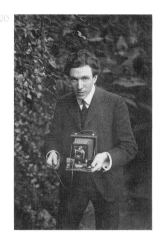

Allport, Morton
1830–78

Morton Allport was a solicitor, naturalist and amateur photographer. He was born in England in 1830 and immigrated to Hobart Town with his family in 1831. Allport started making photographs in 1855. He produced half-plate and stereoscopic images of local scenery, often including members of his family. Like many early amateur photographers, Allport was equally interested in art and science. He had received training in painting and drawing from his mother, Mary Morton Allport (1806–95) and John Skinner Prout (1805–76) and helped to organise exhibitions in Hobart and abroad. In addition, Morton studied Tasmanian botany and zoology, was an active member of the Royal Society of Tasmania, and corresponded with many European scientists.

In 1862–63 he made a photographic expedition to the Lake St Clair region of Tasmania. Using the dry-plate process he captured views of Mount Ida without having to set up a darkroom on site. Nevertheless, he still had to deal with long shutter times and negotiate both the elements and opportunistic insects. Allport exhibited the stereoscopic views of the Lake St Clair region at the Hobart Town Art Treasures and Industries Exhibition of 1862–63. Examples of his work were published in the *London Stereoscopic Magazine* in 1864.

—

American & Australasian Photographic Company
active c1860s–80s

The American & Australasian Photographic Company (A&A Photographic Company) was established by Henry Beaufoy Merlin in Melbourne. With his assistant **Charles Bayliss**, Merlin commenced an ambitious project to photograph every house and building in Victoria and New South Wales. The aim of this venture was to create an image library of the colonies so that properties could be viewed for investment or insurance purposes. The objective, as presented in the *Sydney Morning Herald* on 21 September 1870, was to promote 'a novel means of social and commercial intercourse'.

An encounter with entrepreneur Bernard Otto Holtermann in the gold-rush town of Hill End in 1872 resulted in another remarkable project: an International Travelling Exposition containing photographs, raw materials, zoological specimens, among others. The centrepiece was to be a mammoth panorama of Sydney necessitating the production of wet-plate negatives of 90 x 160 centimetres, the largest in existence.

Merlin retired as New South Wales manager of A&A Photographic Company in 1872 and died a year later. By then, there were A&A offices in Sydney, Melbourne, Hill End and Gulgong, though not, as the cartes de visite claimed, in San Francisco or New York.

—

Anson Bros
active c1872–91

Anson Bros was a photographic firm based in Hobart. Founded by brothers Joshua, Henry Joseph and Richard Edwin Anson, they took over the premises of **Samuel Clifford**'s former studio and continued his practise of view photography. The initial years of the firm were compromised by the imprisonment of Joshua Anson in 1878 for stealing photographic equipment from his former employer, **Henry Hall Baily**. The firm produced remarkable photographs of Tasmanian scenery which were awarded medals at the 1883–84 Calcutta International Exhibition and the 1888–89 Melbourne Centennial International Exhibition.

—

Baily, Henry Hall
active 1865–1918

Henry Hall Baily was a Tasmanian-born professional photographer. He trained at the London School of

Photography in 1861, and on return to Hobart in the mid 1860s established his own firm, advertising vignettes, cartes de visite, and miniature portraits for brooches and lockets.

—

Bardwell, William
active c1859–95

William Bardwell was a professional photographer with a successful business in Ballarat and Melbourne. In Ballarat he formed a partnership with Saul Solomon in 1859 and together they exhibited photographic portraits at the 1862 Geelong Art, Industry and Science Exhibition and the 1863 Ballarat Mechanics' Institute Exhibition of Art and Science. It seems Bardwell was fond of using unusual vantage points: in 1863, the *Argus* reported that he had photographed the ceremony of the laying of the foundation stone of the Burke and Wills memorial in Sturt Street from the roof of the Ballarat Post Office. Bardwell established his own studio in 1866, which included rooms for ladies and gentlemen to prepare themselves for the lens. He showed photographs of Ballarat at the 1870 Metropolitan Intercolonial Exhibition in Sydney (for sale at £6), and 'a photographic panorama of the city of Ballarat', as well as other photographs of its buildings and streets in the Victorian section of London's Third Annual International Exhibition of 1873.

—

Barnes, Henry
active 1859–97

Henry Barnes was a professional photographer based in Sydney. In 1859 he took up a post as a museum assistant and taxidermist at the Australian Museum. Barnes took many official photographs for the museum, including those of the Director, Gerard Krefft, with a large manta ray. To supplement his income, Barnes and his brother Robert ran a sideline in suggestive photographs, which he sold surreptitiously on the museum premises. Barnes's erotic images, impounded by detectives in 1874, featured in the parliamentary enquiry into Krefft's directorship, in which Krefft was found unfit to be a curator and dismissed from the museum under charges of drunkenness and disorderly behaviour. Barnes maintained his employment with the museum, however, and in 1879, with the assistance of EGW Palmer, arranged the Australian Museum's ethnological displays at the Sydney International Exhibition.

—

Batchelder and O'Neill, Batchelder & Co
active 1857–95

The Melbourne companies of PM Batchelder, Batchelder and O'Neill and Batchelder's Portrait Rooms were all connected to the arrival in Australia in 1854 of the entrepreneurial American photographer Perez Mann Batchelder (1818–c1873). Batchelder had made a name for himself on the Californian goldfields, where he set up a mobile 'Daguerreian saloon', replete with skylights and expensive German equipment. Lured to Australia by the commercial prospects of the gold rush, he opened a gallery and studio and was joined in 1856 by his brothers Benjamin, Nathaniel and Freeman. Perez returned to the United States in 1857, the same year Daniel O'Neill was made a partner in the firm.

Freeman Batchelder and Daniel O'Neill ran the outfit as Batchelder and O'Neill until Freeman's accidental death at sea in 1862. They took ambrotype and albumen portraits in a style they claimed 'was surpassed by none in the Colonies'. The pair also offered reproductions of paintings and daguerreotypes and sold cartes de visite of actors and actresses in local theatres, capitalising on the celebrity culture of colonial Melbourne. Batchelder's Portrait Rooms operated as Batchelder & Co, 'Artist Photographers' from 1866 to 1895 under the management of WJ Stubbs.

Bayliss, Charles
1850–97

Charles Bayliss was the most accomplished and innovative landscape photographer in New South Wales in the 1870s and 1880s. He immigrated to Australia with his family from Suffolk in 1854 and began his career as a photographer in the employ of Henry Beaufoy Merlin's **American & Australasian Photographic Company** in 1869. With Merlin he photographed houses and buildings in New South Wales and Victoria. He took over the making of the mammoth panorama of Sydney, along with many other views of the city and environs, for entrepreneur BO Holtermann.

Bayliss developed a keen eye for the composition of landscape views. He also embraced technological developments such as dry-plate processing, wide-angle lenses, and mammoth printing. Bayliss's skills won him prestigious commissions from the government and wealthy property owners. In the 1880s he documented the property of the squatter EA Westbury and photographed Lawrence Hargrave's flying machines and plane models. In 1886 Bayliss accompanied the Lyne Royal Commission into water conservation in New South Wales. Forty photographs were included with the report, but he took hundreds of other dramatic and picturesque views which contribute to a mythology of the bush. Over his successful career Bayliss documented, and was part of, the project of modernity in the colonies.

—

Bean, CEW (Charles Edwin Woodrow)
1879–1968
and Hubert Wilkins
1888–1958

CEW Bean was Australia's official correspondent to and historian of World War I and a driving force behind the establishment of the Australian War Memorial in Canberra. As a correspondent, Bean had accompanied the Australian Imperial Forces (AIF) to Egypt in 1915, and was at Gallipoli on the fateful day of the Anzac landing. In 1919 he led a return mission to Gallipoli to report on the state of the war graves and to resolve lingering uncertainties about the campaign. Bean enlisted the professional photographer Hubert Wilkins to accompany the mission and document the site. With Bean, Wilkins took photographs of the evidence on the ground at Gallipoli, producing images intended to help reconstruct Australia's part in the campaign.

Hubert Wilkins was an experienced war photographer. After working as a cinematographer at the Gaumont Film Company in London from 1908, he was correspondent on the Balkan War for the London *Daily Chronicle* in 1912 and took the first motion pictures from the frontline of a war zone. Returning to Australia in 1917 he was appointed official photographer to the AIF and documented the Passchendaele campaign. He was the only official photographer to be decorated, receiving the Military Cross in 1918.

—

Bear, William
active c1868–82

William Bear was a professional photographer based in Melbourne. Born in London, in the 1860s he was working in the studio of William Insull Burman, Melbourne, and in 1868 he married Burman's daughter, Emily Jane. Bear operated Burman's photographic studios and may have opened his own firm in Geelong in the 1880s.

—

Beattie, JW (John Watt)
1859–1930

John Watt Beattie was born in Aberdeen, Scotland, and immigrated to Van Diemen's Land in 1878. His professional career as a photographer began in the studio of the **Anson Bros** of Hobart where he was

employed in 1882. With Beattie, the Anson studio produced many large-format landscape photographs. They were noted for their images of the Port Arthur penal colony – where both Joshua and Henry Anson had been imprisoned (Joshua for theft of photographic equipment and Henry for drunkenness) – and early settlements on the remote west coast of Tasmania. The work of the studio responded to the rise of tourism in Tasmania, providing dramatic views for locals and visitors. Beattie bought the Anson studio in 1891 along with its negative collection. He made prints from many of the negatives and released them under his own name, the most striking of which are the photographs of Port Arthur shortly after its closure. Beattie also made plates for the Mount Lyell Mining Company, producing a visual record of mining operations.

—

Beavis Brothers
active c1880s–1919

Photographic firm based in Dubbo, Bathurst, Chatswood and Orange, New South Wales.

—

Bishop, Mervyn
1945–

Mervyn Bishop is a documentary photographer and Australia's first Indigenous press photographer. Born and raised in Brewarrina, New South Wales, he practised photography as a teenager with the encouragement of his mother. In 1962 he became a cadet at the *Sydney Morning Herald*. As a press photographer Bishop captured many iconic events and personalities in Sydney in the 1960s, including Roy Orbison and the Rolling Stones in 1965; Barry Humphries as Edna Everage in 1968; and the Pan Am jet crash at Sydney Airport in 1969. In 1971 he won the News Photographer of the Year Award with his front-page photograph, *Life and death dash*.

Bishop worked at the Department of Aboriginal Affairs in Canberra from 1974 and covered major events in Aboriginal communities throughout Australia, including the historic moment in 1975 when Prime Minister Gough Whitlam granted rights to land at Daguragu (Wattle Creek) to the Gurindji people. From 1989 Bishop taught photography at Tranby Aboriginal College in Glebe, Sydney and the Eora Centre TAFE (Technical and Further Education) in Redfern, Sydney. In 2000, Bishop received the Red Ochre Award from the Australia Council in recognition of his pioneering work and lasting influence.

—

Bisson Brothers (les frères Bisson)
active 1852–64

Bisson Brothers was a renowned photographic studio in Paris. Owned by brothers Louis-Auguste Bisson (1814–76) and Auguste Rosalie Bisson (1826–1900), it was initially a portrait studio, but later specialised in architectural photography and reproductions of paintings. In 1841 the firm daguerreotyped the plaster portrait busts of Aboriginal and Torres Strait Islanders made by anatomist and phrenologist Pierre-Marie Alexandre Dumoutier (1797–1871). Dumoutier had accompanied Jules Sébastien César Dumont d'Urville's 1837–40 voyage through the Pacific and the Antarctic Circle. He was commissioned by d'Urville to take life casts of Indigenous people from the various places they visited, to take measurements of skull sizes, document their shapes and, where possible, to acquire actual skulls. Dumoutier made many portrait busts from participants coaxed into sitting in exchange for gifts, including uniform jackets. The daguerreotypes produced by Bisson (made

under the direction of Dumoutier) were subsequently reproduced by the Paris lithographer Leveillé, who specialised in anatomical illustration. The whole process, from life cast to daguerreotype to lithograph, was intended to document and disseminate the discoveries of d'Urville's voyage and to contribute to the racial profiling of the inhabitants of Oceania.

—

Blackwood, William
1824–97

William Blackwood was a successful professional photographer of views and panoramas in Sydney. By 1858 Blackwood had established a photographic studio in East Sydney and commenced photographing streets and buildings in the city using the collodion wet-plate process. These views included the intersection of Bridge and George streets, the site of the first photograph taken in Australia in 1841. The views were not only the largest photographs thus taken, but also described as 'faultless' and 'super-excellent' by the *Sydney Morning Herald*. In the same year Blackwood took a series of photographs of Sydney and its harbour from the roof of Government House, which was combined into a panorama. While not the first panorama of Sydney, it was judged by the press to be superior to one taken by the **Freeman Brothers** two months earlier. Blackwood followed the panorama with an album of views of Sydney's nine banks and photographed the University of Sydney in 1859 at the request of architect Edmund Blacket. Blackwood also introduced the carte de visite to Sydney in 1859, a photographic format that soon became ubiquitous within the colony.

—

Boake, Barcroft Capel
1838–1921

Barcroft Capel Boake was born in Dublin and immigrated to Australia around 1858, spending most of his working life in Sydney. He had a successful photographic business while also working as Captain in the 7th Battery of New South Wales Volunteer Artillery. Boake made portraits and views and is now best known for his monumental mosaic of the returning New South Wales contingent of the Soudan campaign from around 1890 (who had arrived too late to take part in the battle). He also practised in a number of different photographic techniques including the heliograph and the 'instantaneous process'. Despite the fierce competition from other photographic studios in Sydney, Boake maintained a reputation for artistic quality and fineness of execution.

—

Bock, Alfred
1835–1920

Alfred Bock is distinguished as the first known Australian-born photographer. Bock was born in Hobart Town in 1835 to Mary Ann Cameron, née Spencer, who lived with, and eventually married, Thomas Bock. Alfred was given Thomas's surname and regarded him as his natural father. **Thomas Bock** taught Alfred painting, drawing and photography, and he assisted his stepfather in his daguerreotype business until establishing his own studio in 1855. Despite ongoing financial difficulties (he was announced insolvent in 1857 and again in 1865) Bock succeeded in introducing the carte de visite to Hobart in 1861 and became expert in the sennotype process. In addition to his experimentation with photomechanical techniques, he also hand-coloured portraits and experimented with over-painting photographs. Bock showed his work at the London International Exhibition (1873), the Philadelphia Centennial Exhibition (1876), the Sandhurst (Bendigo) Industrial Exhibition (1879), the Adelaide International Exhibition (1887) and the Paris Universal Exhibition (1889), and received several awards.

Bock, Thomas
1790-1855

Thomas Bock was the first professional painter in Tasmania and one of Australia's earliest resident photographers. Born in Warwickshire, Great Britain, he set up an engraving and miniature-painting studio in Birmingham in 1814. In 1823 he was found guilty, along with Mary Day Underhill, of administering drugs to a young woman with the intention of conducting an abortion. He was sentenced to fourteen years transportation to Van Diemen's Land, where he arrived in 1824. His exemplary conduct earned him a pardon in 1832. Bock established a gallery in Hobart in 1831, where he exhibited portraits of wealthy settlers and gave painting lessons. Between 1823 and 1835 he made portraits of Tasmanian Aboriginal people for GA Robinson, missionary and Chief Protector of Aborigines. His initial attempts to establish a photographic business in Hobart in 1843 were stymied by the photographer **George Goodman**, who had just settled in Tasmania after practising in New South Wales. When Bock advertised the imminent opening of a photography studio, Goodman threatened legal action, causing Bock to withdraw. He began taking daguerreotype portraits in 1848, assisted by his stepson, Alfred.
—

Boles, James M
active c1871-73

Professional photographer based in Sydney.
—

Boston, Edwin
active 1880-84

Professional photographer based in Sydney with a studio in Newtown.
—

Boston, Thomas
active 1867-84

Professional photographer based in Sydney and Windsor, New South Wales. He ran the Newtown Portrait Rooms studio from 1867-70 and also worked with **Wykes Norton**, forming the Boston & Norton studio.
—

Boyd, Adolarius Humphrey
1829-91

Adolarius Humphrey Boyd was Commandant of the Port Arthur Penitentiary, sixty kilometres southeast of Hobart, from 1871 to 1874. He was a keen amateur photographer and from 1873 may have worked alongside the professional photographer **Thomas J Nevin** to produce identification photographs of convicts at Port Arthur. A 'photographic house' was reportedly in use at Port Arthur and in 1873 Boyd had photographic chemicals and materials sent to the prison. Photography was introduced into the prison systems in the 1870s as a new way of identifying prisoners and felons. Though made for the purposes of systematic identification, some images of prisoners made by Nevin or Boyd were turned into cartes de visite at the studio of **JW Beattie**.
—

Browne, (Frank) Styant
1854-1938

Styant Browne was a chemist and amateur photographer known for his innovative experiments in photographic technology. Born in England, he arrived in Hobart in 1882 with his wife, Emma Anne Browne (1857-1941). The following year the Brownes moved to Launceston, where he established a homeopathic pharmacy. In 1889 he formed the Northern Tasmanian Camera Club, which held its first meeting in Browne's chemist shop, and of which he remained honorary secretary for twenty years. Browne also sold cameras and photographic equipment and provided a darkroom for paying customers. His interests in photography, though primarily aesthetic, were inseparable from his scientific pursuits. In 1896 he took the first X-rays in Tasmania. The following year he experimented with early forms of three-colour photography, which may have been achieved through tinting and toning, and by 1905 was producing some of the first colour photographs to be made in Australia. His innovations were widely acknowledged and he received many awards in Australia and overseas, including a silver medal from the Royal Photographic Society of India and a silver medal for his autochrome photography at the Franco-British Exhibition in London in 1908.
—

Browne, Thomas
1816-70

Thomas Browne was a professional photographer, lithographer and stationer. Born in London, he immigrated to Van Diemen's Land around 1835, settling in Launceston. Browne initially managed Henry Dowling's printing and stationery shop until opening his own lithography business in 1844. In 1846 he opened a daguerreotype studio on the premises, and became one of the first resident daguerreotypists in Tasmania. Browne specialised in portraits, reassuring his clients in the *Hobart town directory and general guide* (1852) that his daguerreotypes would be taken in the shade to 'better preserve a natural and pleasing expression of countenance'. In addition to standard cased daguerreotypes, he also advertised his services in the making of daguerreotype miniatures for lockets and brooches. He substantially undercut his competitors, such as **Alfred Bock**, in price, deliberately appealing to a less affluent clientele.
—

Bull & Rawlings
active c1880s-90s

Photographic firm based in Brunswick, Victoria.
—

Burgin, Henry William
1830-1914

Professional photographer based in Parramatta, New South Wales, from 1860 to 1864.
—

Burke, Keast
1896-1974

Keast Burke was a professional photographer, journalist and historian of photography. Born in New Zealand, he arrived in Australia in 1904, settling with his family in Sydney. After serving in the Middle East during World War I, Burke was made associate editor (under his father) of the *Australasian Photo-Review (APR)*. In 1932 he published *Achievement*, a photographic study of the Sydney Harbour Bridge, and in 1941 was elected an associate of the Royal Photographic Society of Great Britain for a portfolio of male figure studies. Burke edited the *APR* between 1946 and 1956, and in 1943 began to publish a series of articles on early Australian photographers such as **JW Lindt** and **Charles Kerry**. In 1953 he discovered BO Holtermann's collection of glass-plate negatives by **Charles Bayliss** and Henry Beaufoy Merlin, which became the foundation of his 1973 study of gold-mining imagery, *Gold and silver*. From 1961 to 1969 Burke was editor and art director of *Australian Popular Photography*.
—

Burman, Arthur W (William)
active 1870s-1915
and Frederick Charles
1841-1921

Arthur W Burman was the son of Melbourne photographer William Insull Burman. In the 1870s he worked for the **Paterson Brothers**, in whose studio he photographed the Chinese giant Chonkwicsee, a rival of Chang Woo Gow, another unusually tall gentleman. In 1880, as a photographer for the Victorian Government, he joined a special train of troopers and members of the press to photograph the arrest of the bushranging Kelly Gang at Glenrowan. On 29 June 1880 Burman was captured photographing the body of outlaw Joe Byrne in a now iconic photograph by **JW Lindt**. Burman's younger brother, Frederick Charles, was also a professional photographer with several successful studios in Melbourne between 1860 and 1900.
—

Burnell, George
1831-94

George Burnell was a professional photographer and gold-digger known primarily for his stereographic views of the Murray River. In 1861 he purchased a camera and formed a travelling photographic business with his friend Edward William Cole, who he trained in processing and printing. They initially set out by horse and cart, and in 1861 refitted a flat-bottomed boat as a kitchen and darkroom. Departing on New Year's Day, 1862, the pair rowed and drifted for four months down the Murray, travelling nearly 2500 kilometres from Echuca in northern Victoria to Goolwa, South Australia, taking views along the way. The partnership came to end once the pair reached Adelaide. Burnell continued to work as a photographer and was commissioned by the Governor of Adelaide, Sir Dominick Daly, to take a second trip back up the Murray in 1863. Cole returned to Melbourne, where he ran a pie stall, wrote a book on universal religious values, and became a bookseller, noted for publishing *Cole's funny picture book*.
—

Caire, Nicholas
1837-1918

Nicholas Caire was a professional photographer active in Victoria and South Australia. Born in Guernsey, he arrived in Adelaide with his family in 1858. After a brief stint as a hairdresser in the early 1860s, he was employed in the studio of **Townsend Duryea**. Caire travelled in Gippsland, Victoria in 1865, taking photographs of Aboriginal people and local scenery. In December 1866 he opened his own studio in Adelaide producing portrait cartes de visite and cabinet cards. Around 1869, attracted by the booming commercial and social life of the gold-rush towns, he moved to Victoria, settling in Bendigo and then Talbot. In 1876 he purchased **Thomas Chuck**'s business in Melbourne, specialising in the views trade. With the advent of the dry-plate process in the 1880s, Caire relinquished his studio and dedicated himself to outdoor photography, depicting the mountains and gullies of south-eastern Victoria. He became a health crusader, advocating the benefits of fresh air, loose clothing, natural foods and exercise, values to which he alluded in his photographs. Widely read and interested in music and astronomy, Caire was one of the first photographers to add literary captions and narratives to his images, particularly those of pioneer settlers.
—

Campbell, JP (James Pinkerton)
1865-1935

James Pinkerton Campbell was a professional photographer in the employ of the government and the military. Born in Melbourne, he worked initially as a blacksmith and a clerk, and in 1892 became involved in the Working Men's College Photography Club. On his bicycle, specially adapted to carry his photographic equipment, he travelled around eastern Victoria, taking views in the

pictorialist style. In 1909 he was employed in the Vallan Studio, making postcards of landscape and street views, and in 1911 appointed photographer and cinematographer to the Commonwealth Department of External Affairs, for which he made promotional images of Australia to attract prospective settlers. His first assignment in 1912 was to accompany a federal parliamentary party to the Northern Territory. The following year, however, he was sacked for requesting a raise through the wrong channels. In 1915 Campbell joined the Light Horse Brigade in Gallipoli and 1918 replaced **Frank Hurley** as official war photographer for the Australian Imperial Force. Campbell documented offensives in the Jordan Valley and Damascus until being sacked yet again, due to dissatisfaction with his idiosyncratic photographs and for the slowness of his methodical approach. Back in Australia, Campbell continued to work as a photographer until his death in 1935.

—

Carlisle, Alexander
active 1870-91

Professional photographer based in Sydney.

—

Caves Board of Western Australia

The Yallingup caves consisting of ten chambers were discovered in 1899 by Edward Dawson. The Caves Board appears to have been formed in 1901 by the Western Australian surveyor-general Harry F Johnston, chief inspector of lands C Erskine May, and a draftsman in the Lands Department Herbert Farmer, among others, to protect the various caves in the southwest of the State between Capes Naturaliste and Leeuwin, and to make them easier to access. Contemporary reports noted the funds New South Wales had spent on the Jenolan Caves and that it was hoped that the Western Australian government would match these, given the beauty of the local environment. The Caves House Hotel opened in 1901 and electricity was connected to the Yallingup caves in 1904.

—

Cawston, William
c1820-91

William Cawston was a professional photographer, gilder and framer. He was transported to Australia on a seven-year sentence in 1845 and in 1856 opened a business in Launceston, Tasmania, as a picture-frame maker. By 1862 he had a photographic studio, which continued to operate in Launceston until 1888, when it became Cawston & Sons. Cawston worked as a studio photographer until 1891, producing portraits and views of Launceston.

—

Cazneaux, Harold Pierce
1878-1953

Harold Cazneaux was the leading pictorialist photographer in Australia. Born in Wellington, New Zealand, he moved to Sydney in 1904 where he worked in the studio of **Freeman & Co**. Outside of his working hours Cazneaux captured buildings and views of Sydney, for which he won acclaim from local critics and international members of the pictorialist movement. In 1916 he helped found the Sydney Camera Circle, where he advocated an Australian form of pictorialism that focused on formal rather than narrative concerns and made a feature of local sunlight. Cazneaux left Freeman & Co in 1918 after suffering a nervous breakdown due to the work practices. He was employed subsequently as chief photographer for Sydney Ure Smith's magazine *The Home*. As a photographer, teacher and writer he was dedicated to the development of photography in Australian art and culture.

Chaffer, Walter
1847-1921

Professional photographer active in Sydney between 1870 and 1895.

—

Chandler and Lomer
active 1865-77

Photographic firm operated by Andrew Chandler and Albert Lomer. Both photographers trained in the studio of **Davies & Co** in Melbourne and opened their Sydney partnership in 1865. The company also traded as The London Photographic Studio.

—

Charlier, Jean Baptiste
active 1860-67

Jean Baptiste Charlier was a professional photographer of portraits and views. Born in Belgium, he was active in Melbourne between 1860 and 1867, taking photographs of Melbourne buildings and sites. In 1861 Charlier was commissioned by the Hawthorn council to produce a series of views of prominent Melbourne buildings for the 1861 Victorian Exhibition. These works joined other images that surveyed Victorian life and progress, demonstrating the expansion and growth of the colony. Charlier was arrested in 1862 for deserting his wife, and again in 1863 with disobeying an order for her maintenance. After 1867, records providing evidence of his work as a photographer in Australia cease, and he may have left the colony.

—

Cherry, George
c1820-78

George Cherry was a professional photographer, inventor and penal officer. Born in England, he arrived in Australia in 1848 in Hobart Town, where he established a daguerreotype studio until taking up the post of assistant superintendent of convicts on Norfolk Island in 1849. While on Norfolk Island, Cherry took daguerreotype views which he reproduced as lithographs. His objection to the treatment of inmates in the penal colony led to his departure from Norfolk Island and he resettled in Hobart Town in 1852. He established a second daguerreotype studio and gallery there in 1854. He advertised 'Photographic Portraits on paper, glass and ivory, and on canvas from life to locket size, highly finished in Crayon, Water or Oil Colours and warranted to be as durable as the most permanent oil paintings'. A photograph of Bishop Nixon, enlarged to 75.5 by 65.5 centimetres, and overpainted by **John Dixon**, is one of his most magisterial productions and was exhibited at the 1866 Intercolonial Exhibition in Melbourne. In 1867 Cherry purchased **Henry Albert Frith**'s collection of portrait negatives, thus acquiring his clientele. The following year he was one of the photographers appointed to document the Duke of Edinburgh's Tasmanian tour.

—

Chuck, Thomas Foster
c1826-98

Thomas Chuck was an entrepreneurial itinerant photographer of portraits and views. Born in London, he arrived in Melbourne in 1852 and initially worked as a cabinetmaker. In 1860 he became involved in the production and exhibition of a grand moving diorama of the Victorian Exploring Expedition, a painted panorama wound around two rollers that recounted Burke and Wills' fateful journey. By 1866 he had established a photographic studio called The London Portrait Gallery in Daylesford, where he photographed people and views. Travelling around Victoria's Western District, he took promotional photographic views of the Hampden and Mortlake shires which were exhibited at the Intercolonial

Exhibition, where he also showed photographs of clouds after a heavy storm. In 1868 Chuck returned to Melbourne, establishing himself as an 'artist and photographer' in the newly built Royal Arcade. For three years from 1870 he collected photographs of early settlers for his magnum opus – a mosaic of 700 tiny portraits of explorers and early colonists of Victoria composed into a shield-like shape. In 1876 Chuck sold his business to **Nicholas Caire** and travelled to England. On his return to Melbourne he reportedly gave up photography and become an agent for the Evangelisation Society of Australasia.

—

Clifford, Samuel
1827-90

Samuel Clifford was a professional photographer and grocer based in Tasmania. He made stereoscopic views of Tasmania that he sold, along with photographic equipment, at his Hobart grocery shop. In the early 1860s he opened his own studio, producing stereograph views of Tasmanian scenery until 1878 when his business was purchased by the **Anson Bros**.

—

Collins, Charles
active c1878-1900

Charles Collins was a professional photographer active in Sydney and rural New South Wales. He had a studio in Maclean in 1882, and made cartes de visite of towns, people and properties in Bega, Bombala, and Grafton in New South Wales. Between 1881 and 1900 he established a studio in Sydney, where he advertised inexpensive cabinet-card portraits.

—

Cotton, Olive
1911-2003

Olive Cotton is one of Australia's most compelling photographers and producer of many now iconic images. Born in Sydney, Cotton received no formal training in photography, but had been given a Kodak Brownie at age eleven and taught the basics by her father, Leo Cotton. She joined the Photographic Society of New South Wales and the Sydney Camera Club in 1929. In 1934, after completing her Bachelor of Arts at the University of Sydney, she joined **Max Dupain**'s newly opened Sydney studio. Cotton continued to develop her own compositions and aesthetic approach, which was inspired by her association with **Harold Cazneaux**. The London Salon of Photography exhibited her *Teacup ballet* in 1935, and in 1937 *Shasta daisies* and *Winter willows*. From 1942 to 1945 Cotton managed Dupain's studio while he was deployed on war service. Cotton and Dupain, childhood friends, had married in 1939, but separated two years later and divorced in 1944. In 1946 Cotton moved to Cowra, where she taught mathematics, raised a family, and specialised in portraiture and wedding photography. Her work began to receive greater critical attention in the 1980s and today is acknowledged for its sensitivity to elements of design in nature and its evanescent treatment of light and space.

—

Crawford, Frazer Smith
c1829-90

Frazer Crawford was a professional photographer and lithographer. Born in Scotland, he was in Melbourne by 1859. He worked in Melbourne, Sydney and Adelaide, managing the Adelaide Photographic Company from 1864. From 1868 Crawford was a photolithographer with the South Australian Survey Department.

Croft Brothers
active 1863–65

The Croft Brothers ran a successful photographic business catering to the middle and upper classes in Sydney. In 1863 they transferred their business from Dartmouth, United Kingdom, to South Head Road, Sydney, where they often used a panorama of the harbour as a studio backdrop for their portraits. Though in Sydney for only two years, the brothers ran a popular outfit, producing thousands of portraits and cartes de visite. In 1865, the business was offered for sale in the *Sydney Morning Herald* along with more than 5000 negatives. The same year, the Crofts returned to the United Kingdom, citing health reasons. On the journey, they stopped in New Zealand, establishing a studio in Auckland in 1865.

—

Crowther, Thomas E
active c1860–90s

Thomas Crowther was a professional photographer based in rural New South Wales. He worked in Echuca and Deniliquin from the 1860s to the 1890s and Berrigan after 1890.

—

Cunningham, Andrew
active c1857–1900

Andrew Cunningham was a painter, decorator and professional photographer. Born in Scotland, he had arrived by 1856 in Armidale, New South Wales, and by 1857 was advertising his services in painting, ornamental work and paper-hanging. He was working as Armidale's resident photographer by 1859 and in 1870 claimed to have taken the only photograph of the body of bushranger Captain Thunderbolt (Fred Ward) when he was shot by an off-duty policeman at nearby Uralla. Cunningham produced portraits and views of the Armidale area, often as cartes de visite.

—

Dailey & Fox
active 1861–69

Samuel Dailey and Thomas Moorhouse Fox were the proprietors of a profitable South-Australian photographic studio. The business specialised initially in ambrotype portraits and later, in cartes de visite. In their Clarendon studio, sitters were photographed against an elaborate painted backdrop representing a well-to-do drawing room with wood panelling and a window giving on to parkland and architectural ruins. The backdrop was perhaps intended to add a certain British or continental flair to the resulting image and helped to distinguish the firm from its competitors. While business was strong and the premises were enlarged in 1862 to cope with an increasing clientele, both men continued to ply their trades during the 1860s, Dailey as a carpenter and Fox as a shoemaker.

—

Daintree, Richard
1832–78

Richard Daintree was a prominent geologist and photographer who pioneered the use of photography in fieldwork. Born in England, he was lured to Australia by the gold rush, arriving in Melbourne in 1852. After an unsuccessful stint as a prospector, Daintree was employed as an assistant geologist to Alfred Selwyn in the Victorian Geological Survey in 1854. A return trip to England in 1856, where he studied at the Royal School of Mines laboratory, sparked Daintree's interest in photography, which he began using on rejoining the Victorian Survey in 1859. In 1864 Daintree moved to Queensland, where he initiated a geological survey in 1868. From 1868 to 1870 he was the first government geologist of North Queensland. He took photographs of the Queensland bush and its colourful characters, exhibiting them alongside photographs by other practitioners at the 1871 Exhibition of Art and Industry in London, to which he had been appointed commissioner. His photographs were made in part to attract potential settlers to the area – between 1872 and 1876 Daintree was appointed agent-general to Queensland and avidly promoted the colony's resources, producing handbooks illustrated with his own photographs.

—

Dalton, Edwin
active 1853–65

Edwin Dalton was an English portrait painter, miniaturist and prominent society photographer. He arrived in Victoria in the 1850s, possibly in search of gold, and in 1853 he was advertising his services as a portraitist. By 1854 Dalton was in Sydney, where he painted portraits of colonial notables Henry Parkes, JS Dowling and Walter Lamb, which were celebrated for their naturalism. In 1857 he added daguerreotypes to his list of services, and opened his Royal Photographic Portrait Establishment in George Street. Dalton's great claim to fame was that he had instructed Queen Victoria in etching, although the letter confirming his royal connections was destroyed in a studio fire in 1862. Nonetheless, it was an achievement that drew many illustrious sitters to his studio. While initially working in daguerreotype and ambrotype, Dalton also produced stereographs and photographic mosaics and frequently embellished his images with crayon. In 1858 he advertised the 'crayotype' (now called a biotype), in which a paper photograph was coloured with pastels. In 1865 he sold the business to Thomas Felton, who continued to operate under Dalton's name, and returned to England. When Dalton's finally closed in 1870, William Freeman acquired both the premises and the negatives.

—

Davies & Co
active 1858–82

William Davies was a professional photographer who established a number of studios in Melbourne between 1858 and 1882. Davies was probably born in Manchester, United Kingdom and arrived in Melbourne around 1855. He began his photographic career in Australia in the employ of his friend, Walter Woodbury (inventor of the Woodburytype) and the Meade Brothers. Davies purchased the Meades' business in 1858 and opened his own studio, Davies & Co at 98 Bourke Street, specialising in albumen photography of individuals and local premises. This address was opposite the Theatre Royal, and Davies took advantage of the proximity by selling cartes de visite of famous actors, actresses and opera singers. In 1861, Davies' firm showed a number of portraits and images of Melbourne and Fitzroy buildings, often with the proprietors standing outside, at the Victorian Exhibition, and then at the 1862 London International Exhibition, where they received honourable mention. Along with actresses and buildings, the company also specialised in carte-de-visite portraits of Protestant clergymen posed in the act of writing their sermons. From 1862 to 1870 the firm was located at 94A Bourke Street, where they shared the premises with the photographers Cox and Luckin.

—

Davis, J
active c1860–90

Professional photographer based in Sydney.

—

Dawson, Patrick
active c1866–72

Patrick Dawson was a professional photographer based in Victoria. Dawson opened two studios in 1866, in Hamilton and Warrnambool, Victoria, and at the 1866 Intercolonial Exhibition of Australasia in Melbourne exhibited six life-size portraits for which he won a medal. Dawson's best known work was made in 1867 when he photographed the individual members of the first Aboriginal cricket team to tour England. In his Warrnambool studio, Dawson photographed each member of the team, although only five of the thirteen players were dressed in cricket whites, and the others posed in athletics gear with boomerangs, clubs, spears, spear-throwers and shields. The resulting photographs were assembled into a composite picture with an elaborately decorated mount. The whole was subsequently lithographed and published by de Gruchy of Melbourne. Dawson exhibited a life-size photographic portrait at the Victorian Intercolonial Exhibition in 1872–73, but no works are known after this date, and it is likely that the business closed down.

—

Degotardi, John, (sr)
1823–82

John Degotardi was a professional photographer, engraver and publisher. Born in Ljubljana, he grew up in Austria and worked in Germany and London before arriving in Australia in 1853. In Sydney, Degotardi had a successful printing and lithography business, and by 1866 advertised his services in photolithography and photography, producing panoramic views of Sydney and New South Wales. Examples of his printing and photographic work won medals at the Victorian Intercolonial Exhibition of 1872–73 and the Sydney International Exhibition of 1879–80.

—

Degotardi, John, (jr)
1860–1937

Born in Sydney in 1860, John Degotardi (jnr) was the son of the noted photographer **John Degotardi** (sr) who immigrated to Australia in 1853. In 1900, Degotardi was commissioned by George McCredie, architect and engineer in charge of quarantine activities, to photograph the impact of the outbreak of bubonic plague in Sydney from 19 January to 9 August 1900, a period in which 303 people were infected and 103 died. The Rocks area was the worst affected, and Degotardi focused his efforts there, photographing all the derelict buildings selected for demolition under the supervision of McCredie. The images, of interiors, exteriors, sheds and warehouses, lanes and yards, were arranged into six albums and kept in case of litigation.

—

Dixon, John Cowpland
c1819–85

The Reverend John Dixon was an amateur painter and clergyman. Born in England, the son of an Anglican clergyman, Dixon studied at St John's College, Cambridge. In 1848 he was sent by the London Society for the Propagation of the Gospel to Nova Scotia, and in 1855 he and his wife arrived in Launceston, Tasmania. He became chaplain at Jerusalem (now Colebrook) in 1856 and then transferred to Windermere on the Tamar River in 1861, where he remained until 1883. Only two paintings have been positively attributed to Dixon, and both are portraits made in oils over enlarged photographs by **George Cherry**. Both portraits, of the landowner and politician William Race Allison and the first Anglican Bishop of Tasmania, **Francis Russell Nixon**, commemorate powerful individuals who influenced the development of the colony. Upon retiring in 1883, Dixon returned to London, where he died in 1885.

Docker, Ernest B (Brougham)
1842–1923

Ernest B Docker was a lawyer, Supreme Court judge and an amateur photographer. Born at Thornthwaite, New South Wales in 1842, he was the son of Joseph Docker, a notable early amateur photographer. He assisted his father in making calotype prints and received further lessons in the 1850s from the noted stereographer **William Hetzer**. Docker wrote regularly about photography and his articles were published in the *British Journal of Photography* in the 1870s. As a photographer, he initially used the wet-plate process to make views and portraits of friends and family. In the 1890s he abandoned it for dry-plate photography; his output increased dramatically, and he committed himself to the production of stereograph views, of which he produced hundreds on his travels around New South Wales, Tasmania, Victoria and Norfolk Island. Docker was appointed the first president of the newly established Photographic Society of New South Wales in 1894, a position he held until 1907, and was an avid promoter of photographic knowledge and appreciation through lectures and exhibitions.

—

Drinkwater, Charles
c1818–1902

Charles Drinkwater was an itinerant photographer who worked in numerous locations throughout New South Wales. He took portraits and view photographs in Kempsey in 1867 before setting up in Sydney between 1869 and 1871. He is next recorded as living in Tamworth from 1886 to 1891 and Newcastle in 1896 and 1897.

—

Dupain, Max
1911–92

Max Dupain is Australia's most celebrated modernist photographer. Born in Sydney, Dupain practised photography as a teenager, receiving his first camera in 1924. In 1929 he joined the Photographic Society of New South Wales, and in 1930 was employed in the studio of prominent pictorialist Cecil Bostock, where he received solid training in all aspects of photography. He established his own studio in Sydney in 1934, servicing commercial clients and producing still lifes, figure photography and portraits. In his personal work, he explored the surrealist aesthetic of Man Ray, experimenting with formal abstraction and montage. With the outbreak of World War II, Dupain worked with the Camouflage Unit in 1941, travelling to New Guinea and the Admiralty Islands. The studio was managed in his absence by photographer **Olive Cotton**, whom he had married in 1939, although the pair separated two years later. In the 1930s, Dupain wrote passionately about photography for the magazine *The Home*, advocating modernist modes and techniques; however, after World War II he promoted a straight photo-documentary style. His photography of the 1960s and '70s was shaped by architectural interests and he fostered working relationships with several prominent architects, most notably Harry Seidler.

—

Duryea, Townsend
1823–88
Sanford
1833–1903
Duryea Brothers
1855–63
Edwin
1857–1945

The brothers Townsend and Sanford Duryea were American-born professional photographers who founded photographic studios in Melbourne, Geelong, Adelaide, Hobart and Perth in the 1850s.

Townsend had established a daguerreotype studio in Brooklyn in 1840, only a year after the process had been made public, and in 1853 arrived in Melbourne, followed by Sanford in 1854, where they established two studios in collaboration with **Archibald McDonald**. In 1855 the pair opened a studio in Adelaide, trading as Duryea Brothers. Business thrived, and in 1856 they made a tour of the state, offering their services in a number of country towns. In 1858 Sanford opened the first photographic studios in Perth and Fremantle. During the early 1860s the Duryea studios were renowned for their fine quality carte-de-visite portraits. Sanford returned to New York in 1863 but Townsend remained in Adelaide, where his studio was the busiest photographic practice in town, in possession of over 47,000 negatives by 1870. In addition to portraits, Townsend made panoramas and was appointed official photographer to the royal tour of HRH Duke of Edinburgh to Adelaide in 1867, capturing him on a kangaroo hunt. In 1883, Townsend's son Edwin, assisted by his brother Townsend jnr, took over the studio at Moonta. From 1892 to 1906, his brothers Richard and Frank, reopened the Duryea Brothers studio, trading as itinerant photographers in South Australia.

—

Duval and Co
active c1884–1901

Duval and Co was a photographic firm in Launceston, Tasmania, patronised by Thomas Hinton, who staged cabinet-card photographs in several Launceston studios in which he adopted various poses in costume (including a small loincloth) before an elaborately designed set featuring Australian heraldry.

—

Dwyer, JJ (John Joseph)
1869–1928

JJ Dwyer was an inventive and entrepreneurial professional photographer based in Kalgoorlie, Western Australia. Born in Victoria, son of a miner from Tipperary, Dwyer took up amateur photography in 1880. In 1896 he moved to the Coolgardie goldfields in Western Australia to seek his own fortune, taking photographs of the people and places of the remote outback and boom towns of the region. He managed to find enough gold to open a studio in Kalgoorlie in 1900, initially in partnership with EC Joshua, and then establishing his own in 1903. Dwyer was in high demand as a photographer in vibrant, cosmopolitan Kalgoorlie, where he photographed its permanent and temporary residents, buildings, social events and the 'Golden Mile', a series of ore-laden mines close to the city. In addition to his studio work, Dwyer was commissioned by mining companies to document their machinery, personnel and diggings. In 1922 he joined an expedition from the Perth Observatory to Wallal Downs Station to observe an eclipse of the sun and to test Einstein's theories of the effect of gravity on light. Dwyer photographed the members of the expedition and their equipment and made images of the sun's corona during the eclipse.

—

Fauchery, Antoine
1827–61

Antoine Fauchery was a writer, playwright and professional photographer. Born in Paris, he arrived in Melbourne in 1852, working for two years on the Ballarat goldfields. Back in Melbourne in 1854, he established the Café-Estaminet Français, which became a popular European enclave. In 1856, he returned to France, where he published his experiences in Australia in eight *Lettres d'un mineur en Australie* in *Le moniteur universel* in 1857, offering vivid descriptions of life in colonial Victoria. Within

the same year, he made a return journey to Melbourne, this time on an official photographic mission sponsored by the French government that was to include India and China. In Melbourne he opened a studio on Collins Street and made fine portraits, later collaborating with the photographer and geologist **Richard Daintree** on a series of views. Fauchery and Daintree published an album ambitiously titled *Australia* in 1858, which was received as a work of great artistry documenting the activities of the colony. Fauchery left Australia for Manila in 1859, joining the French army as a war correspondent and official photographer. He sailed to Japan in 1861, where he died in Yokohama from a combination of gastritis and dysentery.

—

Ferran, Anne
1949–

Anne Ferran is an artist, academic and writer. She belongs to a generation of photographers who came to prominence during the 1980s, questioning the role of the medium to articulate ideas beyond its relationship to 'reality', and who engaged more openly with theory, politics and feminism. Since 1995 Ferran has worked with sites and objects from Australia's colonial past, tracing the gaps and absences in the photographic and historical record. In 1999 she was awarded a New South Wales Women and Arts Fellowship to work on a little-known photographic archive from the 1940s of female psychiatric patients. The resulting photographs and artist's books were exhibited in 2003 as *INSULA* and *1–38*. In 2001 Ferran began a long-term visual investigation of two former female-convict prison-sites in Tasmania, which culminated in *The ground, the air* at the Tasmanian Museum and Art Gallery in 2008 and included the series *Lost to worlds*, images printed on aluminium of the remains of sites of incarceration. In 2014, the Lawrence Wilson Art Gallery at the University of Western Australia mounted a major exhibition of her photographs, including new work focusing on the disused library at Fremantle Prison.

—

Fitzalan
active c1860s–90s

Professional photographer based in Trundle, New South Wales.

—

Flintoff, Thomas
c1809–91

Thomas Flintoff was a professional painter and photographer. Born in England, he travelled in North America, Mexico and the Society Islands before arriving in Melbourne in 1853. He established himself in the gold-mining town of Ballarat from 1860 until 1872 when he returned to Melbourne to practise photography until his unexpected death from ammonia poisoning (Flintoff mistook it for cough mixture) in 1891.

—

Foelsche, Paul Heinrich Matthias
1831–1914

Paul Foelsche was a policeman and amateur photographer specialising in landscapes and anthropological images of the Larrakia people. Born near Hamburg, Germany, he immigrated to South Australia in 1856, where he joined the mounted police in Strathalbyn. In 1870 he was appointed sub-inspector in charge of the newly formed Northern Territory Mounted Police and moved to Palmerston (now Darwin), where he remained. Foelsche took up photography in the 1870s, when advances in the medium made it more accessible and affordable. Although he had no scientific training and took photographs part-time,

his images were informed by theories of social Darwinism and supplied ethnologists and anthropologists with data, as well as promoting the Northern Territory as a place for European settlement. He printed all his photographs himself, but because he was a public servant it was not appropriate for him to sell his work. He did, however, send his photographs to international exhibitions and presented albums to friends and important visitors. As an amateur anthropologist, Foelsche wrote about the customs and lifestyles of the various Aboriginal groups, collected artefacts for the South Australian Museum and presented papers at the Royal Society of South Australia.

—

Ford, Sue
1943-2009

Sue Ford was a pioneer of feminist photography and filmmaking in Australia. Born in Melbourne, she began documenting her family with a Kodak Brownie from a young age, and studied photography at the Royal Melbourne Institute of Technology in 1962. Much of Ford's work depicts friends and family in series, representing the impact of passing time and past experience. She worked in collaboration with her sitters, using the camera in a deliberately casual way that departs from the emphasis on technique and objectification that characterises much photography of the 1960s. Ford emerged as a photographer and filmmaker in the context of 1970s second-wave feminism and her work addresses the political impact of personal experience and identity, seeking to validate the experiences of women. Ford's interest in time also extended to the histories of Australia and its Indigenous people, and in 1988 she travelled to Bathurst Island in the Torres Strait to work with Tiwi women.

—

Freeman Brothers
active 1855-1900
Freeman & Co
1900-46

Freeman Brothers was established by the professional photographers William and James who arrived in Sydney from London in 1853 and 1854 respectively. Trading as Freeman Brothers, the pair opened Freeman's Sydney Gallery of Photographic Art in 1855, specialising initially in daguerreotype portraits. James Freeman is credited with introducing the ambrotype process to the colony in 1856. By the 1860s, the studio was busy producing carte-de-visite portraits, amassing nearly 30,000 negatives by 1870. In 1866 the brothers collaborated with the renowned English photographer Victor Prout, capitalising on his fine reputation in the colony and advertising themselves as 'photographers to their Royal Highnesses the Prince and Princess of Wales and His Excellency the Governor'. After William Freeman retired around 1890, the company passed into the hands of employee William Rufus George. Under George's management in the 1890s the firm targeted a wealthy clientele, producing expensive platinum prints. The company still operates in Sydney, specialising in corporate, wedding, architectural and portrait photography.

—

Frith, Frederick
1819-71
Henry Albert
active in Australia 1857-67,
died c1879;
Frith and Sharp
active 1855-56

Frederick Frith was a successful portrait painter and professional photographer in colonial Melbourne and Hobart. Born in the United Kingdom, he was in Melbourne by 1853 after practising, he claimed, in London, Brighton, Scotland and Ireland. Frith initially established himself as a portrait and animal painter, moving to Hobart Town in 1854. On his arrival in Hobart, Frith collaborated briefly with the **Duryea Brothers** and **Archibald McDonald**, and then with John Matthieson Sharp from 1855 to 1856. Together, Frith and Sharp made coloured portraits and landscape views, Sharp taking the photographs and Frith colouring them. Frith established his own studio in 1856, and by 1859 was producing the first commercial albums of views available in Tasmania, entitled *Tasmania illustrated*. In 1857, Frederick's brother Henry joined his enterprise and the pair operated as Frith Brothers, with an additional studio in Launceston. Frith moved back to Victoria in 1862 while his brother Henry remained in Tasmania. In Launceston, Henry was involved in a public stoush with **Alfred Bock** over the correct use of the sennotype process. He continued to operate until in 1867, when he sold his negatives to **George Cherry** and moved to New Zealand.

—

Fry, JW
active c1871

Professional photographer active in Penrith, New South Wales.

—

GB Fenovic and Co
active c1860-90

Professional photographic firm advertising portraits, views and animal photography.

—

Gill, Simryn
1959-

Simryn Gill is an artist based in Sydney and Port Dickson, Malaysia, who works across a variety of mediums. Born in Singapore in 1959, she grew up in Malaysia and was educated in India and England, moving to Adelaide in the 1980s. Gill's work explores issues of place, history and culture in a postcolonial context. It is often animated by themes of transplantation, whether of flora, objects or ideas. In her photographic series *Forest* (1996–98) she grafted book pages onto the leaves, fruits and aerial roots of plants, deliberately intertwining nature and culture. Since the 1990s Gill has participated in major biennales worldwide, such as the Biennale of Sydney (2002 and 2008), the Singapore Biennale and the Biennial of Contemporary Art, Seville (both 2006), and dOCUMENTA (13) (2012). In 2013 Gill represented Australia at the Venice Biennale with *Here art grows on trees*, an exhibition of photographs, objects and collages linked by circular forms including photographs of mines. The exhibition also traced the process of decay and entropy as it was subjected to the elements by Gill's removal of a part of the roof of the Australian pavilion.

—

Glaister, Thomas
1825-1904
Glaister studio
active 1860s (?)

Thomas Glaister was a professional photographer renowned for expensive, high-quality ambrotypes and paper photographs. Born in the United States, Glaister worked for the Meade Brother's photographic studio in New York from about 1850 to 1854 before arriving in Australia. After spending a year in Melbourne he moved to Sydney, establishing his own studio, the American Australian Portrait Gallery, in April 1855, and a second branch in Brisbane, which was managed by John Watson. Glaister advertised his firm as a quality outfit that produced images resistant to fading (a considerable problem in the 1850s and '60s). His studio was admired for the cosmopolitan images of Paris and Rome hung on its walls, and he made sure that patrons were dressed appropriately for the camera. Glaister kept abreast of international developments in the medium and his photographs were celebrated for their technical sophistication and style. He was the undisputed master of the ambrotype process; his images exhibited a subtlety of colouring and greater informality and expressiveness. In 1870 his Pitt Street studio was entirely destroyed by a fire and he may have returned to the United States. Glaister's sons worked as travelling photographers in the 1860s, hence 'Glaister studio'.

—

Glenny, Henry
1835-1910

Henry Glenny was a professional photographer, journalist and entrepreneur. Born in Ireland, he arrived in Australia in search of gold in 1853. He established a photography studio known as the Dublin and Melbourne Rooms in 1857 in Castlemaine, Victoria, opening additional branches in Ballarat and Kyneton shortly after. The firms specialised in portraits and views of churches, streets and public buildings.

—

Goode, Bernard
active 1862-97

Bernard Goode was a professional photographer known for his double and triple portraits. He established a studio and 'Photographic Warehouse' in Adelaide in 1862 where he initially made inexpensive cartes de visite and sold photographic equipment and supplies, including magic lanterns and accompanying slides. In 1865 Goode began to make double portraits, offering to the public, as reported in the *South Australian Register* of 5 June that year, 'portraits of the same person in two styles on the same card, which gives a very novel and pleasing effect'. The *Register* of 30 September 1865 reported that one of the most unusual showed 'the man and his double ... shaking hands – an effect which requires, we should imagine, very careful arrangement and delicate manipulation to produce it'. Other Adelaide-based producers of multiple-image portraits included **Frederick Frith**, **Phillip J Marchant** and George Freeman. In 1872 Goode published a *Pocket album of South Australian views*, giving a 'very favourable impression' of Adelaide's buildings, natural beauties, and the appearance of notable Aboriginal people. The business was sold in 1874 to WA Francis, and Goode moved to New South Wales, where he continued to work until 1897.

—

Goodes, Henry
c1840-85

Henry Goodes was a professional photographer based in New South Wales and Queensland. He established a portrait studio in South Brisbane, Queensland, in 1856. By 1861 he was working in partnership with **William Blackwood** in Sydney and took over the business in 1863. From 1865 he worked as an itinerant photographer throughout rural New South Wales, advertising his services in Mudgee and Wagga Wagga.

—

Goodman, George
active 1842-51

George Goodman was the first professional photographer to work in Australia. He arrived in Sydney from London in November 1842, advertising himself as a fully licenced photographer, having

purchased rights to the daguerreotype process from the British patentee, Richard Beard. Goodman opened his Daguerreotype Gallery on the rooftop floor of the Royal Hotel in George Street, Sydney, in 1842. Photography had been known in the colony since 1839 and Goodman's arrival was greeted with enthusiasm. Reports on the initial results, however, varied, some praising the daguerreotypes as 'forcible' likenesses, others describing them as 'hideous, sulky [and] sepulchral'. During his stay in Australia, Goodman remained itinerant, travelling from colony to colony in search of patrons. He established himself in Hobart in 1843, where he took views, but was back in Sydney in 1844, from where he made regional tours, photographing the Lawson family in Bathurst in 1845. He made a lucrative trip to Melbourne in the same year and was in Adelaide in 1846, where he encountered increasing competition from other daguerreotype studios. Goodman left Australia with his family for London in 1850 and died in Paris the following year.

—

Gorus, John Tangelder
c1830–1916

John Gorus was a professional photographer born in Gelderland, Holland. He arrived in Australia in 1854, working as a photographer on the New South Wales goldfields until establishing himself in Sydney in the early 1860s. He advertised cartes de visite and coloured cabinet cards, remaining at his Sydney premises until 1891.

—

Gove & Allen
active 1880-85

The San Francisco firm of Gove & Allen introduced the popular gem tintype to Australia. Invented in France in 1853 as a cheap and simple alternative to the ambrotype, it was popularised in Europe and America in the 1860s and 1870s and brought to Australia in 1880 when Gove & Allen opened their first studio in Sydney. The firm traded as both The American Gem Studio and The American Studio and had franchises in Adelaide and Brisbane (run by the Danish immigrants Poul and Anders Poulson) as well as Melbourne, Ballarat and Bendigo. All Gove & Allen studios ceased trading by 1885.

—

Great Northern Photographic & Fine Art Company
active c1860-90

Photographic firm located in West Maitland and Newcastle, New South Wales.

—

Gullick, William Applegate
1858–1922

William Gullick was the NSW Government Printer and inspector of stamps and also known for his experiments with colour photography. Born in Wiltshire, United Kingdom, he immigrated to Australia with his family in the early 1860s. He was appointed government printer in 1896, a post he held until his death in 1922. Gullick was a keen collector of stamps and old coins as well as a heraldry enthusiast and in 1906 was commissioned to design the Australian coat of arms. As an amateur photographer, Gullick used dry-plate methods from the 1880s before experimenting with colour photography in the 1900s. He was one of the first in Australia to experiment with the autochrome process, a type of colour photography invented by Louis Lumière in France in 1904.

—

H Roach and Co
active c1860s-90s

Photographic firm based in Melbourne.

Haigh, Edward
active Australia 1861-62

Edward Haigh was a professional photographer and pupil of the celebrated British photographer Roger Fenton. Haigh arrived in Melbourne from London in 1861, opening a studio on Murphy Street, South Yarra. He had brought with him photographic and stereographic views taken in France and England, which he exhibited alongside albumen views and stereographs of Victoria at the 1861 Victorian Exhibition. Haigh's photographs of prominent buildings and gardens in Melbourne joined other promotional images of Victoria commissioned by Redmond Barry to display the progress and achievements of the colony. Haigh travelled to Tasmania in 1861 or 1862, producing stereograph views of the natural beauties of Launceston and Hobart. On his return to London in 1862, he exhibited his photographs of Victoria in the London International Exhibition. The views were exhibited again in London in 1863 and were published by HB Randall in Liverpool and reproduced in the *Illustrated London News* on 1 August 1863.

—

Hall, 'Professor' Robert
1821–66

Robert Hall was an ornithologist, publican, and photographer. He was in Adelaide by 1842, and from 1842 to 1846 he worked as an ornithologist until becoming an agent for the newly arrived German photographer Edward Schohl. In 1846 he began advertising his services as a daguerreotypist, with rather mixed results. In the same year he visited Perth and Fremantle, where he took that colony's first recorded photographs. From 1846 to 1854 Hall worked intermittently as a photographer dividing his time between photography and running the boarding house he opened in 1848. After a return trip to England in 1854 he began to style himself as 'Professor Hall', making portraits and views of local scenery, in daguerreotype, calotype, ambrotype, albumen and collodion processes, as well as painted photographs. In 1854 he advertised stereographic views, the first photographer to do so in South Australia. In 1861 he showed the first specimens of the new carte-de-visite format seen in Adelaide. Hall retired in 1865 to become landlord of the Gresham Hotel and died in Adelaide in 1866. He was remembered in the *Southern Argus* of 1 September 1866 as an 'honest and kindly hearted, if somewhat erratic citizen'.

—

Hardie, Fred
active Australia 1892-93

Fred Hardie was senior company photographer for the Scottish firm George Washington Wilson & Co of Aberdeen. The company specialised in view photography, sending photographers all over Britain, Europe, South Africa and Australia to capture natural scenery and city views for its stock-in-trade. After a photographic tour of the colonial townships of South Africa, Hardie was despatched to Australia in 1892. He travelled through Queensland, New South Wales, Victoria and South Australia, taking photographs of the cities, gold mining towns, and Aboriginal people. On an overland journey from Cairns in Queensland to Gawler in South Australia between 1892 and 1893, Hardie documented the major buildings and landmarks of metropolitan centres using full glass plates. He appears to have returned to Great Britain in 1893. At the auction of the company's assets in 1908, Hardie purchased 1,143 Australian pictures, buying back images he had probably taken during his time in the Antipodes.

Hart, Elijah
d1893

Elijah Hart was a well-travelled professional photographer. Before arriving in Australia in 1852 he had visited China, Manila, California, the South Sea Islands and New Zealand. Hart established himself as a professional photographer in Sydney in 1852, offering hand-coloured daguerreotype portraits, and was one of the first to make use of the ambrotype process introduced to Australia in 1854. Hart gave up his Sydney studio in 1855 to travel around New South Wales, establishing a studio two years later in West Maitland. Hart regularly exhibited his work in Sydney and was a frequent contributor to the *British Journal of Photography*.

—

Hart, Henry
active 1867-72

Henry Hart was a professional photographer and landscape painter based in Melbourne.

—

Harvey & Dunden
active c1873

Professional photographic firm based in Geelong, Victoria.

—

Hatton & Patching
active c1879-81

Photographic firm based in Sydney.

—

Hawkins, 'Professor' Jeffrey
active c1858-75

Jeffrey Hawkins was a professional photographer based in Melbourne.

—

Hetzer, William
active 1850-67

Born in Germany, Hetzer arrived in Sydney in 1850 and opened a studio the same year, advertising calotype portraits and views. Hetzer specialised in paper photography, which was a novel process in the colony, as well as stereograph views. He was assisted by his wife Thekla, who was one of the earliest woman photographers in the colony. In 1858 he made a series of thirty-six photographs taken with a stereo-view camera (available from 1855) of Sydney streets and buildings, which were funded by subscription. They were among the earliest outdoor photographs and were popular souvenirs; one set was owned by the architect Edmund Blacket. Hetzer was a prominent member of Sydney artistic and intellectual life and a member of the Australian Artists Society; in 1859 he exhibited in the inaugural photographic exhibition of the Philosophical Society of New South Wales. In 1862 he sent a coloured composite portrait of freemasons, measuring over a metre tall, to the London International Exhibition, and for the Paris Universal Exhibition 1867 he produced images of the monuments of the expanding colony. Hetzer and Thekla left New South Wales in 1867 and their premises and negatives were purchased by John Degotardi (sr).

—

Hibling, Everitt E
active 1873-77

Professional photographer based in Melbourne, Victoria.

—

Hider, James
active c1860-90

Professional photographer based in Warrnambool, Victoria.

Holledge, Edward
active 1868-90

Edward Holledge was a professional photographer based in Bathurst. He also produced cartes de visite in towns en route from Sydney to Bathurst, including Campbelltown and Penrith.

—

How, Louisa Elizabeth
1821-93

Louisa How was an amateur photographer of portraits and views. Born in England, she arrived in Melbourne with her husband James and two sons in 1849. By 1857 the family was living in Sydney, where her husband became a partner in a merchant and shipping firm. How was a self-taught amateur, relying on an 1850 copy of the English *Art Journal* for knowledge of the medium. Unlike the majority of her Australian colleagues, she used paper photography, a process favoured by professional photographers William and Thekla **Hetzer**, from whom she may have acquired materials and tuition. The subjects of her photographs were mainly visitors to her Kirribilli residence, prominent merchants, settlers and adventurers, including the explorer William Landsborough and his Aboriginal companion, Tiger. She often posed her subjects beside a stereo-viewer and her work is distinguished by the composed, comfortable demeanour of her sitters. In addition to portraits How may have also photographed local buildings and views, including Sydney Cove and Government House. The majority of her surviving photographs can be dated to 1858 and 1859. How died aged seventy-two at her Woollahra residence.

—

Hurley, James Francis (Frank)
1885-1962

Frank Hurley was a celebrated and intrepid documentarian of Antarctica and the two World Wars. Born in Sydney, he began working as a photographer in 1905 in the postcard business of Harry Cave. In 1911 he was employed by Sir Douglas Mawson as official photographer of the Australasian Antarctic Expedition, and took dramatic still and moving images of the mission and the continent. He returned to Antarctica in 1914 as a member of Sir Ernest Shackleton's expedition, photographing the group's struggle for survival. In 1917 Hurley joined the Australian Imperial Forces as official war photographer, although his creative use of footage put him at odds with army administration. In the 1920s Hurley made a number of filming expeditions to the Torres Strait Islands and Papua New Guinea, but his sensational stories about Papua and dubious methods of obtaining artefacts led to further clashes with authorities and he was refused entry in 1925. In 1929 he returned for a third time to Antarctica with Mawson's research mission. He served the army again during World War II, remaining in the Middle East until 1946. Back in Australia he spent the remainder of his career publishing his work and lecturing on photography.

—

Illustrations Ltd
1920-

Illustrations Ltd is Perth's oldest continuous photographic company. Founded in 1920 by Arthur Nash Viveash, the firm specialised in commercial photography and catalogue work for local businesses. It was purchased in 1965 by employee Noel Holly. Between 1996 and 2000 the firm transitioned to digital photography, closing its darkrooms. In 2013 the business reopened in West Perth, specialising in portrait, wedding and corporate photography as well as product advertising.

Irby, Edward
active c1862-70

Professional photographer based in Tenterfield, New South Wales.

—

Jenkinson, GH (George)
active 1860-62

GH Jenkinson was a professional itinerant photographer who worked briefly in Victoria. In 1861 he opened a studio in Dunolly, advertising portraits on glass, paper, leather and tin plate. The same year he was commissioned to take twenty-four ambrotypes of the principal buildings, streets and people of Dunolly, which were exhibited at the 1861 Victorian Exhibition in Melbourne, and for which he was paid nine pounds. These were probably commissioned by town clerk Charles Dicker as a response to the call of Redmond Barry, exhibition commissioner and chairman of the Library Trustees, to the Victorian municipalities for images that represented 'the most striking objects of interest in their district'. In line with Barry's aims for the exhibition, Jenkinson's photographs document the expansion and growth of the colony. With Weekes, his business partner, Jenkinson subsequently travelled to Maryborough and Carisbrook, before leaving the colony in 1862.

—

Jerrems, Carol
1949-80

Carol Jerrems was an artist who worked in Melbourne, Sydney and Tasmania. She studied photography at the Prahran Technical School in Melbourne from 1967 to 1970 where she was an outstanding student and recipient of numerous awards. As an artist, Jerrems' work developed within the context of second-wave feminism. She focused on the documentary and then expressive possibilities of photographs of people, often creating staged tableaux that speak to identity and anxiety. Working in collaboration with her sitters, she attempted to avoid the exploitative qualities of documentary photography to try to reveal something about the individual. Considering her images 'ways of bringing people together', she used photography to promote interpersonal communication. In 1974 Jerrems contributed the photographs to the publication *About Australian women*, published with Virginia Fraser. With their desire to create social change, Jerrems' photographs express the counterculture optimism of the 1970s.

—

Johnstone, O'Shannessy & Co
active 1864-93

Johnstone, O'Shannessy & Co was a leading Melbourne photographic firm established by Henry James Johnstone and Emily Florence Kate O'Shaugnessy (spelt O'Shannessy in the firm's stamp). Charismatic and flamboyant Johnstone took outdoor photographs and portraits of male notables, while O'Shaugnessy, who had previously operated her own studio, photographed female sitters and supplied the darkroom expertise, colouring and developing the negatives. The firm received a medal at the 1866 Melbourne Intercolonial Exhibition for their coloured, plain and 'mezzotint' photographic portraits. They also exhibited photographs on porcelain coloured in oil and watercolour at the Philadelphia Centennial Exhibition in 1876. At the 1888 Centennial International Exhibition in Melbourne, the firm installed a special pavilion for the display of photographs in all processes, lavishly decorated with satin-covered walls and a miniature fountain.

Jones, Henry
1826-1911

Henry Jones was a professional photographer based in Melbourne and Adelaide. Born in England in 1826, he arrived in Victoria with his family in the late 1850s. In 1859 he established a studio, advertising his services as a daguerreotypist and photographic artist, and began producing pannotypes – photographs printed on leather which were possible to send through the post. Jones worked from a number of different addresses in Melbourne before moving to Adelaide to work as a camera operator for **Townsend Duryea** in 1866. In 1870 he opened his own studio in Adelaide in conjunction with a watchmaking and jewellery business. From this location Jones produced a pair of large mosaics, composite images made of hundreds of tiny paper photographs of men and women who had attended the 'Old Colonists' banquet in 1871. The mosaics were received as valuable mementos of the pioneer colonists of South Australia. On the strength of this project, Jones received a vice-regal commission to photograph the governor of South Australia, Sir Anthony Musgrave. In addition to his official, memorial work, Jones also specialised in photographs of children, and renamed his firm The Children's Photographic Company in 1879.

—

Kent, Milton
1888-1965

Milton Kent was a professional photographer and pilot with a studio in Sydney. He worked for the Australian federal government, the Sydney City Council and various other commercial and industrial organisations. Around 1900 Kent was commissioned to photograph smoke hazards and old buildings destined to be condemned and demolished by the Sydney City Council. His photographs offer evidence of dereliction and form the bulk of the 'Condemnations and Demolitions Books', a photographic record of the city's state of repair. In 1926 Kent obtained his pilot's licence and began taking aerial photographs of Sydney and its suburbs using glass-plate negatives. After his death in 1965, Kent's studio was run by son Lindsay until it was sold to Ernest Dorn in 1971.

—

Kerr, John Hunter
1821-74

John Hunter Kerr was a pastoralist, collector and amateur photographer based in Victoria. Born in Edinburgh, he arrived in Melbourne in 1839, taking up land near Heidelberg. The 1840s Depression forced him to return to Scotland for two years in 1847. Back in the colony in 1849, he purchased a property on the plains of the Loddon River in northern Victoria, although he was not a successful squatter. His station was close to an Aboriginal camp, to which he was a frequent visitor, eager to learn about the customs of the Murray and Loddon people. Kerr was a keen photographer and used the medium to make records of Aboriginal people, weapons and ceremonies, some of which were staged at Kerr's request. His photographs of individuals depart from the ethnographic model and suggest cultural exchanges occurring between the station-dwellers and the traditional land-owners. Kerr was a collector of Aboriginal artefacts and was the first to systematically display them to colonial, British and French audiences in the world exhibitions. In 1872, Kerr published *Glimpses of life in Victoria by a resident* in Edinburgh, which was illustrated with prints after his photographs.

Kerry, Charles
1857–1928 and
Kerry & Co
active 1893–1913

Charles Kerry was a professional photographer and owner of the successful photographic firm Kerry & Co. Born in Bombala, New South Wales, Kerry joined the small portrait studio of Alexander Henry Lamartiniere in 1874 and was made a partner in 1883. After Lamartiniere absconded from the business in 1884, taking Kerry's capital with him, Kerry ran the company in partnership with CD Jones. This eventually became Kerry & Co, the largest firm in the colony. In Kerry's hands, the company specialised in views, employing photographers assigned to different subjects: Harold Bradley and William van der Velden specialised in city views, George Bell in country views. In addition, the firm produced portraits of Aboriginal people and ceremonies for the 1886 Colonial and Indian Exhibition in London, photographed pastoral stations, and captured the interiors of the Jenolan and Yarrangobilly caves using candlelight and magnesium flash. By 1900 Kerry & Co were in charge of the major illustrations for the Sydney press. Kerry retired in 1913 to dedicate himself to mining interests in Malaysia and Thailand. He was also a pioneer snow sportsman and contributed to establishment of ski fields in the Jindabyne and Kosciusko area.

—

Kilburn, Douglas Thomas
c1813–71

Douglas Kilburn was one of the earliest and most celebrated daguerreotypists in Melbourne and Sydney. Born in England, Kilburn arrived in Melbourne in 1847, where he opened the city's first daguerreotype studio. Kilburn was the younger brother of London photographer William Edward Kilburn, who had photographed the Royal family in 1846 and 1852, a connection that Douglas freely advertised. In Melbourne he made portraits of Aboriginal people from the Port Phillip area which were engraved to illustrate William Westgarth's *Australia felix* (Edinburgh, 1858) and appeared in the *Illustrated London News* in 1850. Kilburn moved to Sydney in 1849, where he was patronised by well-to-do settlers, producing numbers of finely coloured daguerreotype portraits. In 1850 he went to London to study the latest photographic techniques with his brother; on his return, he settled in Hobart where he made demonstrations of stereoscopic photography, the first in the Australian colonies. His Tasmanian portraits and views were exhibited in Paris in 1855, although Kilburn was concerned that they would be compared unfavourably with European and British productions. Kilburn served as a member of the Tasmanian parliament from 1861 to 1862, and as a photographer for the Melbourne *Argus* from 1862 to 1870.

—

King, Henry
1855–1923

Henry King was a successful and prolific Sydney-based professional photographer who trained in the studios of **John Hubert Newman** before establishing his own studio in 1880. Born in England around 1855, he came to New South Wales about 1857. He travelled widely throughout eastern Australia, primarily photographing Aboriginal people. At the World's Columbian Exposition in Chicago in 1893 he was awarded a certificate and bronze medal. With the invention of the dry-plate process he spent more time on street scenes and views. After his death, King's collection of negatives

was purchased by JR Tyrell and now resides at the Powerhouse Museum, Sydney. In 1975 an exhibition of his Aboriginal portraits was held at the Australian Centre for Photography, Sydney.

—

Konrad, Louis
active 1896–1905

Louis Konrad was a professional photographer based in Launceston, Tasmania. His studio was the location of a photograph staged by Thomas Hinton, who adopted various poses in costume before an elaborately designed set featuring Australian heraldry. The photographs appear to have been dedicated to a Miss Headlam, whom Hinton admired. Interpreted as indecent, however, the photographs resulted in Hinton's hospitalisation for delusions and paranoia.

—

Kruger, Fred (Johan Friedrich Carl)
1831–88

Fred Kruger was a professional photographer based in Geelong. Born in Berlin, he arrived in Australia by 1863, where he joined his brother Bernard as a partner in a Melbourne-based furniture business. In 1866 Kruger opened a photographic studio and in the same year photographed the Aboriginal Australian cricket team that toured England in 1868. Kruger became known as a skilful landscape photographer and his views of the Melbourne area were exhibited to international acclaim in Vienna in 1872 and Philadelphia in 1876. In 1877 he was commissioned by the Victorian Board for the Protection of Aborigines to photograph the Coranderrk Aboriginal Mission Station. The photographs, including a famous image of a cricket match, were compiled into an album and published in 1883. Through the 1870s and '80s Kruger continued to take view photographs, including a three-metre panorama of Geelong and numerous images of estates commissioned by property owners. Conscious of the need to attract business from a local clientele, he often photographed disasters in the Geelong area such as the flooding of the Barwon River and the shipwrecks of the *George Roper* and the *Glanseuse* at Point Lonsdale in 1883 and 1886 respectively.

—

L Lange & Son
active 1881–91

Photographic firm in Majorca, Victoria.

—

Laing, Rosemary
1959–

Rosemary Laing is an artist based in Sydney. Born in Brisbane, she studied art and art education in Brisbane, Hobart, and Sydney, and has exhibited extensively in Australia and overseas since the 1980s. Many of Laing's photographs explore the nature of place, from airports to rainforests and deserts. She has collaborated with astrophysicists, airline employees, film-stunt producers and artists to produce her photographs, which often combine contradictory objects and images, such as commercially woven carpets on a forest floor, or a bride floating in mid-air. In many of her photographs of landscapes she has addressed the history of colonisation in Australia, exploring the nature of habitation and domestication.

—

Lambert, Helen
active c1868–70

Helen Lambert was the wife of Commodore Rowley Lambert, a senior officer of the Royal Navy. She and her husband arrived in Australia in 1867, where

Rowley Lambert was appointed the commander-in-chief of the Royal Navy's Australia Station, and then returned to England in 1870 or 1871. She is thought to be the compiler of an album of photographs, *Who and what we saw in the Antipodes* (1868–70), which features portraits and views taken in Sydney, Hobart and Melbourne. While Lambert is believed not to have taken the photographs, she probably decided their compositional arrangement and the decoration of the page, which conveys the status and identity of those pictured.

—

Lewis, Jon
1950–

Jon Lewis is a photographer based in New South Wales. He was a member of the Yellow House in the early 1970s, an artist's community established by Martin Sharp in Sydney's Kings Cross. Lewis was given his first camera by Sharp, and his experience of the Yellow House collective cemented his interest in art and photography. In the late 1970s Lewis combined photography with activism, travelling to Albany in Western Australia to protest against whaling and to become, in 1977, a founding member of Greenpeace Australia. Lewis has exhibited extensively in Australia and abroad since 1974 and has made photographic expeditions to Indonesia, Paris, East Timor, Bougainville and Kiribati, as well as numerous locations in rural and outback Australia.

—

Liddell, William J
active c1863–84

William Liddell was a professional photographer who opened a Sydney studio in 1863. He went into partnership with A Blitz from 1864 to 1865, after which he went to South Australia and worked for the American Photographic Company. By 1883–84 he appears to have been working in West Maitland under the name of Liddell & Cooper.

—

Lindt, JW (John William)
1845–1926

JW Lindt was a professional photographer and amateur ethnographer. Born in Frankfurt am Main, Germany, he arrived in Australia in 1862, where he worked initially as a travelling piano tuner and repairer in country New South Wales and Victoria. In the late 1860s he worked as an assistant in the Grafton studio of **Conrad Wagner**. He took over as manager in 1868 and opened a second, more luxurious studio in 1870, producing portraits and views of paddle-steamers, wool drays, sheep stations and local goldmines. In 1873–74 Lindt produced a series of studio portraits of Aboriginal people from the Clarence River area posed in elaborate tableaux against painted backdrops. Despite their obvious artifice, the photographs were considered 'truthful' likenesses and purchased by the government of New South Wales for presentation to museums in Britain. In 1877 Lindt established himself in Melbourne, producing images of the new public buildings, gardens, ports and people. In 1880 he was commissioned to photograph the capture of the Kelly Gang at Glenrowan. Lindt was a keen ethnographer and undertook expeditions to New Guinea, the New Hebrides and Fiji in the 1880s and '90s. The depression forced him to close his studio in 1895.

—

Lomer, Albert
active c1865–95

Professional photographer based in Brisbane, Sydney, Melbourne, Mackay and Toowoomba.

McDonald, Archibald
c1831-73

Archibald McDonald was a professional photographer based in Melbourne. Born in Nova Scotia, Canada, he arrived in Melbourne in 1847. By 1852 he was working in partnership with the entrepreneurial photographer **Townsend Duryea**. They jointly exhibited daguerreotypes at the 1854 Melbourne Exhibition, for which they won a medal. The pair travelled to Tasmania in 1854, opening a studio in Launceston. McDonald opened his own studio in Melbourne in 1860 where he specialised in cartes de visite. He produced sixty-nine cartes de visite portraits of Roman Catholic prelates and priests as well as local celebrities, including Chang the Chinese Giant. He also photographed views and local Aboriginal groups. McDonald received a first-class certificate at the 1861 Victorian Exhibition for his daguerreotype portraits and honourable mentions for his photographs at the 1866 Melbourne Intercolonial Exhibition. In 1873 McDonald died in a dressing-room accident after severing an artery on a cracked porcelain sink, but the business was continued by his widow Clara and his brother Alexander until the late 1890s.

McNaught, Rowan

See **Pound, Patrick**.
—

Manning, James
b1845; active 1860s-91

James Manning was a professional photographer and clerk who arrived in Western Australia with his family in 1850. Manning's father, James senior, was a civil engineer and had been appointed clerk of works to oversee penal facilities. Manning was initially employed as a clerk in the Postmaster General's Department. He turned to photography in the early 1860s, going into partnership with a fellow photographer called Knight. He toured Europe to learn of the newest developments in photography in 1867 and on his return worked as an itinerant photographer in Victoria and Western Australia. In the 1870s he ran a successful portrait studio in Perth popular with the well-to-do, continuing there until 1891.
—

Marchand, Annie
1846-1901; active 1866-72

Professional photographer and proprietor of the Royal Photographic Company in Portland, Victoria.
—

Marchant, Philip James
1846-1910

Philip J Marchant was a professional photographer based in South Australia. Born in Devon, England, in 1861 he arrived with his family in Gawler, South Australia. He learnt the techniques of wet-plate photography as a teenager, and in 1864 set off with two companions as an itinerant photographer. Carrying a piece of carpet and a backdrop to create the illusion of a studio setting, they took portraits and views in townships throughout the colony. In 1866 Marchant established a studio in Adelaide, advertising 'good and cheap' portraits. Around this time he produced a double portrait of himself as both photographer and client. The image was celebrated for the cleverness of its illusion, which betrayed no sign of the two separate negatives used. By 1880 Marchant was manufacturing and selling the first commercially produced dry plates in Australia: his 'Adelaide Instantaneous Dry Plates' were used by many professional photographers in Adelaide. In 1887 Marchant and his family moved to Latrobe,

Tasmania. Business was slow, however, and in 1895 they returned to Gawler. Marchant continued to work in South Australia until his death in 1910; the business was then managed by his son, Samuel Bowering Marchant.
—

Maynard, Ricky
1953-

Ricky Maynard is an artist and descendent of the Big River and Ben Lomond people. Maynard began working with photography as a darkroom technician in Melbourne in 1969, an experience that gave him a firm grasp of the technical aspects of the medium. He undertook a three year traineeship as a photographer from 1983 at the Australian Institute of Aboriginal and Torres Strait Islander Studies in Canberra. In 1985, in the lead-up to the 1988 Bicentenary of arrival of the First Fleet, he was commissioned, along with nineteen other photographers, to contribute to *After 200 years*. The project aimed to present positive images of Aboriginal people and to counter a largely negative and stereotypical history of photographic representation. Maynard contributed *The moonbird people* 1985–88 a series of images of community members in the mutton birding season. With this and subsequent series, Maynard has depicted, sometimes in large scale black and white photographs, people and places that emphasise the survival and continuity of Aboriginal culture and community. He inflects the documentary style with humanism and compassion, seeking to portray Aboriginal people in accurate and dignified ways.
—

Milligan, Joseph-Charles and Thomas
active 1862-71

Joseph-Charles and Thomas Milligan were professional photographers who operated the London Portrait Saloon (later known as Milligan Brothers) in Sydney from 1862, specialising in inexpensive cartes de visite.
—

Moffatt, Tracey
1960-

Tracey Moffatt is an artist and filmmaker. Born in Brisbane, she was educated at Queensland College of Art, graduating in 1982. Since the exhibition of her breakthrough series *Something more* in 1989 she has exhibited in museums and galleries all over the world. In 1990 her short film *Night cries* was selected for official competition in the Cannes Film Festival and in 1997 she exhibited in the Aperto section of the Venice Biennale. Her international reputation was consolidated with a major exhibition at the Dia Center for the Arts in New York City 1997–98 and in 2007 she received the Infinity Award for outstanding achievement in photography from the International Center for Photography in New York. Moffatt often works in a quasi-narrative style, exploring the conventions of storytelling and myth-making. Her stylised images weave personal memory and fantasy with the history of art and photography.
—

Moore, David
1927-2003

David Moore was Australia's most renowned and widely travelled documentary photographer. He began working in 1947 in the commercial advertising studio of Russell Roberts. Between 1948 and 1951 he assisted **Max Dupain**, and began to develop his own approach to the documentary style, walking the streets of depressed inner-city suburbs of Sydney taking still photographs. Moore's *Redfern interior*

1949 was included in Edward Steichen's *Family of man* exhibition, which toured internationally from 1955. Moore was one of two Australians to be included. In 1951 Moore turned down the offer of partnership with Dupain and moved to London to work for international picture magazines including the *Observer*, the *New York Times*, *Time-Life*, *Look*, and *Sports Illustrated*. From 1958 he travelled the world for the New York agency, Black Star. His international assignments took him to Asia, America, Antarctica and Africa until the 1980s. Moore's photographs are held in Australian and international collections including the Museum of Modern Art, New York, Bibliothèque Nationale de France, Paris, and the Smithsonian, Washington, DC.
—

Moore, SF
active c1860-90s

SF Moore was a professional photographer who worked in towns in rural New South Wales, including Newcastle, Camden, Tamworth and Orange, and Auburn in South Australia.
—

Morris, Alfred
active 1859-73

Alfred Morris was a professional photographer who worked in Tasmania and Melbourne. By 1859 he had a studio in Melbourne and around 1864 opened an offshoot of the firm as Messrs Morris and Co. The latter company produced photographs of the railways and viaducts in Melbourne and Sandhurst which were lithographed and published in the *Illustrated London News* in 1864. Morris & Co showed examples of the firm's work in the 1873 London International Exhibition.
—

Morris Moss & Co
active 1867-89

Photographic firm based in Sydney and Maitland.
—

Moser, Herman
1838-1905

Herman Moser was a professional photographer and jeweller. Born in Germany, he immigrated to Australia with his family in 1848 and settled in South Australia. In the late 1850s he established himself as a jeweller in the gold-mining town of Ballarat and by 1866 was running a photographic studio. Moser was commissioned to take views of Ballarat for exhibition at the 1866 Intercolonial Exhibition of Australasia in Melbourne. He showed photographs at the Vienna and London exhibitions of 1873, which were awarded a gold medal at the latter. In 1876 Moser gave up his photographic business for farming.
—

Mountford, Charles Pearcy
1890-1976

Charles P Mountford was an anthropologist and amateur photographer. Born in Hallett, South Australia, he trained as an electrical mechanic, and in 1920 was senior telephone mechanic at the Darwin Post Office. His contact with people at the Kahlin Compound sparked his interest in Aboriginal culture. Returning to Adelaide in 1925 he made tracings of Aboriginal rock-carvings near his parents' Peterborough farm and, in 1926, with Norman Tindale of the South Australian Museum, published a paper on the carvings, establishing his credentials as an anthropologist. With Tindale, CJ Hackett and the cinematographer EO Stocker, Mountford undertook an expedition to the Warburton Ranges, Western Australia, in 1935, making photographs and crayon drawings of sites and dreaming tracks. In 1937 he joined another expedition to Nepabunna

Mission in South Australia where he took photographs and made recordings on mythology and social customs, creating a considerable record of the Adnyamathanha people. Throughout the 1940s and '50s Mountford continued to amass research into the art and culture of the Aboriginal people of central Australia through further expeditions. In the 1960s and '70s his work was published in a number of books and films.

—

Müller, Heinrich (Henry)
active c1866–77

Henry Müller was a professional photographer based in the Queensland goldfields. He established a studio in Toowoomba around 1866 but travelled throughout rural Queensland in the 1870s.

—

Nagel, Edward
active 1885–95

Edward Nagel was a professional photographer based in Sydney and proprietor of the firm Nagel & Co.

—

Nelson, Mrs E
active 1878–84

Mrs E Nelson was a professional photographer based in Bathurst and proprietor of Nelson's Saloon.

—

Nelson, William
active 1872

Professional photographer based in Bathurst.

—

Nettleton, Charles
1825–1902

Charles Nettleton was a professional photographer born in the north of England who arrived in Australia in 1854, settling in Melbourne. He joined the studio of **Townsend Duryea** and **Archibald McDonald**, where he specialised in outdoor photography. Nettleton is credited with having photographed the first Australian steam train when the private Melbourne–Sandridge (Port Melbourne) line was opened on 12 September 1854. Nettleton established his own studio in 1858, offering the first souvenir albums to the Melbourne public. He worked as an official photographer to the Victorian government and the City of Melbourne Corporation from the late 1850s to the late 1890s, documenting Melbourne's growth from a colonial town to a booming metropolis. He photographed public buildings, sewerage and water systems, bridges, viaducts, roads, wharves, and the construction of the Royal Botanical Gardens. In 1861 he boarded the *Great Britain* to photograph the first English cricket team to visit Australia and in 1867 was appointed official photographer of the Victorian visit of the Duke of Edinburgh. For the Victorian police he photographed the bushranger Ned Kelly in 1880. This is considered to be the only genuine photograph of the outlaw.

—

Nevin, Thomas J
1842–1923

Thomas J Nevin was a commercial photographer based in Tasmania. Born near Belfast, Ireland, he arrived in Australia in 1852, settling in Kangaroo Valley, Tasmania. In the early 1860s he worked in the Hobart studio of **Alfred Bock**. With partner Robert Smith, he formed the firm Nevin and Smith, and in 1868 was commissioned to make an album of Tasmanian children to be presented to the Duke of Edinburgh. By 1873 Nevin had two commercial studios in Hobart, producing stereographs and cartes de visite, and was working for the Hobart municipal police. Nevin was one of the first photographers to work with the police in Australia.

In 1873 he was contracted to provide prisoner identification photographs for the central registry of the Inspector of Police and began photographing inmates at the Port Arthur Penitentiary. While maintaining his commercial photographic practice, in 1876 Nevin was promoted to office keeper of the Hobart Town Hall, where he managed the city archives, a position he maintained until 1887. From the 1890s, Nevin increasingly dedicated himself to training horses.

—

Newland, JW
active c1848–54

JW Newland was an itinerant professional photographer. He came to Australia in 1848, setting up a portrait studio in Sydney, where he competed with Australia's first resident photographer, **George Goodman**. Before arriving in Australia, Newland had made photographic expeditions to Fiji, New Zealand, Peru and Chile, and in his Sydney premises opened a 'Daguerreian Gallery' to exhibit over 200 views and portraits taken on his travels in the southern hemisphere. Newland also staged magic-lantern displays of views of monuments and scenery from Europe and Britain, which were accompanied by music, as well as a moving diorama on rollers of illuminated scenery almost three kilometres long. Having spent six months in Sydney, Newland moved to Tasmania in September 1848 advertising daguerreotype portraits and exhibiting his photographs of exotic locations. In Tasmania, Newland took Australia's earliest extant view photograph showing the public buildings in Murray Street, the wharf and a corner of the old gaol of Hobart Town. Newland left Australia in December 1848. He was next recorded as the proprietor of a studio in Calcutta, India, between 1852 and 1854.

—

Newman, John Hubert
1830–1916

John Hubert Newman was a professional photographer based in Sydney. He visited Europe in 1860 and received lessons in photography in Paris. In 1862, on his return to Sydney, he worked in the studio of Bradley & Allen. He opened his own studio and gallery in 1863 called Newman's New Photographic Gallery. He was a celebrated photographer and won a number of prizes at various national and international exhibitions. Although declared bankrupt in 1893, he recovered enough to open the Newman Atelier in 1894, where he remained until 1900.

—

Nicholas, Collan
active 1869–1914

Professional photographer Collan Nicholas was based in Launceston, Tasmania, between 1869 and 1903 and Mackay, Queensland, from 1904 to 1914. His practice was one of several locations for the staging of an elaborate tableau by Thomas Hinton (see **Duval and Co**; **Louis Konrad**)

—

Nicholas, George H
active c1855–98

George Nicholas was an itinerant photographer in Sydney and rural New South Wales, active in Cootamundra (c1855 and 1887–98), Sydney (c1860–84), Murrumbarrah (c1887), West Maitland (c1860s–90s) and Temora (1896–97).

—

Nicol, Albert
active 1863–68

Professional itinerant photographer who worked throughout northern New South Wales and southern Queensland.

Nixon, Francis Russell
1803–79

Francis Nixon was an Anglican bishop, amateur painter and photographer. He was consecrated as first Bishop of Tasmania at Westminster Abbey in 1842 and arrived in Hobart Town with his family the following year. In addition to his episcopal duties, Nixon sketched and painted with keen interest, using drawing as a way of recording places encountered on travels throughout his diocese. His *Cruise of the Beacon: a narrative of a visit to the islands of Bass Strait* (1854) is an account of one of his northern Tasmanian journeys and contains ten illustrations after his original sketches. He was a member of the Hobart Town Sketching Club and part of the organising committee of an art exhibition in the Hobart Town legislative Council Chambers in 1845, to which he contributed seven artworks. Nixon made large numbers of wet-plate photographs, few of which survive. **JW Beattie** printed Nixon's work subsequently. In 1858 he photographed Aboriginal people at Oyster Cove with a stereoscopic camera and these were inserted into his own personal copy of *Cruise of the Beacon*. Nixon returned to England in 1862 due to ill health and resigned his bishopric in 1863.

—

Nixon, Samuel
1847–1922
Nixon, Stephen
1842–1910

Samuel Nixon was an itinerant professional photographer. Born in England, he arrived in Australia with his family in 1855, who settled in Adelaide. Nixon and his two brothers, Stephen and Joseph, went into business as photographers in the early 1860s, trading as Nixon Brothers. In 1869 Nixon travelled to Saddleworth, taking portraits of the local people, and returned to the township again in 1871. Nixon probably moved to New South Wales in the 1870s, where he took up residence near Deniliquin. Stephen Nixon took over the Nixon Brothers partnership in 1867, working in the South Australian copper-mining towns of Moonta, Kadina, Yorketown and Tanunda from the early 1870s until the mid 1890s.

—

Norton, Charles
1826–72

Charles Norton was an artist and civil servant. Born in England, he arrived in Victoria with his father in 1842. Norton purchased a number of properties, but moved to Melbourne in 1850 where he found employment as a clerk in the treasury. He exhibited his watercolour landscapes and still lifes to acclaim at the 1862 Melbourne Exhibition of Fine Arts. It is likely that he also worked as an architectural draughtsman for his wife's brother-in-law, John Gill, where he put to use his skills in drawing. Norton may have taken a number of photographs of his family and estate in the 1850s, including a portrait of John Gill.

—

Norton, Wykes
active 1882–92

Professional photographer based in Sydney and proprietor of the Royal Studio.

—

NSW Government Printer
active 1840–1989

The New South Wales Government Printing Office was founded in 1840 to print promotional and documentary images for state parliament, government departments and other organisations. A photographic studio was added in 1860 and the

first photographs produced were intended to advertise the progress of the colony, focusing largely on public buildings and local scenery. Commissioning departments included Main Roads, Agriculture, Health and the Tourist Bureau. The first official government photographer was John Sharkey, who was employed in 1863. By 1889 the photographic department had a staff of twenty-one (see also **William Applegate Gullick**). The photographs taken by the NSW Government Printer, as well as examples of printing, bookbinding and photolithography, were exhibited at numerous exhibitions, including the 1870 Intercolonial Exhibition and the 1879–80 International Exhibition, both in Sydney. The New South Wales Government Printing Office closed in 1989.

—

Paine, John
1833–c1908

John Paine was a successful commercial photographer based in Sydney. Born in England, he arrived in New South Wales in the 1860s. After working as a photographer around Tamworth, New South Wales, from about 1869 to 1874, he established a studio in Sydney in 1875, advertising views of the city and the Blue Mountains. Paine took hundreds of views of Sydney; in 1875 the *Sydney Morning Herald* announced the sale of '500 views of the City, Harbour, Botanic Gardens and Public Buildings of Sydney' by John Paine, along with views of the Blue Mountains and regional New South Wales. Paine was awarded a silver medal at the Sydney International Exhibition in 1879–80 and later exhibited at colonial and international exhibitions in Amsterdam (1883), Calcutta (1883–84) and London (1886). In 1884 he travelled with Augustine Dyer, head of the photomechanical branch of the New South Wales Government Printing Office, to record the establishment of the British protectorate over southeast New Guinea. The trip resulted in the lavish publication *Narrative of the expedition of the Australian Squadron to the south-east coast of New Guinea* 1885.

—

Parker, William
active 1867–69

Professional photographer based in Dunolly, Victoria.

—

Paterson Brothers
active 1858–66, 1869–93

Paterson Brothers was a Melbourne-based photographic firm established in 1858 by William and Archibald Paterson. The brothers worked independently between 1866 and 1868, but resumed their partnership from 1869 to 1893. They specialised in portraits, views, and cartes de visite and received honourable mention for their 'Untouched and Coloured Portraits and Photographic Views' at the 1866 Intercolonial Exhibition of Australasia in Melbourne.

—

Perrin, Florence
c1885–1952

Florence Perrin was a Tasmanian photographer, pioneer bushwalker and naturalist. She was a founding member of the Northern Tasmania Alpine Club and was the first European woman to climb many peaks in the Cradle Mountain and Lake St Clair region. Finding the Northern Tasmania Camera Club male-dominated and oppressive, Perrin organised her own independent photographic excursions into the west Tasmanian bush. Perrin also collected seaweeds and co-authored *Seaweeds of South Australia* with AHS Lucas (1936), and lectured to the Royal Society on the topic. She was

editor of the periodical *Tasmanian Country Woman*, an active member of the Launceston Horticultural Society and collected nearly every orchid native to Tasmania.

—

Poignant, Axel
1906–86

Axel Poignant was a professional photographer and cinematographer. Born in England, he arrived in Australia in 1926 seeking work and adventure. After tough early years of unemployment and homelessness, he settled in Perth and found work as a portrait photographer around 1933. In the 1930s he developed an innovative style of close-ups, low vantage points and unexpected angles, extending his subject matter to dance, theatre and natural history. In 1941 he exhibited his work in Perth with his photographer friend Hal Missingham. During a trip along the Canning Stock Route in 1942, however, Poignant discovered an intense affinity with the landscape and the Aboriginal people he encountered and resolved to work in a documentary style of still and moving photography. Poignant began working in cinematography in the 1940s and in 1947 shot *Namatjira the painter* with the Commonwealth Film Unit. In the 1950s he produced nearly 2500 photographs of individuals, family and daily activities in Arnhem Land, attempting to document ways of life at Liverpool River and Milingimbi. In 1956 Poignant returned to England where he worked as a freelance photographer for the British Broadcasting Corporation, various British newspapers and *Life* magazine.

—

Pound, Patrick
1962–

New Zealand-born and Melbourne-based, Patrick Pound is an artist and collector. He makes installations and web-based displays out of his collections, which constitute a vast archive of found photographs, photographic paraphernalia and ephemera. He collects and organises these photographs and objects according to unexpected categories, including wind, air, space, round things, interruptions, photographs of people holding photographs, photographs including photographer's shadows, and images of amateur models whose bodies bear the impression of socks and waist bands. For Pound, collecting is a mode of artistic practice and the identification and formation of categories reveals ways of understanding human behaviour and the construction of abstract concepts. His classifications are myriad and overlapping; Pound says he is 'interested in the extremes of listing and sorting out the world in words and in pictures' and speaks of the world as puzzle that might be solved by collecting, organising and assembling all of its pieces.

Pound has collaborated with artist, editor and designer Rowan McNaught on several web-based projects. McNaught's largely online practice explores the cultural and material qualities of the internet. He is designer and managing editor of *West Space Journal*, runs the online artist community TLSC, and co-manages Brothersister Records, an artist-run music label.

—

Reynolds, WM
active 1889–90

Professional photographer based in Katoomba, New South Wales.

—

Riley, Michael
1960–2004

Michael Riley was a photographer, video artist, documentary filmmaker and a Kamilaroi/Wiradjuri man. Born in Dubbo, Riley began experimenting with

photography in his early teens and in 1982 enrolled in a photography course with Bruce Hart at the Tin Sheds, University of Sydney. He subsequently worked as a darkroom technician at Sydney College of Arts. Riley's early photographs were documentary images of Aboriginal people from the Redfern community that deliberately countered negative and stereotypical images of Indigenous people in the press. In 1986 he participated in the NADOC '86 Group Exhibition of Aboriginal and Islander Photographers at the Aboriginal Artists Gallery, Sydney. The following year Riley was one of nine Sydney-based Indigenous artists to found the Boomalli Aboriginal Artists Co-operative. Riley's photographs and films focus upon Indigenous people's struggles in the wake of colonisation and explore themes related to religion, land and forms of social injustice. In the 1990s he made a number of documentary films for the Australian Broadcasting Commission. His work has been widely exhibited in biennales, group exhibitions and major solo retrospectives and is held in national and international collections.

—

Roarty, J
active 1871–91

Professional photographer based in Sydney, also known as J Rourty.

—

Robert W Newman, & Co
active 1870–81

Photographic firm based in Sydney.

—

Robinson, William
active c1850–90

William Robinson was a professional photographer active in Melbourne in the 1850s and the United Kingdom in the 1880s and '90s. Robinson worked for Negretti & Zambra, official photographers to the Crystal Palace Company, in the 1880s. In 1884 he photographed the members of RA Cunningham's Australian Aboriginal international touring company.

—

Russell, Henry Chamberlain (HC)
1836–1907

Henry Chamberlain Russell was an astronomer and meteorologist. He graduated from the University of Sydney in 1859 and was employed at the Sydney Observatory the following year, succeeding GR Smalley as government astronomer in 1870. Russell reorganised the observatory for systematic work on star positions and clusters and made significant use of photography in recording and promoting astronomical and meteorological events. In 1874 he observed and photographed the transit of Venus in Sydney, having attached a portrait lens camera with wet collodion plates to the end of a special kind of telescope called an astrograph. He showed the results to the Royal Astronomical Society in England where they were greatly admired. In 1887 Russell attended the first international conference of astronomers in Paris and committed Australia to the Carte du Ciel, or 'map of the stars' project using photography. In 1890, a new instrument, which he called the Star Camera, was installed at the observatory and used to take photographs of the portion of the sky allotted to him. The photographs taken using the instrument were published in 1892. Russell retired in 1904 after a serious illness and died in 1907.

—

San Francisco Photo Co
active 1880s

Photographic firm based in Sydney, New South Wales, managed by Solomon Flohm.

Sargent, William
active 1886-91

Professional photographer with a studio in Manly, New South Wales.

—

Scott, David
active c1857-91

David Scott was a professional photographer based in Sydney. He was trained in the studio of Edwin Dalton in 1857 and opened his own premises in Sydney the following year. Scott specialised in portraits and was inventive in his use of many different photographic processes, including dry plate, autotype and gelatin silver.

—

Scott, Eugene Montagu
1835-1909

Montagu Scott was a professional photographer, painter, illustrator and cartoonist. Born in London, he immigrated to Australia in the 1850s, settling briefly in the Victorian goldfields. In 1866 he relocated to Sydney to take up the position of chief cartoonist for *Sydney Punch*. He was employed in Edwin Dalton 's studio in 1866 and continued to operate as a photographer in Sydney into the 1870s. During this period he also supplied illustrations for the *Illustrated Sydney News*.

—

Short, James Walter
1865-1943

James Short was an astronomical photographer in the employ of Sydney Observatory. He was appointed to the Observatory in 1890 to work with Henry Chamberlain Russell on the international mapping of the stars project, the Carte du Ciel. From 1898 to 1930 he operated the Red Hill Observatory in Pennant Hills outside of Sydney, where he continued to work on the Carte du Ciel, taking advantage of the clear skies to make numerous glass-plate negatives of stars. The compounding effects of Short's retirement and the Great Depression led to closure of the Pennant Hills observatory in 1931.

—

Short, William
1833-1917

William Short was a professional photographer and painter. Born in England, in 1852 he came to Australia with his family, who settled in Melbourne. After struggling to find a market for his oil paintings, Short opened a photographic studio in 1863, advertising a new technique for reducing exposure times suitable for photographing babies. Short was more successful as a photographer than as a painter and maintained his Melbourne business into the 1880s, although he was also active near Bendigo, Victoria, in the late 1880s and early 1890s.

—

Smith, Professor John
1821-85

John Smith was a scientist and amateur photographer. Born in Scotland, Smith first travelled to Australia in 1847, and settled in Sydney in 1852 to take up the post of foundation professor of chemistry and experimental physics at the University of Sydney. At the university, Smith illustrated his lectures with examples of his own of photography. Smith began taking photographs as chairman of the New South Wales Water Board, using the medium to document his travels around the remote parts of the state. The majority of his photographs were taken between 1854 and 1862 and primarily depict family groups, picnic scenes, geological subjects, views of Sydney Harbour, some Tasmanian scenes

and the construction of the University of Sydney. Many of Smith's photographs are consciously artistic, posing women with classical statues and arranging figures in carefully orchestrated groups. Smith took a strong interest in public matters, advocating the admission of women to the University of Sydney. He worked to secure a sustainable fresh water supply to the growing city and promoted non-denominational primary school education.

—

Smith, R Dermer
active 1860-1900

Professional photographer active in Melbourne, Sandhurst and Bendigo in Victoria.

—

Smithies, Frederick
1885-1979

Fred Smithies was a pioneer bushwalker and photographer based in Tasmania. Born in Ulverstone, Tasmania, he was committed to exploring the state and promoting its natural beauties. Smithies took numerous dramatic stereoscopic photographs of the Cradle Mountain and Lake St Clair region. He was also an early user of 16mm motion-picture film and the 'waistcoat' camera. As Scenery Preservation Board chairman, Smithies publicised the Tasmanian wilderness and promoted the establishment of reserves and national parks through public lectures and photographs. From the 1920s he gave lantern-slide lectures in various states on behalf of the Tasmanian government to encourage tourism and in 1935 he organised the Tasmanian display at the Melbourne Centenary Exhibition. In 1930 he married the naturalist Florence Perrin; from the 1950s they lived and ran cattle at St Leonards.

—

Souter, J
active c1873

Professional photographer based in Gulgong New South Wales.

—

Spencer, Walter Baldwin
1860-1929

Walter Baldwin Spencer was an evolutionary biologist, anthropologist and amateur photographer. Born in 1860 in Lancashire, he immigrated to Australia in 1887 to take up the chair of biology at Melbourne University. In 1896 Spencer, with ethnologist FJ Gillen, embarked on several intensive fieldwork projects researching the customs and social structures of Aboriginal groups in Central Australia, following this in 1911 with similar research in the Northern Territory. In 1899 Spencer was appointed honorary director of the National Museum of Victoria, authoring its *Guide to the Australian ethnographical collection* in 1901.

Spencer was an accomplished photographer and documented Aboriginal life and customs, his eye for composition producing images with a strong aesthetic appeal. In his voluminous written work on Australian Aboriginal society and technologies, Spencer applied models of biological evolution in a mechanistic manner. His influential studies often dehumanised Aboriginal people by presenting them as 'survivals' from an early stage of social development. Some of his photographs, however, suggest a more empathetic relationship with his subjects, who are represented as individuals embedded in culture.

—

Stacey, Robyn
1952-

Robyn Stacey is an artist based in Sydney. She has exhibited nationally and internationally since the 1980s and her work is held in numerous state and

university collections in Australia. In her large, intensely coloured and theatrically lit photographs, Stacey traverses popular culture and film noir, Australia's past and its colonial cultural legacy, and the experience of time and space in the contemporary world. She has worked extensively with historic collections since 2002, exploring the movement of objects, their meanings in relation to colonial culture and the personal lives of their owners. Staging large-scale, photographic still-lifes in the series *The great and the good* 2008, *Empire line* 2009 and *Tall tales and true* 2010, Stacey reflects on the nature of domesticity and the transfer of taste and knowledge systems to colonial Australia. In addition to her photographic series, Stacey has also collaborated with museums and collections in New South Wales to produce a number of photography books including *Herbarium* (2004), *Museum* (2007) and *House* (2011). Her more recent work, *Guest relations* 2013, depicts the transient space of the modern hotel room using pin-hole photography, superimposing interior and exterior and the historical and contemporary.

—

Stephenson, David
1955-

David Stephenson is an artist who lives and works in Tasmania. Educated at the Universities of Colorado and New Mexico, he moved to Australia in 1982 to teach photography at the University of Tasmania. Since the 1980s his work has been exhibited widely in Australia and abroad with major solo exhibitions in Sydney, Hobart, Paris, and New York. Informed by an interest in the artistic category of landscape and the relationship between humanity and nature, Stephenson uses photography to explore abstract themes of time, mortality and spirituality. He takes as his subject matter ice formations, stars, sacred architecture and landscapes. Depicted in ways that eliminate or destabilise spatial coordinates such as horizon lines or markers of scale, these natural and built forms are turned into elaborate geometric matrices that engage the viewer in an experience of vast time and space. Stephenson describes his work as 'essentially spiritual' and motivated by a search for the sublime – the profound and awe-inspiring apprehension of the scale and forces of nature and time. Stephenson uses the medium of photography to transcend visible reality and invite reflection on the intangible aspects of the natural and phenomenal worlds.

—

Stewart, Robert
active c1859-80
Stewart & Co
active 1871-1915

Robert Stewart was a professional photographer based in Sydney and Melbourne. Born in Scotland, he was working in partnership with Charles Pickering in Sydney from 1859 to 1861 and established his own studio in 1862. He transferred his business to Melbourne in 1871, and continued to work there until 1880. Robert's brother Richard established the successful firm of Stewart & Co in Melbourne in 1871, which had fifty employees, four studios and six operators by 1887 and continued until 1915.

—

Stone, Alfred Hawes
1801-73

Alfred H Stone was a lawyer and amateur photographer based in Perth. Born in England, he practised as a solicitor in Tunbridge Wells before immigrating to Perth in 1829, only four months after the establishment of the Swan River colony.

In the 1860s Stone became an enthusiastic photographer. He photographed public buildings, garden parties and leading citizens, as well as his own house and family. In 1868 he presented an album to his daughter, Fanny Anne Hampton, which included multiple images of the people and places of Perth, constituting a valuable record of the development of the colony.

—

Story, George Fordyce
1800-87

George Story was a medical practitioner and amateur photographer. Born in England, he was educated in Scotland, where he studied medicine and botany. Story arrived in Australia in the late 1820s, where he practised as a surgeon in numerous locations in Van Diemen's Land. As a keen naturalist he helped found the Royal Society's Gardens in Hobart Town in 1843, and remained in charge until 1847. Story was raised a Wesleyan, but adopted the Quaker faith in the 1850s. He later lived at the residence of fellow Quaker Francis Cotton on the eastern coast of Tasmania, where he provided medical and horticultural services to the estate and practised photography.

—

Strangman, Richard Charles
1895-1969

Richard Strangman was a commercial photographer in Tumut, New South Wales, from 1915 to 1926, and in Canberra from 1927 to 1969. In Tumut he ran a well-patronised studio specialising in portraits. Moving to Canberra in 1927, he documented the growth of the city, photographing the monuments, public buildings, growing suburbs and new hotel accommodation. He also made numerous views of the construction of the Australian War Memorial and the then recently completed Parliament House. These images were disseminated in the form of postcards, greetings cards, tourist information, and souvenirs.

—

Sweet, Captain Samuel White
1825-86

Samuel Sweet was a master mariner and photographer born in England. After an initial career in the navy, he immigrated to Queensland with his family to grow cotton in 1864. Success in cotton-growing eluded him, however, and he was working as a photographer in South Brisbane by 1866. Sweet was already an accomplished photographer and had brought his equipment with him from England. In mid 1866 he moved to Sydney and established a studio in Rushcutters Bay, advertising views of private residences. At the end of 1866 he was in Adelaide, where he practised as a photographer and ship's captain until his death in 1886. Sweet was a noted landscape photographer and documented the economic, cultural and industrial growth of Adelaide. His views were exhibited by the South Australian government to advertise the progress and amenities of the state and to promote settlement and investment. Sweet was one of the first Australian photographers to use the dry-plate process and toured South Australia with a horse-drawn darkroom taking hundreds of views of the outback and remote homesteads. After Sweet's death in 1886, his wife Elizabeth continued to run the photography business from their Adelaide Arcade Studio until 1892.

—

Sydney Photographic Co
1872-98

Photographic firm with numerous branches throughout New South Wales and Queensland, and offices in South Australia.

Talbot, Henry
1920-99

Henry Talbot was a professional photographer and teacher who worked in Melbourne from the 1950s until 1985 when he and his family moved to Sydney. Born Heinz Tichauer in Hindenburg, Germany, to middle-class secular Jews, Talbot was educated in graphic arts in Berlin, and then after 1938 at the College of Art, Birmingham. Talbot was arrested as an enemy alien when Germany declared war on England, and sent to Australia on the infamous *Dunera* (2000 people crammed onto a boat licensed to carry 600) and later served in the Australian army between 1942 and 1945. His parents had fled to Bolivia where Talbot was to join them for a few years after World War II, and where he perfected the craft and art of photography.

Returning to Melbourne in 1950, Talbot worked as a portrait photographer then teamed up with Helmut Newton and ran a highly successful fashion-photography business (he was fashion photographer of the year in 1958) until the 1970s when he closed his studio and concentrated on teaching at Preston Institute of Technology. There he worked with peers and young innovative photographers such as **Carol Jerrems**.

—

Talma & Co
active 1893-1932

Talma & Co was a successful commercial photography studio based in Melbourne (managers Andrew Barrie and Henry Weedon) and Sydney (manager W Pascoe) whose heyday was at the turn of the twentieth century. It specialised in celebrity portraiture and advertised its staff as 'vice-regal photographers'. The Melbourne studio was housed in the Talma Building, and occupied three floors. They photographed actors, debutantes, party goers, sportspeople, and their work appeared in the newspapers and popular press of the day, as well as being widely circulated as cartes de visite and postcards.

—

Thwaites, Walter William McLean
1840-88

Walter Thwaites was born in Sydney, six years after his parents' arrival from England. Thwaites' father was a painter, engraver and photographer and Thwaites junior would have learnt photography in his father's studio between 1860 and 1864. By this time the family had relocated to Hobart Town. In 1865 he worked with his father and brother in South Australia and then moved to Fremantle in 1867. Thwaites most likely photographed at the New Norcia Mission around this time, before leaving the tiny settlements in Western Australia to return to the larger markets of Victoria and then New South Wales. The New Norcia Mission had been founded in 1846 by Spanish Benedictine monks. The arrival of photographer–monk Fr Santos Salvado in 1867 coincided with Thwaites' stay and resulted in an extraordinary archive of monastic life and the lives and work of the Yued people who also lived at New Norcia.

—

Tilbrook, Henry Hammond
1848-1937

HH Tilbrook was a successful businessman and amateur photographer. Born in Wales, he immigrated to Australia with his family at the age of six. His first job was with the *Register* newspaper in Adelaide. He then worked in outback South Australia and tried mining in New Zealand. He established the *Northern Argus* in 1869 in Clare, South Australia and such was his success that he retired to

Adelaide aged forty-one. Tilbrook pursued various interests from astronomy to geology but his legacy as a photographer is striking. By the time he perfected his craft the dry-plate process was well underway, enabling travel with prepared glass plates which could be developed later. Adelaide in the 1890s was the centre for Australian pictorialism given the activities of the South Australian Photographic Society and return from Europe of John Kauffmann in 1897 but Tilbrook was not interested in that 'fuzzy' style, preferring pin-sharp images of coastal and inland locales. Tilbrook liked to include himself in his pictures, having invented an ingenious shutter release, as well as very carefully arranging other figures and objects in his compositions. His meticulousness is never dull and veers toward the metaphysical in its delight in nature.

—

Tims, Edward George
c1843-82

Edward Tims was a professional photographer active in South Australia, with studios in Mount Gambier and Adelaide. He specialised in portraits and views and travelled around the state in search of sitters and commissions.

—

Toose, Henry
active 1870s

Henry Toose was a travelling photographer active along the south coast of New South Wales in the 1870s. He was based in Wollongong in 1872, Bombala in 1873, and Bega from 1873 to 1879.

—

Tronier, August
active 1871-97

A professional photographer based in Sydney, August Tronier worked from 1893 to 1897 as an itinerant photographer in New South Wales.

—

Turner, Edward
1836-1913

Professional photographer based in Sydney in the 1870s.

—

Turner, Joseph
active 1856-83

Joseph Turner was professional photographer with two distinct careers. The first was as a highly successful portrait photographer in Geelong from 1856 until fire destroyed his premises in 1869. He was then appointed to the Melbourne Observatory in 1873 and worked there for ten years producing fine photographs of the Orion Nebula, the Moon and other heavenly bodies using the Great Melbourne Telescope. Turner was able to reconcile his religious faith with his scientific and artistic interests. As historian Paul Fox wrote in 1987, Turner believed that the photograph was made in the image of the creator for capturing light, thereby exposing a world of beauty and regularity. Turner pursued perfection in the name of the divine whether through his excellent portraits, via his town views which he showed in the 1866 Intercolonial Exhibition of Australasia in Melbourne, or through his later images of the heavens.

—

Vaniman, Melvin
1866-1912

Melvin Vaniman was born and educated in Illinois, United States. He began his working life as an opera singer in a touring company. He turned his

hand to panoramic photography and spent two years from 1902 until 1904 taking exceptional town and country shots in Australia and New Zealand which were then contact printed for sale by the platinum process. Originally commissioned by the Oceanic Steamship Company to make pictures as promotional tools, he worked for the New Zealand Government and Mount Lyell Mining Company among others. In pursuit of greater accomplishment Vaniman became very interested in making panoramas from balloons. On leaving Australasia Vaniman concentrated on aeroplanes and ballooning in Europe and then the United States, endeavouring to break various records in order to get to the North Pole or across the Atlantic. He died in 1912 on one of the latter attempts when his balloon exploded. On reporting his death in its 22 July 1912 issue, *Harringtons' Photographic Journal* noted how 'All...will remember the clever little American, Mr Vaniman for his wonderful panoramic photographs of Sydney and its environs, secured on film two feet long, and photographed from a balloon at an altitude of 1000 feet from the earth'.

—

WH Schroder & Vosper
c1880

A brief partnership between professional photographers William Henry Schroder and WH Vosper, with a studio in Sydney.

—

Wagner, Conrad
c1818-1910

Conrad Wagner was active as a painter and professional photographer on the New South Wales north coast from around 1860 until 1891. Born in Offenbach, Germany he came to Australia in 1856. He was based in Grafton from that year though he worked in Sydney with photographer **Henry Goodes** in 1863. He was **JW Lindt**'s father-in-law. Wagner moved to Glen Innes, New South Wales, soon after Lindt married his daughter in 1872 and moved to Melbourne. Wagner produced pastels, watercolours and painting over enlarged photographs. He died in Sydney.

—

Walker, James
active 1859-c1890s

Professional photographer based in Sydney and Barnsley, New South Wales.

—

Walter, Charles (aka Carl)
1831-1907

Charles Walter was born in Germany and arrived in Victoria around 1856. He was active as a professional photographer, botanist and journalist from the 1860s until 1873. His photographic work recorded Aboriginal people at Victorian mission settlements, scenic views, areas being surveyed for minerals, and was frequently used as the basis for newspaper illustrations. He described himself as a 'Country Photographic Artist' and spent a decade tramping though the more remote regions of Victoria and southern New South Wales, sending photographs and stories back to Melbourne for publication. He usually travelled alone carrying apparatus and tent on his back. In the *Illustrated Australian News* of 31 December 1873, Walter wrote, 'In giving the following minute description of the track, I have been prompted by a desire to assist any tourists in search of the picturesque that they may find their way through a rather difficult but nevertheless interesting part of our colony'. Walter was official photographer on the eclipse expedition to Cape Sidmouth, Queensland, in 1872.

Watson, John
active 1855-75

Professional photographer based in Sydney and Brisbane. Watson operated a branch of **Thomas Glaister**'s studio in 1855 and was working in partnership with **James Walker** from 1860 to 1862. In 1862 he moved to Brisbane where he ran a popular portrait and views business until 1875.

—

Wherrett & McGuffie
active 1887

Professional partnership between Charles B Wherrett and Richard McGuffie in Elizabeth Street, Hobart.

—

White, Jill
1940-

Jill White was born and educated in Sydney. She worked as assistant and studio manager to **Max Dupain** from 1958 until 1960 and then 1970 until 1992. Since 1993 she has worked on her own as well as being part owner and director of Max Dupain & Associates. She has been owner of the Max Dupain negative archive since 1995 and has produced a number of books on Dupain's work as well as exhibiting her own photography.

—

Wilder, Joseph Warrin
active 1861-82

Professional photographer with studios in Ipswich and Rockhampton, Queensland, specialising in portrait cartes de visite of local citizens and celebrities.

—

Wilkins, Hubert
1888-1958

See **Bean, CEW.**

—

Wood, William
active 1884-85

Professional photographer based in Melbourne.

—

Woolley, Charles A
1834-1922

Charles Woolley was a prolific portrait and views photographer based in Hobart from about 1860 until about 1875. He began experimenting with the medium in the mid 1850s and was working professionally within five years. In 1866 he took a series of portrait photographs of the Aboriginal Tasmanians Truganini, William Lanne, Wapperty, Patty, and Bessie Clark, which were later reprinted by **JW Beattie**. These portraits were exhibited in the 1866 Intercolonial Exhibition of Australasia and the 1872-73 Victorian Intercolonial Exhibition, both in Melbourne. Some of Woolley's portrait photographs were over-painted; for example, Henry Dowling's portrait of Sir Richard Dry was painted in England from a Woolley photograph. Woolley also photographed Louisa Ann Meredith's 1866 Christmas tableaux vivants.

—

Wyatt, Thomas JJ
active 1856-c1880

Thomas Wyatt initially pursued a career as a painter, but received little public encouragement; his compositions being found 'stiff, inexpressive, and unskilfully overlaboured'. In 1857 he established himself as a professional itinerant photographer, working in numerous towns in rural Victoria and South Australia.

—

Yates, John
active 1857-80

Professional photographer based in Sydney who advertised inexpensive cartes de visite and cabinet cards.

Youdale, Joseph
active 1869-98

Professional itinerant photographer who worked in Sydney, Maitland, Port Macquarie and Bega in New South Wales and Charlotte Plains and St Arnaud in Victoria.

—

Zahalka, Anne
1957-

Anne Zahalka was born and educated in Sydney. She began exhibiting in the early 1980s and her work often deals with the constructed nature of culture through portraiture and the examination of social activities. Her portraits of artists have been a preoccupation since she produced the suite *Resemblance* during her 1986 residency at the Kunstlerhaus Bethanian, Berlin. This series depicted artists as central figures in genre scenes which stylistically acknowledged a debt to Northern Renaissance painting. Later series showed artists with their tools of trade or in an active role. Zahalka has never shown artists, including herself, as iconic and therefore purely static, otherworldly figures. As Daniel Palmer wrote in *Hall of mirrors* 2007, 'The subjects have helped create the environment for their pictures, and the artists' character is displaced onto what they do; thus the portraits are less celebrations of the great individual and more akin to the Constructivist belief that artists perform a productive social role'. Zahalka wrote in the same publication that 'the making and taking of portraits is such a contrivance. There is nothing natural about the process, yet the aim is for it to appear so...'

1770
• Captain James Cook of the *Endeavour* lands at Botany Bay, an area inhabited by the Eora people, having viewed the transit of Venus and in search of the 'Great South Land'

1779
• Joseph Banks, botanist on Cook's 1770 voyage, recommends Botany Bay to an English parliamentary committee as a suitable site for a penal settlement

1788
• The First Fleet arrives at Botany Bay, bearing 543 convict men and 189 convict women

1789
• A smallpox epidemic kills nearly half of the Aboriginal population around the Sydney settlement

1802
• In England, Thomas Wedgwood uses light-sensitive chemicals to capture silhouette images on paper

1803
• The settlement of Van Diemen's Land (modern-day Tasmania) begins

1805
• 'Australia' (suggested by the explorer Matthew Flinders) becomes a widely used name for the southern continent

1807
• The camera lucida is invented by William Hyde Wollaston in England

1824
• A penal colony is established at a site on Redcliffe Peninsula and in 1825 moved to the Brisbane River, site of modern-day Brisbane

1825
• Tasmania is declared a separate colony from New South Wales

1826
• In France, Joseph Niépce produces the earliest fixed images using a camera

1829
• The Swan River colony is established by the British in modern-day Perth

1834
• WH Fox Talbot develops the photogenic drawing process in England

1835
• John Batman and John Fawkner, sons of convicts, found Melbourne. They sign a treaty with members of the Kulin nation, which is later declared null and void by the British government

1836
• South Australia is founded by Governor John Hindmarsh with free settlers only

1837
• Louis-Jacques-Mandé Daguerre invents the daguerreotype in France

1839
• Daguerre's process is presented to the public in Paris and patented to restrict commercial use

• Fox Talbot's photogenic drawing technique is published in England

• Tasmania's *Cornwall Chronicle* publishes news of the photogenic techniques of Fox Talbot and Dr Andrew Fyfe

• Convict transportation from Britain to Brisbane ceases

1840
• In England, Fox Talbot develops the calotype process

1841
• Captain Augustin Lucas produces the first daguerreotype in Australia in a demonstration on Bridge Street, Sydney

• English photographer Robert Hunt publishes the first treatise on photographic methods

1842
• Australia's first professional photographer, George Goodman, opens a daguerreotype portrait studio on George Street, Sydney

• The *Illustrated London News*, one of the world's earliest illustrated periodicals, is first published

1843
• First elections for Legislative Council in New South Wales are held

1847
• Douglas Kilburn makes daguerreotypes of Kulin people, which are engraved and published in England in 1850

1848
• The Australasian Anti-Transportation League, the first popular national movement, is established

1849
• Convict transportation from Britain to Port Phillip (in present-day Victoria) ceases

1850
• The German photographers William and Thekla Hetzer introduce the calotype process to Sydney

• In France, LD Blanquart-Evrard invents the albumen photograph

• Convict transportation from Britain to New South Wales ceases

1851
• Six nations (Canada, America, France, Russia, Germany, Britain) exhibit photography at the Great Exhibition of the Works of Industry of All Nations in London

• Britons Frederick Scott Archer and Peter Wickens create the ambrotype using the wet-plate collodion process

• In response to popular demand, the British government separates the colonies of Queensland and Victoria from New South Wales

• Gold is struck in Bathurst, New South Wales, and Ballarat, Port Phillip District

1852
• The *Illustrated Sydney News* becomes Australia's first illustrated newspaper

1853
• Frenchman Adolphe Martin invents the tintype

• Douglas Kilburn demonstrates the stereoscopic process in Hobart

• Convict transportation from Britain to Tasmania ceases

1854
• French photographer André-Adolphe-Eugène Disdéri creates the first carte de visite

• Exhibitions of works to be sent to the Universelle Exposition de Paris 1855 are held in Sydney, Hobart and Melbourne, creating an early showcase for photography

• The ambrotype is introduced to Australia by James Freeman

• Polish naturalist and artist William Blandowski leads an expedition to northwest Victoria, the earliest known Australian scientific expedition to include photography

• The Eureka Stockade is erected by goldminers at Ballarat

• The wet-plate process reaches Australia

1855
• Australian photographers exhibit at the Universelle Exposition de Paris 1855

• French photographer Taupenot develops the dry-plate or collodio-albumen process

• The portable stereoscopic camera arrives in Australia

• John Sharp and Frederick Frith take the first paper panorama using the wet-plate process in Australia, a five-part view of Hobart nearly one metre long

• Due in large part to the gold rush, the Chinese population in Australia reaches 50 000

1856
• Male landowners and tenants over twenty-one years are granted the right to vote in the self-governing territory of South Australia, followed by Victoria (1857), New South Wales (1858) and Tasmania (1896). Britain retains control over foreign affairs and defence.

1857
• In Sydney, the Freeman Brothers are the first to adopt the English practice of publishing mosaic group portraits of distinguished citizens

1858
• The tintype process reaches Australia under the name 'melainotype'

• Fothergill's process, an early dry-plate process, is introduced to Australia

1859
• William Blackwood introduces the carte de visite to Sydney

• John Walter Osborne invents the world's first commercially viable photolithographic process while working as a photographer in the Department of Crown Lands and Survey of Victoria

• Charles Darwin's *On the origin of species* is published

1860
• The Lambing Flat riots, a series of anti-Chinese demonstrations in the Burrangong region of New South Wales, drive 1000 Chinese miners off the fields.

• Solar photographic enlargers are marketed in Australia from the 1860s

1861

- The colony of South Australia grants propertied women the right to vote in local elections, and in parliamentary elections in 1894. Western Australia follows suit in 1899

1867

- Victorian government photographer RLJ Ellery begins photographing the Moon

1868

- Convict transportation to Western Australia from Britain ends, ceasing all convict transportation to Australian colonies

- A team of Aboriginal cricket players tours England

1869

- An Act for the 'Protection and Management of Aboriginal Natives' is passed by the parliament of Victoria

1870

- The first Aboriginal children are enrolled in public schools in New South Wales

1871

- Richard Leach Maddox pioneers gelatin emulsion in Britain, paving the way for the gelatin negative

1872

- The first Amateur Photographic Society of New South Wales is formed

- Photographs of the Moon are taken with the Great Melbourne Telescope and sent to Britain

- Mug shots are made the standard photographic format for recording criminals and suspects in New South Wales police departments

1875

- BO Holtermann commissions from Charles Bayliss the largest ever wet-plate panorama, each of the negatives measuring 90 x 160 cm

1880

- The gelatin dry-plate process is introduced to Australia, and the first commercially produced plates are manufactured and sold by Philip J Marchant in Adelaide

- The bushranging Kelly gang is captured at Glenrowan, Victoria

1883

- The first photographs of the Orion Nebula from the southern hemisphere are taken by Joseph Turner using the Great Melbourne Telescope

1884

- Henrietta Dugdale forms the first Australian women's suffrage society in Melbourne

1885

- The first transparent negative roll is introduced by the Eastman company in the United States as an alternative to fragile glass plates

1888

- The first Kodak camera, capable of taking one hundred photographs before being returned to the manufacturer for processing, makes photography accessible to millions of amateurs

1890

- HC Russell takes the first photographs of the Milky Way in Australia using the Star Camera at the Sydney Observatory

1893

- Glossy gelatin-silver paper reaches Australia

1894

- Andrew Barrie's Talma studios in Melbourne are the first to use electric lighting

1896

- One-guinea Pocket Kodak cameras are available in Australia. Over 3000 are sold within two months

1899

- Crown Studios in Sydney introduces colour photography to Australia with the three-exposure Joly and Ives process

- Three-minute automatic photo booths are established in Sydney

1900

- The Kodak Brownie, the first mass-marketed camera, is released

- The New South Wales Department of Public Works undertakes a photographic record of The Rocks area in Sydney after an outbreak of bubonic plague

1901

- The British self-governing colonies of Tasmania, Queensland, New South Wales, Victoria, South Australia and Western Australia are federated into a single nation, forming the Commonwealth of Australia

- The Immigration Restriction Act privileges British and other 'white' migration to Australia, commencing the White Australia Policy

1902

- The Commonwealth Franchise Act grants voting and standing rights to women in Australian federal elections

1905

- Picture postcards achieve popularity, combining photography, printing and postage

1907

- Autochrome process, invented by Louis Lumière in France in 1904, is introduced to Australia

1908

- Melbourne company Baker & Rouse merges with Kodak to form Australia Kodak Limited, which opens a manufacturing plant in Abbotsford, New South Wales

1909

- Harold Cazneaux's solo exhibition at the New South Wales Photographic Society's Sydney rooms marks the growing acceptance of photographers as artists

1911

- The Australian Commonwealth appoints JP Campbell as its first official cinematographer

- Frank Hurley is appointed official photographer to Douglas Mawson's Australasian Antarctic Expedition

1914

- World War I begins

1916

- Harold Cazneaux, Cecil Bostock and James Stening form the Sydney Camera Circle, advocating a national photographic aesthetic utilising local sunshine

1917

- Frank Hurley is appointed Australia's first official war photographer for the Australian Imperial Force during World War I

1918

- World War I ends

1921

- The Western Australian Edith Cowan is the first woman to be elected to any Australian parliament. In 1943 Dame Enid Lyons and Senator Dorothy Tangney are the first women to be elected to federal parliament.

1934

- Associated Press starts its wire photo service in the United States

- The illustrated *Walkabout* magazine begins publication in Australia

1935

- *Art in Australia* publishes Max Dupain's images informed by the functionalist aesthetic of the New Photography movement, signaling the beginning of modernist photography in Australia

1937

- Kodachrome 35mm roll film becomes available in Australia

1938

- *Pix* magazine, the first Australian weekly to employ North American–style presentation and photojournalism, is launched in Sydney

- The Contemporary Camera Groupe is formed by Max Dupain

- The Australian Aborigines Advancement League stages a day of mourning to mark the sesquicentenary of the arrival of the First Fleet

1939

- World War II begins

1940

- Damien Parer, Australia's first combat cameraman, travels to Palestine with the Australian Imperial Force.

- Photographer Frank Hurley documents the Australian Imperial Force in Palestine

1942

- Photographer Max Dupain enlists in the Camouflage Unit, Department of Home Security

1945

- World War II ends

1946

- Australian Geoffrey Powell publishes *Photography: a social weapon*, arguing photographers have a responsibility to draw attention to social realities

1947

- The Institute of Photographic Illustrators, aimed at raising the standard of photography, is formed in Sydney

- In the United States, Edwin Land invents the Polaroid camera

- The Cold War begins

1948

- The 35mm Nikon camera is introduced in Japan

- The White Australia policy is dismantled by the Menzies government, ending racially motivated immigration policies

1952
- The Melbourne *Argus* is the first daily newspaper in the world to publish colour photographs

1955
- Jack Cato's *The story of the camera in Australia* is published in Melbourne

- Frank Hurley's *Australia: a camera study* is published in Sydney

1956
- In the United States, Xerox introduces the first office photocopier

- The Second Indo-China War (known in Australia as the Vietnam War) begins

1957
- The United Soviet Socialist Republic (USSR) launches *Sputnik I* and *II*, the first satellites

1959
- The exhibition *Family of man*, from the Museum of Modern Art in New York (MoMA), tours Australia, and includes the work of Australian photographers David Moore and Laurence Le Guay

1961
- The Great Melbourne Telescope is rebuilt at Mount Stromlo Observatory near Canberra, with a 1.25-metre glass mirror and new controls.

1963
- Kodak makes the first Instamatic cameras

- Colour Polaroids are introduced

- Mervyn Bishop begins a cadetship at the *Sydney Morning Herald*, later becoming Australia's first Indigenous press photographer

1964
- Push-button telephones and the Picturephone service come into use

1966
- Soviet spacecraft *Luna 9* lands on the Moon, as does a United States spacecraft which transmits more than 11,000 television images of the terrain

1967
- Australia's first satellite *WRESAT 1* is launched from Woomera Rocket Range in South Australia

- A federal referendum removes discriminatory references to Indigenous people from the Australian Constitution

1968
- The Earth is photographed from the Moon

1969
- The first pictures of the *Apollo XI* crew's Moon walk are relayed to the world by the Parkes radio telescope

1971
- Neville Bonner becomes the first Indigenous parliamentarian

1972
- The National Gallery of Victoria opens the first curatorial photography department in an Australian art museum

1973
- The Australian Centre for Photography opens in Sydney and engages John Szarkowski, director of photography at MoMA, New York, to participate in a nationwide tour

- A USSR space-probe lands on Mars, and the United States' *Mariner* transmits detailed pictures of Venus and Mercury

1975
- Steven Sasson at Eastman Kodak develops the first digital camera using an image sensor

- The Fall of Saigon ends the Vietnam War

1976
- The Aboriginal Land Rights Act allows for the return of Commonwealth lands to traditional owners

1977
- Japan launches a geostationary satellite to provide cloud-cover pictures of Australia to the Bureau of Meteorology

- *Light vision: Australia's international photography magazine* is founded in Melbourne

1981
- *Photodiscourse: critical thought and practice in photography*, edited by Kurt Brereton, is published by Sydney College of the Arts

1982
- Sony demonstrates Mavica, the first commercial camera with electronic picture-storage rather than film

1983
- Peter Dombrovski's photograph *Rock Island bend* is used as a campaign image for conservation groups protesting against the damming of the Franklin and Gordon rivers in Tasmania

- *Photofile* magazine is launched by the Australian Centre for Photography, Sydney

1986
- NADOC '86 Exhibition of Aboriginal and Islander Photographers, the first exhibition by Indigenous photographers, is shown at Aboriginal Artists Gallery, in Sydney and Melbourne

1987
- Boomalli Aboriginal Artists Co-operative Gallery is established by Brenda L Croft, Tracey Moffatt and Michael Riley to promote urban Aboriginal art

1988
- The Bicentenary of the arrival of the First Fleet is celebrated in Australia, spurring massive protests and the largest ever demonstrations for land rights

- Gael Newton's *Shades of light: photography and Australia 1839–1988* and Anne-Marie Willis's *Picturing Australia: a history of photography* are published

1989
- The first portable digital camera, the Fuji DS–X, is commercially marketed in Japan

1991
- Dissolution of the USSR and the end of the Cold War

1992
- The Great Melbourne Telescope is rebuilt for the MACHO project, a search for the evidence of dark matter

1993
- Michael Aird's *Portraits of our elders* is published in South Brisbane

- Wayne Ludbey's photograph of Aboriginal footballer Nicky Winmar's historic protest against racial taunts is published in the *Age*

- The Native Title Act is founded to facilitate the recognition and protection of traditional land ownership

1994
- The internet moves out of universities and into commercial use

1999
- Australians vote 'no' in a referendum on whether Australia should become a republic

2000
- The world's first camera phone, the J-Phone, is released in Japan

- The development of new Photoshop software techniques leads to the rise of the internet meme

2001
- The federal government refuses to allow the Norwegian freighter *Tampa*, carrying rescued asylum seekers, into Australian waters

2002
- Allegations supposedly proven in 2001 by widely circulated photographs that asylum seekers rescued by the *Tampa* had thrown children overboard to ensure passage to Australia, are dismissed

2004
- Social networking sites Facebook and Flickr emerge with image-database functions

- Kodak Australia closes its manufacturing plant in Melbourne

2007
- Apple releases the first generation iPhone

- Google Street View is launched, providing panoramic images of cities in the United States taken using nine directional cameras at a height of around three metres

2008
- Photographs of Australian cities are added to Google Street View

2010
- The photo-sharing application Instagram is launched and attracts over a million users within its first six months

2011
- Google Inc engineers the reverse image search, which allows internet users to trace the origin of and information about photographs used for advertising and other purposes

- Snapchat, a photo-messaging application, is developed by Evan Spiegel and Robert Murphy, students at Stanford University

2013
- Over 300 million photographs are uploaded to Facebook every day, more than twenty times the total number of analogue photographs held by the Library of Congress

- 'Selfie' is included in the online version of the *Oxford English dictionary*

2014
- Google Glass, a wearable computer with a head-mounted optical display, goes on sale.

GLOSSARY

albumen photograph
Invented in 1850 by Louis-Desiré Blanquart-Evrard, the albumen photograph was the most prevalent type of photographic print until c1890. It was made by floating a sheet of thin paper on a bath of whisked, filtered egg white containing salt. After drying, the paper was sensitised, exposed (often in contact with a glass negative), and the resulting print fixed in a solution of hyposulfite of soda ('hypo'), washed and toned. The resulting prints range in tone from reddish to purplish brown and tend to curl at the corners.
—

ambrotype
An ambrotype is a unique negative on glass, which is backed with a dark opaque substance to create a positive image. Invented in 1851, ambrotypes had superseded the earlier **daguerreotype** in the late 1850s but were overtaken by **tintypes** and **cartes de visite** in the 1860s. Ambrotypes looked similar to daguerreotypes but were easier and cheaper to produce. They came in standard sizes, and varied from a whole plate (measuring 16.5 x 21.5 cm) to a sixteenth plate (3.5 x 4 cm).
—

autochrome
An early form of colour photography, the autochrome was patented in 1904 by Louis Lumière. Autochrome glass plates were coated with a mixed layer of microscopic potato-starch grains dyed red-orange, green and blue-violet, which created a colour filter for the light to pass through before striking the sensitised emulsion. The resulting print had a soft, hazy effect with faint stray colours in open, light areas.
—

autotype
Patented by Joseph Wilson Swan in 1864, the autotype was a photomechanical technique for reproducing photographs. It involved a carbon-transfer process and resulted in rich, detailed images with deep contrasts of light and dark.
—

cabinet card
A stiff piece of card measuring around 15.9 x 10.8 cm that bore an attached paper photograph (either **albumen**, **gelatin silver** or **carbon**) and the photographer's name or insignia. Cabinet cards joined the ubiquitous **carte de visite** in the 1870s, although their popularity waned in the 1890s.
—

calotype
A photographic process using a paper negative sensitised with silver nitrate and potassium iodide, the calotype was patented by William Henry Fox Talbot in 1841 and was the first iteration of the negative–positive photographic process. It was popular in England from 1841 to 1850, when it was superseded by the **wet-plate** process.
—

carbon photograph
Patented in 1855 by Alphonse Louis Poitevin, the carbon photograph was popular between 1870 and 1910. The process involved coating a sheet of paper with a gelatin emulsion containing gum bichromate and carbon black, which was then put in contact with a negative and exposed to light. The resulting highly durable paper print exhibited dense, glossy, dark areas with slight relief contours.
—

carte de visite
A stiff card of about 10 x 6.4 cm, with an attached paper photograph, the carte de visite was invented in 1854 by André-Adolphe-Eugène Disdéri. Cartes were usually portraits and were made by the millions worldwide. Multi-lens, or 'multiplying', cameras were introduced in the 1860s, capable of producing from two to thirty-two images in quick succession, and dramatically increasing the number of cartes de visite that could be made from a single photographic plate. Cartes were easily reproduced by making paper contact prints from the glass plates, then cutting and pasting these prints onto card.
—

collodion process
The **wet-plate** collodion process was invented in 1848 by F Scott Archer. It was prevalent from 1855 to about 1881. The collodion used to coat glass plates was made from cotton soaked in nitric and sulphuric acid then dried. This was then dissolved in a mixture of alcohol, ether and potassium iodide and poured onto plates as the first step in the production of negatives. The dry-collodion process had a brief life of ten years from the mid 1850s due to its complexity and inconsistent results.
—

colour photograph
There are two main modern colour processes: type C and type R. Type C photography is the most common and involves printing colour paper enlargements from colour negatives. In the R (for reversal) type print, a positive slide or transparency is printed onto type R paper to give exactly the same colour saturation as the original image. Both type C and type R paper are composed of three main dye layers: cyan, magenta and yellow.
—

daguerreotype
A unique positive image on a sheet of polished silver-coated copper, the daguerreotype was announced by Louis-Jacques-Mandé Daguerre in 1839, and became wildly popular as a medium for portraiture until the mid 1850s despite the expense and difficulty of production. The process, using iodine and mercury, was toxic, but the resulting clarity was highly prized. Daguerreotypes came in standard sizes which were fractions of a plate (measuring 16.5 x 21.5 cm), and varied from a whole plate to a sixteenth plate (3.5 x 4 cm). They were often protected by tooled leather cases and brass mounts.
—

digital image
A digital image is produced via a gridded mosaic of light-sensitive picture-elements called pixels, which are then digitised (converted into numeric form) and stored as a computer file ready for viewing, processing, publishing or printing.
—

dry plate
The dry plate is a thin sheet of glass or metal coated with a light-sensitive emulsion and dried prior to use in-camera. Invented in 1871 by Richard Maddox, this kind of plate was widely used by the 1880s as a practical alternative to the **wet plate** because it could be transported, exposed, and then processed at a later date.
—

gelatin silver photograph
In the 1870s paper coated with gelatin containing silver salts was introduced for making black-and-white prints from negatives, and is a product still in use. By 1895 such paper had superseded the **albumen** process because it was more stable and simpler to produce.
—

hand tinting
Since the **daguerreotype**, various means have been used to manually colour the surface of black-and-white photographs, including watercolour, oil, crayon and other paints and dyes.
—

photolithography
In photolithography, a process for printing a photographic image from a negative, a flat stone or metal plate is coated with sensitised albumen or gelatin, which hardens when exposed to light travelling through a photographic negative. The unexposed areas are then removed with water, and the remaining gelatin matrix is coated with printer's ink and pressed against paper. The process derives from **lithography** (invented by Alois Senefelder in 1796), which uses a stone and a greasy crayon to which the ink adheres.
—

platinum photograph
Invented in 1873 by William Willis, platinum papers were sensitised with chloro-platinate and ferric oxalate, contact-printed from a negative, then developed and washed. Also known as platinotypes, they were valued for their tonal range, expanded mid-tone greys, and permanence. Platinum was popular until the 1920s when the price made it prohibitive and it was replaced with the cheaper palladium.
—

salted paper print
A matte-textured, reddish-brown print made by direct contact with the negative. Invented by William Henry Fox Talbot, salt prints were made by sensitising a sheet of paper with sodium chloride and silver nitrate, placing it under a negative, and exposing both to light. The print was then fixed, washed and toned. They are often confused with single-layer **albumen** photographs.
—

stereograph
A pair of photographs on a single support that, when viewed through a stereoscope, create the illusion of three-dimensionality. Taken with a dual-lens camera, the photographs exhibit very slight shifts in point of view to approximate human binocular vision. Viewing stereographs was a popular pastime from the mid 1850s to the 1930s.
—

tintype
Invented in 1856 by Professor Hamilton Smith in Ohio, United States, the tintype is a unique image made on a thin sheet of iron coated with a black or brown lacquer or enamel. An inexpensive and popular process often used for portraits, it has a limited tonal range and images appear flat and soft.
—

wet plate
The wet plate is a thin sheet of glass coated with a light-sensitive emulsion and exposed in the camera while still damp. Invented in 1848 and prevalent from 1855 until c1881, wet-plate photography was valued for its detail and, in comparison to **daguerreotypes** and **calotypes**, its reduced exposure times. The process was complex and involved coating, exposing and processing the plate within a short window of time and photographers had to take portable darkrooms with them in order to achieve results.
—

X-ray radiography
An image produced by electromagnetic radiation passing through a body and casting shadows onto a sensitised plate or digital detector. X-rays, which move through human tissue but not bone or metal, were discovered by Wilhelm Conrad Röntgen in 1895 and were first used to view and record the internal structure of bodies in medicine in 1896.

LIST OF WORKS

Unless stated otherwise, all works are albumen photographs; and all cased objects, albums and books are closed size.

Dimensions are the image size (unless stated otherwise) in centimetres (cm): height x width x depth

Please be advised that original titles have been maintained throughout, some of which make use of inappropriate language.

Alfred Morris & Co

Coliban viaduct c1860
29.4 x 37 cm
Picture Collection, State Library of Victoria, Melbourne, anonymous gift, c1930
H3987

Taradale viaduct c1860
29.5 x 34.6 cm
Picture Collection, State Library of Victoria, Melbourne, anonymous gift, c1930
H3993

Morton Allport

Self-portrait 1854
9.9 x 7.7 cm
Allport Library and Museum of Fine Arts, Hobart
B3SH5

Elizabeth Allport and baby Mary M Allport in garden of 'Fernleigh', Davey Street c1856
stereograph
7.3 x 7.3 cm (each);
8.3 x 17.4 cm (card)
Allport Library and Museum of Fine Arts, Hobart
AP17

My drawing room 1860
stereograph
7.6 x 7.3 cm (each);
8.6 x 17 cm (card)
Allport Library and Museum of Fine Arts, Hobart
AS13

Mary Marguerite & Curzona FL Allport (?) taken at Morton Allport's residence, upper Davey Street c1860s
stereograph
7.2 x 7.5 cm (each);
8.1 x 17.4 cm (card)
Allport Library and Museum of Fine Arts, Hobart
AP26

No 19 Looking westward from Mt Arrowsmith and *no 20 Mount Gell (Eldon Range to the extreme left)* in the

album *Excursion to Lake St Clair February 1863* 1863
bound album of 24 stereographs and text
24.5 x 20.4 cm (album)
Allport Library and Museum of Fine Arts, Hobart
MSS box 11, folder 7

Fern Gully, Tasmania 1865–70
14.7 x 20.6 cm
National Gallery of Australia, Canberra, purchased 1986
86.1671

American & Australasian Photographic Company

Batchelder's Portrait Rooms, 41 Collins Street East, Melbourne c1860–70
carte de visite
10.2 x 6.4 cm (card)
Picture Collection, State Library of Victoria, Melbourne
H82.94/1

Photographer Charles Bayliss lazing on the bank of the Parramatta River 1870
carte de visite
6.5 x 10.5 cm (card)
Caroline Simpson Library & Research Collection, Sydney Living Museums
35532

B Holtermann with the largest specimen of reef gold c1873
photograph, hand-tinted
36.7 x 27.7 cm
State Library of New South Wales, Sydney
PXD 762/9

Milsons Point from Christchurch, Blues Point Road (with Garden Island in the background) 1875
glass-plate negative
56 x 42.9 cm
State Library of New South Wales, Sydney
ON 4 Box 82 No 28

Anson Bros

Fern Tree Gully, Hobart Town, Tasmania 1887
17.4 x 21.1 cm
Art Gallery of New South Wales, gift of Josef & Jeanne Lebovic, Sydney 2014
568.2014

William Bardwell

Portraits of William H Bardwell, photographer, in his studio, Ballarat c1870–73
3 cartes de visite
approx 10 x 6.5 cm (each card)
State Library of New South Wales, Sydney, presented by Purves
P1 / 91

3 photographs 1872
approx 30 x 37 cm (each)
Picture Collection, State Library of Victoria, Melbourne, transferred from The Victorian Patents Office to the

Melbourne Public Library 1908
H96.160/2716–2718

The city of Ballarat taken from the Town Hall looking south west

Ballarat from the Town Hall Tower looking east

Ballarat from the Town Hall tower looking north east

Henry Barnes

Four views of curator Gerard Krefft in the courtyard of Australian Museum with holotype of the Alfred Manta, Manta alfredi [Krefft, 1868] (Australian Museum specimen no 1.1731) 1868
in *Australian Museum photograph albums 1870–90, vol 14, fishes 1* c1880
47.6 x 32.5 x 7.4 cm (album)
Australian Museum, Sydney
AMS421 (vol 14, p 72)

Batchelder and O'Neill

William Landsborough with his native guides Jack Fisherman and Jemmy c1862
8.6 x 5.8 cm
Pictures Collection, National Library of Australia, Canberra
PIC P533

Charles Bayliss

Middle Head defences 1874
43.5 x 158 cm
State Library of New South Wales, Sydney, presented by BO Holtermann 1952
XV1 / Def / Mid H / 1

Kirribilli, fifth panel of panorama of Sydney Harbour and suburbs from the North Shore 1875
56 x 42.9 cm
Art Gallery of New South Wales, gift of Josef & Jeanne Lebovic, Sydney 2014
571.2014

Lawrence Hargrave flapping wing flying machine model c1884
24.5 x 29.8 cm
Museum of Applied Arts and Sciences, Sydney, gift of Mr William Hudson Shaw 1994
94/23/1-7/12

Lawrence Hargrave trochoided plane model consisting of two floats and a clockwork mechanism c1884
25.3 x 29.5 cm
Museum of Applied Arts and Sciences, Sydney, gift of Mr William Hudson Shaw 1994
94/23/1-7/1

Lawrence Hargrave trochoided plane model 1884
24 x 28 cm
Museum of Applied Arts and Sciences, Sydney, gift of Mr William Hudson Shaw 1994
94/23/1-7/9

Lawrence Hargrave trochoided plane model consisting of two floats 1884
17.2 x 29.2 cm
Museum of Applied Arts and Sciences, Sydney, gift of Mr William Hudson Shaw 1994
94/23/1-7/2

Eight Lawrence Hargrave flying machines models 1885
23.8 x 30 cm
Museum of Applied Arts and Sciences, Sydney, gift of Mr William Hudson Shaw 1994
94/23/1-7/8

New South Wales Royal Commission: Conservation of water. Views of scenery on the Darling and Lower Murray during the flood of 1886 1886
10 from a series of 37
Art Gallery of New South Wales, purchased 1984
74.1984.5, 6, 10, 12, 13, 16, 21, 23, 34, 36

Distant view of Jandra Rocks
20.4 x 28.9 cm

A reach on the Darling
21.1 x 29.4 cm

Junction of the Darling and Warrego Rivers (second view)
20.5 x 28.4 cm

View from Dunlop Range, near Louth, Darling River (looking west)
20.7 x 29.1 cm

View from Dunlop Range, near Louth, Darling River (looking south)
21 x 28.6 cm

Homestead, Dunlop Station, Darling River
20.9 x 28.2 cm

Mob of 1000 bullocks crossing Darling River, near Wilcannia (second view)
23.1 x 28.8 cm

Waterworks, Wilcannia
19.8 x 28.6 cm

Devil's Elbow, Lower Murray (second view)
20.5 x 28.8 cm

Group of local Aboriginal people, Chowilla Station, Lower Murray River, South Australia
23.6 x 29.5 cm

Collection of a country property, New South Wales 1886–91
3 from a series of 18
Art Gallery of New South Wales, purchased 1984
149.1984.2, 3, 10

Shearing shed
13 x 20 cm

Stacking wool bales onto a cart
15.1 x 19.9 cm

Homestead garden showing perimeter fence and carriageway
21.2 x 29.2 cm

Charles Bayliss, Henry Beaufoy Merlin

Holtermann gold as gold-bearing quartz c1872
24.5 x 29.4 cm
Art Gallery of New South Wales, gift of Josef & Jeanne Lebovic, Sydney 2014
569.2014

Holtermann gold as ingots c1872
24.5 x 28.2 cm
Art Gallery of New South Wales, gift of Josef & Jeanne Lebovic, Sydney 2014
570.2014

CEW Bean

Official history, 1914–18 war: records of CEW Bean, official historian 1914–18
album of gelatin silver photographs, annotated
33.5 x 28 x 5.5 cm (album)
Australian War Memorial, Canberra
3DRL/6673/1016 Part 1

John Watt Beattie, Anson Bros

Prison buildings, Maria Island 1877
26.5 x 33 cm
State Library of New South Wales, Sydney
PXA 609 / 29

Dead Island, Port Arthur 1877
26.5 x 33 cm
State Library of New South Wales, Sydney
PXA 609 / 36

Hall and cell, corridor, model prison, Port Arthur 1877
26.5 x 33 cm
State Library of New South Wales, Sydney
PXA 609 / 46

The rocking stone, Mount Wellington, Tasmania 1880s
26.5 x 33 cm
State Library of New South Wales, Sydney
PXA 609 / 105

Henty River at railway bridge 1880s
26.5 x 33 cm
State Library of New South Wales, Sydney
PXA 609 / 163

Mervyn Bishop

Prime Minister Gough Whitlam pours soil into the hands of traditional land owner Vincent Lingiari, Northern Territory 1975, printed 1999
type R3 photograph
30.5 x 30.5 cm
Art Gallery of New South

Wales, Hallmark Cards
Australian Photography
Collection Fund 1991
58.2000

*Jimmy Little – state funeral
Kwementyaye Perkins* from
the series *A Dubbo day with
Jimmy* 2000
gelatin silver photograph
30.4 x 50.5 cm
Art Gallery of New South
Wales, purchased with funds
provided by the Photography
Collection Benefactors
Program 2002
109.2002

Leveillé after Bisson Brothers

*Kaour & Kaour-Iga natives
of Torres Strait* 1846
lithograph after daguerreotype
28.4 x 35.8 cm
Art Gallery of New South
Wales, Tony Gilbert Bequest
Fund 2013
305.2013

William Blackwood

*Bridge Street and Exchange,
Sydney* in *Album by W
Blackwood of Australian
scenery* c1858
album of 13 photographs
31.4 x 42.6 cm (album)
National Gallery of Australia,
Canberra, purchased 1986
86.1670.6

Barcroft Capel Boake

*NSW contingent. Soudan
campaign 1885* c1890
montage of gelatin silver
and albumen photographs
and oil paint on canvas
172 x 221.5 cm
Australian War Memorial,
Canberra
P02706.001

Alfred Bock

Self-portrait c1855
daguerreotype
8.3 x 7 cm;
12.2 x 11 cm (frame)
Queen Victoria Museum
and Art Gallery collection,
Launceston
QVM.1991.P.0006

Thomas Bock or Thomas Browne (?)

*Portrait of unknown man
and woman* c1850
daguerreotype
7 x 5.6 cm;
9.2 x 8 x 1.8 cm (case)
Tasmanian Museum and
Art Gallery, Hobart
Q1988.34.51

attributed to **Thomas Bock**
*Henry Sultzer Barnard b1846
and James Barnard Jnr
b1847* c1850
daguerreotype, hand-tinted
5 x 3.9 cm;
7.3 x 6.3 x 1.3 cm (case)
Tasmanian Museum and
Art Gallery, Hobart
Q610

Frank Styant Browne

Hand 1896
X-ray
16.5 x 21.5 cm
Queen Victoria Museum
and Art Gallery collection,
Launceston
QVM.1998.P.0870.1

Fish 1896
X-ray
16.4 x 21.4 cm
Queen Victoria Museum
and Art Gallery collection,
Launceston
QVM.1998.P.0870.7

Keast Burke

Husbandry 1 c1940
gelatin silver photograph
30.5 x 35.5 cm
Art Gallery of New South
Wales, gift of Iris Burke 1989
95.1996

Arthur W Burman

*Chinese giant Chonkwicsee
and companion* 1876
carte de visite
13 x 6.4 cm (card)
National Portrait Gallery,
Canberra, purchased 2010
2010.27

George Burnell

4 stereographs from the
series *Stereoscopic views
of the River Murray* 1862
approx 7 x 7.5 cm (each);
8.1 x 17.5 (each card)
Art Gallery of South Australia,
Adelaide, South Australian
Government Grant 1980
805Hp70 (54, 55, 58, 60)

*Mission School, Point
McLeay, Lake Alexandrina*

*Aborigines in their canoes,
Overland Corner*

Artist's boat, Murray River

Murray at Swan Hill

Nicholas Caire

*Fairy scene at the Landslip,
Blacks' Spur* c1878
28.2 x 22.4 cm
National Gallery of Victoria,
Melbourne, purchased 1994
1995.8

Your photographer at work
c1886
18.5 x 22.3 cm
Picture Collection, State
Library of Victoria, Melbourne
H27519

JP Campbell

*The station kitchen,
Horseshoe Creek Police
Station* from the album
*Souvenir of the visit of the
Federal Parliamentary Party
to the Northern Territory,
April–May 1912* 1912
gelatin silver photographs
in album
approx 28.5 x 38 x 7 cm
(album)
Pictures Collection, National
Library of Australia, Canberra
PIC7459/85

Harold Cazneaux

*Self-portrait – Harold
Cazneaux* 1904
gelatin silver photograph
14 x 9.3 cm
Art Gallery of New South
Wales, gift of Mrs Rainbow
Johnson 1985
35.1985

Soil erosion near Robe 1935
gelatin silver photograph
17.8 x 27 cm
State Library of South
Australia, Adelaide
PRG 737/20

*Permo-carboniferous
glaciated pavement,
Inman Valley* 1937
gelatin silver photograph
25.7 x 36.5 cm
State Library of South
Australia, Adelaide
PRG 737/13

Rock face, Flinders Ranges
1937
gelatin silver photograph
30.2 x 20 cm
State Library of South
Australia, Adelaide
PRG 737/15

Spirit of endurance 1937
gelatin silver photograph
28.1 x 33.1 cm
Art Gallery of New South
Wales, gift of the Cazneaux
family 1975
134.1975

Jean Baptiste Charlier

*Cottages, Yarra Bend
Asylum (Fairfield)* c1861
23.1 x 28.5 cm
Picture Collection, State
Library of Victoria, Melbourne
H36668 (9)

George Cherry

Portrait of Matilda Cherry
c1850
ambrotype, hand-tinted
8.9 x 6.6 cm (oval);
12.3 x 9.7 cm (case)
Pictures Collection,
National Library of Australia,
Canberra
PIC/8848/30

George Cherry 1855
carte de visite
10.5 x 6.2 cm (card)
Pictures Collection, National
Library of Australia, Canberra
PIC/8848/6

*Portrait of George Rodney
Cherry* c1856
ambrotype
4.3 x 3.2 cm;
7.5 x 6.1 cm (case)
Pictures Collection,
National Library of Australia,
Canberra
PIC/8488/27

Portrait of Ada Cherry c1860
ambrotype
5.2 x 3.9 cm;
7.5 x 6.5 cm (case)
Pictures Collection,
National Library of Australia,
Canberra
PIC/8848/29

*Portrait of George Rodney
Cherry* 1864–67
cabinet card
16.5 x 10.5 cm (card)
Pictures Collection,
National Library of Australia,
Canberra
PIC/8488/26

Thomas Foster Chuck

*The explorers and early
colonists of Victoria* 1872
mosaic of albumen photographs
49 x 43 cm
Pictures Collection,
National Library of Australia,
Canberra
PIC P2222

Olive Cotton

*'Only to taste the warmth,
the light, the wind'* c1939
gelatin silver photograph
33.2 x 30 cm
Art Gallery of New South
Wales, purchased with
funds provided by John
Armati 2006
174.2006

Nude 1941
gelatin silver photograph
16.5 x 19.5 cm
Art Gallery of New South
Wales, gift of Joan Baines
2000
201.2000

Croft Brothers

Portrait of a man 1863–65
ambrotype (Union case)
12.4 x 10.2 x 2.3 cm (case)
Private collection

Dailey & Fox

*Photographers SJ Dailey and
Thomas Moorhouse Fox in
their Clarendon studio* c1862
ambrotype
9.5 x 7 cm (oval);
10.8 x 9.6 cm (frame)
Art Gallery of South Australia,
Adelaide, JC Earl Bequest
Fund 2006
20063Ph5

Richard Daintree

Alfred Daintree in the
*Cogger album of
photographs* c1854–62
album of albumen and gelatin
silver photographs
29 x 23 x 4 cm (album)
Picture Collection,
State Library of Victoria,
Melbourne
H2009.84/46

*Gold diggers sale,
Queensland* 1864–70
photograph, overpainted
with oils
39.2 x 60.7 cm
Rex Nan Kivell Collection,
National Library of Australia,
Canberra
PIC #T3218 NK1302/F

Midday camp 1864–70
photograph, overpainted
with oils
24.6 x 30 cm
Queensland Museum,
Brisbane
H28015

*Chinese digger starting
for work* 1864–78
photograph, overpainted
with oils
16.4 x 12 cm
Queensland Museum,
Brisbane
H28014

Homestead 1864–78
photograph, overpainted
with oils
24.7 x 30.4 cm
Queensland Museum,
Brisbane
H27935

*Young Aboriginal female
holding a boomerang*
1864–78
photograph, overpainted
with oils
31.2 x 25.7 cm
Queensland Museum,
Brisbane
H27915

*Settlers outside a hut in the
bush, Gympie, Queensland*
c1870
photograph, overpainted
with oils
38.8 x 60.5 cm
Rex Nan Kivell Collection,
National Library of Australia,
Canberra
PIC #T3214 NK1302/B

Richard Daintree & Antoine Fauchery

Group of diggers c1858 in
the album *Sun pictures of
Victoria* 1857–59
album of 53 photographs
29.5 x 39.2 cm (album)
Picture Collection, State
Library of Victoria, Melbourne
H84.167/30

attributed to **Edwin Dalton**

Eleanor Elizabeth Stephen
c1854
daguerreotype
10.8 x 8.2 cm;
12.1 x 9.5 cm (case)
State Library of New South
Wales, Sydney
MIN 194

Eliza Morisset c1860
ambrotype
8.3 x 7 cm
State Library of New South
Wales, Sydney, presented
by Sir Kenneth Street 1960
MIN138

Davies & Co

*Norfolk House WB Naunton's
Bakery, 105 Wellington Street,
East Collingwood* 1862
34.2 x 28 cm
Picture Collection, State
Library of Victoria, Melbourne,
presented by Melbourne
City Council 1928
H644

*Isaac Fawcett, tailor,
Westmoreland House, 46
Gertrude Street, Fitzroy* 1866
28 x 32.4 cm
Picture Collection, State
Library of Victoria, Melbourne,
presented by Melbourne
City Council 1928
H639

Patrick Dawson

Aboriginal cricket team of 1868 1868
61 x 51 x 2 cm (frame)
National Museum of Australia, Canberra
2004.0049.0001

John Degotardi (jr), **George McCredie**

No 841 George-street (kitchen) and *Rear of 883 George Street* from *Views taken during cleansing operations, quarantine area, Sydney, 1900, vol IV* 1900
gelatin silver photographs on album leaves
26.5 x 38 cm (album leaves)
State Library of New South Wales, Sydney
PXE 93 vol 4 leaves 224–225

John Dixon, over a photograph by **George Cherry**

Bishop Nixon 1860
oil paint over photograph over two layers of canvas
75.5 x 65.5 cm
Queen Victoria Museum and Art Gallery collection, Launceston
QVM.1962.74.1

Ernest B Docker

Junction Falls Lawson
27 Jan 1893
stereograph
10.3 x 17.1 cm (card)
Macleay Museum, The University of Sydney
HP82.7.44

The Three Sisters, Katoomba – Mrs Vivian, Muriel Vivian and Rosamund 7 Feb 1898
stereograph
10.7 x 17.7 cm (card)
Macleay Museum, The University of Sydney
HP82.7.46

GFS garden fete, Greenoaks – the tea tables, Lady Mary Lygon 29 Aug 1900
stereograph
10.7 x 17.7 cm (card)
Macleay Museum, The University of Sydney
HP82.7.26

Sydney – Vaucluse
13 Oct 1900
stereograph
10.7 x 17.7 cm (card)
Macleay Museum, The University of Sydney
HP82.7.27

Max Dupain

Self-portrait 1930s
gelatin silver photograph
19.3 x 14 cm
Art Gallery of New South Wales, gift of Diana Dupain 2000
102.2003.7

Sunbaker 1937, printed 1970s
gelatin silver photograph
37.9 x 42.8 cm
Art Gallery of New South Wales, purchased 1976
115.1976

Nude 1938, printed later
gelatin silver photograph
31.2 x 24.4 cm
Art Gallery of New South Wales, purchased 1976
116.1976

Edwin Duryea

Portrait of two young women, one with crucifix at neck c1885
carte de visite
10.4 x 6.2 cm (card)
RJ Noye Collection, Art Gallery of South Australia, Adelaide, gift of Douglas and Barbara Mullins 2004
20041RJN1877

Portrait of young woman against trompe l'oeil screen, umbrella and bag in hands c1890
carte de visite
10.4 x 6.2 cm (card)
RJ Noye Collection, Art Gallery of South Australia, Adelaide, gift of Douglas and Barbara Mullins 2004
20041RJN1871

attributed to **Sanford Duryea**

Edward and Theodocia Hester and family c1859
daguerreotype
16.5 x 21.5 cm;
17.8 x 23 cm (case)
Private collection, on loan to the National Gallery of Australia, Canberra

Townsend Duryea

9 cartes de visite
10.4 x 6.5 cm (each card)
RJ Noye Collection, Art Gallery of South Australia, Adelaide, gift of Douglas and Barbara Mullins 2004
20041RJN1714, 20041RJN2204, 20041RJN2906, 20041RJN1710, 20041RJN1727, 20041RJN1736, 20041RJN1765, 20041RJN1762, 20041RJN1778

Portrait of seated woman, gentleman at side c1864–65

Portrait of little girl named Frances, aged four years 1864

Studio portrait of small girl with toy horse, beside chair 1864–65

Portrait of gentleman, hand directed skyward 1864–65

Portrait of child wearing plaid dress, toy dog at side 1865

Portrait of woman, photographic case in hand 1866 (?)

Portrait of child upon chaise longue 1868

Portrait of small child, basket of flowers upon parlour chair 1868

Portrait of girl, elbow resting on writing desk 1869 (?)

Panorama of Adelaide 1870
10 photographs in sequence on board
380.5 x 32 cm (overall)

State Library of South Australia, Adelaide
B 16004 Blue folio

Townsend Duryea studio

5 cartes de visite
10.4 x 6.5 cm (each card)
RJ Noye Collection, Art Gallery of South Australia, Adelaide, gift of Douglas and Barbara Mullins 2004
20041RJN1828, 20041RJN3332, 20041RJN1853, 20041RJN1846, 20041RJN1848

Portrait of young woman seated at side table with open album c1875

Portrait of young woman wearing dress with velvet bodice panel c1875
gelatin silver photograph (pre-baryta layer)

Portrait of young woman, one hand held to cheek, the other lightly clasping flower c1875

Portrait of young woman with open parasol c1880

Portrait of James and Amelia Bowering 1881

Duval & Co

Thomas Hinton in a diorama featuring a figure labelled 'Wolseley' 1900
cabinet card
16.3 x 10.7 cm (card)
National Museum of Australia, Canberra
2012.0015.0001

JJ Dwyer

JJ Dwyer c1898
gelatin silver photograph
20 x 15 cm
State Library of Western Australia, Perth
5871B/1

Sacred Nugget Kanowna/ Crowd promising not to ask Father Long any more questions 1898
gelatin silver photograph
23 x 28.5 cm
Kerry Stokes Collection, Perth
2008.370.196

Associated Northern 600ft level c1900
gelatin silver photograph
23 x 28.5 cm
Kerry Stokes Collection, Perth
2008.370.199

Hannan Street c1900
gelatin silver photograph
22.5 x 28.5 cm
Kerry Stokes Collection, Perth
2008.370.200

Kalgoorlie's first post office c1900
gelatin silver photograph
23 x 28.5 cm
Kerry Stokes Collection, Perth
2008.370.203

Antoine Fauchery

Joanna Apperly Gill 1858
14.8 x 11 cm (oval)
Picture Collection, State Library of Victoria, Melbourne
H88.21/1

Anne Ferran

from the series *Lost to worlds* 2008
5 digital prints on aluminium
120 x 120 cm (each)
Tasmanian Museum and Art Gallery, Hobart, donated through the Australian Government's Cultural Gifts Program by Anne Ferran
07-04, 07-05, 07-09, 07-11, 05-11

Paul Foelsche

Source of the Edith River, 2nd fall 1883
gelatin silver photograph
15.4 x 20.5 cm
RJ Noye Collection, Art Gallery of South Australia, Adelaide, gift of Douglas and Barbara Mullins 2004
20041RJN303

4 photographs
13.8 x 20.4 cm (each)
Art Gallery of New South Wales, gift of Josef & Jeanne Lebovic, Sydney 2014
579.2014, 573.2014, 574.2014, 575.2014

Adelaide River 1887

In the gorge, Katherine River 1887

Railway pier 1888

Port Darwin steam engine 1888

Dr Stirling at Knuckey's Lagoon 1891
gelatin silver photograph
15.3 x 20.4 cm
RJ Noye Collection, Art Gallery of South Australia, Adelaide, gift of Douglas and Barbara Mullins 2004
20041RJN341

8 gelatin silver photographs
15.2 x 10.2 cm (each)
Art Gallery of New South Wales, purchased 1986
16.1986.2.c-d, 16.1986.1.a-b, 16.1986.4.c-d, 16.1986.10.a-b,

Portrait of 'Almarara', Point Essington and Malay Bay, Iwaidja, NT, aged 7 years November 1877

Portrait of a girl, Alligator River, Bunitj, NT, aged 15 years 1880s

Portrait of man, Alligator River, Bunitj, NT, aged 27 years 1889

Portrait of a girl, Bunitj or Woolna, NT, aged 15 years 1889

Portrait of 'Nellie', Davy wife, Woolna, NT, aged 17 years January 1889

Portrait of a woman, Minnegie, Limilngan, NT, aged 20 years 1887

Portrait of a man, Daly River Copper Mine, Malak Malak, NT, aged 17 years 1890

Portrait of a man, 'Charley' Waggite/Daly River?, aged 24 years 1890

Sue Ford

Self-portrait with camera (1960–2006) 2008
47 photographs: gelatin silver, type C, colour Polaroid
various dimensions
Art Gallery of New South Wales, purchased with funds provided by the Paul & Valeria Ainsworth Charitable Foundation, Russell Mills, Mary Ann Rolfe, the Photography Collection Benefactors and the Photography Endowment Fund 2015

Freeman Brothers

The first responsible government of New South Wales (Thomas Holt, Treasurer; Sir William Manning, Attorney General; Sir Stuart Donaldson, First Premier of New South Wales; Sir John Darvall, Solicitor General; and George Nichols, Auditor General) 1856
13.4 x 18.4 cm
National Portrait Gallery, Canberra, purchased 2009
2009.58

Frederick Frith's assistant

Double self-portrait c1866
carte de visite
11 x 7 cm (card)
State Library of New South Wales, Sydney
PXB 1582 / 8c

Frederick Frith, John Sharp

Panorama of Hobart, in five pieces, taken from The Domain 1856
5 salted paper prints
15.6 x 85.8 cm (overall)
Tasmanian Archive and Heritage Office, Hobart
NS2960/1/1

Henry Albert Frith

The last of the native race of Tasmania 1864
photograph, hand-tinted
20 x 17 cm
Auckland Art Gallery Toi o Tāmaki, New Zealand, gift of Sir George Grey, 1893
AAG 1893/2

attributed to **Henry Albert Frith**

Aborigines of Tasmania 1864
stereograph
7.2 x 7 cm (each);
8.5 x 17.5 cm (card)
State Library of New South Wales, Sydney, presented 1973
PXB 199/25

Simryn Gill

from the *Vegetation* archive (Melaluca) 1999, 2008
gelatin silver photograph
25.5 x 25.5 cm
Collection of the artist

Eyes and storms #21 2012–13
1 of 24 Ilfochrome
photographs
125 x 125 cm
Collection of the artist

Eyes and storms #13 2012,
printed 2014
1 of 24 Ilfochrome
photographs
121.7 x 121.2 cm
Art Gallery of New South
Wales, purchased with funds
provided by the Photography
Collection Benefactors
program 2014
57601

Thomas Glaister

Portrait of two girls c1858
ambrotype, hand-tinted
6.2 x 8.8 cm;
10.6 x 12.8 cm (case)
National Gallery of Australia,
Canberra, purchased 1983
83.1160

*Professor John Smith,
1821–85. First professor of
chemistry and experimental
philosophy, University of
Sydney* c1858
stereo daguerreotype,
hand-tinted
9 x 12 cm;
12.2 x 15.5 cm (Mascher case)
Tasmanian Museum and
Art Gallery, Hobart
Q185

The Moore family c1860
ambrotype, hand-tinted
14.8 x 19.8 cm;
31.5 x 36.6 cm (frame)
National Gallery of Australia,
Canberra, purchased 1987
87.459

attributed to Thomas Glaister

Seated lady c1857
ambrotype
35.7 x 27.8 cm
State Library of New South
Wales, Sydney, presented
by Sir William Dixson
DL ON 1 item 2

Glaister studio

*Portrait of a man and three
girls* 1855–70
ambrotype, hand-tinted
6.5 x 9 cm;
9.3 x 11.9 cm (case)
Art Gallery of New South
Wales, purchased 1989
206.1989

Bernard Goode

*Bernard Goode's advertising
carte with 'gem' self-portrait*
c1866
carte de visite
10.4 x 6.5 cm (card)
RJ Noye Collection, Art Gallery
of South Australia, Adelaide,
gift of Douglas and Barbara
Mullins 2004
20041RJN878

Rundle Street, Adelaide c1866
Rundle Street, Adelaide 1869
from an album of 50
photographs 1860s–70s
15.5 x 12.5 x 4.5 cm (album)
Art Gallery of South Australia,
Adelaide, gift of Douglas and
Barbara Mullins 2001
200111Ph16.20-21

George Goodman

Dr William Bland c1845
daguerreotype
6 x 5 cm;
7.5 x 6.3 cm (case)
State Library of New South
Wales, Sydney, presented
under the Taxation
Incentives for the Arts
Scheme 1993
MIN350

*Caroline and son Thomas
James Lawson* 1845
daguerreotype
5 x 4 cm;
7.5 x 6.2 x 2 cm (case)
State Library of New South
Wales, Sydney, presented 1991
MIN323

Eliza Lawson 1845
daguerreotype
6 x 5 cm;
8 x 6.8 cm (case)
State Library of New South
Wales, Sydney, presented
by Sir Kenneth Street 1960
MIN157

Maria Emily Lawson 1845
daguerreotype
5 x 4 cm;
7.5 x 6.2 x 2 cm (case)
State Library of New South
Wales, Sydney, presented 1993
MIN345

Sarah Ann Lawson 1845
daguerreotype
5 x 4 cm;
7.5 x 6.2 x 2 cm (case)
State Library of New South
Wales, Sydney, presented
by Sir Kenneth Street 1960
MIN142

Sophia Rebecca Lawson 1845
daguerreotype
5 x 4 cm;
7.5 x 6.2 x 2 cm (case)
State Library of New South
Wales, Sydney, presented
by Sir Kenneth Street 1960
MIN155

Gove & Allen

*Portraits of the Simson
family* c1880
2 'Gove' albums of tintypes,
hand-tinted
2 x 1.5 cm (each);
9.1 x 8 x 1.3 cm (each album)
Tasmanian Museum and
Art Gallery, Hobart
Q8435 & Q8436

William Gullick

*Gullick family: Mary Gullick,
Zoe Gullick, Marjory Gullick,
Chloe Gullick* c1909
autochrome
7.1 x 9.1 cm
State Library of New
South Wales, Sydney,
presented 1991
Slides 45 / 5

Edward Haigh

Patent slip Williamstown c1861
20.4 x 26.6 cm
Picture Collection, State
Library of Victoria, Melbourne
H36668(13)

'Professor' Robert Hall

*Portrait of a gentleman
with check pants* 1855–65
stereo ambrotype,
hand-tinted
6 x 5.5 cm (each);
8.8 x 17.1 cm (overall)
RJ Noye Collection, Art
Gallery of South Australia,
Adelaide, gift of Douglas
and Barbara Mullins 2004
20041RJN413

Fred Hardie

Flinders Street, Melbourne
1892–93
23 x 27.5 cm
Pictures Collection,
National Library of Australia,
Canberra
PIC P155/16

*General Post Office,
Melbourne* 1892–93
27.6 x 22.7 cm
Pictures Collection,
National Library of Australia,
Canberra
PIC P155/48

William Hetzer

*Australian Aborigines
Burragorang tribe near
Camden* 1858 (Tharawal
and Gandangara at
Camden Park)
stereograph
8.3 x 17 cm (card)
Macleay Museum, The
University of Sydney
HP80.51.27

*The Gap, Watson's Bay,
NSW* 1858–67
stereograph
8.5 x 17.4 cm (card)
Macleay Museum, The
University of Sydney
HP83.62.2

*George Str. Sydney Bullock
team* 1858–67
stereograph
8.5 x 17 cm (card)
Macleay Museum, The
University of Sydney
HP80.51.4

*George Str. Sydney post
office* 1858–67
stereograph
8.7 x 17 cm (card)
Macleay Museum, The
University of Sydney
HP80.51.3

*W Hetzer's stereoscopic
views of Sydney and environs*
1858–67
stereograph box
9.3 x 18.6 x 1.6 cm (box)
Macleay Museum, The
University of Sydney
HP83.62.61

Louisa Elizabeth How

John Glen in an untitled
album 1858–59
single-layer albumen
photographs
15.9 x 21.4 x 1.8 cm (album)
National Gallery of Australia,
Canberra, purchased 1982
82.1158.26

*Mr William Landsborough,
Tiger and JL* 1858–59

salted paper print (?)
11.5 x 15.9 cm
Art Gallery of New South
Wales, purchased 1989
208.1989

Frank Hurley

Antarctic views c1912
carbon photograph
46 x 59.1 cm
State Library of New South
Wales, Sydney, presented
1923–47
PXD 679 / 28

Antarctic views c1912
carbon photograph
31.1 x 77.5 cm
State Library of New South
Wales, Sydney, presented
1923–47
PXD 679 / 36

*Antarctic views – a turreted
berg* c1912
carbon photograph
43.7 x 59.4 cm
State Library of New South
Wales, Sydney, presented
1923–47
PXD 679 /42

*Blizzard at Cape Denison,
Antarctica* c1912
carbon photograph
35.9 x 44.5 cm
State Library of New South
Wales, Sydney, presented
1923–47
PXD 679 / 30

*Coastal ice formation,
Antarctica* c1912
carbon photograph
43.8 x 59.3 cm
State Library of New South
Wales, Sydney, presented
1923–47
PXD 679 / 35

*Mushroom ice formation,
Antarctica* c1912
carbon photograph
39.1 x 44.1 cm
State Library of New South
Wales, Sydney, presented
1923–47
PXD 679 / 41

Burketown 1914
gelatin silver photograph
7.5 x 13.2 cm
Art Gallery of New South
Wales, accessioned 1996
377.1996

Illustrations Ltd, Perth

*With the Fiat Club of WA:
Perth to Adelaide* 1926
album with 72 gelatin silver
photographs
22.4 x 27 x 4.5 cm (album)
opening 21 & 22
Kerry Stokes Collection, Perth
2008.15.472

Edward Irby

*Studio portrait of a six-year-
old girl Ann Plummer* c1864
ambrotype, hand-tinted
6.5 x 7.5 x 1.5 cm (case)
Museum of Applied Arts
and Sciences, Sydney, gift
of D Snoor 1962
H6998

GH Jenkinson

Broadway Dunolly c1861
ambrotype
12.2 x 16.5 cm
Picture Collection, State
Library of Victoria, Melbourne
H26116

*Broadway 'looking north'
(Dunolly)* c1861
ambrotype
12.1 x 16.7 cm (oval)
Picture Collection, State
Library of Victoria, Melbourne
H26130

Dunolly Hospital c1861
ambrotype
12.4 x 16.7 cm (oval)
Picture Collection, State
Library of Victoria, Melbourne
H26128

Carol Jerrems

Vale Street 1975
gelatin silver photograph
20.1 x 30.4 cm
Art Gallery of New South
Wales, purchased 1979
46.1979

Juliet holding 'Vale Street'
1976
gelatin silver photograph
30.4 x 20.1 cm
Art Gallery of New South
Wales, purchased 1979
47.1979

Henry Jones

Women old colonists 1871
126 x 93.5 cm
State Library of South
Australia, Adelaide
B 19985

possibly Milton Kent

William St, East Sydney c1916
in *City architect and building
surveyor's album* (known
as *The Demolition Books*)
1906–49
gelatin silver photographs
in album
52 x 43 x 5 cm (album)
City of Sydney Archives
NSCA CRS 51/1810

John Hunter Kerr

A corrorobby [corroboree]
(Victoria) c1851–55
salted paper print
14.1 x 21.5 cm
Picture Collection, State
Library of Victoria, Melbourne,
gift of Mr Bruce Lang 1982
H 82.277/10

Native lad – Port Phillip
c1851–55
salted paper print
18.2 x 13 cm
Picture Collection, State
Library of Victoria, Melbourne,
gift of Mr Bruce Lang 1982
H 82.277/11

*J Hunter Kerr's station –
Loddon Plains, Victoria* c1851–61
salted paper print
18.8 x 25.4 cm
Picture Collection, State
Library of Victoria, Melbourne,
gift of Mr Bruce Lang 1982
H 82.277/5

John Hunter Kerr, George Priston

Aboriginal spears, boomerangs and implements c1865–75
14 x 20.3 cm
Picture Collection, State Library of Victoria, Melbourne
H30158/29

Full-length portrait of Aboriginal man, standing, holding stockwhip and wearing European clothes c1865–75
14.4 x 9.6 cm
Picture Collection, State Library of Victoria, Melbourne
H30158/28

View of a tree c1865–75
19 x 15 cm
Picture Collection, State Library of Victoria, Melbourne
H30158/20

Kerry & Co

Fern Gully, Blue Mountains c1884–95
14.6 x 20.3 cm
Art Gallery of New South Wales, gift of Frank Hinder 1985
389.1996

Douglas Kilburn

Group of Koori men c1847
daguerreotype
7.5 x 6.5 cm;
9.2 x 7.9 x 1.7 cm (case)
National Gallery of Victoria, Melbourne, purchased from Admission Funds 1983
PH407.1983

Two Koori women c1847
daguerreotype
6.7 x 5.4 cm;
9.2 x 8.1 x 2 cm (case)
National Gallery of Victoria, Melbourne, purchased 2004
2004.603

Group of Koori women 1847
daguerreotype
6.6 x 5.4 cm
National Gallery of Victoria, Melbourne, purchased 1999
1999.97

South-east Australian Aboriginal man and two younger companions 1847
daguerreotype
8 x 6.8 cm
National Gallery of Australia, Canberra, purchased 2007
2007.81.122

Louis Konrad

Thomas Hinton with 'Advance Australia' banner 1900
cabinet card
16.3 x 10.7 cm (card)
National Museum of Australia, Canberra
2012.0015.0004

Fred Kruger

Scene, Lake Wendouree, as seen from Wendouree Parade, Ballarat c1866–87
13.3 x 20.1 cm
National Gallery of Victoria,

Melbourne, gift of Mrs Beryl M Curl 1979
PH232-1979

Annie Rees with her children, Maryann and Charlotte at Coranderrk Aboriginal station, Victoria c1876–77
carte de visite
10.2 x 6.6 cm (card)
Museum Victoria, Melbourne
XP 1787

Charlotte Arnott and child at Coranderrk Aboriginal station, Victoria c1876–77
carte de visite
10.2 x 6.7 cm (card)
Museum Victoria, Melbourne
XP 1842

Aboriginal cricketers at Coranderrk c1877
13.3 x 18.6 cm
National Gallery of Victoria, Melbourne, gift of Mrs Beryl M Curl 1979
PH225-1979

Album of Victorian Aboriginals – kings, queens, &c c1877
leporello album
10.2 x 14.1 x 0.8 cm (album)
Johann Friedrich Carl Kruger Collection, South Australian Museum, Adelaide
AA566/1

Badger Creek, Coranderrk Aboriginal Station, fishing scene c1877
18.4 x 27.2 cm
National Gallery of Victoria, Melbourne, gift of Mrs Beryl M Curl 1979
PH252-1979

Victorian Aboriginals' war implements, Coranderrk c1877
27.2 x 19.9 cm
National Gallery of Victoria, Melbourne, gift of Mrs Beryl M Curl 1979
PH226-1979

View on the Moorabool River, Batesford c1879
18.4 x 27.2 cm
National Gallery of Victoria, Melbourne, gift of Mrs Beryl M Curl 1979
PH213-1979

A view of the You Yangs, from Lara Plains c1882
18.4 x 27.2 cm
National Gallery of Victoria, Melbourne, gift of Mrs Beryl M Curl 1979
PH338-1979

Rosemary Laing

Eddie from the series *leak* 2010
type C photograph
110 x 257.6 cm
Art Gallery of New South Wales, purchased with funds provided by Andrew and Cathy Cameron 2011
240.2011

attributed to Helen Lambert

Oval portrait of Edith Gladstone, Mrs Dumaresq and *My drawing room Phillip Street Sydney* in the album *Who and what we saw at the*

Antipodes 1868–70
29.4 x 26.4 x 5.6 cm (album)
National Gallery of Australia, Canberra, purchased 1983
83.25.45

Jon Lewis

Portrait photograph of Michael Riley 1986–88
gelatin silver photograph
58.5 x 48.5 cm
National Museum of Australia, Canberra
2000.0041.0327

JW Lindt

No 11 Mary Ann of Ulmarra 1873
20 x 15 cm

No 14 Family group, Ulmarra tribe, Clarence River NSW 1873

No 18 Man seated holding a rifle 1873
20 x 15 cm

No 21 Reclining man 1873
15 x 20 cm

No 22 Two stalwart men of the coastal tribe 1873
20 x 15 cm

No 29 Mother and daughter from the Orara River 1873
20 x 15 cm

No 34 Timbergetters 1873
20 x 15 cm

No 36 Reclining miner 1873
15 x 20 cm

No 37 Bushman and an Aboriginal man 1873
20 x 15 cm

No 38 Shearer 1873
20 x 15 cm

JW Lindt Collection, Grafton Regional Gallery, Grafton, gift of Sam and Janet Cullen and family 2004

The artist's camp near Wintervale on the Newton Boyd 1875
18.8 x 25.5 cm
JW Lindt Collection, Grafton Regional Gallery, Grafton, gift of the Friends of Grafton Gallery 2005
2005.69

Body of Joe Byrne, member of the Kelly gang, hung up for photography, Benalla 1880
gelatin silver photograph
20.2 x 40.4 cm
National Gallery of Australia, Canberra, purchased 1977
77.59.28

Sandridge railway pier in an untitled album 1880s–90s
20.6 x 25.6 x 3.6 cm (album)
National Gallery of Australia, Canberra, purchased 1985
85.191.1

Coontajandra and Sanginguble 1893
carbon photograph
61 x 30.5 cm
National Gallery of Australia, Canberra, purchased 2005
2005.576

Archibald McDonald

Chang the Chinese giant in European dress, with Chinese boy and three European men, one of whom is his manager c1871
carte de visite
13 x 6.1 cm (card)
National Portrait Gallery, Canberra, purchased 2010
2010.31

Chang the Chinese giant with his seated wife Kin Foo with fan and manager c1871
carte de visite
10.3 x 6.1 cm (card)
National Portrait Gallery, Canberra, purchased 2010
2010.29

David McRae

Mervyn Bishop at Mt Liebig aka Watiya Wanu c2000, printed 2014
type R3 photograph
12 x 18 cm
Courtesy Mervyn Bishop, Sydney
56996

Philip J Marchant

Double self-portrait c1866
carte de visite
10.4 x 6.4 cm (card)
RJ Noye Collection, Art Gallery of South Australia, Adelaide, gift of Douglas and Barbara Mullins 2004
20041RJN2223

Ricky Maynard

Portrait of a distant land 2005
10 gelatin silver photographs
Art Gallery of New South Wales, purchased with funds provided by the Aboriginal Collection Benefactors Group and the Photography Collection Benefactors Program 2009
328.2009.1-10

Custodians
43 x 41.2 cm

Broken heart
42.9 x 41.2 cm

Traitor
43 x 41.7 cm

Free country
41.3 x 50.7 cm

The Healing Garden, Wybalenna, Flinders Island, Tasmania
34 x 52 cm

Coming home
33.8 x 52 cm

Death in exile
33.6 x 53 cm

Vansittart Island, Bass Strait, Tasmania
33.9 x 52.1 cm

The spit
41.8 x 50.4 cm

The Mission
43 x 41.2 cm

Tracey Moffatt

Beauties (in cream) 1994
Beauties (in wine) 1994
Beauties (in mulberry) 1997
gelatin silver photographs, colour-tinted
approx 99.2 x 77.5 cm (each)
Queensland Art Gallery, purchased 2008 with funds from Xstrata Community Partnership Program Queensland through the Queensland Art Gallery Foundation
2008.223.001, 002, 003

I made a camera 2003
photolithograph
22 x 29 cm
Collection of the artist
56006

David Moore

Redfern interior 1949, printed later
gelatin silver photograph
21.8 x 30.4 cm
Art Gallery of New South Wales, purchased 1980
98.1980

Migrants arriving in Sydney 1966, printed later
gelatin silver photograph
30.2 x 43.5 cm
Art Gallery of New South Wales, gift of the artist 1997
429.1997

Charles P Mountford

Carved rocks at Salt Creek, Panaramittee c1936
gelatin silver photograph
25.3 x 19.9 cm
State Library of South Australia, Adelaide
PRG 1218/33 exCPM/115

Dingo: hand, with fingers turned tightly inward, is moved up and down from wrist in the album *Gesture language of the Australian Aborigine: the Nagagadjara tribe; the Wilbiri* [Walpiri] *tribe* 1938–49
album of gelatin silver photographs and text
33 x 28 cm (album)
State Library of South Australia, Adelaide
PRG 1218/33: ex CPM/260

Thomas J Nevin

Elizabeth St 1860s
stereograph
7.3 x 7 cm (each);
8.5 x 17.4 cm (card)
Tasmanian Museum and Art Gallery, Hobart
Q1994.56.12

JW Newland

Murray St, Hobart 1848
daguerreotype
15 x 20 cm;
27.5 x 32.5 cm (frame)
Tasmanian Museum and Art Gallery, Hobart
Q612

Portrait of Edward TYW McDonald 1848
daguerreotype

12 x 9 cm
14 x 10.7 x 0.7 cm (overall)
Macleay Museum, The
University of Sydney
SC1997.40.6

Francis Nixon, JW Beattie

Tasmanian Aborigines 1860
stereograph
7.8 x 7.5 cm (each);
8.2 x 17.2 cm (card)
National Gallery of Australia,
Canberra, purchased 1993
93.451

Samuel Nixon

Self-portrait c1867
carte de visite
10 x 6.2 cm (card)
RJ Noye Collection, Art Gallery
of South Australia, Adelaide,
gift of Douglas and Barbara
Mullins 2004
20041RJN2229

NSW Government Printer

*The burning of the Garden
Palace* 1882
album
33.5 x 44 x 3 cm (album)
Museum of Applied Arts and
Sciences, Sydney
86/949

*The General Post Office,
Sydney* 1892–1900
27 x 35.5 cm
State Library of New South
Wales, Sydney, presented 1969
PXD 116 / 48

*Goulburn Gaol, New South
Wales* 1892–1900
27 x 35.5 cm
State Library of New South
Wales, Sydney, presented 1969
PXD 116 / 50

Imperial Arcade, Sydney
1892–1900
27 x 35.5 cm
State Library of New South
Wales, Sydney, presented 1969
PXD 116 / 66

attributed to John Paine

Black Bluff, leaf 23 from the
Colonies album c1870–80s
album of albumen and gelatin
silver photographs
36.4 x 50 x 6.4 cm (album)
National Gallery of Australia,
Canberra, Joseph Brown Fund
81.2866.22

Paterson Brothers

*Chang the Chinese giant
and party* c1871
carte de visite
13 x 6.3 cm (card)
National Portrait Gallery,
Canberra, purchased 2010
2010.28

Florence Perrin

*View of Cradle Mountain and
Dove Lake, Tasmania* 1920s
stereograph
9.8 x 18 cm (card)
Queen Victoria Museum
and Art Gallery collection,
Launceston
QVM.1988.P.0159

*View of Flynn's Tarn and
Little Horn, Cradle Mountain
area, Tasmania* 1920s
stereograph
9.7 x 17.9 cm (card)
Queen Victoria Museum
and Art Gallery collection,
Launceston
QVM.1988.P.0100

*View of snow-covered trees
on the road to Waldheim,
Cradle Mountain area,
Tasmania* 1920s
stereograph
10.1 x 17 cm (card)
Queen Victoria Museum
and Art Gallery collection,
Launceston
QVM.1988.P.0158

*View taken from the kitchen
door at Waldheim Chalet,
Cradle Mountain, Tasmania*
1920s
stereograph
9.6 x 17.9 cm (card)
Queen Victoria Museum
and Art Gallery collection,
Launceston
QVM.1988.P.0148

Axel Poignant

*Aboriginal stockmen's camp,
Wave Hill cattle station,
Central Australia* c1946,
printed later
gelatin silver photograph
23.2 x 36 cm
Art Gallery of New South
Wales, purchased 1978
178.1978

*Aboriginal stockman, Central
Australia* c1947, printed 1982
type C photograph
35.6 x 24.4 cm
Art Gallery of New South
Wales, purchased 1984
24.1984

Patrick Pound

The readers 2011–15
found photographs,
site specific installation
Collection of the artist

Patrick Pound with
Rowan McNaught

*The compound lens
project* 2014–15
projection and web,
room in a room
approx 480 x 480 cm
Collection of the artists

Michael Riley

Maria 1985
gelatin silver photograph
45.5 x 47.9 cm
Art Gallery of New South
Wales, Mollie Gowing
Acquisition Fund for
Contemporary Aboriginal
Art 1999
12.1999

William Robinson, Negretti
& Zambra

*Remaining seven of the first
group of Aboriginal people
removed from Queensland,
Crystal Palace, London* 1884
cabinet card
10.8 x 16.8 cm (card)

Pictures Collection, National
Library of Australia, Canberra
PIC/15606

Henry Chamberlain Russell

Jupiter 1889–92
gelatin silver photograph
10.8 x 16.7 cm
Museum of Applied Arts
and Sciences, Sydney
P3549-68

Flame at Miller's Point 1890
gelatin silver photograph
16.4 x 10.6 cm
Museum of Applied Arts
and Sciences, Sydney, gift
of Mrs Carole Short 2005
2005/124/1-37

*Lightning strikes taken from
Sydney Observatory* 1892
25 x 30.5 cm
Museum of Applied Arts
and Sciences, Sydney, gift
of Dr Lucy Crowley 1995
95/239/25

James Short

The Moon c1890–1922
2 gelatin silver photographs
21.4 x 16.3 cm (each)
Museum of Applied Arts
and Sciences, Sydney, gift
of Mrs Carole Short 2005
2005/124/1-45, 2005/124/1-44

Total solar eclipse c1890–1922
7 gelatin silver photographs
16.5 x 20.6 cm (each)
Museum of Applied Arts
and Sciences, Sydney, gift
of Mrs Carole Short 2005
2005/124/1-38, 2005/124/1-39,
2005/124/1-40, 2005/124/1-41,
2005/124/1-42, 2005/124/1-43,
2005/124/1-44

Omega, Centauri 1899–1930
gelatin silver photograph
9.3 x 7 cm
Museum of Applied Arts
and Sciences, Sydney
P3549-101

Lunar eclipse 1906
13.2 x 19 cm
Museum of Applied Arts
and Sciences, Sydney, gift
of Mrs Carole Short 2005
2005/124/1-34

Trifid Nebulae 1908
8.9 x 12.7 cm
Museum of Applied Arts
and Sciences, Sydney, gift
of Mrs Carole Short 2005
2005/124/1-33

Sun spot 6 April 1914
gelatin silver photograph
20.5 x 16.5 cm
Museum of Applied Arts
and Sciences, Sydney
P3549-100

Professor John Smith

*Conservatory at Entally House,
Hadspen, Tasmania* c1859
stereograph
7.2 x 7 cm (each)
8.5 x 17.5 cm (card)
State Library of New South
Wales, Sydney, presented 1973
PXB 199/29

Frederick Smithies

*Paddy Hartnett on Mount
Oakleigh* c1930
stereograph
9 x 17.7 cm (card)
Queen Victoria Museum and
Art Gallery collection,
Launceston
QVM.1998.P.1715

Walter Baldwin Spencer

*Unloading supplies, Daly
River, Northern Territory,
Australia* 1911
gelatin silver photograph
5.6 x 18.5 cm
Museum Victoria, Melbourne
XP 14727

*View of Roper River, Northern
Territory, Australia* 1911
gelatin silver photograph
10.2 x 31.1 cm
Museum Victoria, Melbourne
XP 14677

*Panorama photo of a group
of children, the Bungalow
Mission, Alice Springs,
Northern Territory* 1923
gelatin silver photograph
5.4 x 17.2 cm
Museum Victoria, Melbourne
XP 14967

*Portrait of Agnes Draper
taken at the Bungalow Mission,
Alice Springs, Northern
Territory* 1923
gelatin silver photograph
8.2 x 13 cm
Museum Victoria, Melbourne
XP 14911

*Portrait of Clem Smyth and
Annie Giles taken at the
Bungalow Mission, Alice
Springs, Northern Territory*
1923
gelatin silver photograph
13 x 8.2 cm
Museum Victoria, Melbourne
XP 14859

*Portrait of a group of children
taken at the Bungalow
Mission, Alice Springs,
Northern Territory* 1923
gelatin silver photograph
8.2 x 13 cm
Museum Victoria, Melbourne
XP 15229

*Portrait of two children taken
at the Bungalow Mission,
Alice Springs, Northern
Territory* 1923
gelatin silver photograph
13 x 8.1 cm
Museum Victoria, Melbourne
XP 14862

*Portrait of a young boy taken
at the Bungalow Mission,
Alice Springs, Northern
Territory* 1923
gelatin silver photograph
12.9 x 8.1 cm
Museum Victoria, Melbourne
XP 15228

Robyn Stacey

Walnuts from the series
Empire line 2009
type C photograph
90 x 67.5 cm

Art Gallery of New South
Wales, purchased with funds
provided by Nanette
Ainsworth, John & Kate
Armati, The Freedman
Foundation, the Mackay
family, the Whiston family
and the Photography
Collection Benefactors
Program 2010
182.2010

Chatelaine from the series
Tall tales and true 2010
type C photograph
110 x 82.5 cm
Art Gallery of New South
Wales, purchased with funds
provided by the Photography
Collection Benefactors
Program 2011
327.2011

David Stephenson

*Stars #807, #903, #1008,
#1311* 1995
4 gelatin silver photographs
approx 77 x 77 cm (each)
Art Gallery of New South
Wales, purchased with funds
provided by the Art Gallery
Society of New South Wales
Contempo Group 1997
405-408.1997

Alfred Hawes Stone

Panorama of Perth in the
*Stone album of photographs
of early Perth and Fremantle
1860–68*
album of 146 photographs
30.5 x 25.5 x 3 cm (album)
State Library of Western
Australia, Perth
6909B

George Fordyce Story

Emma and Esther Mather
c1858
9.2 x 6 cm
National Gallery of Australia,
Canberra, purchased 2011
2011.1043

Self-portrait 1858–60
9.1 x 6.3 cm
National Portrait Gallery,
Canberra, purchased with
funds provided by Graham
Smith 2009
2009.65

Richard Strangman

9 gelatin silver photographs
1915–26
approx 13.5 x 8.2 cm (each)
Pictures Collection, National
Library of Australia, Canberra
PIC/8330

*Portrait of lady in hat,
Tumut, New South Wales*

*Portrait of man beside chair
with hand behind his back,
Tumut, New South Wales*

*Portrait of three children
and chair, Tumut, New
South Wales*

*Portrait of unidentified
young woman wearing
white embroidered dress
and pendant, Tumut,
New South Wales*

Portrait of unidentified young Southeast Asian man seated wearing a striped suit, Tumut, New South Wales

Portrait of two unidentified girls wearing white lace dresses and brooches, Tumut, New South Wales

Portrait of man with one hand on chair, Tumut, New South Wales

Portrait of two girls and doll in front of bush, Tumut, New South Wales

Portrait of two men wearing hats, one smoking, Tumut, New South Wales

Samuel Sweet

Aboriginal man in animal skin cloak c1876
21.3 x 15.8 cm
Captain Samuel White Sweet Collection, South Australian Museum, Adelaide
AA492/1/2

Aboriginal woman with baby 1880
20.5 x 15.5 cm
RJ Noye Collection, Art Gallery of South Australia, Adelaide, gift of Douglas and Barbara Mullins 2004
20041RJN374.2

Captain Sweet taking photos in the far north 1882
15.9 x 21.5 cm
National Gallery of Australia, Canberra, purchased 2007
2007.81.120AB

Mr Satow taken with the school children outside the church, Poonindie Mission 1884
17.4 x 24 cm
Art Gallery of South Australia, Adelaide, JC Earl Bequest Fund 2006
20063Ph3

Poonindie Mission – machinery, Aborigines, Mr Bruce and children 1884
17.5 x 24 cm
Art Gallery of South Australia, Adelaide, JC Earl Bequest Fund 2006
20063Ph2

Henry Talbot

Carol Jerrems nude 1973
gelatin silver photograph
20.6 x 28.8 cm
Art Gallery of New South Wales, gift of Edron Pty Ltd 1995 through the auspices of Alistair McAlpine
314.1996

Talma & Co

Barak drawing a corroboree c1898
gelatin silver photograph
16.8 x 12 cm
Picture Collection, State Library of Victoria, Melbourne
H141210

attributed to **Walter Thwaites**
New Norcia Benedictine Mission: priest nursing boy with Aboriginal men 'Chiuck' and 'Biug' wearing skin cloak standing l-r, and mission boys seated on floor 1867
carte de visite
10.5 x 6.3 cm (card)
National Gallery of Australia, Canberra, purchased 2012
2012.938

Henry Tilbrook

Lizzie Smelat 1880s (?)
gelatin silver stereograph
7.1 x 15.3 cm;
8.8 x 17.5 cm (card)
RJ Noye Collection, Art Gallery of South Australia, Adelaide, gift of Douglas and Barbara Mullins 2004
20041RJN61

Elder Range panorama with inset self-portrait 1894
4 gelatin silver photographs
11.4 x 69 cm (overall);
38 x 93.7 cm (frame)
RJ Noye Collection, Art Gallery of South Australia, Adelaide, gift of Douglas and Barbara Mullins 2004
20041RJN1

Spoils of the ocean and *Breakfast in the boat* in *Album of photographs by HH Tilbrook (2)* 1898
album of gelatin silver photographs
30.4 x 52.2 cm (open album)
RJ Noye Collection, Art Gallery of South Australia, Adelaide, gift of Douglas and Barbara Mullins 2004
20041JN43 opening 27–28

A stormy camp, Lake Frome 1900
gelatin silver photograph
20 x 56 cm;
40.4 x 74.8 cm (frame)
RJ Noye Collection, Art Gallery of South Australia, Adelaide, gift of Douglas and Barbara Mullins 2004
2041RJN31

H Toose

Aboriginal group in front of Toose's cart, Bega 1878
carte de visite
6.2 x 10.1 cm (card)
Private collection

Joseph Turner

James Henty and Co building, Brougham Place, Geelong c1857–67
ambrotype
8.5 x 11.6 cm;
12 x 15 x 1.7 cm (case)
The University of Melbourne Art Collection, gift of the Russell and Mab Grimwade Bequest 1973
1973.0745.00A.00B.

Studio portrait of three children c1857–67
ambrotype
11.8 x 8.8 cm (irregular);
24.6 x 21.5 cm (frame)

National Gallery of Australia, Canberra, purchased 1987
87.460

Eta Argus Nebula taken with the Great Melbourne Telescope 7 January 1883
gelatin silver photograph
13.6 x 9.7 cm
Museum Victoria, Melbourne
MM030402

Orion Nebula taken with the Great Melbourne Telescope 26 February 1883
gelatin silver photograph
14 x 9.7 cm
Museum Victoria, Melbourne
MM030403

Orion Nebula taken with the Great Melbourne Telescope 26 February 1883
gelatin silver photograph
19.2 x 24.4 cm
Museum Victoria, Melbourne
MM 107609

Kappa Crucis Cluster taken with the Great Melbourne Telescope 3 March 1883
gelatin silver photograph
13.8 x 9.9 cm
Museum Victoria, Melbourne
MM 107620

Unknown photographers

Thomas Sutcliffe Mort and his wife Theresa c1847
daguerreotype
6.8 x 5.5 cm;
9.5 x 8.2 cm (case)
National Portrait Gallery, Canberra, purchased 2001
2001.60

Portrait of a boy, possibly Alexander III McKenzie 1848–52
daguerreotype, hand-tinted
5.4 x 4.1 cm (oval);
7.5 x 6.3 x 1.8 cm (case)
Art Gallery of New South Wales, purchased with funds provided by the Photography Collection Benefactors Program 2012
174.2012

Nareeb Nareeb, residence of Charles Gray c1849–61
daguerreotype
6.9 x 13 cm (oval)
Picture Collection, State Library of Victoria, Melbourne
H18056

Barrack St, Perth (?) c1850
daguerreotype
approx 7 x 8.3 cm
State Library of Western Australia, Perth
4791B

Dr Godfrey Howitt's garden c1850
daguerreotype
approx 7 x 8.3 cm;
10.8 x 12.8 cm (frame)
Picture Collection, State Library of Victoria, Melbourne
H2010.61/1

Northeast bird's eye view of Rose Cottage, the Australian residence of WH Walker c1850
ambrotype

6.2 x 7.6 cm;
18.4 x 20.3 cm (frame)
National Gallery of Australia, Canberra, purchased 1986
86.1816

Unidentified Aboriginal Australian man in European dress 1854–65
ambrotype, hand-tinted
6.7 x 5.2 cm;
9 x 8 x 1.5 cm (case)
Picture Collection, State Library of Victoria, Melbourne
H4951

Aboriginal man of Poonindie c1855
ambrotype
11.8 x 13.4 cm
With the permission of Special Collections, University of Bristol Library, United Kingdom
DM130/239

Isabella Carfrae on horseback, Ledcourt, Stawell, Victoria c1855
daguerreotype, hand-tinted
approx 7 x 8.3 cm;
9.3 x 11.8 x 1.6 cm (case)
National Gallery of Australia, Canberra, purchased 2012
2012.1336

James Henty c1855
daguerreotype, hand-tinted
7.2 x 5.7 cm;
9 x 7.8 cm (case)
Picture Collection, State Library of Victoria, Melbourne
H83.158/2

Margaret Mortlock and her daughter Mary c1855
daguerreotype, hand-tinted
11.6 x 8.8 cm;
15.2 x 24.2 cm (case open)
Ayers House Museum, National Trust of South Australia, Adelaide
#788

Probably Samuel Conwillan c1855
ambrotype
11.4 x 13.8 cm
With the permission of Special Collections, University of Bristol Library, United Kingdom
DM130/238

Henry Kay c1855–60
2 ambrotypes, hand-tinted
12 x 9.5 cm (case)
Picture Collection, State Library of Victoria, Melbourne, gift of Mrs WG Haysom 1964
H2727/1 & 2

Watch the birdie! c1855–60
ambrotype
5.2 x 4 cm;
6.6 x 5.5 cm (case)
Picture Collection, State Library of Victoria, Melbourne, bequest of Miss Sybil Craig 1990
H90.90/33

Southern or back view of Rose Cottage, Prahran c1856
daguerreotype
7.3 x 5.6 cm;
18.5 x 20.3 cm (frame)

National Gallery of Australia, Canberra, purchased 1986
86.1815

John Gill and Joanna Kate Norton 1856
12.8 x 10.8 cm
Picture Collection, State Library of Victoria, Melbourne
H88.21/14

Carfrae property, Ledcourt, Stawell, Victoria c1857
daguerreotype
8.5 x 6.2 cm; 11.8 x 9.2 cm (case)
National Gallery of Australia, Canberra, purchased 2008
2008.954

Baud and Bazeley's Balaclava Store on the north side of the Balaclava Hill, Whroo c1858–59
ambrotype
8.5 x 11.7 cm;
12 x 15.1 cm (case)
Picture Collection, State Library of Victoria, Melbourne, gift of Mr RH Baud 1977
H39204

Lewis and Nickinson's crushing battery at the Balaclava Mine, Whroo c1858–59
ambrotype
13.3 x 18.5 cm;
17.7 x 22.5 cm (case)
Picture Collection, State Library of Victoria, Melbourne, gift of Mr RH Baud 1977
H39206

Henry Chamberlain Russell 1859–65
ambrotype, hand-tinted
9.5 x 12 x 1.8 cm (case)
Museum of Applied Arts and Sciences, Sydney, gift of Dr Lucy Crowley 1995
95/239/1

Jemima, wife of Jacky, with William T Mortlock c1860
daguerreotype, hand-tinted
6.5 x 5.3 cm
Ayers House Museum, National Trust of South Australia, Adelaide
#784

Lydia Featherstone c1860
ambrotype, gilding
4.9 x 3.6 cm;
7.5 x 6.3 cm (case)
Art Gallery of South Australia, Adelaide, JC Earl Bequest Fund 2010
20102Ph2

Portrait of a family c1860
ambrotype
14 x 9.5 cm
Pictures Collection, National Library of Australia, Canberra
PIC P762

Brothers William Paul and Benjamin Featherstone c1860 (?)
ambrotype, gilding
11.5 x 8.5 cm;
15.5 x 12.1 cm (case)
Art Gallery of South Australia, Adelaide, JC Earl Bequest Fund 2010
20102Ph3

Jacky, known as Master Mortlock c1860–65
ambrotype
9.5 x 7 cm;
12 x 19 cm (case open)
Ayers House Museum,
National Trust of South
Australia, Adelaide
#787

William Ranson Mortlock
1860–65
ambrotype, hand-tinted
11.5 x 9 cm;
15.3 x 24.5 cm (case open)
Ayers House Museum,
National Trust of South
Australia, Adelaide
#793

Unidentified Robertson child c1861
ambrotype, hand-tinted
6.8 x 5.5 cm;
9.5 x 8.2 cm (case)
National Portrait Gallery,
Canberra, gift of Fiona Turner
(née Robertson) and John
Robertson 2011, donated
through the Australian
Government's Cultural
Gifts Program
2011.9

Unidentified Robertson woman and child c1861
ambrotype, hand-tinted
9 x 6.4 cm;
10.7 x 9.2 cm (case)
National Portrait Gallery,
Canberra, gift of Fiona Turner
(née Robertson) and John
Robertson 2011, donated
through the Australian
Government's Cultural
Gifts Program
2011.8

2nd view of Yarra from corner of Flinders St (Melbourne) 1861
and *View looking up Wellington Parade from 1 Spring St before the road was cut down (Melbourne)* 1861
approx 14 x 21.8 cm (each)
Picture Collection, State
Library of Victoria, Melbourne
H88.21/25 & 26

Fanny Maria Davenport, aged 12 years and
Walter Charles Davenport, aged 8 years 1861
2 ambrotypes
7 x 8 cm (each)
Narryna Heritage Museum,
Hobart
TMAG 26 & 27

Dewhurst family album 1861–62
album of 22 cartes de visite
15.4 x 22.6 x 3 cm (album)
Art Gallery of New South
Wales, gift of Josef & Jeanne
Lebovic, Sydney 2014
606.2014.a-x

The store and residence of John Bourne Crego and his partner, Henry Wilshire Webb 1863
ambrotype, hand-tinted
6.4 x 8.9 cm;
9.5 x 11.9 cm (case)
Art Gallery of New South
Wales, purchased 1989
229.1989

Duryea Gallery, Grenfell Street, Adelaide c1865
carte de visite
9.9 x 6.3 cm (card)
State Library of South
Australia, Adelaide
B 5663

Sandford, the home of John Henty, Portland Region, Victoria c1865
ambrotype
8.5 x 12 cm
Pictures Collection, National
Library of Australia, Canberra
PIC P727

Susanna Fisher and *Letitia Fisher* both c1865
2 tintypes, with oil paint and
gilding
21.5 x 16.5 cm (each, irregular)
Queen Victoria Museum and
Art Gallery, Launceston
QVM.1996.P.0231, P.0232

Caroline McLeod c1865–70
ambrotype
6.5 x 5.2 cm (case)
Picture Collection, State
Library of Victoria, Melbourne
H83.158/4

MA Olley 18 September 1879
tintype on carte de visite
approx 10 x 6.5 cm (card)
State Library of Western
Australia, Perth
9980B /2/117

Unidentified members of the Olley family c1880
7 tintypes on cartes de visite
approx 10 x 6.5 cm (each card)
State Library of Western
Australia, Perth
9980B/2/52, 90, 92, 93, 94, 114, 132

Effie Dalrymple in *Lethbridge family photograph album*
1885–95, pp 13–14
29.5 x 24 x 6.8 cm (album)
John Oxley Library, State
Library of Queensland,
Brisbane
Acc 6537, APE-58

Chang the Chinese giant, with his manager cowering on the floor and *Chang the Chinese giant, with his wife Kin Foo* both c1871
2 cartes de visite
10 x 6.2 cm (each card)
National Portrait Gallery,
Canberra, purchased 2010
2010.30 & 32

William Russille (?)/native/free (?)/2 months c1874
carte de visite
10.3 x 6.3 cm (card)
Tasmanian Museum and Art
Gallery, Hobart
Q15623

Alfred and Fred Thomas, proprietors of the Ravenswood Hotel 1880–90
2 tintypes
6 x 9 cm (each)
State Library of Western
Australia, Perth
5827B/1 & 2

Portrait of Catherine Reilly William, Richard, George or Patrick Reilly (2)

Portrait of Bridget Reilly Portrait of George Green (2)
6 tintypes all c1887
9 x 6 cm (each)
State Library of Western
Australia, Perth
BA1684/1,2,3,4,5,6

Queensland natives c1890s
10.4 x 14 cm
Queensland Art Gallery,
purchased 2003, Queensland
Art Gallery Foundation
2003.178.026

Unidentified members of the Weaver family 1890–1910
3 tintypes
9 x 6 cm (each)
State Library of Western
Australia, Perth
BA539/18, 19 & 20

Criminal history sheet, Edward Kelly 1898
2 gelatin silver photographs
on paper
34.8 x 22.4 cm (each)
VPRS 8369/P1
Correspondence, Photographs
and History Sheets of Certain
Male Criminals, Unit 1
Public Record Office Victoria

Thomas Hinton wearing a loincloth with 'Advance Australia' banner 1900
cabinet card
16.3 x 10.6 cm (card)
National Museum of Australia,
Canberra
2012.0015.0002

Thomas Hinton with 'Advance Australia' banner 1900
cabinet card
16.3 x 10.6 cm (card)
National Museum of Australia,
Canberra
2012.0015.0003

Portrait of John Watt Beattie c1901–20
gelatin silver photograph
14.6 x 10.4 cm
Allport Library and Museum
of Fine Arts, Hobart
Photo AP 57

Unknown photographer, Caves Board of Western Australia

Chamber of mysteries, Yallingup cave in *Photos of caves between Capes Naturaliste and Leeuwin* 1901
album of 66 photographs
34 x 23.7 x 5.3 cm (album)
State Library of Western
Australia, Perth
1796B

Melvin Vaniman

Panorama of Blue Mountains scenery at Leura 1903
platinum photograph
30 x 116.5 cm
State Library of New South
Wales, Sydney
DLPg27

Panorama of intersection of Collins and Queen Streets Melbourne 1903
platinum photograph

39.6 x 118.6 cm
State Library of New South
Wales, Sydney
DLPg25

Queenstown 1903 1903
platinum photograph
37.7 x 118.8 cm
Tasmanian Archive and
Heritage Office, Hobart
NS1711-1-2122

Panorama of Fremantle, looking east across the water
1904
platinum photograph
40 x 119 cm
State Library of Western
Australia, Perth
1493B

Panorama of Fitzroy Vale Station, near Rockhampton
1904
platinum photograph
30 x 116.5 cm
State Library of New South
Wales, Sydney
DLPg28

Conrad Wagner

(Mr Barne's) Ettrick Blacks, Richmond River c1869
24 x 30.8 cm
State Library of New South
Wales, Sydney, presented by
Ian M Hedley, May 2012
PXA 1489/5

Mr & Mrs Sherwood & family. Unumgar, Queensland c1869
24 x 30.8 cm
State Library of New South
Wales, Sydney, presented by
Ian M Hedley, May 2012
PXA 1489/4

Charles Walter

Coranderrk Aboriginal Settlement 1865
panorama of 4 photographs
14.5 x 67.1 cm
State Library of New South
Wales, Sydney
V / 110

Jill White

David Moore being photographed by Max Dupain in Clarence Street studio 1959
gelatin silver photograph
27.8 x 27.6 cm
Pictures Collection, National
Library of Australia, Canberra
PIC/3351/7

Charles Woolley

Bessy Clark 1866
21.7 x 16.4 cm
Tasmanian Museum and
Art Gallery, Hobart
Q176.2

Patty – Kangaroo Point Tribe 1866
21.7 x 16.4 cm
Tasmanian Museum and
Art Gallery, Hobart
Q179.2

Truganini 1866
21.7 x 16.4 cm
Tasmanian Museum and
Art Gallery, Hobart
Q177.2

Wapperty, Ben Lomond Tribe portrait 1866
21.7 x 16.4 cm
Tasmanian Museum and
Art Gallery, Hobart
Q178.2

William Lanne, Coal River Tribe 1866
21.7 x 16.4 cm
Tasmanian Museum and
Art Gallery, Hobart
Q180.2

Anne Zahalka

artist #13 (Rosemary Laing)
1990
from the series *Artists*
colour Duraflex photograph
72.5 x 72.5 cm
Collection of the artist

PHOTO BOOKS

David Beal, Donald Horne,
Southern exposure, William
Collins (Australia) Ltd,
Sydney, 1967
28.5 x 22.2 x 1.3 cm
Art Gallery of New South
Wales Research Library
and Archive
56998

Jeff Carter, *Outback in focus*,
Rigby Limited, Adelaide, 1968
29.5 x 23.7 x 2.4 cm
Art Gallery of New South
Wales Research Library and
Archive, Sydney
56999

Richard Daintree, *Queensland, Australia: its territory, climate and products: agricultural, pastoral and mineral, &c, &c, with emigration regulations. With maps* 1872–73
book with 20 autotypes,
illustration no 17
21.4 x 14.2 x 1.7 cm
Art Gallery of New South
Wales, gift of Josef & Jeanne
Lebovic, Sydney 2014
57051

Robert B Goodman,
George Johnston
The Australians, Paul Hamlyn,
London, 1966
28 x 26.1 x 3.2 cm
Art Gallery of New South
Wales Research Library
and Archive
56997

Marion Hardman,
Peter Manning
Green bans: the story of an Australian phenomenon,
Australian Conservation
Foundation, Melbourne, 1975
27.2 x 23.1 x 0.9 cm
Art Gallery of New South
Wales Research Library and
Archive
57001

JW Lindt, Nicholas Caire

Companion guide to Healesville, Blacks' Spur, Narbethong and Marysville, The Atlas Press (E Newlands), Melbourne, 1904, 18.5 x 12.4 x 0.8 cm
Art Gallery of New South Wales Research Library and Archive, Sydney, gift of Paul Fox
57002

Julie Rigg (ed), Russell Richards

In her own right: women of Australia, Thomas Nelson (Australia) Ltd, Melbourne, 1969
19.3 x 26.8 x 2.2 cm
Art Gallery of New South Wales Research Library and Archive
57000

Henry Chamberlain Russell

Nebeculae in the book *Photographs of the Milky Way and Nebulae taken at Sydney Observatory* 1890, p 5, no 2
28.4 x 21 cm
National Gallery of Australia, Canberra, purchased 1988
88.317.1-16

The Star Camera of the Sydney Observatory, Sydney, New South Wales, Australia, ST Leigh & Co Pty Ltd, Sydney, 1892, introduction and frontispiece
31 x 25 cm
Museum of Applied Arts and Sciences, Research Library

William Saville-Kent

The Great Barrier Reef of Australia: its products and potentialities, WH Allen & Co, London, 1893, frontispiece
35 x 27 x 5.5 cm
Australian Museum, Sydney
RB D919.43/SAV/RARE BOOKS

Reverend G Taplin

The folklore, manners, customs, and languages of the South Australian Aborigines: gathered from inquiries made by authority of the South Australian Government, E Spiller, Acting Government Printer, Adelaide, 1879, pp 64–65
21.6 x 14.9 x 2.9 cm
Robert Dein collection, Sydney

POSTCARDS

18 postcards
13.5 x 9 cm (each)
Art Gallery of New South Wales, purchased 2014

Charles Kerry

A warrior 1907–11
589.2014

Aboriginal corroboree 1907–11
586.2014

Fighting men 1907–11
587.2014

Kerry & Co

513.2014, 517.2014, 521.2014
518.2014, 524.2014, 520.2014
519.2014, 516.2014, 515.2014
514.2014, 523.2014, 512.2014
522.2014

A duel to the death 1901–07

A fighting man 1901–07

A queen of the soil and a queen's castle 1907–15

Aboriginal chief 1901–07

Aboriginal fight 1901–07

Aboriginal mia mia 1907–15

Aboriginal princess 1901–07

Aboriginal with devils mask 1901–07

Aboriginal with throwing stick 1901–07

An Australian wild flower 1901–07

Untitled 1901–07

Group of black trackers 1901–07

Native climbing tree with vine 1901–07

JW Lindt

Australian Aboriginal 1870–79, printed 1907–15
386.2014

Unknown photographer

Portrait of Aboriginal man 1901–07
466.2014

CARTES DE VISITE 1860–90s

3 cartes de visite
approx 10 x 6.5 cm (each)

Art Gallery of New South Wales, gift of Josef & Jeanne Lebovic, Sydney 2014
581.2014, 582.2014, 585.2014

Frazer Smith Crawford
'Professor' Robert Hall
Unknown photographer

278 cartes de visite
approx 10 x 6.5 cm (each)
or approx 6.5 x 10 cm (each),
1 card 6.7 x 11.8 cm
Art Gallery of New South Wales, purchased 2014
252.2014–261.2014, 263.2014–289.2014, 295.2014–306.2014, 310.2014–365.2014, 367.2014–379.2014, 381.2014–385.2014, 387.2014–464.2014, 468.2014, 472.2014–473.2014, 479.2014–489.2014, 491.2014–511.2014, 525.2014–548.2014, 551.2014–563.2014, 583.2014–584.2014, 600.2014, 604.2014–605.2014

Henry Hall Baily
William Bardwell
William Bear
Beavis Brothers
William Blackwood
Barcroft Capel Boake
Alfred Bock
James M Boles

Edwin Boston
Thomas Boston
Bull & Rawlings
Henry William Burgin
Arthur W Burman
Frederick Charles Burman
Alexander Carlisle
William Cawston
Walter Chaffer
Chandler & Lomer
George Cherry
Thomas Foster Chuck
Samuel Clifford
Charles Collins
Croft Brothers
Thomas E Crowther
Andrew Cunningham
Edward Dalton
Davies & Co
J Davis
John Degotardi (sr)
Charles Drinkwater
Townsend Duryea
Fitzalan
Thomas Flintoff
Freeman Brothers
Freeman Brothers & Prout
Frederick Frith
JW Fry
GB Fenovic & Co
Thomas Glaister
Henry Glenny
Henry Goodes
John Tangelder Gorus
Gove & Allen
Great Northern Photographic & Fine Art Company
H Roach & Co
Elijah Hart
Henry Hart
Harvey & Dunden
Hatton & Patching
'Professor' Jeffrey Hawkins
William Hetzer
Everitt E Hibling
James Hider
Edward Holledge
Johnstone O'Shannessy & Co
Henry Jones
Henry King
L Lange & Son
William J Liddell
Albert Lomer
James Manning
Annie Marchand
Henry Beaufoy Merlin
Joseph Charles Milligan
Milligan Brothers
SF Moore
Morris Moss & Co
Herman Moser
Henry Müller
Edward Nagel
William Nelson
Nelson's Saloon
Charles Nettleton
John Hubert Newman
George H Nicholas
Albert Nicol
Stephen Edward Nixon
Wykes Norton
William Parker
WR Reynolds
John Roarty aka Rourty
Robert W Newman & Co
San Francisco Photo Co
William Sargent
Montagu Eugene Scott
William Short
R Dermer Smith
J Souter
Robert Stewart
Stewart & Co

Sydney Photographic Company
Edward George Tims
August Tronier
Edward Turner
Various unknown photographers
WH Schroder & Vosper
James Walker
John Watson
Wherrett & McGuffie
Joseph Warrin Wilder
William Wood
Thomas JJ Wyatt
John Yates
Joseph Youdale

ACKNOWLEDGMENTS

This project has been four years in the making and has built on the work of photo historians Australia-wide. Firstly, without the meticulous research of Alan Davies and Gael Newton, this publication and the related exhibition would not have been possible. Secondly, the team at the Art Gallery of New South Wales, Sydney – most particularly my curatorial, conservation, public programs, design and publishing, library and archive colleagues – have enabled the successful completion of this book. In particular I thank assistant curators Eleanor Weber 2012–14, Isobel Parker Philip 2014–, assistant editor and writer Georgina Cole, researchers Jess Hope, Macushla Robinson, and interns Jacqueline Au and Amy Hill. Thirdly, as I have travelled across Australia and looked abroad for help and advice, I have been assisted in numerous ways by the following people and institutions:

ACT
Michael Desmond, Helen Ennis, Martyn Jolly, David Kaus, John Mulvaney, Andrew Sayers, Martin Thomas; Rose Montebello, Rebecca Nielsen, Gael Newton and Elspeth Pitt, National Gallery of Australia; Ian Affleck, Aine Broda, Janda Gooding and Alison Wishart, Australian War Memorial; Kathryn Barnes, Nicola Mackay-Sim and Eliza McCormack, National Library of Australia; Patrick Baum, Anthea Gunn and Sara Kelly, National Museum of Australia; Tasha Lamb, Australian Institute of Aboriginal and Torres Strait Islander Studies; Joanna Gilmour and Maria Ramsden, National Portrait Gallery.

New South Wales
Geoff Barker, Anthony Bourke, Brenda L Croft, Kathleen Davidson, Robert Dein, Anne Ferran, Simryn Gill, Jonathan Jones, Craig Judd, Josef and Jeanne Lebovic, John McPhee, Martin Terry, Anne Zahalka, Roslyn Oxley9 Gallery and Utopia Art Gallery; Alan Davies and Caroline Lorentz, State Library of New South Wales; Frances Fitzpatrick, Katrina Hogan and Paul Wilson, Museum of Applied Arts and Sciences; Jan Brazier, Rebecca Conway and Jude Philp, Macleay Museum, University of Sydney; Caroline Butler-Bowdon, Peta Hendriks and Megan Martin, Sydney Living Museums; Ben Arnfield, Jill Farish, City of Sydney; Susan Charlton, State Records Authority of New South Wales; Vanessa Finney, Australian Museum; the Royal Australian Historical Society; Cher Breeze and Jude McBean, Grafton Regional Gallery; Frank Mack, Clarence River Historical Society.

Queensland
Michael Aird; Julie Ewington, Angela Goddard and Michael Hawker, Queensland Art Gallery | Gallery of Modern Art; Gavin Bannerman, Dianne Byrne and Patricia Parr, State Library of Queensland; Nicholas Hadnutt, Bridget Kinnear and Tracy Ryan, Queensland Museum.

South Australia
Tom Gara, Ian North and Ken Orchard; Dorothy Woodley, Ayers House; Shane Agius, Lea Gardam and Philip Jones, South Australian Museum; Julie L Robinson and Maria Zagala, Art Gallery of South Australia; Rod Shearing, Royal Geographic Society; Pauline Cockrill, History SA; Brian Bingley, Mark Gilbert, Beth M Robertson and Suzy Russell, State Library of South Australia.

Tasmania
Nic Haygarth, Rhonda Hamilton, John Millwood; Bill Bleathman, Cobus van Breda, Vicki Farmery and Jane Stewart, Tasmanian Museum and Art Gallery; Ian Morrison, Caitlin Sutton and Stephanie McDonald, State Library of Tasmania, Hobart; Scott Carlin and Samuel Dix, Narryna Heritage Museum; Gemma Webberley, Runnymede; Jon Addison, Yvonne Adkins, Amy Bartlett and Ross Smith, Queen Victoria Museum and Art Gallery, Launceston.

Victoria
Ben Ford and Joy Hirst, Virginia Fraser, Kyla McFarlane, Anne Maxwell, Melissa Miles, Patrick Pound, Tim Smith and Elizabeth Willis; Shaune Lakin and Stephen Zagala, Monash Gallery of Art; Gerard Hayes, Eve Sainsbury, Madeleine Say, Claire Williamson and Fiona Wilson, State Library of Victoria; Richard Barnden and Kate Prinsley, Royal Historical Society of Victoria; Val Brown, Fiona Kinsey, Lorenzo Iozzi, Mary Morris, Melanie Raberts and Nell Ustundag, Museum of Victoria; Robyn Hovey, Ian Potter Gallery, University of Melbourne; Sebastian Gurciullo, Kathy McNamara and Jack Martin, Public Records Office of Victoria; Sophie Garrett and Helen McLaughlin, University of Melbourne Archives; Isobel Crombie, Susan van Wyk and Maggie Finch, National Gallery of Victoria.

Western Australia
John Dowson, Anna Haebich, Felicity Johnson, Jane Lydon and Robert Reece; Emma-Clare Bussell, Janet Muir, Jayne Orton and Erica Persak, Kerry Stokes Collection; Robert Cook, Jenepher Duncan and Melissa Harpley, Art Gallery of Western Australia; Peter Hocking, New Norcia Archive; Cristina Albillos, Adrian Bowen, Kate Gregory and Steve Howell, State Library of Western Australia.

New Zealand
Geoff Batchen, Victoria University, Wellington; Ron Brownson, Fiona Moorehead, Auckland Art Gallery.

Europe
Françoise Reynaud, Paris; Bente Jensen, Aalborg, Denmark; Monika Farber and Martin Keckeis, Photoinstitut Bonartes, Vienna.

United Kingdom
Jamie Carstairs and Hannah Lowery, University of Bristol, Library Special Collections; Sarah McDonald, Getty Images, London; Alison Morrison-Low, National Museums Scotland, Edinburgh

United States
Paula Fleming; Gina Rappaport, Smithsonian Institution, Suitland, Maryland; Keith Davis, Nelson-Atkins Museum of Art, Kansas City, Missouri.

CONTRIBUTORS

Author

Judy Annear has been senior curator photographs at the Art Gallery of New South Wales, Sydney since 1995. She developed an extensive program of collection-based exhibitions as well as curating major national and international exhibitions. Previous publications as editor and essayist include *Photography: Art Gallery of New South Wales collection* (AGNSW, 2007), *Bill Henson: Mnemosyne* (Scalo/AGNSW, 2004) and *Portraits of Oceania* (AGNSW, 1997).

Contributors

Michael Aird has worked as a curator, researcher and writer in the area of Aboriginal arts and cultural heritage since 1985. In 1996 he established Keeaira Press in Queensland, an independent publishing house, which has published over thirty books.

Geoffrey Batchen is professor of art history at Victoria University of Wellington in New Zealand. He has been published extensively, and his most recent books include the co-edited volume *Picturing atrocity: photography in crisis* (Reaktion Books, 2012) and *Suspending time: life, photography, death* (Izu PhotoMuseum, 2010).

Georgina Cole is lecturer in art history and theory at the National Art School, Sydney. Her research focuses on art and ideas in the Enlightenment. Her most recently published essay is 'Rethinking vision in eighteenth-century paintings of the blind', in Harald Klinke (ed), *Art theory as visual epistemology* (Cambridge Scholars Publishing, 2014).

Kathleen Davidson is an independent photography scholar. Her book, *Photography, natural history and the nineteenth-century museum: exchanging views of empire*, is forthcoming (Ashgate).

Martyn Jolly is head of photography and media arts at the Australian National University School of Art. His research projects include new technologies and the curating of Australian art photography (with Daniel Palmer), Australiana photobooks, and Australia's projected image heritage.

Jane Lydon is an Australian Research Council Future Fellow and the Wesfarmers Chair of Australian History at the University of Western Australia. Her research focuses on Australia's colonial past and its legacies in the present. Her most recent publication is *Calling the shots: Aboriginal photographies* (Aboriginal Studies Press, 2014)

Daniel Palmer is associate dean of graduate research and senior lecturer in the art history and theory program at MADA, Monash Art Design & Architecture. His most recent book is *Digital light*, with Sean Cubitt and Nathaniel Tkacz (Open Humanities Press, 2014).

INDEX

307

Published by Art Gallery of New South Wales
Art Gallery Road, The Domain
Sydney 2000, Australia
artgallery.nsw.gov.au

in association with the exhibition
The photograph and Australia

Art Gallery of New South Wales
21 Mar – 8 Jun 2015

Queensland Art Gallery
4 Jul – 11 Oct 2015

National Library of Australia
Cataloguing-in-Publication entry
Annear, Judy, author
The photograph and Australia / Judy Annear;
with essays by Geoffrey Batchen (postscript),
Michael Aird, Katherine Davidson, Jane Lydon,
Daniel Palmer and Martyn Jolly.
ISBN 9781741741162 (hardback)
Includes bibliographical references and index
Subjects: Photography – Australia – History.
Historiography and photography – Australia.
Australia – Pictorial works. Australia – History –
Pictorial works. Australia – In art. 770.994

Managing editor: Julie Donaldson
Text editor: Linda Michael
Proofreader: Amber Cameron
Photography (AGNSW): Jenni Carter
Rights and permissions: Megan Young
Index: Sherrey Quinn, Libraries Alive

Design: Matt Nix
Production: Cara Hickman
Prepress: Spitting Image, Sydney
Printing and binding: Australian Book Connection

The Art Gallery of New South Wales is a statutory
body of the NSW State Government

Distribution
Australia and New Zealand
Thames & Hudson Australia
11 Central Boulevard, Portside Business Park
Fishermans Bend, Melbourne 3207
T: 03 9646 7788
E: enquiries@thaust.com.au

North America
University of Washington Press
washington.edu/uwpress

All other territories
Thames & Hudson UK
181A High Holborn, London WC1V7QX
T: 44 20 7845 5000
E: sales@thameshudson.co.uk
thameshudson.co.uk

Cover image:
Tracey Moffatt *Beauties (in mulberry)* 1997 (detail)
(see p 121)

Anson Bros *Fern Tree Gully, Hobart Town,
Tasmania* 1887 (detail)
(see p 192)